# Studies in Rhetorics and Feminisms

Series Editors, Cheryl Glenn and Shirley Wilson Logan

# Antebellum American Women's Poetry

## A Rhetoric of Sentiment

WENDY DASLER JOHNSON

Southern Illinois University Press • *Carbondale*

Southern Illinois University Press
www.siupress.com

Copyright © 2016 by the Board of Trustees,
Southern Illinois University
All rights reserved
Printed in the United States of America

19 18 17 16    4 3 2 1

Library of Congress Cataloging-in-Publication Data
Names: Johnson, Wendy Dasler, author.
Title: Antebellum American women's poetry : a rhetoric of sentiment / Wendy Dasler Johnson.
Description: Carbondale : Southern Illinois University Press, 2016. | Series: Studies in rhetorics and feminisms | Includes bibliographical references and index.
Identifiers: LCCN 2015050493 | ISBN 9780809335008 (pbk. : alk. paper) | ISBN 9780809335015 (e-book)
Subjects: LCSH: American poetry—Women authors—History and criticism. | American poetry—19th century—History and criticism. | Persuasion (Rhetoric) | Sentimentalism in literature. | Social problems in literature.
Classification: LCC PS147 .J64 2016 | DDC 811/.3099287—dc23
LC record available at http://lccn.loc.gov/2015050493

Printed on recycled paper. ♻

# Contents

List of Illustrations  vii
Acknowledgments  ix

Introduction  1

PART 1.  Lessons in Logos
1. Antebellum American Women Poets  17

PART 2.  Ethos-in-Process: Sentimental Women Poets and "True Womanhood"
2. Frances Ellen Watkins Harper, Black Poet Ventriloquist  51
3. Reviving Lydia Huntley Sigourney  76
4. Julia Ward Howe's "I—s" and the Gaze of Men  108

PART 3.  Pathos: Who Reads Sentimental Poetry? And Who Cares?
5. Slave Market Matrix of Harper's Critical Pedagogy  135
6. Problems for Sigourney's Readers of Sentimental Rhetoric and Class  162
7. Howe's *Passion-Flowers* Dialogue with a Master  184

Conclusion: Sentimental Rhetoric's Poets and Prospects  205

Notes  211
Works Cited and Consulted  233
Index  257

# Illustrations

"Infancy," 1845   19

Frances Ellen Watkins Harper, about 1870   52

Black woman wearing bandanna, about 1860   72

Sethe and Beloved in *Beloved*   74

Lydia H. Sigourney, about 1860   77

Julia Ward Howe, about 1860   109

"A wasted female figure"   117

"A lank-haired hunter"   118

"A keen and bitter cry"   119

"Plump dropped the holy tome"   119

"The open window sill"   120

"To give it to the Devil!"   121

# Acknowledgments

Many more colleagues, friends, and family than I can name have made this book possible. Among them, mentors and my students have been crucial to the start and finish of this project. Suzanne Clark lives academic life with flair and has inspired me and listened, encouraged, and read my work before I knew this could happen for me. David Robinson showed me academic life can have heart and Over-Soul. Bill Rossi has seen promise in my wandering, cultivating ripe fruit from the tints. Mary Wood demonstrated a generosity of spirit that includes even me. Jane Donawerth has offered me a hand and insight through many difficult passages. Teaching me courage and persistence, my students Brian Schlosser, Kay Stephens, Amy Huseby, and Tyler Thralls have read drafts and caught errors, combed the formats, called libraries, and now press on to their own great work. Southern Illinois University Press editors Cheryl Glenn, Shirley Logan, and Karl Kageff continue to demonstrate patience, tough grace, and faith in the process.

After people, academics need libraries. Thanks seem small return for the work and commitment of librarians and curators at Oregon's Knight Library, the Connecticut Historical Society, Washington State Libraries, and the Library of Congress, who preserve and promote archives that made my searches into discoveries. Special thanks are due to curator Wendy Chmielewski of the Records of the Universal Peace Union in the Swarthmore College Peace Collection for permission to use an image of Frances Ellen Watkins Harper. The University of Oregon Humanities Center and Washington State University's College of Arts and Sciences have granted me space, travel, and support at important turns of this work.

I acknowledge *Romanticism on the Net* and the *South Atlantic Review* for publication of very early versions of chapters 3 and 4, on the ethos and personae of Lydia Huntley Sigourney and Julia Ward Howe.

Ongoing commitment to me and to us from Ron Johnson gives me heart in life's storms, and friends Al Bernstein, Edie Blakley, Cathi Von Schimmelmann, Betty Watkins, and Andrea Herling steady my keel.

Antebellum American Women's Poetry

# Introduction

*On my people's blighted bosom,*
  *Mountain weights of sorrow lay;*
*Stop not now to ask the question,*
  *Who shall roll the stone away?*

*Set to work the moral forces,*
  *That are yours of church and state;*
*Teach them how to war and battle*
  *'Gainst oppression, wrong, and hate.*
    —Frances Ellen Watkins Harper, "Be Active" (1856)

*"Oh, speak no ill of poetry,*
*For 'tis a holy thing."*
    —Lydia Huntley Sigourney, "Poetry" (1836)

The problem is, we don't know how to read their poems.
    —Cheryl Walker on antebellum women
        poets, *Nightingale's Burden*

If excerpts above from two poems cause today's readers embarrassed smiles, make us shake puzzled heads, or simply push us away, we have yet to come to terms with antebellum American women's writing. The purpose of this book is to provide a rhetorical framework and some of those terms, so that we can read these women's poems.

With this book in press, thirteen collections of nineteenth-century women's poems are in print, plus a 2008 digitized version of Caroline May's 1853 *American Female Poets*. Not another anthology of missing poetry, this book does include women's verse little discussed until recent years. Not a rehearsal

of women's biographies, still it includes material context from these poets' lives. Not a store of reception histories, yet some account of nineteenth-century readers' reactions is here. What then is this book? Cheryl Walker edited a 1992 collection, *American Women Poets of the Nineteenth Century*, and wrote the landmark 1982 *Nightingale's Burden*, setting antebellum poetry in historical context; nevertheless, Walker admits that Lydia Huntley Sigourney is "one of many poets we now know something about. The problem is, we don't know how to read their poems" ("Lydia Sigourney" 1). Despite literary historians' attention to antebellum women poets, recent collections and these women's lives may be lost once more unless we figure out how to understand their work.[1] This book is a rhetoric designed to make sense of an enormous body of women's texts—in verse.

What sort of rhetoric amplifies women poets' muffled voices? Today's familiar "rhetoric" discusses writing conventions, a text that writing instructors and students use alongside model essays. Such rhetorics work something like this book, for composition texts too aim to develop critical faculties for reading, critiquing, and producing "all available means of persuasion," Aristotle's classical definition of rhetoric. Many means of persuasion—arguments, tropes, figures, genres, styles, invention and revision strategies, with politics and cultural logics of each—are subjects of composition rhetorics. Instructors want inexperienced writers examining their own views and crafting their own arguments, coming to terms with conventions that mark shifting boundaries of appropriate discourse. So students too can use and break the rules to their own ends. In good rhetorics, students catch glimpses of why writing goes astray, why writers sometimes miss their goals. Thus composition rhetorics support both instructors' and students' work. Only here the subject is not academic essays, but poetry—women's poetry written more than 150 years ago.

We need a rhetoric of U.S. antebellum women's poetry for nearly all the same reasons we need a composition rhetoric. This rhetoric revives many means of persuasion outside today's usual repertoire, emphasizing registers of the rhetoric of sentimental *ethos*, *pathos*, and *logos*—the writing personae, audience appeal, and logic—exemplified in poems by African American abolitionist Frances Ellen Watkins Harper, working-class prophet Lydia Huntley Sigourney, and feminist socialite Julia Ward Howe. Emily Dickinson published only a handful of poems in her lifetime, but these three were the best-known and most-read women poets of their day. That poets once enormously popular remain today virtually unknown is one good reason for this rhetoric. Moreover, a heuristic framework to read

these exemplars should also help us read personae, audiences, and logic of their contemporaries—a substantial contingent of that "damn'd mob of scribbling women" looming large in Nathaniel Hawthorne's 1854 letter of jealous complaint to his editor. Feminist rhetorical work today seeks "innovative ways to engage in an exchange with these women both critically and imaginatively" in a "more dialectical and reciprocal engagement" than Aristotle afforded objects of analysis (Royster and Kirsch 14). I offer instead, in C. Jan Swearingen's words, rhetorical frameworks to revive "a living museum of actual voices, possible selves" that by specifically rhetorical analysis can again be effective "models for interacting with others" (236). Recovering a rhetoric of sentiment would amplify and project voices of serious sentimental poets, so we may hear and respond to them and other urgent, muffled appeals.

## *Poetry as Rhetorical, Persuasive*

Poetry, however, is one voice rarely heard in histories of women's rhetoric. Catherine Hobbs collected thoughtful critical essays in *Nineteenth-Century Women Learn to Write* (1995) with such topics as literacy instruction, oratory, law, and fiction. Yet Hobbs observes that "listening to women's 'voices' from our past has only begun" (4).[2] To construct a fuller account, Jacqueline Jones Royster insists we "not automatically discount the discordant, revolutionary, or evolutionary voices of the unsanctioned or un-institutionally authorized" (284). In a day when women speaking before "promiscuous" or mixed-gender audiences risk becoming "promiscuous" themselves, women speak more in print than in public, and thousands of these rhetors are poets. Reading their poems, we acknowledge one more historically unsanctioned chorus of women rhetors.

After 1865, English departments arose as we know them, and virtually all women's poems got swept from the stage of critical discussion. English studies was "centered," Hobbs points out, "on the reading and criticism of vernacular literary texts," (3), almost all by men. Soon "literary" to describe English studies obscured "rhetorical," which included the overt appeals of women's sentimental poetry. *Antebellum American Women's Poetry: A Rhetoric of Sentiment* joins a gathering movement in "the three Rs, . . . rescue, recovery, and (re)inscription" that Royster and Kirsch advocate, reengaging both sentiment and nineteenth-century women's texts as objects of serious study (14), specifically that chorus of women's poetry calling for reform in public sentiment before and during the U.S. Civil War.[3]

Some readers will want an explanation of poetry as persuasive and rhetorical, for many hold to a modernist view that literature by definition makes no arguments. That belief permeates today's problem with sentimental poetry. Eminent feminist critic Paula Bennett discovers that "after a century or more in history's dustbin, the Poetess has made a stunning comeback" ("Poetess" 266), but she has resisted the sobriquet "Poetess." Earlier, introducing the 1997 collection titled *Nineteenth-Century American Women Poets*, she confessed herself a "recovering New Critic," for "knowing what made a poem 'bad' easily became more important than understanding what may have made it 'good' to a previous generation" (xxxv). Analysis in rhetorical frameworks offers one response to Bennett's quandary on recovering virtues of sentimental poetry obvious to previous readers. Theirs was a culture that saw verse as one more subcategory of rhetoric. Since sentimentalism focuses on moral questions, theorists of the day asserted by extension the discourse deals with thought or intellect—invoking Aristotle's classic definitions. Thus the poetry characteristic of sentimental discourse must also be a part of rhetoric. With no apparent qualms, Aristotle blurred his own distinctions between "art" and "persuasion," arguing that thought "is shown" in poetic discourse the same way thought appears elsewhere "in everything to be effected by [characters'] language—in every effort to prove or disprove, to arouse emotion . . . or to maximize or minimize things" (*Poetics*, 1455:34–38). In that vein, Cheryl Glenn writes that attributing suasive dimensions to poetry as a genre demonstrates that for Aristotle, "rhetoric subsumed the productive art of poetics, recognizing it as a particular case of persuasion" (138). Indeed, for most of its long, checkered past, rhetoric is the discipline under which education itself sprang up, including study of fine arts such as poetry.

To glimpse the sweep of sentimental rhetoric as a historic discourse, Carol Mattingly directs us to "immerse ourselves in a broad range of historical texts across genres including but not limited to texts of speeches" ("Telling" 105). Studies in nineteenth-century American rhetoric must include poetry, James Berlin maintains, characterizing those decades as one of many "historical moments" when "rhetoric has been the larger category, including poetry as one of its subdivisions" (*Rhetorics* 3).[4] In early American discourse, one critic finds "the word 'rhetoric' becoming . . . an omnibus term meaning the entire field of language and literature" (Bigelow 34). A "wedding" between the rhetoric of sentiment and literate pursuits, reports Winifred Horner, lasted nearly two hundred years, joining "the study of English literature, and critical theory and the new psychological rhetoric" (5). Frances Harper is one antebellum woman unfazed by genre boundaries,

incorporating poetry into abolitionist speeches she delivered. Harper writes as do African American women Alice Walker and Toni Morrison today, according to Jacqueline Jones Royster, "blurring genres in one text, using multiple forms... as part of a meaningful matrix of activities" (237). Many recognize again that all discourse—including sentimental poetry—is rhetorical, with persuasive and epistemic powers urging upon us the matrix of all we can discern and know.

Among notable studies extending our knowledge of nineteenth-century rhetorical practices, Mattingly's *Appropriate[ing] Dress: Women's Rhetorical Style in Nineteenth-Century America* (2002) recovers the importance of clothing to tailor an acceptable ethos for women orators new to public speaking.[5] With clothing, spatial arrangement, architecture, digital media, and a host of other discourses open to rhetorical inquiry, the term *rhetoric* has reinserted its omnibus self into conversations well beyond language and literature. Such inclusions reassert rhetorical analysis as an expansive project where poetry is not an intruder. My approach to the rhetoric of serious sentimental poetry builds on two commonplaces of rhetorical tradition: one, that all discourse is persuasive; and two, that exchanges in whatever medium or genre (including poetry) advance arguments both shaped by material circumstances and bent on affecting them.

### *Fall and Rise of "Dangerous" Sentiment*

Doubts many of us share with Paula Bennett on what makes sentimental poetry good were sown by such critics as Edmund Fuller, in 1957 condemning as "sentimental" those texts performing a "peculiar transposition of values." Whether objecting to a nineteenth-century rhetoric of sentiment or to a new twentieth-century strain, Fuller contrasted noble modernism to "weird sentimentality" such as John Steinbeck's with its "inverted pathos." To Fuller, sentimentality was dangerous because it promoted "the fallacy of 'the beautiful little people'—which almost always meant the shiftless, the drunk, the amoral, and the wards of society."[6] Sentimentalism by the 1950s had devolved to its low state, Fuller believed, from an earlier "foolish romanticizing of the scalawag: a beery, brass-rail sentimentality" (57). Feminist editors and critics since have made sure women's nineteenth-century texts would reappear, and because of this work, we may "alter some of our early prejudices," Carol Mattingly observes, about what count as fit subjects for research ("Telling" 104). Rhetorical studies play a key role in reeducating today's readers about the sentimental.

Some now find anti-establishment views characteristic of many antebellum U.S. women poets—and perhaps a few were "beery"—although Mattingly's work reveals hundreds of thousands of women drove the temperance movement.[7] Fuller's indictment of sentimentalism's reform agenda may reveal too why it was excluded decades before from curricula drawn up by U.S. literary elites. Sentimentalism threatened their power over literate audiences. "God preserve us," Fuller pleaded, from that peculiar discourse that risks "the inversion of good and bad" (65). Suzanne Clark's perceptive book *Cold Warriors: Manliness on Trial in the Rhetoric of the West* (2000) examines effects on literary culture of such modernist campaigns in the 1950s, drawing force from Senator Joe McCarthy's hearings and the House Un-American Activities Committee. Modernists kept sentimentalism off reading lists because much of it advanced progressive causes. Such stuff could contaminate a literary domain largely established against it.

Persuasion in poetry, after high modernism, again flexes popular political muscle. Readers are moved by the appeal and power of poetry. Thousands of poems flooded radio, TV, and commemorative websites following the 2001 attacks on New York City, and the 2003 Bush White House canceled a conference of poets because anti-war sentiments threatened to disrupt it. State and national poet laureates gathered at the April 2003 New Hampshire Writers' Project conference to speak under the banner of "Poetry and Politics." The poets know their work is controversial. Already by the 1990s, women swelled the ranks of activist poets out to change the world: "Perhaps at no time since the early nineteenth century have poets so consciously spoken to help change the world," writes Florence Howe, introducing a 1993 edition of twentieth-century women's verse (lxvi). Howe's encomium to foremothers among poets of sentiment along with political moves by American poet laureates indicate a groundswell of poetic power well under way. Reintroducing a rhetorical heritage of nineteenth-century popular poetry, this book may also help us read even newer arguments in verse.

I am not urging everyone to write poetry in the style of antebellum sentimental verse. Yet taking these three poets seriously—Harper, Sigourney, and Howe—we might better grasp the powerful appeal of poetry jams, hip hop, and the work of former Tennessee state poet laureate Maggi Vaughn, who says her twenty-first-century readers "want a poet of the people, someone who can go to the crossroads and big cities, and people will understand" (qtd. in Dinitia Smith). For the trail they blaze for later women, for their courage and broad appeal, for their attempts to change their world, antebellum women poets deserve new attention. This book could turn up the

volume on antebellum poets' rhetoric of sentiment, just one of those past collections of "shared interpretive strategies" Steven Mailloux discerns as "historical sets of topics, arguments, tropes, ideologies . . . which determine how texts are established as meaningful through rhetorical exchanges" (15). Attending to the rhetoric of three poets, we find other lost ways of seeing and thinking. My aim echoes the intent of any "rhetoric" text now in print: with more sympathy for overlooked discourses, we better craft for our day sophisticated repertoires of understanding and persuasion.

## *Sentimentalism's Codes and Theorists*

The extent of current amnesia on antebellum sentimental poets as rhetors, a kind of cultural hearing loss, might be measured not only by loss of poetry as persuasion but also by distortion of the "sentimental" from earlier use. Many have forgotten terms of the eighteenth and nineteenth centuries that I have noted linked "sentiment" to "moral" and "sensible," not to an excess of feeling.[8] Claiming a (today contested) genealogy from Aristotle, theorists used such early qualifiers to associate sentimental codes with Enlightenment language about inductive scientific inquiry, undercutting the scholastic regime of deductive logic. George Campbell, influential theorist of what Winifred Horner dubs the "new psychological rhetoric," assured students that "what is addressed solely to the *moral* powers of the mind is not so properly denominated the pathetic [or passionate] as the *sentimental*" (80; emphases and brackets in original). Soon after its 1776 publication in London, Campbell's *Philosophy of Rhetoric* became a standard textbook at Yale, Horner says. Training decades of New England preachers, teachers, lawyers, and businessmen, Campbell's version of the rhetoric of sentiment remains a landmark of rhetorical theory. Hugh Blair's *Lectures on Rhetoric and Belles Lettres*, first printed in 1783 in London, with countless later U.S. school editions and abridgments, was more widely published than Campbell's *Philosophy* and reached innumerable rank-and-file readers and writers. For statements about sentimental theory, I refer in this study to Campbell. For application and literary examples, I refer to Blair's *Lectures*.

Citing these texts does not elevate men's theories over women's work. Indeed, recent anthologies of rhetorical practice and theory include both Harper's and Sigourney's later comments on genres and topics other than poetry.[9] Rather, works by poets foundational to this study are framed by their contemporary theories of rhetoric to point out, first, that U.S. sentimentalism got linked to women pejoratively only with the "alarming" spread of

nineteenth-century women's literacy and rising popularity of their texts—
and with the establishment of mostly male English departments. Sentimental
discourse was articulated from the first in established scholarly discussions
of rhetoric set out and also used by men. Nineteenth-century sentimental-
ists were never only women, and U.S. sentimentalism was as male as it was
female.[10] Second, and more important to this book as a feminist project,
connecting textual strategies of antebellum women's poetry with a code of
sentimentalism indicates the craft and persuasive intent of women's own
discourse. Knowing the code of rhetoric they followed is one way to better
read these women's poetry on its own terms.[11]

The rhetorical system these poets engaged exploited the faculty psychol-
ogy of Enlightenment empiricism to shape public sentiment. Lydia Huntley
Sigourney endorses this take on the mind in *Letters to Young Ladies* (1833),
a conduct book including instruction on the fourth canon of rhetoric, the
memory. The poet says the best way to strengthen memory is not by verba-
tim repetition, but by

> giv[ing] the substance of the author . . . in your own language.
> Thus the understanding and memory are exercised at the same
> time, and prosperity of the mind is not so much advanced by the
> undue prominence of any *one faculty*, as by the true balance and
> vigorous action of *all*. (Donawerth, *Theory* 145; italics Sigourney's)

Engage the faculty of understanding along with memory putting more of
the mind to work, and you will more likely retain what you read, she says.
Campbell distinguished between raw passions (synonymous with appetite
or emotion) and acceptable virtues to be cultivated (allied with sentiments
and morality) as motives to action. To Scottish collegians, he explained,
"The difference is akin to that, if not the same, which rhetoricians observe
between *pathos* and *ethos*, passion and disposition" (80; emphasis in original).
Campbell separated passions and virtues, pathos from ethos, but he aimed
to engage both in order to persuade.

In current rhetorical studies, pathos refers broadly to strategies of audience
appeal, and I generally use the term in this sense. But in the sensationalist
epistemology Sigourney and Campbell used, pathos or passions were raw
materials of the psyche; passions were understood as one of four mental
faculties (along with imagination, understanding or reason, and the will)
that worked in every human mind to absorb, sort, store, and respond to
sensory impressions. (Pathos as strategies of audience appeal is inseparable
from the passions in any strict sense; rhetorical theories all acknowledge that

readers' and hearers' emotions have a part in persuasion.) Cultivating raw mental faculties was necessary to establish an acceptable ethos for speakers or writers and also to shape audience sentiments. Hugh Blair explained to readers and writers of poetry, "The ultimate end of all Poetry, indeed, of every Composition should be to make some useful impression on the mind" (1:361, lecture 40).[12] In sum, a sensible poet's disposition in the text and her attempts to make "useful impressions" on the minds of antebellum Americans (both her ethos and her pathos) are both rhetorical constructions born of sensationalist epistemology and its extension, a theory of persuasion designed to cultivate proper sentiments.

Underscoring longevity of the new mental science, Nan Johnson observes that nineteenth-century North American rhetoricians shared with "eighteenth-century predecessors . . . an understanding of how the rules and principles of rhetoric are related to operations of the mind" (*Rhetoric* 67). Johnson cites Edward T. Channing, Boylston Professor of Rhetoric and Oratory at Harvard (1819 to 1851), who declared rhetoric "a 'helpmate of nature,' a body of rules 'derived from experience and observation' showing how to make the expression of thoughts effective 'in the way that nature universally intends, and which man universally feels'" (*Rhetoric* 70). Channing's use of "man" reflected the reality that Harvard students were then all men, but their sisters and other rhetors took full advantage of principles he laid out; moreover, Channing's rhetoric was direct heir to the experience-based, empirical definition Campbell articulated half a century before: rhetoric is "that art or talent by which the discourse is adapted to its end" (Campbell 1). The end of antebellum rhetoric is to inculcate proper moral sentiments in the minds of its audience; popular women poets deliberately appropriate the available rhetoric of sentiment, convinced verse is one useful way to stamp right feeling on the minds of American readers.

If "useful" sentimentalism sounds strange to us now, the shock of sentimentalism's unconventional, sometimes blasphemous challenge to received thinking has been obscured by twentieth-century claims that it restricted only women's lives.[13] The new rhetoric, born of Enlightenment skepticism, turns upside down scholastic assertions that one can deduce the truth by syllogism alone.[14] Instead, the rhetoric of empiricism persuades audiences to accept socially constructed truths via textual images replete with sensory detail and powerful textual personae, figures in the text drawing readers to identify with them. The object was to re-create bodily experience in print, so readers share a writer's sensory perceptions and judgments.

### *Harper's Command of the Craft*

The effects on the mind from lines in this introduction's epigraph, the first two stanzas of Frances Watkins Harper's 1856 poem "Be Active," are a case in point. Here too is the final stanza:

> Oh! be faithful! Oh! be valiant,
>   Trusting not in human might!
> Know that in the darkest conflict,
>   God is on the side of right!          (*Day* 77)

Audiences first hearing the abolitionist speech this poem was likely part of—along with later readers of the print poem—are to feel on their own chests the "mountain weights of sorrow" victims of American slavery bore. Earlier Harper presents other graphic details of slave life: a "brother . . . bleeding" under "oppression's feet of iron," a "despairing mother" holding "her burning brow in pain," a "trembling maiden, / Brutal arms around her thrown," and "a hundred thousand / New-born babes" born every year on the "gory, reeking altars" of chattel slavery. Such details should grip imaginations and passions in a way that forces every person to share burdens carried by slaves. The poet's enthusiastic exhortations to faithful, valiant action—to "roll the stone" of oppression away as angels rolled the stone from Jesus' tomb—are carried along by the pulse of tetrameter or "sixteener" rhythm familiar from hymns. Biblical allusion and the poem's hymn meter would connect Christian tradition and principles of faith to Harper's abolitionist cause. The poet's hearers and readers must become angels of liberation working to abolish slavery with the fervor and action profound faith requires.

Sentimentalism's lack of syllogism does not mean "this rhetoric presented no arguments," as Clark and Halloran once claimed (14).[15] Jane Tompkins instead describes sentimentalism as "a rhetoric [that] *makes* history." This insistently reformist discourse works, Tompkins argues, "by convincing the people of the world that its description of the world is the true one" (*Sensational* 141; italics in the original).[16] Engaging sentimentalism's logic, Harper piles up sensory data obvious to any thoughtful observer of the slave system. The full impact of this data cannot fail to bring "you" implicit in her imperative mood to her conviction: She uses sentimental conventions to persuade her audience they must join the abolitionist cause.

Along with induction, the rhetoric of sentiment implies metonymic logic asserting *a* equals *b*, and anything true of *a* automatically fits *b*. Like transference in psychoanalysis, sentimental codes depend on sympathetic

identification between a rhetor and her or his audience.[17] Thus if "I" as rhetor move "you" to identify with me, the common sense of faculty psychology moves you to judge as I do and to take my position on any topic. An effect of such sympathy, a "main engine" of rhetoric, Campbell claims, was to allow a speaker or writer to "insinuate himself" and automatically "transfuse his sentiments and passions into their [readers'] minds" (98). And if "himself," why not "herself"? My sentiments, each a righteous blend of intellect and feeling, almost magically become yours. (Predictably, however, my own description of nonsyllogistic sympathy does not escape syllogistic syntax.) To this end, useful indeed is a rhetorical system promising readers or hearers an experience just like being there by means of faculty psychology and sympathetic identification. Women poets, believing their texts one genre of this wider discourse, put its several engines into gear.

### *Women Poets' Courage to Speak*

Along with sentimentalism's Enlightenment roots, obscure likewise until recently has been the fabulous act of daring required of the early American or nineteenth-century woman aspiring to the role of writer—not to mention of serious sentimental poet. One unconventionally bookish, philosophical nature poet inspires this project's discussion of sentimentalism. Young widow Holmes is named admiringly the "serious sentimentalist" of William Hill Brown's 1789 *Power of Sympathy*, a novel of the new American republic. In Brown's cautionary tale, Holmes is foil and counselor to flighty young women; thus her sentimentalism could have a conservative effect. Holmes advocates a country life of books and writing in contrast to "scenes of boisterous pleasure and riot," fashionable haunts of early American city dwellers. She represents also, however, a woman resisting the crowd to think and act on her own. In a day when proper single women were to seek the protective wing of male authority and marriage, Holmes enjoys a measure of dignified freedom (35, 37–39). She remains unmarried, pursuing scholarly interests. Her life excludes domestic pursuits and motherhood, so in effect she is for her day a radical model for women.

"Serious sentimentalism" in this sense runs contrary to excess of feeling that characterizes modernist stereotypes. Were antebellum women poets considered sentimental in their day? In this specific sense, yes. Antebellum poetry by Harper, Sigourney, and Howe usually engages Holmes' serious tone, but these later poets more overtly urge on readers political agendas of abolition, economic justice, and women's rights. Not ignoring cultural

challenges, as well as these poets' own complicity at times with cultural constraints, this book as a rhetoric emphasizes antebellum women poets' agency and power produced by strategies offered them by sentimentalism.[18] Sentimental poets were out to change the world.

## *Rhetorical Design of This Study*

Engaging also classic rhetorical dimensions of analysis, this study considers in turn the logos, ethos, and pathos of antebellum American women's sentimental poetry. Never separate, each aspect of discourse and persuasion is useful to interpret this poetry and, as Aristotle claimed, to generate arguments—here, arguments in verse by Frances Ellen Watkins Harper, Lydia Huntley Sigourney, and Julia Ward Howe.

This book begins in part one by tuning our new millennium's ear to reasoning and theories of persuasion that propelled antebellum poets into print, and these are issues of logos: How dare they speak up—all three in print and Harper customarily from the podium—when proper women hardly appear in public at all? What logics of discourse, poetry, and their culture sustain these women as writers? What characteristics of these poets' ways of seeing and writing suggest patterns instructive for research into other antebellum women poets?

Part two asks questions that amplify echoes of the poets' own selves: By what values, characteristic strategies, and visions does each poet define her task? What textual personae are constituted by these strategies and values in poems by Harper, Sigourney, and Howe? These issues comprise a writer's ethos, her character or disposition in the text. Questions of ethos also necessarily involve how particular material conditions of race and class affect each poet's life work. In other words, what difference does it make that Harper is born a free black in Baltimore? That Sigourney is a gardener's daughter? That Howe is oldest daughter of a wealthy banker's family?

In part three, this book also cocks an ear for echoes from these poets' readers, asking questions of pathos: What strategies in their poems unlock sentimentalism's power to move the antebellum reading public? From figures in these women's texts, as well as from contemporary and recent critical comments, what can we know of those new multitudes in an increasingly literate public? What might mid-nineteenth-century readers of poetry have to tell us now about rhetorical power?

A closing word on Sigourney's benediction for poetry at the head of this introduction: Sentimental poetry is holy to Lydia Huntley Sigourney

and her sister poets perhaps precisely because of its common touch. In this poem, Sigourney writes on behalf of young women, poor, homeless, sick, and bereaved readers—everyday folk who are inspired and comforted by poetry. Poetry accompanies people morning, noon, and night as analogies for youth, hardworking adulthood, and death. To end each stanza, a young woman, a worker, and a dying soul defend poetry with the epigraph: "Oh, speak no ill of poetry / For 'tis a holy thing."

What is holy is deemed valuable and good—sacred. For everyday folk, poetry could be a daily comfort, very nearly a sacred presence standing by when powerful people do not. As more people can read and write, poetry in print becomes a means of reaching and hearing from many voices, a more open forum than virtually any podium at the time. When being seen in public is risky for women, not to mention being heard, poetry in print gives women permission to speak their minds and their hearts. As a vehicle of persuasion, poetry offers women a means to shape public sentiment when most other means are denied. In an age claiming to respect displaced people and perspectives, it may be high time to go beyond reprinting antebellum women's poetry—and learn to read more of it.

PART I

Lessons in Logos

# 1. Antebellum American Women Poets

*So, singing along, with a buoyant tread,*
*I drew out a line as I drew out a thread.*
    —Lydia Huntley Sigourney, "The Muse," *Poems* (1842)

This is a common cause; and if there is any burden to be borne in the Anti-Slavery cause . . . , I have a right to do my share of the work.
    —Frances Ellen Watkins Harper, 1854 letter to William Still

With and beyond ideology, writing remains—a painful, continuing struggle to compose a work edge to edge with the unnamable sensuous delights of destruction and chaos.
    —Julia Kristeva, *Black Sun*

### *Lesson One: Learn Dominant Discourses*

Before dismissing nineteenth-century women's sentimental discourse, we could seek to know what its poets tried to do. Learning their logos, their strategies and aims, we might realize, as from Julia Kristeva's warning on academic writing, "One does not deconstruct before having constructed" (Clark and Hulley 156). These poets' approach might even move us to better adapt our own day's discourse. One aim of this study would demonstrate that for American antebellum women, learning and unlocking dominant discourse means deploying tactics of sentimentalism—not because they are women, but because sentimentalism is the discourse at hand used by preachers, lawyers, merchants, novelists, poets, even famous essayists like Ralph Waldo Emerson. These women learn and use a code not

designed for them, but divert its strategies such as metonymy to their own ends.

In the rhetoric of sentiment, metonymy equates items in a series and so lets those items identify with each other. Lydia Huntley Sigourney persuasively uses metonymy to link writing with sewing. Metonymy moves between flirtation and theology to support Julia Ward Howe's literary ambitions. In the opposite direction, slides from radicalism to maternity and home let Frances Ellen Watkins Harper maintain propriety as she stumps about the North for abolition and, after the Civil War, for reconstruction and feminist causes.

All three make clear (Sigourney via conduct book advice, Howe through speeches, and Harper in letters and stories) that reading, writing, and poetry build women's life raft on seas of American nineteenth-century culture that otherwise could engulf women in idealized roles of wife and mother. I argue in this chapter Sigourney's insight into aural effects of poetry suggests that metonymy in micro-dynamics of sentimental language—between "maternal" registers and the sounds of verse—accounts for women's delight in sound and rhythm of poetry. But I also argue that Frances E. W. Harper's call to poet-mothers to shape a new world gives women permission to effect social change. Micro-rhetoric on linguistic and psychological levels, with macro-rhetoric on the level of topics, together allow a woman writer both to separate from—and to stay connected with—affective dimensions of domestic and maternal life. Large and small, the rhetorical logic of metonymy permit her to impact her world.

Too many today forget these terms of the eighteenth and nineteenth centuries link sentiment to the adjective "moral," not merely to feeling. In *Philosophy of Rhetoric* (1776), George Campbell distinguished the sentimental from the sensational, lecturing his students, "What is addressed solely to the *moral* powers of the mind is not so properly denominated the pathetic [or passionate] as the *sentimental*." As motives to action, he differentiated between passions (then associated with feeling, appetite, and women) and virtues (allied with sentiments and morality). Campbell added, "The difference is akin to that, if not the same which rhetoricians observe between *pathos* and *ethos*, passion and disposition" (80; italics and brackets in original). The sentimental, according to then dominant rhetorical theory, works alongside pathos, or persuasion of public feeling, but more specifically, this rhetoric invokes arguments about ethics, rational values, and judgments. Women want a say on these issues.

If a woman's aim or logos is to shape public sentiment, she indeed goes after feeling but also after values and rational argument. Always at stake as

well in sentimental rhetoric is the "disposition," which I read as character or personae and subjectivities of readers and hearers (pathos) directly responding to ethos of the writer or speaker. It is no accident that in rhetorical analysis of the long tradition of black women's writing, Jacqueline Jones Royster underscores "the extent to which pathetic *and* ethical arguments . . . assume value in the sense-making process" (31; italics added). This sentimentalism engages Locke's epistemology of the senses, the new mental science developed by Locke's successors, and moral philosophy. Burgeoning commercial interests will then target public sentiment with designs on its industrialized buying power, interlacing commerce and sentiment in such texts as economic theorist Adam Smith's 1759 *Theory of Moral Sentiments*.

Consider the complicity of commerce and sentimental metonymy in a haunting illustration, "Infancy," from *Godey's Lady's Book* (February 1845). Here metonymy plays on a light-haired child who sleeps with a black kitten clasped to its breast. Both are cradled in a puffy white bed (figure 1.1). Children should be taken care of; this is one moral assertion undergirding the illustration. The title focuses attention on the child, but a pearl bracelet displayed on the chubby wrist along the diagonal of the kitten and baby's

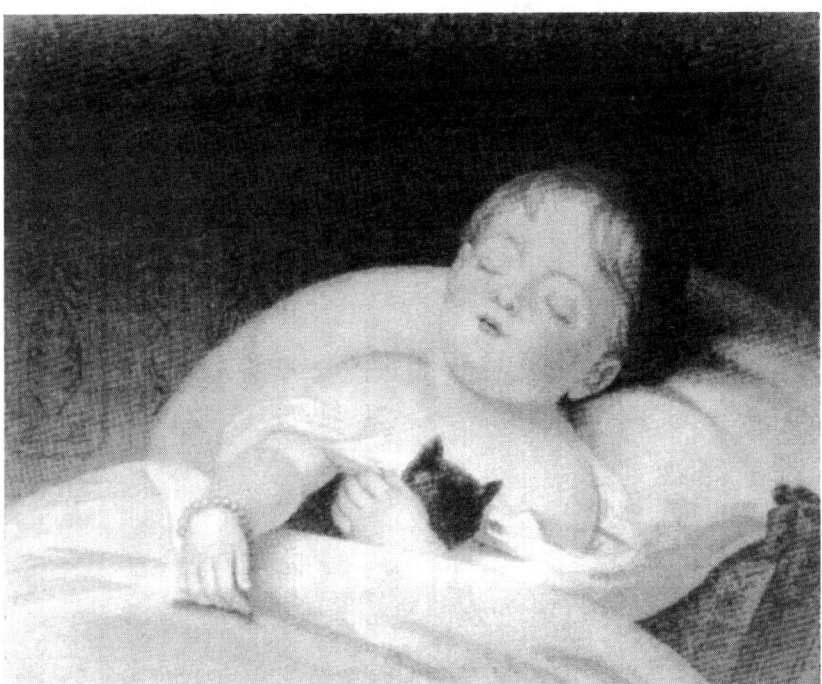

Fig. 1.1. "Infancy," frontispiece in *Godey's Lady's Book*, February 1845. KNIGHT LIBRARY, UNIVERSITY OF OREGON.

face suggests this tot plays into both a reader's middle-class and maternal status. The diagonal works its metonymy to displace a bourgeois white woman reader's gaze along a line from child, to pet, no doubt to purchase of the bracelet. Referring to this picture, Isabelle Lehuu asserts, "The lessons of *Godey's* visual texts were conformist.... They embodied an ideology of domesticity, maternal instruction, and the power of sentiment" (89). And commerce.

## HARPER'S METONYMY FROM MARKET TO PODIUM

Nineteenth-century American sentimentalism does not always move arguments along a single displacement from white motherhood to consumerism, however, a divergence starkly enacted by African American Frances E. W. Harper. She anticipates in 1885 John F. Kennedy's "Ask not what your country can do for you," declaring to a society still divided by race:

> The education of the intellect and training of morals should go hand in hand. The devising brain and the feeling heart should never be divorced, and the question worth asking is not simply, What will education do for us? But What will it help us to do for others? (*Day* 276)

Intellect and morals are of a piece, Harper's logic insists. She learned as a student of rhetoric in her Uncle Watkins' antebellum Baltimore school that sentiments knit together "the devising brain and the feeling heart." To practitioners of the rhetoric of sentiment, the rhetorical aim or logos to shape sentiment means joining feeling to reason to get readers and audiences on their feet, moved to be activists themselves. Royster conducts rhetorical analysis of sentimentalism revealing nineteenth-century women's interests, particularly black women's, "are not just in expressing themselves in writing but in using language in such a way as to affect the reader's heart, mind, and soul" (21). Serious sentimentalism seeks to move readers' passions but does so in order to transform thought and action.

While Isabelle Lehuu rightly warns of cultural texts like "Infancy," I argue the broad rhetorical context of U.S. sentimentalism undermines arguments locking sentimental discourse into an equation with mothers, bourgeois domesticity, and what many believed was its logical end: European America's ideal of feminine conformity. That narrow trajectory bypasses the haunting power of this picture and the broader force of sentimental logos. Association or strategic metonymy in the rhetorical logos of sentiment can give women a voice. Women's so-called proper activities may thus slide away through piety and sewing—to poetry, to sex, to sanity, to women's risky and radical

projects in a male-dominated culture—that is, to becoming published writers and public activists.

Perhaps sometimes the sentimental poet is a predatory businesswoman. But along the way, not incidentally, sentimental displacement between domestic and other realms—often public and activist—links a nineteenth-century woman irrevocably to the act of writing and to poetry. A rhetorical double-step achieves precisely the aims, the logos, of an antebellum woman writer. And what does she want? She wants to write.

Fanny Fern's remark about American women is commonsense before the Civil War: "At this day it is difficult to find one who does not write, or has not written, or who has not, as least, a strong desire to do so" (qtd. in Warren, Fern 214). "One" obviously desires to do her work, to write. The difficult labor necessary for antebellum women to write at all fits Kaja Silverman's characterization of metaphor and metonymy. Silverman says these two figures "respond to similarity and contiguity as the basis for the *temporary replacement* of one signifying element by another." A metonymic relationship "assert[s] neither the complete identity nor the irreducible difference" between two terms (109; italics in the original). By this strategy, a host of antebellum women could make writing and kitchen tasks, piety and seduction, motherhood and abolition appear on the same page, and the one never quite obscures the other.

Kenneth Burke defined metonymy as "reduction," taking to task scientific behaviorists for uncritically representing "some incorporeal or intangible state in terms of the corporeal or tangible"—that is, squeezing human behavior into mathematical charts ("Tropes" 506). The charge is just as critiqued by Burke. But with positive effects for nineteenth-century women's writing, sentimental displacement often reduces women's production of texts to the status of more mundane work. Metonymy sets up an ambivalent relationship between the material world of domestic matters and symbolic domains of literature, the marketplace, and political action. The last three are otherwise realms beyond the grasp of an antebellum woman poet. If such metonymy from safe to radical serves as reduction for these women, a gulf between the woman poet and publication of her work could be shrunk to arm's length—where she holds her pen.

How might a woman antebellum sentimentalist make this move? By metonymy, that slide between items in a series she might have called association, the woman writer enters forbidden zones from the safety of home. One could say that despite her constraints, what an antebellum woman wants, her imagination through sentimental metonymy gets her. Displacement in language becomes one means of antebellum women's "mediating the boundaries

between masculine and feminine codes of behavior," notes Carla L. Peterson, a necessity for black women orators such as Frances E. W. Harper, who for the sake of abolition "negotiat[ed] the public exposure of the black female body" (119). Peterson further observes, against conventional wisdom:

> Much sentimental literature, in fact, illustrates the extent to which the public comes to infiltrate and inhabit the domestic, thereby politicizing it, and conversely the degree to which metaphors of domesticity are appropriated to express the political, thereby domesticating it. (126)

A woman wants to write. She must write to change her world. Metonymy lets her do both.

Introducing an early example of the last thirty years' flood of recovered texts, Florence Howe's 1993 collection of women's verse begins with an encomium to antebellum poetry, the power of those women writers, and the logical aim of their sentimental rhetoric, all lost for over 150 years:

> Perhaps at no time since the early nineteenth century have poets so consciously spoken to help change the world. And perhaps at no time have young women poets been able to read and hear and learn from multiple generations of older women poets still writing and often revered. (lxvi)

Antebellum poets indeed set out "to help change the world." If effective, this present rhetoric of sentimental discourse can help us "read and hear and learn from" a generation including three women poets: Harper, Sigourney, and Howe. "Going repeatedly not to our assumptions and expectations but to the women," as Royster and Kirsch have lately directed, these historical "women have much to teach us if we develop the patience to attention in a more paradigmatic way" (20). We discover one purpose, one dimension of their logos, is insistently rhetorical, reformist, in many ways transformative, for it participates in nineteenth-century sentimentalism, which Jane Tompkins declared to be a rhetoric "that *makes* history . . . by convincing the people of the world that its description of the world is the true one" (*Sensational* 141). Perhaps shamelessly, antebellum sentimentalism is a discourse announcing its aim to be "epistemic," to use Patricia Bizzell and Bruce Herzberg's classic term (1128). That is, sentimental discourse produces the world its audiences and readers come to know.

To that end, Harper, Sigourney, and Howe's various conflations of literary work with familiar activities accomplish "the major function of rhetoric

and its figures," according to postmodern theorist Roland Barthes: "To make us understand, *at the same time*, something else" ("Chateaubriand" 52; italics in the original). Writing verse often continues *topically* to situate antebellum women within conventional domains, while at the same time it *formally* draws them outside strict boundaries of convention. "Form in literature is an arousing and fulfillment of desires," Kenneth Burke famously argued (*Counter-Statement* 124). Exactly such an exchange between form and desire gets engaged when women poets' metonymy sets unlike subjects—one proper, one suspect—side by side. Feminine propriety slides away from conventional behavior to sanction the so-called unfeminine practice of writing, and from there to sanction other frowned-upon public activity. This slide itself changes a woman's culture, and it constitutes a remarkable model of desire in action through form.

## WOMEN IN AMERICAN LETTERS

On one level, an overt goal of antebellum women poets is simply to write and get recognized. All three poets imagine like others of the early republic they can answer calls to compose a literature distinctively American.[1] Assuming her poetry could powerfully as any man's affect public abolitionist sentiment, Harper asserts to the apparently doubtful William Still, "I have a right to do my share of the work" (*Day* 47). Elsewhere, she makes a fictional character, Jenny, describe her life's goal: "I want to be a poet, to earn and take my place among the poets of the nineteenth century" (*Day* 225). Critical opinion through the end of the century, as all three poets desired, takes for granted Harper, Sigourney, and Howe have successfully entered the American canon. By the 1870s, without reference to gender, William Still, chronicling the Underground Railroad, acknowledges Harper as "the leading colored poet in the United States" (755). As late as 1902, reviewer Grace Collin treats Sigourney's poems seriously, believing they stood the new century's "test of being regarded as contributions to literature. Taken from their setting they still have interest" (22). It is telling that of ten women included among fifty-seven poets in the 1912 *Yale Book of American Verse*, Harper and Sigourney are missing, and Julia Ward Howe and Margaret Fuller are the only two women with three poems.[2]

Beyond getting published, some might reason American nineteenth-century women write poetry, just as men did, simply to address a wide range of immediate causes and issues. Hugh Blair, rhetorician of *belle lettres* most influential to antebellum American poets, asserted poetry could bring "elevated sentiments and high examples . . . under our view [which] naturally

tend to nourish in our minds publick [*sic*] spirit, the love of glory, contempt of external fortune, and the admiration of what is truly illustrious and great" (1:13, lecture 1). The broad pronoun "our" might suggest that to Blair, poetry's thematic work as a genre was no different for men than for women. Sure enough, a comparison of poem titles by women to those by men in antebellum anthologies suggests striking similarity, not difference, in topics.³ Recently, without mention of either rhetoric or gender, Mary Louise Kete gathers antebellum poets under one banner producing a "romantic reading experience" that would "deploy the grammar and lexicon of shared emotion" ("Reception" 23). You could align prosody and topics of nineteenth-century women poets so closely to men's that it seems peculiar to ask why women write. Why shouldn't they?

Such a challenge assumes, however, men and women writers had equal footing in the new nation's Enlightenment values. Instructive here are gendered implications of George Campbell's eighteenth-century rhetorical text: its two chapters on audience refer to "Hearers as Men in general [or] . . . in particular" (71, 95). Campbell's hearers and readers in classrooms and other forums except the church were virtually all men, just as were nearly all public speakers until well into the nineteenth century. Misplaced belief in a level playing field similarly grounds a line of reasoning Joyce Warren presses, wrongly to my mind, in her otherwise inspiring discussion of why antebellum newspaper columnist and novelist Fanny Fern wrote. Warren emphasizes "the female individualism in Fern's writing" (*Fern* 307), maintaining such a stance set her at odds with other women, "contrary to the prevailing attitudes of her culture." That same heroic boldness, Warren insists, is the source of Fern's "immense popularity" and later why she is dismissed from the American canon (*Fern* 3).⁴ The problem is, the later canon embodying aesthetic refinement was not set up by prevailing popular attitudes, but by elite white male *literati*. I would argue instead Fern gets left behind with Harper, Sigourney, Howe, and many popular male writers of the nineteenth century because she engages a rhetoric of sentiment that *en masse* gets labeled "feminine" and so for the elite falls out of fashion.⁵

What women want from writing goes beyond themes of taste or individualism: hopeful, liberal notions of "man in general" overlook displacements based on gender, not to mention those based on race. Not simply "individuals," women writers including Fern rather speak from "a doubleness of defiance and complicity" with bourgeois culture that, as Suzanne Clark says of Alice Walker's Celie in *The Color Purple*, "cannot be foreclosed as one or the other" (*Modernism* 185). Antebellum women writers deftly situate

themselves both within and against prevailing feminine convention, a stance necessarily entangling the poet in dominant culture's demands.

## WOMEN'S TEXTS IN A TANGLE OF YARN

Considering the opposition women poets endure, is it any wonder needlework and texts draw close in Lydia Huntley Sigourney's imagination? Perhaps as defense against critics, an antebellum woman finds it useful to consider writing, like sewing, part of her daily work. If the poet imagines writing another job in domestic routine, she can deflect accusations she abandons feminine tasks. Discourses of needlework and writing intersect, for example, in Sigourney's *Lucy Howard's Journal*, a kind of epistolary novel become conduct book. It is divided into daily entries by a star pupil who, like Sigourney, Harper, and many other antebellum women, leaves school when about thirteen. The book suggests how a woman keeps on reading and writing once her formal schooling has ended. Lucy bravely reports in her journal:

> I begin to like knitting very much. I find I can knit and read at the same time. It is mighty interesting to do two things at once. In the long evening, by a bright fire, I knit at my mother's side, and learn of her to shape a stocking, which is quite an art. (67)

Knitting and reading, Lucy insists, occur simultaneously. Placing lost schooling in the same line of syntax and displacement as her new cooking duties, the girl continues, "I don't see why [cooking] won't be as nice as learning a new language, and about as extensive too, if one only gives their mind to it" (67). "One" might be as satisfied knitting up the family's socks and cooking up a complex meal, the girl imagines, as she once was cooking up a poem at school.[6]

Swallowing my twenty-first-century anguish at what seems strained optimism in the face of a girl's lost schooling, I see Sigourney designing a way for antebellum women to keep a foot in both worlds. Lucy has read expectations of her situation, and she strives to both fulfill and rework them. Could this mix also rework another day's dominant discourse and our lives? A popular line of thinking says students new to the academy can learn expectations of its literacy if conventions are spelled out. If academic rules are conventions provisionally devised for specific historical situations, not transcendent truth, we and our students may venture into scholarly discourse more confidently. Just as Sigourney's Lucy learns daily disciplines of housekeeping, sewing, and cooking, as well as how to write daily—this thinking goes—so too can

our students practice everyday academic analysis and argument. Learning dominant discourses, Lucy and other antebellum writers can both satisfy and challenge sentimentalism handed them by convention. By extension, writers today can use and extend forms and formats; we can move readers by addressing topics held in common and advance arguments touching on and challenging received wisdom.

Too cheery, parallels between texts and Lucy's home duties seem grim compensation for what women today know are the pleasures of scholarship. Indeed, when her formal education ends, Sigourney's Lucy is in despair:

> Alas! alas! what shall I do? It is decided that I must not go to school any more. . . . I wonder if this does not come from getting the medal. I'd rather never have had it, nor any of my other prizes. (61)

What is going on here? Lucy frets school achievements have made her conspicuous, perhaps conspicuously not domestic. Now she pays the piper for success. Denied the arena of public success, how can this accomplished girl be happy with domestic duties? Could it be, against all odds, because she can satisfy her desire to read and compose texts *while* she knits, the girl can find pleasure in domestic tasks? One interpretation reads Lucy's sentimental metonymy as displacing an attachment *from* books *to* new domestic pursuits. In a conformist way, then, her plan of reading works like the "Infancy" picture to narrowly channel a woman's desires.[7] Constriction certainly seems to be a part of what happens in Lucy's journal. Yet, as I have noted, this is duplicitous conformity.

What if Lucy's metonymy also moves in the opposite direction, from domesticity to writing?

### Lesson Two: Write between Lives

I must point out that along with knitting, Sigourney exhorts the woman at home not only to read but also to write. Reading and writing serve not just to domesticate the extrovert of *Lucy Howard's Journal*. Interweaving texts with domesticity can serve as well to legitimate a woman's call to write. Lucy's writing thus serves to resist the domestic sphere as sole defining context.

Consider the syntax of ex-scholar Lucy setting out a plan for home routine: "I shall try, also, to fix my own hours in conformity with [mother's] plans, and my seasons for reading, writing, needle-work and social intercourse. It will be beautiful, I am sure" (65). To empathize with Sigourney's account of Lucy's invention and drafting process, today's woman must

accept the author's belief that writing and chores ennoble each other. Lucy claims reading = writing = needle-work = conversation. From this perspective, Lucy's string of identities in the home schedule does not harm her writing. To the contrary, Lucy's print literacy survives because of its place in this string, performed in the company of conversation and needlework. Jane Donawerth finds Sigourney's negotiations despite "the constraints of femininity" comprise "a domestic rhetoric that assumes conversation as a model for all discourse" (*Conversational* 53). In women's community groups of the day, importantly, one reads aloud while the rest sew or knit. Lucy's writing, in addition, may now serve the same end as sewing, knitting, and cooking; all connect the sentimental poet to people she cares about. Writing and reading assume a status that equals and eventually challenges Lucy's needlework partly because pen, paper, and books get tangled up in her yarn.

It is revealing that Lucy hides her first verses from her mother. This gesture indicates a risk Lucy takes by writing at all, and by writing poetry specifically. Lucy tells her mother about the journal but is too shy to show it to her. More than the journal, somehow poetry marks a separation between the girl and her mother. Like others since Plato, Lucy questions the morality of verse and feels sure her mother will too.

> I wonder if it is wrong to write poetry. Some wise people say it is a waste of time, and that poets are always poor. I do not wish to waste time, which is so precious; and I am not willing to be poor and beg. But when any thought keeps singing in my ear, just like a bee, I do write it down, and it comes in rhyme. . . . I have quite a pile of such things hid away. I hope mother will not find them. I never tried to conceal any thing from her before. (14–15)

Reminiscent of Emily Dickinson tucking away fascicles of verse, Lucy at ten years already has a "pile of such things hid away." Unlike Plato, however, who was certain poets cause civic strife, compliant Lucy worries most about a poet's finances. Sigourney herself is industrious and successful if never rich. By the time she writes *Lucy Howard's Journal* in the late 1850s, Sigourney is widely famous as one of the country's first professional and best-known white woman poets. She might well take special pleasure in writing the entry above, for though it repeats a critique her materialistic culture leveled at indigent poets, it also reminds Sigourney's readers that at least one poet, a woman, has succeeded in the marketplace.

In contrast to Sigourney's comfortable status, her young poet of the narrative is in some danger of a bad end. Maybe Lucy fears if her mother sees

the journal or poetry, she will make Lucy stop writing, for Mrs. Howard may agree that the girl who works at poetry neglecting other tasks can be headed for the poorhouse. In this text, however, Lucy's poetry writing is not motivated by money. Despite fear of poverty, the fictional Lucy never sells her verse. Indeed, if anything, poetry threatens Lucy's financial future, and it certainly threatens her relationship to her mother. If it complicates Lucy's life because it is entangled in domestic tasks, writing nevertheless accomplishes other ends.

Part of the logos of Lucy's journal writing is at first for a school assignment, but her text and poetry later become much more. While the journal might be a repressive tool, a snare forcing the schoolgirl into feminine convention, Lucy's little book also supplements and perhaps threatens conventional influence from her mother and religious faith. The young woman confides:

> The intimacy one forms with a Journal is remarkable. It seems as a living friend. It is always ready for us, and has no occupation but our concerns. As soon as we have formed the habit of resorting to its society, it gets a strange sort of power over us. It remembers for us, and gives new life to scenes and emotions which might else have been forgotten. It never speaks a word, yet it has a reproving power, so that we respect it. If we should persevere in evil doing, I think we should be afraid to meet it. (134)

With this entry, the journal's function expands past duty or entertainment to take full charge of the girl's moral growth. With the phrase "It remembers . . . ," Lucy's characterization shifts from simile ("as a living friend") to personification. Moreover, because of its "strange sort of . . . reproving power," the persona of the book takes on spiritual influence, what Christian orthodoxy calls the work of the Holy Spirit. Until this moment, the mother alone personifies spiritual morality to the girl. Despite Lucy's worry about the morality of poetry, we do well to remember she innocently enjoys its sounds "singing in my ear, just like a bee." Eventually, the journal's influence deepens beyond pleasant sounds and innocent entries on daily events. The young woman hands over to the journal her entire sense of moral well-being.

Oddly important after fretting over poetry's morality, Lucy's very next entry begins, "I am glad that I must knit my own stockings" (15). These two entries are parallel in the syntax of her journal, just as their topics are also parallel in the syntax of Lucy's schedule. Formally, if not thematically, Lucy's suspect versifying is set into metonymic equation again with the safe

occupation of knitting. As a rhetorical strategy, the two entries together tell readers fussing about the morality of poetry to back off: someone secretly writing verse is still trustworthy if she does not neglect the knitting. Thus Sigourney's message to an aspiring woman poet: stick to the knitting to cover for your writing. Writing today may still reweave frayed threads of our lives.

### *Lesson Three: Count the Costs of Writing for Women*

After expansive lessons one and two, lesson three sounds a note of caution. Women must count the costs of entangling competing selves and discourses. It is likely becoming a wife and mother signaled the end of, if not a break in, many writing careers; maternal metonymies may be fatal to aspirations of some antebellum sentimental poets. One of many male poets not encountering such odds was John Greenleaf Whittier, critic, editor, and Quaker abolitionist who remained a serenely unmarried son and brother, never intimately connected to a partner, woman or man, and without children through a long and productive life. Like these women, Whittier was never able to complete college, yet he pursued a literary career uninterrupted. Still today cultural expectations for women scarcely include a call to publish. If women do write, they are often considered out of line.

Before each marries, nevertheless, Harper, Sigourney, and Howe all publish a remarkable amount, but when the two white women wed, and as expected raise children, maternal discourse interrupts their publishing careers. Howe speaks for many fondly remembering their "own true life" in adolescence as "a student," a time when Howe is already a published poet and "a dreamer" (*Reminiscences* 84). This woman poet finds "the early years of my married life interposed a barrier between my literary dreams and their realization" (213). In adulthood, Howe feels slipping away what must have seemed then a vain youthful "hope of contributing to the literature of my generation" (79). Pressures of marriage, motherhood, roles the culture assigns to a white woman, all threaten Howe's sense of self as a poet.

Not so for Frances Ellen Watkins Harper, who publishes two collections of poetry and prose before she marries and also travels widely, speaking (in Maryemma Graham's description) throughout her life as a "committed artist and activist-intellectual" (xxxv). "Harper decided," says Frances Smith Foster, "that her personal survival and well-being were inextricably linked with the survival and well-being of the larger society and that confrontation, not silence, was the way to mental, if not physical, health" (*Day* 3). Already a celebrated lecturer for abolitionist societies several years before the Civil

War, at thirty-five in 1860 Frances Watkins marries widower Fenton Harper, who had three children, and she soon bears a baby girl. The marriage lasts only four years before Fenton's sudden death. Most accounts say Harper continues to speak publicly during marriage, "sometimes traveling as far as Rhode Island" (*Day* 18). Melba Boyd finds a note of "yearning for her literary and political pursuits" in poems from this period, with Harper's speaking and publishing somewhat curtailed (*Legacy* 52), yet clearly while married and mothering, Harper nevertheless does get some work into print.

In a long chapter about Harper in *The Underground Railroad*, William Still records that "notwithstanding her family cares, consequent upon married life, she only ceased from her literary and Anti-slavery labors, when compelled to do so by other duties" (764). More overtly than fictional Lucy, more openly than Howe or Sigourney, Harper lives a metonymy between public writing and domestic maternal life. Constraints of the "nightingale's burden," of domestic responsibilities, are neither hindrances as for white contemporaries, nor sole motivators of Harper's writing. This difference marks all aspects of her work, and toward the end of this chapter I articulate profound differences between her aims and those of Howe and Sigourney. Nevertheless, before mostly white women at the Eleventh National Woman's Rights Convention of 1866, Frances Ellen Watkins Harper finds it necessary to characterize her briefly married self as a properly domestic "farmer's wife" who "made butter for the Columbus market" (*Day* 217). A public intellectual of mid-nineteenth-century America who is also a woman, of whatever race, has somehow to stir the home fires and public sentiments in the same sentence.

From the first days of American letters, women find themselves torn between writing and domestic expectations. In 1650, poet Anne Bradstreet feels keen tension between culturally designated tasks symbolized by a needle and her poetry. She remarks, "I am obnoxious to each carping tongue / That says my hand a needle better fits" (16, lines 28–29).[8] Women's verse and other writing continue to aggravate "carping" in public conversations still perhaps overwhelmingly male. Studies of workplace discourse suggest women still come across as "marked," to use Deborah Tannen's word. Women's part in conversation is taken as "not quite serious, often sexual." Centuries after Bradstreet, the language of women entering many professions yet carries a disconcerting message she is an intruder. "In a setting where most of the players are men," Tannen famously notes, "there is no unmarked woman" (112). To be female is still abnormal where conventional business discourse is male.

One sign antebellum verse is conspicuously marked for gender comes from the preface of Rufus Griswold's anthology. Today his derogatory comments on women poets can paradoxically be interpreted as a blessing in disguise. In his preface to *The Female Poets of America*, Griswold announces:

> By the publication of *The Female Poets of America* in 1849, this survey of American Poetry was divided into two parts. From *The Poets and Poetry of America* were omitted all reviewals of our female poets, and their places were supplied with other authors. The entire volume was also revised, re-arranged, and in other respects improved. (3)

Poets are men, Griswold assumes from the title of part one, *The Poets and Poetry of America*. Part two's title suggests women are females first and only then perhaps poets. One might construe Professor Griswold's words to say the anthology of true poets is improved now that the females are gone. In this sense, his segregation by gender is an affront, automatically excluding women from the corps of real poets. However, since 1855, readers of his two-volume green and gilt-embossed sixteenth edition of the women's volume apparently disagree on the relative worth of Griswold's categories. The University of Oregon Knight Library's "poets" collection remains almost untouched, while the "female" volume has been read to pieces.

## PRIVILEGE AND CONVENTIONAL PRESSURE

The wealthy banker's home where Julia Ward Howe grows up, conventionally enough, expects all three daughters to perform chores. For Julia, however, needlework and other domestic tasks are no fun. On a favorable review of her first serious work, a translation of Lamartine's "Jocelyn," Julia's uncle John remarks, "This is my little girl who knows about books and writes an article and has it printed, but I wish she knew more about housekeeping" (Tharp 32).[9] We know Uncle John's barb to be cultural commonplace, for the same criticism is central to a challenge Harper's character Uncle Glumby raises when in one of the later "Fancy" pieces Jenny reads him a poem. He says nothing about her writing. He asks only, "Can you cook a beef steak?" (226). Rather than expend much effort on domestic skills, Julia Ward Howe learns to exploit the "not quite serious, often sexual" connotations that Tannen notes still mark women's entry into male discourse.

On the "not quite serious" side of Howe's domesticity, one twentieth-century biographer remarked, the "graceful poem called 'Washday Rosary' [1857] earned for Mrs. Howe the adjective 'domestic'—which, poor dear, she was not" (Tharp 230). The title mixes prayer with laundry, a job likely not

familiar to Howe. But the title also hints at her preferred metonymy—from spiritual discourse to writing. After "she told / each garment for a bead," in a third-person voice lovingly associating a rosary bead with each of six children and clothes flapping on a clothesline, Howe's poetic narrator identifies merely as "a stranger passing" and smiling "to think how near of kin / Are love and toil and prayer" (Walker, *American Women Poets* 165–66). In a poem about prayer and the wash, even if she does not scrub or hang laundry herself, Howe enacts a metonymic slide between washing and prayer to her true calling or "toil." Since Howe's life work is writing, not washing, then mother love and writing and prayer are simultaneously enacted in this poem. A persuasive strategy of metonymy among the terms lets her get away with what she longs most to do—write.

After one of Margaret Fuller's famous "Conversations," the young Julia Ward puts into Fuller's hands a sheaf of poems written the year both the girl's father and closest brother, Henry Ward, died. In later skeptical years, Howe reports to her diary "a season of religion (or irreligion)" then ensued, saying of the doctrines of her lost father's evangelical faith, "They now came home to me with terrible force" (Clifford 39). "A deeper train of thought than I had yet known . . . took form in a small collection of poems," she recalls (*Reminiscences* 61). The intensity of these piece surprises Fuller, and she hardly reconciles the flighty look of a young society woman at the discussion with "the steady light of her eye" beaming from Howe's poems. Fuller observes of the young woman's appearance, "I . . . caught no glimpse at the time of this higher mood" (Richards, Elliott, and Hall 1:69). Margaret Fuller does, however, urge the girl to publish her poems.

A "higher mood" indeed pervades the verse Howe is most famous for. I say more in later chapters about free-spirited Continental sentiment and transcendentalism combining to support Howe's religious and literary inspiration. Lawrence Buell summed up transcendentalism in Emerson's view as "the whole creative process as a divine mystery" (*Transcendentalism* 65). Late in life, Howe is likewise fond of saying that in transcendentalist literary circles, and especially in sermons of Unitarian Theodore Parker, she found "not atheism, but a theism" (*Reminiscences* 100).[10] Apparently for Howe, when she locates herself in sentimental transcendentalism, the abode of true divinity lies not in traditional religion, but in language, the language of her own poems.

Howe invokes neither an orthodox deity nor a conventional muse as her source of poetic inspiration in the *Passion-Flowers* poem "Correspondence" (87–89):

> May I turn my musings to thee
> In my wintry loneliness?
> May my straggling measure woo thee,
> May my deeper thought pursue thee,
> Till thy sunlight, striking through me,
> Pause to fertilize and bless?

Romantic and transcendentalist discussions of "correspondence" between "great souls" reverberate in Howe's title, but hints of eroticism in some American transcendentalists' texts turn explicit in Howe's poem. Potent "sunlight" of Howe's muse "striking through me . . . to fertilize and bless" invokes Bettine von Arnim's passionate exchange with a German Master in her 1835 *Goethes Briefwechsel mit einem Kinde* [*Goethe's Correspondence with a Child*]. Howe uses religious language, but her cozy appeal from a "wintry loneliness," like von Arnim's appeal to a literary mentor, approaches not some ethereal spirit, but a full-blooded man. The logos of such texts by these two transcendentalist women may include seduction of their male mentors.

Only in the last two of eleven stanzas does the poet of Howe's lines demurely look to "permanence" in her relationship with the male muse, something "loftier" than the sexual liaison suggested by her sly invocation. She piously describes that higher friendship:

> Heart more nobly heart befriending,
> Eyes that in their deepest blending
> Cannot lose their heavenward glance.

Howe's poetic coquetry extends suggestive invitation under a thin veil of religious discourse. In chapter 7 of this study, I discuss Howe's explicitly seductive "Master" dialogue between three later *Passion-Flowers* poems and how this exchange embodies her rhetorical pathos, the complex strategies that draw an audience of mostly men. My point here for sentimental logos is by what aims Howe justified writing at all, and by what metonymy this particular woman justifies the role of poet.

In Julia Ward Howe's *oeuvre*, flirtation with male readers is fairly common, presumably to silence their objections; these are men who could otherwise frown on women who wrote, especially on a woman poet. In "The Fellow Pilgrim" (*Passion-Flowers* 156–57), Howe alludes coyly to "the pilgrim's pious debt" a woman pays when she and a male escort tour Roman "tombs of poets and of kings." A delicate confusion between organ chords

and tones of his voice, between her faith and affections, between holy sites and her companion's mind produces these lines:

> The mighty cadence shook my heart
> Like a frail pennon in the gale;
> And while I wept and prayed apart,
> Thy cheek with strange delight grew pale.
>
> At tombs of poets and of kings
> The pilgrim's pious debt I paid;
> Oft as my faint soul spread its wings,
> Thy manlier thought did give it aid.

The "pilgrim's pious debt," paid not only to "poets and . . . kings" but also to her tour guide, suggests something more than a chaste prayer or handshake. It sounds like a secret kiss in the catacombs.

Similarly, "Handsome Harry" (*Passion-Flowers* 169–71) celebrates the poet's exhilarating sail with an admirer:

> His hand upon the wheel, his eye
> The swelling sail doth measure:
> Were I the vessel he commands,
> I should obey with pleasure.

The poet's suggestion that her body would sail in his hands as does the boat implies that breathtaking pleasures of this outing, like those of the earlier pilgrimage, are not quite innocent. Readers familiar with such texts as Kate Chopin's *The Awakening* or Henry James' *Daisy Miller* will recognize in Julia Ward Howe's poems a European-influenced convention of married women's dalliance with young male followers. Howe's verses suggest one fairly early U.S. example of the type of erotic discourse familiar to readers of Continental sentimentalism from works such as von Arnim's, where a masculine muse enthralled the German woman writer. Critics such as Paula Bennett and others have also recovered erotic dimensions of poems by Frances Sargent Osgood, Emily Dickinson, and even Lydia Sigourney.

When Howe adds a slide into the maternal to metonymies between religious and erotic discourse, all three work like a shell game to shift meaning among at least four contexts. Sex, birth, religion, and literary sentimentalism—four parallel but shifting terms—all rhetorically support and justify the process and ultimate goal of Howe's writing. Recall that "striking" rays

in Howe's poem "Correspondence" would "fertilize" her imagination, and that confluence of light and inspiration now induce labor as the woman brings forth a poetic brainchild. In "Mother Mind," she answers a question about how she conceives her powerful poems:

> 'Tis thus—through weary length of days,
> I bear a thought within my breast
> That greatens from my growth of soul,
> And waits, and will not be expressed.
>
> It greatens till its hour has come;
> Not without pain it sees the light;
> 'Twixt smiles and tears I view it o'er,
> And dare not deem it perfect, quite.   (*Passion-Flowers* 92)

Howe presents a remarkable account of childbirth, from gestation of "a thought" in the woman's pregnant body "that greatens from [her] growth of soul," through a long labor "not without pain," to the moment of birth when at last her infant poem "sees the light." Sue Armitage, a historian of women in the American West, reports in a private conversation that nineteenth-century women almost never record pregnancies, even in private journals. Thus when Howe takes the enormous risk of confiding pregnancy and childbirth to a man who is not her husband, she may intimate he is her brainchild's father even if he is a clergyman:

> These children of my soul I keep
> Where scarce a mortal man may see;
> Yet not unconsecrate, dear friend,
> Baptismal rites they claim of thee.

He should, she says, legitimate and christen his own child.[11] She insists the man who inspires her to write must acknowledge and accept her texts, her poems.

Such lines whisper volumes about this woman poet's ethos, but I find the poem important here for its powerful metonymy whose logic and logos give a woman permission to talk publicly about sex, pregnancy, and her writing by combining them with religion. Religious overtones perhaps displace and disguise for inattentive readers Howe's references both to an erotic register of European romanticism and to the act of writing. The woman poet's dangerous game ensures that the literary Master seduced into reading her poems is in no position to complain that this writer is a woman.

While slides from sewing, sex, or spirit to production of text may distract critics and safeguard the woman poet's calling, writing in the thick of things also puts at risk the quality of a woman's writing. For Sigourney as for Howe, domestic demands compete with literary goals. Lydia Sigourney concedes that home duties steal time from writing and make her write a lot in a hurry. She is aware of critics' astonished disbelief at her massive, speedy rate of production; nevertheless, with steady calls for her work, the professional woman poet can almost laugh off complaints. It "was a study" how to keep house and meet editors' deadlines, so she knits as she composes "the slight themes that were desired." But she knows:

> This habit of writing *currente calamo* is fatal to literary ambition. It prevents the labor or thought by which intellectual eminence is acquired. If there is any kitchen in Parnassus, my Muse has surely officiated there as a woman of all work and an aproned waiter. (Collin 23)

She is self-effacing but determined. Sigourney lets critics think she is more comfortable in domestic pursuits than in the scuffle of hack writers, but her mix of classical and domestic figures clearly, if stiffly, associates the woman writer of "slight themes" with weightier stuff. She certainly reminds detractors that her so-called trivial verses are in high demand. Negative criticism matters less than that her works get read. Even if kitchen work hinders elegance of style, yet precisely because she mixes discourses, Sigourney achieves her aim to overcome cultural disapproval and keep writing.

### *Lesson Four: Get It Together and Write Defiantly*

Sharply different historical circumstances for white and black antebellum women generate vastly different understandings of literacy—and particularly of writing poetry. Marking the gulf is Frances Harper's sharp satire in 1866 of the narrow myth hampering lives and writing of such white women poets as Howe and Sigourney: "I do not believe that white women are dewdrops just exhaled from the skies" (*Day* 218). Historical records of any antebellum woman's life, white or black, deny she lives within strict boundaries of piety, purity, domesticity, and submission that Barbara Welter in 1966 announced nineteenth-century bourgeois culture demanded of women. Yet this caricature of virtuous femininity bears heavily upon women of the mid-nineteenth century, undercutting their common desire to write.

Unsubtly defiant of these strictures, Sigourney emphasizes a homebound woman's need to read and write, and she is far more direct than her cautious,

deferential diary writer in *Lucy Howard's Journal*. Sigourney flatly insists in *Letters to Young Ladies*, "A taste for reading is important to all intellectual beings. To our sex, it may be pronounced peculiarly necessary." She hails books as "an armour of defense" against the "little things" of domestic life (12). Worried about young women without books and writing who approach marriage and domestic life, Sigourney insists, "Confirm *now* your taste for reading into a habit, and when the evil days come, you will be better able to prove its value, than I am to enforce it" (134; italics in the original). Echoing biblical injunctions to prepare for "end times," the antebellum poet's exhortation does not mold a conventional housewife out of a writer. To the contrary, the goal of Sigourney's warning could be to make resistant scholars out of housewives.

Like Sigourney, Julia Ward Howe advises women who would feed literary appetites. She negotiates, as Sigourney in *Lucy Howard's Journal*, for a schedule parceling out time for books and study amid household demands. "If you have at your command," Howe begins, "three hours *per diem*, you may study"—and here she offers a long list echoing the day's liberal arts college curriculum—"art, literature, and philosophy." Howe next recommends, "If you have but one hour in every day," women must "read philosophy, or learn foreign languages." Finally, to those with little help at home, "If you can command only fifteen or twenty minutes, read the Bible with the best commentaries, and daily a verse or two of the best poetry" (*Reminiscences* 216). Parleying for three hours, one hour, or fifteen to twenty minutes, Howe's language recalls negotiations between the deity and Lot for ancient Sodom and Gomorrah, vainly trying to stave off destruction.

Shorter and shorter spans in Howe's curriculum may concede the nineteenth century's cultural odds against women's securing space and time for their mental health, not to mention for their writing. Near the end of her study regimen for married women, Howe invokes a prophetic tone paralleling Sigourney's apocalyptic warning about "evil days":

> I recall the piteous image of two wrecks of women, Americans and wives of Americans, who severally poured out their sorrows to me, saying that the preparation of "three square meals a day," the washing, baking, sewing, and child-bearing, had filled the measure of their days and exceeded that of their strength. (*Reminiscences* 217)

Her last phrases make characteristic reference to religious discourse, but Howe's diction belies the promise they allude to. The *King James Bible*

reads, "As thy days, so shall thy strength be" (Deut. 33.25). Not the new American republic promising individual freedom for "Americans and wives of Americans," nor religion promising freedom for individual souls, is strong enough, in Howe's view, to interrupt for these "two wrecks of women" the cultural syntax imposed by women's daily chores. Howe's curriculum may also desperately echo Benjamin Franklin's optimistic schedule of moral reform written the century before; Franklin checked off honesty and humility, among other virtues, as he mastered them. Howe's schedule could not assure perfection. It did hold out hope that where scripture and the *Constitution* fail to interrupt the force of relentless convention in women's lives, deep-rooted practices of reading and writing might succeed.

Julia Ward Howe's studies prove these powers. Her own "evil days" coincide with her husband's wrath following publication of two verse collections, *Passion-Flowers* (1854) and *Words for the Hour* (1857), and also of *Leonora; or, The World's Own*, a satiric feminist verse play (1857). She writes her sister that her husband proposed separation a number of times, each on condition he retain custody of two of their then four children. "His dream was to marry again," she tells Louisa, "some young girl who would love him supremely" (Tharp 237). A wife's call to write challenges Dr. Howe's sense of feminine loyalties and threatens to end the marriage.[12] Although she publishes no poetry for some years after 1857, Howe will not give up literary work. "My studies help me a good deal," she confesses at one low point. "I should sink without them" (Tharp 233–34). Howe's life is profound testimony to Sigourney's warning that "without a radical love of knowledge," a woman can be overwhelmed by domestic pressures (*Letters to Young Ladies* 135). Despite her studies, it is little wonder that despair, "a subtle poison" (*Passion-Flowers* 23), sometimes creeps into Howe's poetry.

To the extent domestic contexts limit women's publishing and drain their energies, one can see why Nina Baym viewed antebellum women poets as the "narcissistic woman's poetic tradition" ("Reinventing" 60).[13] Self-centered despair constitutes the "nightingale's burden," as Cheryl Walker once framed it. Yet the emotional tone of antebellum verse is not solely "a deep and ineradicable strain of female pessimism" (Walker, *Burden* 140). Why not? First, both men and women write sad, commemorative verse, as I discuss in chapter 3. If there is sadness in nineteenth-century poetry, it is male as well as female.[14] Second, and more important, because they can participate in metonymies offered by poetry, antebellum women writers and readers are neither pessimistic nor self-absorbed.

## HARPER'S ACTIVISM UNBURDENED

The aim of writing in circumstances of Howe, Sigourney, and other white women, is to carve out, maintain, and expand a space for self-definition, a channel to swim in and not sink beneath conventions of womanhood. Writing also holds this promise for Harper, but her poetry spans beyond the formidable goal of individual sanity—to construct possibilities for her people.

A closer look at Frances Ellen Watkins Harper's presentation of an African American woman's call to write, the logos of her verse, shows her activist agenda throwing off the "nightingale's burden."[15] Harper's "Fancy Etchings" series (later "Fancy Sketches") features Jenny, a new college graduate, back home chatting with her visitor, Aunt Jane. The "Fancy" series appears after the Civil War, but these often autobiographical dialogues look back on many years of Harper's writing life. Sigourney's *Letters to Young Ladies* and Howe's speeches late in life reconsider the woman poet's earlier call; so the "Fancy" columns also review a literary life beginning for Harper in the 1850s. The 24 April 1873 column centers on what Jenny will do after college, and Harper articulates the impulses that at first moved this black poet to write.

For one thing, Harper underscores that Jenny left for college, but she has also returned. Jenny's reappearance shows she can figuratively and literally both get education and go home again. This reassures "Aunty" (and readers of the African Methodist Episcopal Church's *Christian Recorder*) that to a college graduate, home folks are not "too old fashioned for companionship"; they will not lose their "loving little girl in the accomplished woman." Moreover, the column takes care early on to announce Jenny intends to dive into the familiar task of spring cleaning, but she will not "commence that job till next week" (*Day* 224). In other words, women college graduates still have homebody chores, but these columns make clear erudition and home are not exclusive. Moreover, despite both household duties and a call to write, there is time in the narrative's present for heart-to-heart talk. The nineteenth-century African American woman, Harper says, should have the best of both worlds: intimacy of home life and access to public discourse.

A striking difference between Jenny and Jane's conversation and white women's worries is evident in lack of any mention of marriage or children. Like Janette, protagonist of Harper's first published short story, "The Two Offers," Jenny is another "conflation between the narrator and Watkins Harper herself," according to Carla Peterson, and this strong-minded poet might not become a wife and mother (173). For most nineteenth-century women, these additional domestic roles are foregone conclusions, the conventional

path. Harriet Brent Jacobs' assertion that *Incidents in the Life of a Slave Girl* "ends with freedom; not in the usual way, with marriage" comes to mind (302). Because, like others seeking the ear of nineteenth-century culture generally, Harper did use textual conventions of sentimental discourse, I disagree with Peterson that with characters like Jenny and Janette, Harper "decisively rejected the values of sentimentality" (173) and avoided persisting stereotypes of "true womanhood." Yet I am persuaded by Rachel Carby's research in *Reconstructing Womanhood* demonstrating that antebellum black women writers such as Harper and Jacobs did not fit today's cartoon of the sentimental. As Peterson indicates, Harper and courageous contemporaries targeted sentiments of U.S. readers to deliberately "reconceptualize the social construction of African-American identity on their own terms" (175), not to mention to influence the social construction of womanhood generally.

Although Jenny is not eager to become wife and mother, her thorough education need not make a woman into a good-for-nothing "snob," as Aunt Jane fears may happen to her niece the poet ("Gender" 55). Harper's ambition, "to earn and take my place among the poets of the nineteenth century," surfaces in Jenny's words, but Aunt Jane immediately scrutinizes the poet's motives: "Do you think by being a poet you can best serve our people?" In response, Jenny allows that contemporary poets' aims "to make the most of ourselves" must necessarily involve "helping others." Still, Aunt Jane cannot help pressing, "What do you expect to accomplish among our people by being a poet?" Despite Jenny's unflagging answer to this second probe, Aunt Jane doubtfully puts the question to her again: "What time will our people have in their weary working every day life to listen to your songs?" (Harper, *Day* 225). Jane's three questions constitute a trial by fire, an elder's examination of the poet's fitness for her call. Every one of Aunt Jane's reservations has to do with a concern for "our people," African Americans who, by the time the "Fancy" series appears post Civil War, have suffered manifold degradations of slavery and struggle still to establish cultural presence, visibility, and a sense of agency. What could *poetry* do for Jenny's people?

Jenny's answers show Harper's poetry is designed to expose and stop the degradation, to "speak truth to power" as the American Friends Service Committee gets so often quoted by Cornel West a hundred some years later. Not elite art for art's sake; rather, as Joan Sherman declares, "Harper believed in art for humanity's sake" (113). Thus the black woman poet aims to "learn myself and be able to teach others to strive to make the highest ideal, the most truly real of our lives." Poetry is not an add-on, but the very thing offering a vision to oppressed people. Through Jenny, Harper asserts

poetry belongs in the middle of "weary working everyday life," because with poetry, she would "amid life's sad discords introduce the most entrancing strains of melody" and thereby "teach men and women to love noble deeds by setting them to the music, of fitly spoken words" (*Day* 225). The logos of Frances Ellen Watkins Harper's poetry, in sum, performs a magic not only making life bearable but also setting a hope before black readers and hearers to change visions of their future and themselves. A context of hopes and dreams recalls the swell of enthusiasm among voters hearing Barack Obama's speeches before the 2008 presidential election. Likewise, for Jenny and Harper, as well as for such twentieth- and twenty-first-century poets as Audre Lorde: "Poetry is not a luxury. It is a vital necessity of our existence" (37). Jenny's and her creator's poetry carry two urgent messages to their culture, saying, "Here I am," a brilliant, thoughtful black woman writing herself into the literature of the nation, and enjoining her people, "Come along."

Asserting herself as a nineteenth-century writer, a black woman speaking to and for black people, Frances Harper set down for her day what Audre Lorde articulates more recently: "Poetry is the way we help give name to the nameless so it can be thought. The farthest horizons of our hopes and fears are cobbled by our poems, carved from the rock experiences of our daily lives" (37). Lorde announces: "Those fears which rule our lives and form our silences," faced down in lines of poetry, "begin to lose their control over us." For Harper, as for Lorde, "Poetry is not only dream and vision; it is the skeleton architecture of our lives. It lays the foundations for a future of change, a bridge across our fears of what has never been before" (36, 38). Harper's poetic bridge calls her people to new possibilities.

"Bridging" is key to Jacqueline Jones Royster's rhetorical analysis of black women's "literacy as sociopolitical action" (61). Royster cites Harper as prime example of one who

> in order to articulate an alternative viewpoint . . . had to construct a space that bridged her view and . . . liberal expectations of the day . . . and that permitted a new horizon to emerge. From this new horizon, Harper could speak with agency and authority across chasms of systemic disbelief. (54)

In language echoing Harper's purpose, Royster traces three "communicative goals" in the historic stream of African American women's literacy: "the subversion of old ways of thinking, being and doing; the conversion to new ways . . . ; the affirmation of fused horizons, newly negotiated and mediated spaces that bridge communicative gaps and direct us toward the

future" (60). Like any good rhetorician, Harper knows, "If one takes with her a manner that unlocks other hearts" (128), she can approach entrenched prejudices; offer alternate ways to think, be, and do; and guide hearers and readers to new selves and new topics of cultural discourse. Over her knitting, Aunt Jane's cross-examination ensures that if the young black woman must write her poetry, she becomes a committed poet of "our people," so African American listeners plainly hear the black poet's song. In response to challenges like Aunt Jane's, Harper lifts her manifesto guiding four decades of courageous publishing on behalf of her people, a life even skeptical inquisitor Aunt Jane might begin to imagine for herself.

## POETIC SLIDES FROM THE BURDEN

Harper, Sigourney, and Howe do not succumb to despair, I argue, precisely because they tap into and offer readers what Kristeva calls a "desiring metonymy" of artistic pleasure (*Sun* 14). For all three, and those heeding their advice, the metonymy of literacy, especially of writing poetry, functions by a rhetorical tactic Julia Kristeva asserts all imaginative writing uses, allowing writers' and readers' "*affect* to slip into the *effect*" (*Sun* 217; italics in the original). For Harper, Carla Peterson connects such slides to rhetorical aims with political impact:

> In her poetic collections of the 1850s Harper chose . . . to narrate the histories of "private" individuals victimized by different public institutions. These sentimentalized individuals—the Syrophenician woman, the slave mother, the drunkard's child, the fugitive's wife—function as metonyms of the disorders that are rending the social fabric of the nation. (213)

"Private" realms usually link to feeling, or "affect" in Kristeva's terms. But all three women produce texts that show a sensibility, an "affect," that urges not mere emotional survival but immediate transformative "effects" in their own and readers' "private" lives. Beyond a so-called private sphere, Harper argues for a vision to transform her world. This aim to transform racial consciousness distinctively marks the logos of Harper's work. Incomplete perhaps during their own lives, a slide from despair to accomplishment, from degradation to agency—and in the broadest vision, from private peace to social change—is one obvious rhetorical aim of antebellum women poets' work.

Antebellum women's metonymies effect not mere sensations for enthusiastic readers, by which "sentimental" is usually defined. Deliberate, logical shifts from the domestic and maternal into literary, religious, and political

discourse allow these writing women to construct imaginary bridges between competing claims in their lives and to offer readers bridges from old worlds into formerly unimaginable lives. Workings of such metonymies in "literary (and religious) representation," says Kristeva, "constitute a very faithful semiological representation of the subject's battle with symbolic collapse" (*Sun* 24). If they read and write, antebellum women emphatically do *not* collapse. They stitch, read, and write, patching holes in their lives, sewing up new garments for new selves in a new world. It is no accident Harper, Sigourney, Howe, and many others urge one another to read *and* write, because their lives depend on it.

Why verse in particular? Sigourney believes "the poets will naturally be favorites" of young women (*Letters to Young Ladies* 140). Importantly, poetry is Howe's sole recommendation alongside scripture for study in the scant fifteen minutes a day women must reserve. To sense what poetry means to antebellum women, consider Lydia Huntley Sigourney's meditation in *Lucy Howard's Journal* on emotional effects of verse when the protagonist is a teenager:

> There is something very soothing in the search and linking of poetical sounds. Sometimes they so beguile the mind that the thought which should give them solidity escapes. The "tinkling cymbal" amuses, and the sense becomes secondary, or takes flight. Nevertheless, this writing of rhymes is a fascinating, and may be a useful thing. (139)

The girl worries a little herself about witchery in poetic sounds whose "soothing" pleasure endangers "solid" thought. Yet brave Lucy concludes, as Blair's lectures promised, that verse may still be virtuous and "useful."

Adult Lucy confirms the utility of verse in a journal entry after her grandfather dies. "The poetical element, like the religious one, is a source of happiness," she writes. "It may be so cultivated as to soothe suffering, to refine enjoyment, and to sublimate our whole nature." Lucy adds these lines directed to her muse:

> I bring a broken spirit. Make it whole
> With the sweet balm of song.
>                             To her I spake
> Who rules the spirit's inborn harmonies.
> And not in vain; for as she struck her harp
> Of varied symphony, and claimed response,
> Forthwith the brooding sadness fled away,
> And, sitting at her feet, I was made whole.    (*Journal* 317)

By convention, male poets request emotional healing from feminine muses with unconventional powers. Here, likewise feminine, this unorthodox woman poet's muse "rules the spirit's inborn harmonies" whose internal effects resonate with—but do not duplicate—the overall moral effects of Lucy's journal. The journal's *prose* may influence the girl's morality, but Lucy says by its own kind of logic—in this case, its sounds—*poetry* works specifically to heal emotions.

A belligerent masculine logic derisively called "wordy warfare" by theorist of sentimental rhetoric George Campbell (73) would not have "claimed response" from Lucy in mourning. Syllogism is hardly the rhetorical power poetry uses to strike "her harp / Of varied symphony" to make whole the "broken spirit." Rather, a feminine-gendered, maternal persona comforts the poet's frayed nerves. In Sigourney's terms, the sounds of poetry might well "beguile the mind" (*Journal* 139). Not ignoring loss, but by imbuing that event with sound, sentimental poetry might absorb a woman's pain.[16]

Since poetic language often favors sound, feeling, and other impressions over obvious semantic content, verse threatens to reverse the "parceling" of language Lacanian theorists such as Barbara Johnson and Kristeva associate with fathers. The logos of poetry as a genre connects closely to what Kristeva calls the "maternal" register of language (*Sun* 19). It makes sense that writing—especially poetry—openly enacts that "painful, continuing struggle" between the symbolic and the semiotic, these so-called paternal and maternal realms. Working from the page, or spoken in our ears, poetry articulates diction and syntax against a field of sound and feeling, thus dramatizing an archaic, fundamental dialectic that weaves paternal distinctions through an inchoate matrix of sound.

Taken together, Sigourney's love for the mother and for learning exemplify the profound dynamic at stake in the logos of sentimental verse. Notably, Sigourney has young Lucy exclaim after leaving the "man's school" for domestic training, "I think I am in love with my beautiful mother!" (*Journal* 111). Kristeva's discussion in *Black Sun* linking women's melancholy to language applies here, for she underscores the "tremendous psychic, intellectual and affective effort a woman must usually make" in white bourgeois European culture to establish herself apart from her mother. Separation of this self requires "a massive introjection of the ideal"—that is, a large dose of the "symbolic," a large dose of language. Kristeva emphasizes that with its special effects, poetic language "succeeds, at the same time in satisfying" a desire to maintain connections with maternal pleasures and likewise "the longing to be present in the arena where the world's power

is at stake" (*Sun* 30). Lucy's studies and writing let her declare a love for her mother and also maintain a claim on the "man's" world of language. Antebellum poetry's special effects reweave limits of white women's conventional domestic roles—using cords that simultaneously pull these writers into the public eye.

## HARPER'S REVERSE METONYMY TO HOME

As with Jenny's trial by Aunt Jane, however, domestic and public realms have different valences for the black woman poet, and for the logos and effects of her poetry. If, for nineteenth-century white women, verse allows some psychic separation from their mothers while many remain at home, it makes sense that for the social activist Harper, sound and sense of poetry reconnect her to maternal and domestic realms while she spends most of life in public discourse. Harper's poetry suggests for black women, Kristeva's comment on the work of poetic language should be reversed. Rather than stay home and connect with the world, the black woman out and about through poetry both maintains connections to public life, and simultaneously is accepted in conventional roles. A shift of significance for the black poet reminds critics to avoid a reductive semiotic reading of texts from diverse contexts. Psychoanalytic paradigms, Hortense Spillers insists, especially those "attach[ing] to the 'Twin Towers' of human and social being—'Mama' and 'Papa'"—must change to do African Americans any good; frameworks must account for ethical and cultural implications of what Spillers calls a very specific "socionom" ("Mother" 139, 140). That is, white folks often take for granted relationships to families whose emotional and legal fabric was for African Americans torn apart during four hundred years of chattel slavery. Shock waves of that destruction still reverberate; reading Frances Harper's poetry today requires attention to this different dynamic.

In sum, Spillers' "new repertoire of inquiry into human relations" ("Mother" 152) must involve issues of power traditional psychoanalysis too often ignores. In similar terms, bell hooks reiterates Spillers' claim that for black people, psychoanalysis must "take into account a political understanding of our personal pain" and link not only to self-knowledge but also "to progressive action for political change" (*Yearning* 142). I focus on Frances Harper's work in the specific realm of poetry's language or "words, words, words," a location Spillers calls prime for articulating "interior intersubjectivity." New African American identities, Spillers argues, are born "in the transgressive unpredictable play of language" ("Mother" 149). Harper's Jenny likewise strives "amid life's sad discords [to] introduce the most entrancing

strains of melody." As I have noted, Jenny means to engage poetry's transformative power, she tells Aunt Jane, "to make the highest ideal, the most truly real of our lives" (*Day* 225). Harper leads African American efforts to "extend the possibility of what might be known," in Spillers' language ("Mother" 152), nearly 150 years before work to connect race, gender, and identity resumes for such courageous literary women as Audre Lorde, Toni Morrison, Alice Walker, bell hooks, and Hortense Spillers herself.

Whether poet, novelist, or public speaker, Harper aims always for her people's self-definition, sometimes in agreement with—but often in stark contrast to—white Americans' expectations. Later chapters address how Harper manages to carve out her ambivalent stance toward nineteenth-century social norms—for her own ethos as a poet and for her audience. For this lesson on the logos of writing defiantly, the poet's logic appears in themes of "The Two Offers" from the 1859 *Anglo-African*, the first short story published by an African American (*Day* 105). Harper sets out lessons for woman poets in this fable about two cousins.

Laura, petted and spoiled by wealthy parents, giddily chooses between marriage proposals, a conventional enough event. In contrast, Janette, orphaned as a youngster, finds "the achievements of her genius had won her a position in the literary world, where she shone as one of its bright particular stars" (*Day* 107). She now lives fulfilled as a writer, a poet. Laura dies toward the end of this story, agonizing over a handsome, alcoholic husband who abandoned her. At the deathbed of her cousin, Janette earnestly resolves "a higher and better object in all her writings than the mere acquisition of gold," but this too is a predictable outcome. Janette's writing, like Harper's vocation, becomes "a high and holy mission on the battle-field of existence." That is, she will write on behalf of "the down-trodden slave," among others who need an advocate (*Day* 114). Accompanying other reforms is Janette's remarkable resolve to remain unmarried, a signal early in Harper's career that she never fully subscribed to conventional nineteenth-century feminine norms.

Most striking, poetry itself in Harper's story becomes a flexible metaphor for the power women have at their disposal. The ne'er-do-well husband's mother "pampered his appetite, but starved his spirit" and so failed to grasp real maternal power:

> Every mother should be a true artist, who knows how to weave into her child's life images of grace and beauty, of love and truth, and teaching it how to produce the grandest of all poems—the poetry of a true and noble life. (*Day* 110)

If you are called to be a mother, Harper says, then do it well and with diligence—like a poet called to take up her pen. The most fundamental role prescribed for nineteenth-century women gets redefined by this black woman poet in terms of her most beloved pursuit—poetry. These lines indicate that to Harper if marriage and motherhood are optional for nineteenth-century women—especially for black women—poetry is not. You may be married or single, but you must have poetry. Although Harper's protagonist in "The Two Offers" resists marriage and mothering, both are ultimately honored, not demeaned. After all, in 1860, Harper does take on both roles, but never exclusively. While she challenges dominance of domesticity for black women, by characterizing motherhood as sheer poetry, the logic of Harper's verse not only offers alternatives but also places the poet inside boundaries of conventional wisdom. Beyond concessions made by Sigourney and Howe when they wed, Harper operates in both worlds.

## TODAY'S STRUGGLE TO MOVE AND MEND

As for women poets' logos of nineteenth-century sentimentalism, it is today dangerous and difficult to write critically about maternal, domestic, and affective connections. Ask Linda Kintz, a scholar who articulates positive and negative effects of mothers' involvement in religious right politics. Ask Alice Walker and Toni Morrison, who both honor and criticize African American culture. Ask Jane Tompkins scolding scholars for unloving values in the academy. Ask Louise Erdrich and Linda Hogan writing between Native and Anglo worldviews. Ask Julia Kristeva, who asserts, "With and beyond ideology, writing remains—a painful, continuing struggle to compose a work edge to edge with the unnamable sensuous delights of destruction and chaos" (*Sun* 187). It is still true in that "painful, continuing struggle" to write about "the unnamable sensuous delights" of human connection, you get misunderstood. You can get dismissed along with your subjects. Making and maintaining connections can be painful in academe.

Painful and pleasurable, sentimental metonymies in poetry by Howe, Sigourney, and Harper constitute a "doubleness of the female," a still familiar unstable self. I second Suzanne Clark's assertion that the woman writing in this new millennium still "desires not separation but a remedy to loss" (*Modernism* 188). By the logic of sentimentalism with its conflations, an antebellum woman poet can minimize losses. She can both keep face in antebellum America and have her way. She can write. She can keep herself and her sister writers afloat. With Harper's courage, she may write new perspective into the visions of her people. No small accomplishments,

these, combed from what C. Jan Swearingen honors as the "living museum of actual voices, possible selves, and models for interacting with others" (236), an archive revealed by studies in the history of rhetoric. Rather than trace flaws in the duplicity of antebellum sentimentalism, perhaps we can learn from it.

Four old lessons from the logos of antebellum sentimentalism could help us stay connected in our own writing, hang together in our own times. Read traditional academic discourse as carefully as we can: try on preferred forms, find their limitations, test their biases. Next, in our own complex ways, follow nineteenth-century women's attempt to straddle nondominant writing and the academy's preferred forms. Third, acknowledge the difficulty of opening up academic writing to unwarranted discourse—and acknowledge the pain inflicted by critics of our own unsanctioned writing. Finally, we can keep spinning out defiant and connected webs despite all difficulties. We must weave our own yarns and poetry and arguments, branching out in unexpected ways.

Then our writing too, like those old sentimental texts, might move and mend both heart and mind.

PART 2

Ethos-in-Process: Sentimental Women Poets and "True Womanhood"

## 2. Frances Ellen Watkins Harper, Black Poet Ventriloquist

> They speak as themselves (whomever they imagine those selves to be) as speaking subjects, face to face, eye to eye with their readers, and, they construct themselves variously as "I."
>
> —Jacqueline Jones Royster on African American women writers, *Traces of a Stream*

> I'm just trying to look at something without blinking, to see what it was like, or it could have been like, and how that had something to do with the way we live now.
>
> —Toni Morrison on expectations for black literature, *Salon* interview

His look is stunned. Hers, worn and wary. In the 1998 film version of Toni Morrison's novel *Beloved*, Oprah Winfrey as Sethe unfolds for Paul D (Danny Glover) her version of the tattered article he holds out. How could the woman he loves kill her own child? How can she possibly explain that violence again even to someone who cares?

Oprah and Morrison are not the first to conjure this black mother's voice out of shocked silence. African American Frances Ellen Watkins Harper (figure 2.1) likely recited her poem "The Slave Mother: A Tale of the Ohio" in abolitionist rallies soon after the 1856 incident when fugitive Margaret Garner killed her two-year-old daughter rather than let slave hunters return the girl to the South. This poem appears along with others in the 1857 second edition of Harper's *Poems on Miscellaneous Subjects*.[1] This chapter reinvokes the voice of Margaret Garner in the ethos of Harper's poetic ventriloquism;

Fig. 2.1. Frances Ellen Watkins Harper in a photograph taken about 1870. PHOTOGRAPHY STUDIO F. GUTEKUNST, PHILADELPHIA, PENNSYLVANIA, UNIVERSAL PEACE UNION RECORDS, SWARTHMORE COLLEGE PEACE COLLECTION.

the fugitive slave mother speaks for herself through the dynamics of serious sentimental rhetoric.

Not all critics of the film are favorable, but a diverse public is mesmerized by its favorite talk-show host playing Toni Morrison's protagonist Sethe. Oprah's warm voice and Hollywood magic draw viewers to identify with this fugitive slave mother, a historical figure of the pre–Civil War United States. The "I" we know as Oprah is inhabited by a woman haunted by the death of her own child, killed to thwart slave hunters. Two personae converging on screen produce an ethos, a sense of self, recognizable in Jacqueline Jones Royster's take on African American women artists' and writers' self-presentation: "They speak as themselves (whomever they imagine those selves to be) as speaking subjects, face to face, eye to eye with their readers, and, they construct themselves variously as 'I'" (*Traces* 21). Without benefit of Hollywood

or talk show host, 140 years before *Beloved*, Harper uses a similar layering to animate the figure of beleaguered African American, Margaret Garner, and to effect a persuasive identification between Garner and her hearers.

How did she do that? What ethos did Harper muster and master to write such verse? In this chapter, I analyze how Harper's text not only reanimates Garner's voice but also appropriates and projects a rhetorical persona directly into readers' imaginations. Harper's animation proves more politically charged than the "Poetess" prosopopoeia, or personification, that critic Virginia Jackson claims all sentimental women poets enact (57), folding instead the poet into a historical figure, doubling up the sophisticated, educated black intellectual into a desperate slave mother on the run. Frances Harper's self-within-a-self performs a kind of associative and dissociative ventriloquism by a sentimental rhetoric that subverts, converts, and transforms her culture's disposition toward black people. To set Harper's work in the culture of her day and suggest how it still speaks to us, I read her poetry through the nineteenth century's rhetoric of sentiment and also within frameworks articulated by black feminist rhetoricians of the twenty-first century. With a projection of ethos perhaps inherited from this popular antebellum black poet, Morrison and Winfrey insist we hear and identify with more voices muffled by race violence.

## *Black Women's Ambivalence and Subversion*

Shirley Wilson Logan analyzes Harper's speeches for their ambivalence toward white audiences, a black writer's "womanist" stance Logan credits to Alice Walker (*Speakers*). Applying Lucie Olbrechts-Tyteca and Chaim Perelman's principles of "associative and dissociative processes," Logan writes, "Calling for unity in diversity, Harper aligned her interests with those of white auditors 'to bring separate elements together.'" Qualifying that alignment, however, Logan observes, "On other [issues], she engaged in dissociation, pointing out ways in which her experiences had been different from theirs" (*"We Are Coming"* 45). I focus in this chapter on how Harper sets up associative and dissociative dynamics in her poetry by "throwing" a marginalized voice into white readers' imaginations. The poet thus identifies with middle-class white readers' notions of womanly propriety while she sharply challenges cultural commonplaces.

By strategic use of poetic ventriloquism, Harper also produces another stance Jacqueline Jones Royster describes as a goal for many African American women writers. The poet accomplishes a "subversion of old ways of

thinking, being, and doing" but also a "conversion of old ways." The goal Royster envisions is an "affirmation of fused horizons, newly negotiated and mediated spaces that bridge communicative gaps" (60). These three transformations of subversion, conversion, and fusion are not so much sequential as simultaneous in Harper's "ventriloquism." Merging voices from the past with her own speaking or writing persona and readers' own speech, the black poet ventriloquist envelops harsh racialized contradictions to transform them.

## *The Poet's Liminal Ethos*

Harper's facility for rhetorical bridge building between black and white women may have arisen from her own liminal context, historically. An orphan, she nevertheless has a strong family. A domestic servant for a time, she nevertheless follows a call to teach and preach. Presenting herself as a thoroughly proper woman according to dominant standards, she strides boldly to the speaker's podium, a place women then rarely stand. Frances Ellen Watkins is born a free black in Baltimore in 1824 or 1825.[2] Maryland was a slave state, a border state of the Confederacy, but had a large free black population since colonial times. Harper is orphaned at age three, and an aunt and uncle raise her. Because of audience comments about the poet's light skin, Frances Smith Foster allows, "It is quite possible that Frances Watkins, like many African Americans, was fathered by a white man" (*Day* 6). Whether her own mother fled slavery, sources do not say, but Harper is educated by her prominent antislavery uncle at his school, the William Watkins Academy for Negro Youth. Foster cites Rev. William H. Morris' description of Watkins' institution as "a school of oratory, literature and debate" with a curriculum emphasizing "biblical studies, the classics and elocution." The school's strong reputation led even slaveholders from neighboring states to send mixed-race sons there. Watkins is strict with all charges, Foster reports from accounts of a former student, not sparing "that strap . . . designed to make profound orthoepical, orthographical, geographical and mathematical impressions. And it made them" (*Day* 7).

Given Watkins' curriculum, it is no surprise he is an effective orator with an "incendiary" antislavery message, according to African American poet Melba Joyce Boyd. He contributes essays and poems to abolitionist publications familiar to black and white readers, both *Freedom's Journal* and later the *Liberator*. A dedicated educator of anyone within his sphere, he exults in the "liberationist doctrine and black consciousness" of the new African Methodist Episcopal Church, says Boyd (*Legacy* 37). Not incidentally, this

man persuades William Lloyd Garrison to reject the removal of African Americans to Liberia.

Frances' training at Watkins' Academy ends at thirteen, as does formal schooling for all three poets of this study. She pursues her own education during domestic service to a family owning a Baltimore bookstore, publishing her first collection of poetry and prose at age twenty-one. In 1850, Frances Watkins leaves Baltimore and the borderland south to become a teacher herself, in Ohio and then in Pennsylvania. She marries in 1860 and becomes Frances Harper, cutting back—but not quitting—her antislavery work to raise a family and run a small Ohio farm. In 1864, she is widowed and resumed a heavy speaking schedule. The poet's adoption into her activist uncle's family likely leads her to adopt his abolitionist mission. She writes a friend, "Oh, is it not a privilege, if you are sisterless and lonely, to be a sister to the human race, and to place your heart where it may throb close to downtrodden humanity" (Still 763). In 1853, a Maryland law puts persons of color from the North at risk of being sold into slavery. That law costs Frances her home and her adopted family but intensifies her commitment to fight slavery. From then on, activist papers and journals frequently print her poems. Moody and Cali report, "She publishe[s] at least ten volumes of poetry between 1846 and 1891" (*Oxford Bibliographies* online, 2013). On her twenty-ninth birthday in 1854, Frances Watkins begins travel through the North as orator and writer for the Maine Anti-Slavery Society (Boyd, *Legacy* 43).

"Slavery comes up like a dark shadow between me and the home of my childhood." From the abolitionist circuit in 1858, Watkins reflects on the Maryland law to William Still, friend and Philadelphia conductor on the Underground Railroad. "Well, perhaps it is my lot to die from home and be buried among strangers; and yet I do not regret that I espoused this cause; perhaps I have been of some service to the cause of human rights." She weaves into this letter the first stanza of "Bury Me in a Free Land," perhaps her best-known poem:

> Make me a grave where'er you will,
> In a lowly plain, or a lofty hill;
> Make it among earth's humblest graves,
> But not in a land where men are slaves.             (Still 763)

The poet speaks of exile from Maryland, but she situates her pain among wrongs suffered by her people.

Harper's "I" merges with the ethos of all black people where she invokes a collective self later in the letter:

> I have lived in the midst of oppression and wrong, and I am saddened by every captured fugitive in the North; a blow has been struck at my freedom; North and South have both been guilty, and they that sin must suffer. (Still 763)

"My freedom" is at stake for Harper in the plight of every runaway slave. Like an Old Testament prophet, she warns the whole United States will be judged for fugitive slave laws.

Still cautions her in 1859 against spending too much from her own meager wages to support fugitive slaves, but Harper protests that "this is a common cause; and if there is . . . anything to be done to weaken our hateful chains or assert our manhood and womanhood, I have a right to do my share of the work" (*Day* 47). In a key act of "association," to use Shirley Wilson Logan's term, Harper emerges from a childhood stance between family and dominant U.S. culture, to take up adult identity and "common cause" with her oppressed people. Identification of the poet's ethos with all black people characteristically becomes rhetorical ventriloquism when Harper's first-person "I" is inhabited by situations and thoughts of past and contemporary figures significant to African Americans.

Fusing the poet with textual personae operates especially in Harper's recitation of first-person poems, a common feature of antebellum oratory. She also sells collections of her verse at abolitionist gatherings. Interweaving print and oratory, prose and poetic genres, she combines passions of poetry with the intellect of oratory; both teacher and preacher, she becomes a universalized "voice of moral conscience itself," according to Carla Peterson (127).

Harper's appropriation of common sense reverses a too-familiar critical gaze upon women, particularly black women, when they speak before an audience.[3] Instead she displaces the gaze from herself to the fictive personae speaking through her. Embedding in this poem the fleeing black mother's voice, Harper tempers it and so acknowledges risks for a black woman in white culture. Even today a woman of color "does not have a voice of her own," Dorene Ames writes of Native women; "her voice must always be projected to or through another in order to maintain her own subjectivity" ("Wandering"). Yet ventriloquism also authorizes Margaret Garner's voice and elevates the fleeing black mother's position. Wary of stereotypes about the danger of educated black people, Peterson says the poet's quiet speaking voice and manner acknowledge notions of propriety for nineteenth-century mixed-race and mixed-gender audiences.[4] Even more subtly manipulating

rhetorical form, Harper's ventriloquism in poetry bypasses propriety: she exploits identification between hearers and orator to reach white audiences' hearts with an African American fugitive's cause.

While Harper's antislavery speeches are not sermons, she often speaks from northern pulpits to people familiar with biblical allusions.[5] I elaborate in chapter 5 on the part Harper's Unitarianism plays in her educational agenda. Unitarian openness to women and their issues likely encourages this rhetor's call to speak. Her lectures, like sermons, aim both to uplift spirits and to exhort action. Rhetorical emphasis in Uncle Watkins' curriculum prepares Frances to braid all Harper's mental faculties into her speeches and poems, and oratorical convention advises Harper to insert a poem just before closing, clinching her aim to shape public sentiment by folding those hearing her into the speaker's ethical stance.[6]

Along with attaching her ethos and feeling by poetry, Harper's ventriloquism accomplishes another effect from rhetorical theorist Hugh Blair: "The great secret" in a sermon, Blair confides, is "to make every man think that the Preacher is addressing him in particular." He recommends, "As much as possible, the Discourse ought to be carried on in the strain of direct address to the Audience" (2, lecture 29). What better direct address than to skip the "you" and insert directly into hearers' minds a first-person fugitive, Margaret Garner? Inhabited herself by first-person characters when the poet read what Smith Foster calls "personae monologues" to the crowds, Harper employs this tactic of sentimental rhetoric for its accepted "ability to create character" in an audience (Peterson, 125). When readers buy Harper's verse collections to recite at home, she can thus project fictive voices of black figures right into the mouths and minds of her audiences, white or black. In this way, not only does the character of a historical figure speak through Harper, but by extension the readers too identify with personae of the past.

## *A Ventriloquist's Many Voices*

Harper uses this tactic of association and ethical appeal in at least ten other poems among the thirty-six she publishes between 1853 and 1864 (*Day* 56–94). After the war, her most remembered personae monologues portray the wise, old freed slave Aunt Chloe. Before 1864, voices brought to life by Harper address questions raised by white northerners, such as this one in "The Fugitive's Wife": Why do black men leave the South without their wives and children? A black woman testifies to her husband's losing battle for self-dignity under slavery:

> He vainly strove to cast aside
> > The tears that fell like rain:—
> Too frail, indeed is manly pride,
> > To strive with grief and pain.
>
> . . . . . . . . . . . . . . . . . . . . . . . . . . . . . .
>
> "Bear not," I cried, "unto your grave,
> > The yoke you've borne from birth;
> No longer live a helpless slave,
> > The meanest thing on earth!"       (*Day* 72–73)

Through Harper's first person, the slave wife urges her man to flee north, preserving some shred of self-respect and sanity. Why didn't more women run away too? They had children, the woman explains. In this poem, a wife and mother is more resigned than her husband to her "sad and weary lot / to toil in slavery" (*Day* 73). Her voice presents a more resigned disposition than Harper's version of another slave mother, Margaret Garner, who flees with her children.

    A more assertive first-person woman resists her husband in a frankly feminist poem, "Vashti." Harper gives a woman's perspective on why her husband, an Old Testament king, abandons his wife and queen for the girl Esther. In Harper's expansion of the Bible story, Vashti refuses to "entertain" the king and his male guests with a strip tease. For the American nineteenth century, his request constitutes a compelling reason any respectable queen would abdicate her position. Vashti's assertions answer a broader question for women: How can we find agency to refuse demands of powerful men? Harper's readers might associate this question with women bound to southern slave owners, but all women in a male-dominated culture face some version of this question. Vashti demonstrates one courageous response by dismissing the king's messenger:

> "Go back!" she cried, and waived [*sic*] her hand,
> > And grief was in her eye:
> "Go tell the King," she sadly said,
> > "That I would rather die."       (*Day* 183)

According to Vashti's testimony in other stanzas, the kingdom itself is at stake in her resistance. The king's "counsellors" warn the queen must be punished for rebelling, or all "the women, restive 'neath our rule" would learn from Vashti "to scorn our name" (*Day* 183). Not only Vashti but also black women slaves and some white women speak through these lines where a feminist

Harper stands up to the patriarchy of her day. In tones ringing for women readers like Patrick Henry's in the Revolutionary War, Vashti cries out: Death is better than life without dignity. Ventriloquism of the poet's ethos and freedom over life in bondage also distinguish the Ohio slave mother.

A five-canto epic titled "Moses" is an especially revealing instance of Harper's ethical ventriloquism. Published in the late 1860s, but likely begun just after the 1863 Emancipation Proclamation, this poem conjures the voice of Moses' sister Miriam, the Bible's first woman prophet. Along with Miriam, other women also speak in snatches, including Moses' mother and Pharaoh's daughter, who adopted infant Moses rather than allow the regime to kill this baby boy. The long poem traces questions arising in U.S. culture from the Emancipation Proclamation until just after the Civil War. Mary Loeffelholz stresses Harper's postwar "cultural mediation" rather than her witness to black people's concerns ("Difference" 105). However, particular to Harper's ventriloquist ethos is Miriam's response to a question like Vashti's: How can a woman, a black woman, speak up against white governmental power? Miriam and Harper respond: What higher calling can a woman poet have than to speak liberation to her people?

In the figure of Miriam, says black critic Frances Smith Foster, "a woman now becomes . . . [Israel's] poet and historian" (*Day* 85). Herself also a poet and historian, Harper invokes the Egypt story in this emancipation poem to comment on U.S. race and gender politics—as do other nineteenth-century poets and writers. Some of Harper's contemporary white readers must have heard or read with alarm the prophet Miriam's description of the tenth plague, killing all firstborn males among Israel's captors:

> A wail in the palace, a wail in the hut,
>    The midnight is shivering with dread,
> And Egypt wakes up with a shriek and a sob
>    To mourn for her first-born and dead.         (*Day* 161)

Few in power during the Civil War could have failed to sense in these lines a threat from newly free African Americans. Like Egyptian masters, white people may find their laws curbing black people's freedom will ignite new rebellions, like Nat Turner's 1831 massacre. Black people will rise, Harper warns, if justice is denied after the conflagration that should establish their freedom. State and federal legislatures will hammer out a new vision of postwar America (soon mitigated by Jim Crow laws), and Harper exhorts white governments they face certain doom if they suppress rights of black Americans. In Miriam's words, Harper's poetic ethos recalls the consequences

of Egypt's hounding Jews fleeing Pharaoh; simultaneously, however, the ventriloquist poet warns that America can avoid further turmoil only by respectful treatment of emancipated slaves.

Through Miriam, Harper sings her people's song of liberation from the Pharaoh of chattel slavery:

> As a monument blasted and blighted by God,
> Through the ages proud Pharaoh shall stand,
> All seamed with the vengeance and scarred with the wrath
> That leaped from God's terrible hand.  (*Day* 161)

A woman prophet's voice ties the Israelites' fate to African Americans' legacy of hard-won freedom, claiming God's hand is on the side of the oppressed. Perhaps the Civil War itself is Harper's "monument" to God's vengeance for the evil of slavery. By putting into "Moses" such a strong woman's voice, "Harper makes a case for women's active participation in politics," says Frances Smith Foster; "moreover, she gives a biblical precedent for women as poets and social analysts" (*Day* 138). Layering the first-person Miriam with her own voice, Harper herself assumes the office of poet for "an entire nation," Foster argues. Thus, like that first woman Hebrew poet, Frances Ellen Watkins Harper becomes "a kind of poet laureate" for nineteenth-century African Americans ("Gender" 85). Far beyond the entertainment of elocution exhibitions (Loeffelholz, "Mapping" 139), if white people recite these first-person poems, their voices converge with the ethos of Miriam, Vashti, the slave mother, and Harper into a voice of feminist and abolitionist conscience.

### *Margaret Garner's "Fearful Daring"*

Long before Harper's emancipation epic, with its voice of Miriam, the protagonist of "The Slave Mother: A Tale of the Ohio" presents readers with a determined, resistant, race-conscious female persona, one who acts, as Foster notes, with "fearful daring" to resist slavery ("Frances Harper" 86). Harper's ventriloquism is one tactic of nineteenth-century bridge building available to a poet with designs on subverting and converting readers' sensibilities. By such strategies, rhetorician George Campbell said, a rhetor can "transfuse" or "insinuate" new sentiments wholesale into audiences' minds (98). This Ohio slave mother poem animates a person and event that may not quite share Miriam's biblical sweep of scenery and time, yet the first-person ethos Harper constructs does engage the same rhetorical power to deliver an epic call to liberation.

Initially, however, Margaret Garner's voice does not sound like Miriam's battle hymn. This voice sketches a conventional domestic scene in flowery metaphor:

> I have but four, the treasures of my soul,
>   They lay like doves around my heart;
> I tremble lest some cruel hand
>   Should tear my household wreaths apart.          (*Day* 84)

Any woman glancing over the poem's first stanza, then and now, recognizes the language of a nineteenth-century feminine ideal. The speaker is a mother. She fears for her home. Her life revolves around her children, and she worries about their future. The children are the speaker's "treasures" and "doves around [her] heart." She "tremble[s]" that her family circle, her "household wreaths," will be destroyed.[7] The next three stanzas elaborate on the plight of this mother and her children. If this is not "true womanhood," identified with piety, purity, submission, and domesticity by Barbara Welter in 1966, what is? The ethos of this poem, the slave woman, performs Logan's rhetorical goals of association with—and dissociation from—prevailing norms, but Harper's rhetorical strategy of ethical ventriloquism also dramatizes the process Royster identifies: subversion of restrictive conventions and also conversion of readers to revised standards, new cultural norms.

Harper appropriates only to subvert the sentimental trope of motherhood by locking her speaker and such metaphor as "household wreaths" into equation with so-called universal standards for women—any woman might speak these words. Intensifying that identification and deepening her subversion, the poet omits any race marker from her description. Harper even employs supposedly nonracial commonplaces about "dark" and "light" by referring later in the poem to the "darkness of [her children's] future lot" and the baby girl's "pale and cold" body.[8] Such elisions and inclusions serve Harper's goal of associating the slave mother with Campbell's "hearers in general" and with white women in particular, yet she declares that this mother is a slave in the poem's title and proceeds to elaborate on the fate this slave system imposes on children. Her strategy acts at once to associate her protagonist with and dissociate her protagonist from a narrow private norm that white readers might imagine applies exclusively to them. Here Harper invokes "true womanhood" and overturns it in the same lines:

> My baby girl, with childish glance,
>   Looks curious in my anxious eye,

> She little knows that for her sake
>    Deep shadows round my spirit lie. (*Day* 84)

Watching her "baby girl" and her "playful boys," the speaker cannot feel joy, only dread; she fears—in stereotypical terms—the "deep shadows" of her children's "darkly threatened doom" (*Day* 84–85). By the fourth stanza, the mother is distraught, unable to stop thinking about sexual exploitation her infant daughter is sure to face: "Oh! when I think upon thy doom / My heart grows faint and then throbs wild" (*Day* 84). All mothers dote on their children, but white mothers do not fear the oppression of their children by chattel slavery. Thus, while Harper's first-person pronoun openly invites women to sympathize with her protagonist, the poet also linguistically overturns and pushes past individual identity to mark and then leap a deep racial divide.

Like Harriet Brent Jacobs' Linda in the 1861 narrative *Incidents in the Life of a Slave Girl*, Harper's narrator does not flinch from exposing dire consequences facing black slave women. In effect, the "I" of the poem makes every woman in Harper's audience (willingly or not) identify with the slave mother and vicariously participate in her plight.

> The Ohio's bridged and spanned with ice,
>    The northern star is shining bright,
> I'll take the nestlings of my heart
>    And search for freedom by its light. (*Day* 85)

By the time they reach this fifth stanza, audience identification with the slave mother is transformed from common maternal associations to a renewed identification with a mother who flees to save her children. Through dissociating from white women while still alluding to motherhood generally, Harper indicates how slavery endangers the woman's domestic tranquility. White readers should come to understand why the fugitive slave mother makes the decision to break state and federal laws and run across the ice of the Ohio River. Harper's ventriloquism subverts the conventions of private white female domesticity by hearers' and readers' conversion to accept this black mother's initial radical, very public decision.

### *Epic Echoes in Garner's Flight*

More background on rhetorical precedent for Harper's ventriloquist ethos may help explain the mother's second decision. By this strategy, Harper expands on a tactic from the tradition of classical rhetoric that constructs

ethos, or "character as it emerges in language," as defined in the *Encyclopedia of Rhetoric* (Baumlin 263). Harper uses a pointedly rhetorical prosopopoeia, a tactic akin to ventriloquism that makes the apparently inanimate speak for itself. This rhetorical move is traceable from early Greek drama, where an actor wore an enormous mask that worked as "an instrument of projection, amplifying his voice and enlarging (as well as fixing) his facial expression" (Baumlin 264). The huge mask seemed to speak for itself. In Harper's poem, the slave speaks for herself. If Harper's audience accepts the humanity of the poem's pronoun "I," they are persuaded of the black mother's humanity represented by that "I" and thereby may justify the slave's painful decisions.

As Greek actors spoke from behind a mask, so Harper uses her poem to amplify this slave mother's voice, ensuring that readers encounter a Margaret Garner with the "practical wisdom [*phronēsis*] and virtue [*aretē*] and good will [*eunoia*]" recommended by Aristotle for a rhetor's ethos (Baumlin 266). Characters of a tragic poem, "first and foremost," Aristotle insisted, "shall be good." Aristotle also added, "Such goodness is possible in every type of personage, even in a woman or a slave, though the one is perhaps inferior, and the other a wholly worthless being" (1454:15–16, 19–23). Neither worthless nor inferior, the ethos of Harper's ventriloquism is a good mother, a good woman, a good person, despite her criminal decision to flee a "master"—all this before she is accused of murder.

Separation of private and public spheres is breached by the slave mother's public decision to run, but her maternal values also undercut legal precedents of states' sovereignty and property rights that had established the fugitive slave laws. Presenting as Harper does a figure who has wisdom, virtue, and goodwill, James Kinneavy and Susan Warshauer argue, is "a type of *cultural* appeal." In this approach, "members of the audience are persuaded by sentiments resembling their own" (qtd. in Baumlin 266–67; italics in the original). Assuming common sentiments through her poem's open-ended maternal "I," the canny Harper has conjured an identity between potentially hostile readers and the poet's textual ethos, convincing white and free black women that they share the maternal impulses and moral reasoning called upon by this slave mother, though not her dire state. Because Harper not only successfully associates the black mother with domesticity but also dissociates her plight from womanly norms, the poet prepares her audience to think about radical ways to challenge racist practices.

The poet's tactic of not naming this Ohio slave mother nevertheless associates Harper's public with one figure, yet also urges their consideration of what might happen to a great wave of people fleeing the South before and

during the Civil War. The poet's open-ended first-person pronoun locates that identification in both past and future, for Aristotle defined the "function" of a tragic poet "to describe, not the thing that has happened, but a kind of thing that might happen" (1451:37–38).

Morrison in *Beloved* takes the opposite tack with the same end. The novelist names her character Sethe, perhaps feminizing the biblical name Seth, Adam and Eve's son born after Cain killed Abel. According to notes in the *New Oxford Annotated Bible*, Seth's name is a pun on the Hebrew verb for "appointed." The story says Eve "bore a son and named him Seth, for she said, 'God has appointed for me another child instead of Abel'" (Gen. 4.25). Perhaps *Beloved*'s Sethe is Morrison's appointed replacement for Garner. Sethe's story may dramatize how it might have been if Margaret Garner's flight to the North had freed herself and some of her children. Harper's poem imagines how it might work if fugitive slaves, Margaret Garner in particular, are able to speak for themselves in 1856. If the slave mother could speak in her own defense, Harper infers, the second decision might be different.

From teaching and speaking, Harper knows many slaves flee yearly across the river ice from Kentucky to the North. Steven Weisenburger in *Modern Medea*, a narrative based on records of the Garner incident, estimates that in 1856, "175 fugitives passed through Cincinnati during the eleven weeks when the Ohio was frozen" (71). The flight of mothers with children entered antislavery iconography even before Harriet Beecher Stowe's 1852 *Uncle Tom's Cabin*. Stowe herself only popularizes a commonplace of abolitionist lore by describing Eliza jumping from ice floe to ice floe with an infant in her arms.

The actual Garner flees Kentucky with her four children, her husband, and his parents. Nine others also cross that day (Weisenburger 60). They come from neighboring plantations on foot across the ice to the so-called free state of Ohio. Levi Coffin, a Quaker conductor for the Underground Railroad in Cincinnati, tells in his 1876 *Reminiscences* that the other nine find various friends in Cincinnati abolitionist circles and are immediately spirited away to Canada and to freedom. But Coffin says, "An old slave named Simon and his wife Mary, . . . with their son Robert and his wife Margaret Garner and four children," look for a particular contact in the city, and these eight are seen several times stopping to ask directions.

Harper relates this phase of the narrative in the third person, and then the poem shifts into a second-person voice, which turns to address the fleeing woman:

> She fled, and with her children all,
> > She reached the stream and crossed it o'er,
> Bright visions of deliverance came
> > Like dreams of plenty to the poor.
>
> Dreams! Vain dreams, heroic mother,
> > Give all thy hopes and struggles o'er,
> The pursuer is on thy track,
> > And the hunter at thy door. *(Day* 85)

Shifts in grammatical personae signal accelerating tempo in the poem's narration. The third person moves the fleeing family across the river, allowing the poet to connect a fugitive's futile dreams to economic conditions facing all destitute people: dreams, she exclaims, cannot overcome the economy of a culture corrupted by greed. Second-person address slows down Harper's story, like a camera narrowing from wide angle to close-up. The poet's lens refocuses crisply on the "heroic mother," pausing next on the Cincinnati house supposed to be the family's refuge.

As Coffin tells the story, within hours, the friend's cabin hiding Garner and her family was

> surrounded by . . . the masters of the fugitives, with officers and a posse. . . . The doors and windows were barred, and those inside refused to give admittance to the slavers. The fugitives . . . were determined to die, rather than be taken back. Margaret . . . declared that she would kill herself and her children before she would return to bondage.

Newspapers report that her husband, Robert, has taken "a fully loaded six-shooter" from the plantation when he flees (Weisenburger 61), and Coffin confirms there is at least one gun in the cabin, noting, "The slave men were armed and fought bravely." But at last, pursuers beat down the door. Coffin continues:

> Margaret's husband fired several shots, and wounded one of the officers, but was soon overpowered and dragged out of the house. At this moment Margaret Garner seeing that their hopes of freedom were in vain, seized a butcher knife that lay on the table, and with one stroke cut the throat of her little daughter. . . . She then attempted to take the life of the other children and to kill herself, but she was overpowered, and . . . the whole party was then arrested.

Ohio is not free. Slave hunters chase down the family in Cincinnati, and they are jailed.

Today's university students studying "The Slave Mother: A Tale of the Ohio" for rhetorical strategies of ethos recognize its ballad form and note these shifts from first to third and then to second person—and back. Irregular tetrameter of a ballad and the poem's casual *abcb* rhyme scheme allow Harper to popularize a folk narrative and seal it in the collective memory. Carla Peterson comments on Harper's deft appropriation of the ballad's oral, communal, and political traditions. Wendy Olson has also applied Harper's appropriations of the ballad to this poem. Such formal conventions signal nineteenth-century readers that Harper is well versed in conventions of poesy usually associated with white male writers and later with white women poets. This black writer knows poetic form well to use it, subvert it, and reflect on a contemporary incident. Using the ballad as political broadside, Harper assumes authority to comment on social and moral issues raised by the Garner event. This text is people's poetry, embracing a white audience but telling a story of African Americans that the poet insists her audience heed and act on.[9]

More abrupt shifts in pronouns of the seventh, eighth, and ninth stanzas mark Harper's attempts to identify with readers. Student readers tell me the shifts work to maintain their empathy with the fugitive slave in difficult passages where the text lays out details of the child's death. At the point where slave hunters close in and the slave mother approaches her second decision, the woman resumes her own first-person account. Yet the last line of the seventh stanza shifts back to third person, as does Harper's later description of the murder.

> Then, said the mournful mother,
>     If Ohio cannot save,
> I will do a deed for freedom,
>     She shall find each child a grave.
>
> I will save my precious children
>     From their darkly threatened doom,
> I will hew their path to freedom
>     Through the portals of the tomb.
>
> A moment in the sunlight,
>     She held a glimmering knife,
> The next moment she had bathed it
>     In the crimson fount of life.     (*Day* 85)

Both uses of the third person here serve to avert a reader's eyes from the act, yet students discussing the poem focus on details of the child's murder. The mother's first-person voice explains this death as a "deed for freedom." Yet not "I," but "She" will do the deed. Harper retreats from placing this decision in the mother's own mouth, although parataxis of lines before and after the end of stanza eleven insists that "she" is the same woman as "I." No one else will "save my precious children," so the parallel sentence structure asserts that "I" must act. The poet's voice-over steps in again to narrate the murder, perhaps again dissociating Garner's act from maternal norms. With a prophetic third person as auspicious as Miriam in "Moses," Harper slows the scene to crawl. A glint of sunlight freezes this horrific tableau a split second before the knife descends, recalling another biblical drama when an angel stopped the patriarch Abraham before he could plunge a knife into his only son, Isaac. In the book of Genesis, Abraham was divinely ordered to perform this human sacrifice but also divinely halted. Not this time. This mother may believe she has a divine calling like Queen Vashti, who valued freedom in death over a degraded life. No angel stopped Garner. Harper's third-person voice halts readers at the brink of the deed; it does not restrain the mother.

Rather like Harper's third-person shift, Oprah's version puts this action in a shed, leaving details to viewers' imaginations. Yet Harper's graphic detail is necessary to the epistemology governing its rhetoric of sentiment, requiring detail to place readers at the scene, making them face the same exigency as the protagonist. Harper states in her earliest published essay, the 1857 "Christianity," that the goal of her writing is to mold the mental faculties, for she gives virtually the same list as Campbell in his 1776 *Philosophy of Rhetoric*.[10] Harper says literature's purpose is "to cultivate the intellect, enlighten the understanding, give scope to the imagination, and refine the sensibilities" (*Day* 98). Her "sensibilities" traverse the same territory as Campbell's faculty of "passion." The title "Christianity" shows, however, that Harper puts no stock in literature or rhetoric for its own sake. Harper asserts that without high moral purpose, texts "open not, to our dim eyes and longing vision, the land of crystal founts and deathless flowers . . . both here and hereafter" (*Day* 98). Foster remarks that such declarations are typical of Harper's "activist poetics" (*Written* 134). Her poetics appropriate Enlightenment rhetorical tradition and its faculty psychology so as to convert apolitical hearers and transform their culture. A mother's own graphic story of infanticide in gothic fiction of the day might have garnered sensationalist appeal to sell books, but mere sensation will not serve Harper's cause. Delivered solely in the mother's own voice, plans and description of the murder would risk

undermining sympathetic connections Harper works so hard to build between white readers and this desperate slave mother.

## Garner's Own Voice

The Cincinnati trial of Garner and her family lasts "four weeks and a day" in the spring of 1856, according to Weisenburger's sources (192). According to Coffin's account, the defense called witnesses asserting the fugitives traveled with their masters into Ohio a number of times before. Weisenburger's research further reveals that Margaret served as nursemaid to her "master's" children, traveling with the family at least once to the North. Because of this, by a law emancipating slaves brought by their owners into free states, she should already have been legally free. And not only Margaret, but any children subsequently born to her. Prevailing laws that children of slave women follow the condition of their mothers ensure that "masters" who father many of these children increase their property. If children follow the condition of "master" fathers, the population of *free* African Americans would increase. Nevertheless, Coffin records the presiding commissioner's declaration that Margaret's "voluntary return to slavery, after a visit to a free state, re-attached the conditions of slavery.... Thus the fugitives were legally slaves at the time of their escape." As if Garner's return to Kentucky as a girl in bondage could be "voluntary"!

Important to Harper's first-person voice as rhetorical strategy is Coffin's recall of "touching appeals" and "eloquent pleadings" others make during the trial. Although Margaret Garner is brought into court to speak to her children's status, Weisenburger points out she is prevented from testifying because fugitive slave laws forbid testimony from the runaway (163–65). To no one's surprise, proslavery commissioner John L. Pendery finds for the slave owners: "It was not a question of feeling, to be decided by the chance current of his sympathies. The law of Kentucky and the United States make it a question of property" (Coffin). Conventional arguments in a court of law are ineffectual on Garner's behalf.

Commissioner Pendery concludes:

> It has been our duty, as a Court, to listen with attention, and, we trust, with courtesy to all those arguments which have urged the decision of this question upon moral rather than legal grounds. We conceive that our highest moral obligation in this case is to administer with impartiality the ... provisions of the law. (Weisenburger 190–91)

The judge sees his primary "moral obligation" to uphold property laws of slavery, so the whole party gets returned to Kentucky. Weisenburger's research turns up detailed records of a steamboat wreck soon after the trial, an accident in which Garner's other daughter drowns (224–25). Margaret herself slips this child into the river, Henry Louis Gates Jr. reports in the PBS documentary *The African Americans: Many Rivers to Cross*. Months later, the drawn-out shell game ends, and Margaret is shipped south with her husband and the two boys. She dies of typhoid in 1858 after working a few months as a field hand (Weisenburger 280).

Harper's poem—like Morrison's and Oprah's drama—takes up Garner's case where courtroom defense fails. If the woman has a chance to speak to issues other than property, hearers must attend to moral issues of feeling and justice. Harper urges the prerequisite of right action, as does Harriet Beecher Stowe: "Every individual . . . can see to it that *they feel right*" (624; italics in the original). Working together, feeling is guided by moral reasoning in *Uncle Tom's Cabin*, Stowe's narrative argument for antislavery sentiment. According to activist women rhetors of sentiment, there should be no "chance current" of sympathies (Pendery's term). Rather, say Harper, Morrison, and Oprah, hearers' loyalties must attach securely to this human being, Margaret Garner. If she can defend herself, then juries, audiences, and readers will agree that slavery, laws supporting it, and racist practices must end. Garner's first person makes an eloquent argument to be heard and treated with respect.

Once the slave woman completes her bloody "deed for freedom," the poet's persona steps clear of the ventriloquist's mask. Harper as narrator pleas for feeling leading to right action:

> Sends this deed of fearful daring
>    Through my country's heart no thrill,
> Do the icy hands of slavery
>    Every pure emotion chill?
>
> Oh! if there is any honor,
>    Truth or justice in the land,
> Will ye not, as men and Christians,
>    On the side of freedom stand?       (*Day* 85)

The first two rhetorical questions in Harper's final stanzas appeal to patriotic sympathies to evoke antislavery sentiments. Her queries indicate incredulity that her country passed and now enforces fugitive slave laws responsible

for planting infanticide in Margaret Garner's mind. "Pure emotion," feeling mixed with virtue to construct antislavery sentiment, would never let the peculiar institution thrive so long, never tolerate corrupt jurisprudence in Garner's case. In the dark days before the Civil War, the poet identifies with the Union cause, asking fellow citizens if their hearts are frozen stiff by slavery's "icy hands."[11] Readers and hearers must respond to the ethos Harper offers.

The poet's final question prepares hearers for what amounts to an altar call: "Will ye not . . . [o]n the side of freedom stand?" Ticking off universal values that ought to bring all to their feet—honor, truth, justice, humanity, faith—the black poet readies her audience to march down the aisle when her oration's final comments give the signal. Here the poet's own voice addresses "my country" and "ye . . . Christians." By contrast, this direct address emphasizes Harper's first-person ventriloquism in earlier stanzas. Having heard the fleeing woman's testimony, the audience must turn away from vile laws and practices and be "converted," to use Royster's key term for African American women's discourse. Hearers with hearts warmed by the fugitive's story must next act, the poet insists, to change the system.

By this ventriloquism Margaret Garner, dead and gone, speaks through Harper to abolitionist audiences. Probably as peroration of a stump speech, the poet would read the Ohio slave mother's words. By another synchronicity, Garner could speak through Harper's readers when they later recite the poem. Obviously for this study, "ventriloquism" as Harper's strategy of ethos is not the cheap parlor trick denoted by the word. Rather, Harper's first person in dramatic narratives calls up more ancient associations of "prophecy and . . . divination with ventriloquism, which is to say speaking with the voice of another, or the voice of another speaking through oneself," as Steven Connor explains in *Dumbstruck: A Cultural History of Ventriloquism* (49).[12] Eerie sensations arise, Connor notes, even when this illusion could be a joke, for ventriloquism of all sorts characteristically produces "the breaking in of one time upon another, the sundering together of times" (416).[13] It is easy to press this analogy too far and conjure up ghastly black-faced minstrel marionettes popular in post–Civil War America, who performed only in response to racist caricatures.

### *Magic of the Ventriloquists*

Critics, even some African Americans, mistakenly identify the poet Harper with such caricatures. Some fault Harper for paying too much deference to white abolitionists, for being too intent on racial uplift and assimilation of

black people into dominant white bourgeois culture. Ironically, in light of imputed goals, some also say this poet does not measure up to modernist literary criteria and is "lacking in technique" (Benjamin Brawley, qtd. in Boyd, *Legacy* 20). Admitting Harper does reach a broad public, J. Saunders Redding snipes that she was "overwhelmed" by "demands of her audience for the sentimental treatment of the old subjects," so she would "gush with pathetic sentimentality" (qtd. in Peterson 125). Occasionally, a critic damns her with faint praise: among nineteenth-century poets, "Mrs. Harper was in no sense the least skillful among them" (Vernon Loggins, qtd. in Boyd *Legacy* 21). This view says Harper embraces the servant role forced upon Margaret Garner and many black women under slavery.

Harper is relegated by such critics to the nursemaid of white culture (figure 2.2). The black woman's stiff posture, blank expression, bandanna, and modest clothing indicate the dependence of white privilege and power on the slave system. The cultural power the child represents forces a black nursemaid's humanity into the background. In these views, it is as if Harper is slave to sentimental conventions. Recent black feminists attribute such slights to blatant misogyny, but even a woman anthologizer opines that, "varying little in mechanical forms, trite diction and rhymes, and generalized sentiments," many of Harper's poems "seem superficial stock pieces" (Sherman 113). Harper is not that woman. A few scholars recognize Harper's ethos to be a rhetorical move shaped to engage white sympathies: She aims precisely to transform the nation's sentiments on race. She reaches that goal by exploiting popular conventions of sentimentalism.

Alice Walker and Toni Morrison write of projecting historic voices in their texts, personae calling readers to action. Their subjects resonate with Harper's strategies of ethos. Linking life and language, Walker says:

> I learn that the writer's pen is a microphone held up to the mouths of ancestors and even stones of long ago. . . . The magic of this is . . . in the ability of the . . . human animal to perceive its being.

She concludes, "It is, in the end, the saving of lives that we writers are about. . . . *the life we save is our own*" (qtd. in Royster 28; italics in the original). If we care enough for humanity to perceive human beings through print and performance, foremothers such as Margaret Garner and Frances Ellen Watkins Harper can still speak. Their ethical goals change ours as their causes live again in our imaginations.

Morrison responds likewise to complaints about difficulties reading another of her novels, *Paradise*. With some heat, she tells an interviewer that

Fig. 2.2. Black woman wearing a bandanna and holding a white child, carte de visite, about 1860. YALE UNIVERSITY LIBRARY, BEINECKE RARE BOOK AND MANUSCRIPT COLLECTION.

compared with works by white authors, there are somehow "different expectations. Different yearnings, I think, for black literature." Her questioner probes the novelist: "You mean, they want you to step into what they've already heard?" Morrison nods and responds:

> And say, once again, "It's going to be all right, nobody was to blame." And I'm not casting blame. I'm just trying to look at something without blinking, to see what it was like, or it could have been like, and how that had something to do with the way we live now. Novels are always inquiries for me. (Jaffrey)

Like Harper, Walker and Morrison have expended great effort to make the past speak. It behooves us to look without blinking and to hear without flinching the record of past people. What was life like? How does that impact the way we live? By collapsing the past into the present as Harper does, these black women make historical issues immediate and urgent.[14]

Analysis of Frances Harper's rhetoric reveals this skilled poet was no puppet of convention, but an expert in "art for humanity's sake," as Joan R. Sherman once characterized Harper's work (113). To subvert norms, to convert sentiment, and to affirm transformed principles of humanity, Harper's ventriloquism requires "rhythms and rhymes . . . easy to memorize and to recite," Frances Smith Foster explains. She could "use her words as weapons" (*Day* 29), but Harper's ventriloquism works less as attacks from outside than like tiny time pills—internally. She knows blaming is not as effective as replacing audiences' internal monologues with new poetic scripts making vivid what might have been—and how that story affects our lives now. Memorization and recitation, in other words, make a slave woman's words roll off readers' tongues, resonate in their bodies, ring in their minds. The point is to affirm her readers' deepest values while transforming premises of womanhood, so that women's concerns could include freedom from social and economic oppression. With Harper's words in their mouths, white readers literally must come to terms with why the slave mother killed her child. Under desperate conditions, they hear themselves say, "I could have done it myself."

The fugitive slave woman becomes the protagonist of her drama, not backdrop. The woman tells her story her way. Through a poet's magic, we have dramatic reversal of what Emile Benveniste has called "the status of 'person'" (729). In Benveniste's analysis, that status is inscribed by pronouns. By many strategies, the mother in Harper's poem appropriates to herself the authoritative "I." She asserts the empirical, true eyewitness account of slave life. She elaborates on her values as a mother, her rationale for fleeing. And she alone expresses terror for her children at the prospect of recapture. Denying anyone the status to usurp or interrupt her account, the fugitive slave mother in Harper's poem can give full testimony in the court of public opinion.

Consider as replacement for the antebellum nursemaid this still from *Beloved* as narrated by Oprah Winfrey, more than once rated the most influential woman in America by such institutions as *Ladies Home Journal*. Here a black woman cradles her grown child (figure 2.3). Some complain director Jonathan Demme's adaptation is too faithful to the book, and

Winfrey's Sethe does stick closely to the original. Faithful adaptation was the movie's goal, the author retorts, zeroing in on the hard work it took to make Winfrey into Sethe/Garner. The problem is, Morrison admits, "Oprah cries, Sethe doesn't." Critics did not like the cool, "iron-eyed" Oprah of this film, but Morrison approved. "As soon as I saw her I smiled to myself," she says, "because I did not think of the brand name. She looked like Sethe. She inhabited the role" (Corliss 75). Inhabiting the role, Oprah is possessed body and soul by Sethe. If some did not like this Oprah, at least they did not leave the theater hissing, like the novel's slave hunter, "Animal!" Harper and her audience once recited this poem; likewise, Oprah breathes life into Sethe to become both Morrison's—and Garner's—medium for ventriloquism, a body in which forceful black women's voices converge. Because she is still Oprah, even when folded into Sethe and the historical Garner, the character forces audiences to think about black slave mothers with new understanding. You cannot dismiss the fugitive woman's subjectivity projected by the warm voice of a favorite TV host.

Fig. 2.3. Sethe and Beloved in the motion picture *Beloved*, directed by Jonathan Demme and featuring Oprah Winfrey, Danny Glover, and Thandie Newton. TOUCHSTONE PICTURES, HARPO FILMS, 1998.

Transforming the culture's racist sentiments is the aim of Morrison and Oprah, as it was Harper's more than 160 years ago. Sethe and Beloved gaze "eye to eye" at movie-goers (says Royster), "without blinking" (says Morrison) at racist attitudes. Like Harper, these self-aware, confident black women not only throw off chokeholds of racist culture but also reverse its power over the status of persons. They make the dead speak and the deaf hear.[15]

Without the magic of these ventriloquists, dominant authorities have enormous, unbridled capacity to forget there are other voices on the stage. Scripting the voice of Margaret Garner and other African Americans back into a courtroom of cultural opinion, Harper, Morrison, and Winfrey demonstrate that the humanity of every person commands respect. Not the black woman, but systems choked with racism are inhumane and will be judged.

# 3. Reviving Lydia Huntley Sigourney

*[T]he strong mind whose heaven-born thought*
  *No earthly chain could bind,*
*The holy heart divinely fraught*
  *With Love to all mankind,*
*The humble soul whose early trust*
  *Was with its God on high,*
*These were thy Sister, who in dust*
  *May sleep, but cannot die.*
    —Lydia Huntley Sigourney, "She Is
      Not *Dead*, but *Sleepeth*" (1836)

We say not thou art dead. We dare not. No!
  —Lydia Huntley Sigourney, "Felicia Hemans" (1836)

Much sentimental literature . . . illustrates the extent to which the public comes to infiltrate and inhabit the domestic, thereby politicizing it, and conversely the degree to which metaphors of domesticity are appropriated to express the political, thereby domesticating it.
  —Carla Peterson, *"Doers of the Word"*

It is time to revive, not just to reinvent, the ethos or writing subject supported by Lydia Huntley Sigourney's texts. So much has been made of Sigourney (figure 3.1) as the elegist emblematic of nineteenth-century "true womanhood" that it is impossible to dissociate this writer from pervasive twentieth-century views of antebellum women and consolatory verse.[1] Far

Fig. 3.1. Lydia H. Sigourney, engraving done about 1860. FROM *EMINENT WOMEN OF THE AGE*, EDITED BY JAMES PARTON AND HORACE GREELEY.

from ignoring Sigourney's concerns about death as a topic, this study moves to analyze rhetorically the ethos or textual personae constructed in her lines, reasserting her own "strong mind . . . no earthly chain could bind." I argue our attention should focus on the significance of a death and resurrection repeatedly enacted by Sigourney's ethos, a writing self comprised of feminine—and some masculine—personae who appear in her poems, disappear, and rise again transformed. Excerpts from Sigourney's commemorative poems at the head of this chapter not only testify to the afterlife of some other soul but also stand as tribute to this indefatigable poet. Sigourney rises from the dead in her poems, transformed by a characteristic sentimental trope: metonymy, a slide from one subject to another. Such resurrection affords her release from a world unwelcoming to women poets or to any woman rhetor. In her own context, more prominent than some morose elegist is the resilient Sigourney who "cannot *die.*"

## *Sigourney's Flexibly Gendered Ethos*

Four variations characterize the flexibly gendered ethos of the sentimental rhetor in Lydia Huntley Sigourney's texts. Each of the first three—Sigourney as "the American Hemans," the sermonizer, and the prophet—is a strong, purposeful voice. Yet each enacts an eclipse of the woman poet's self, a kind of textual death, because she is hiding behind someone else. I begin this chapter with a pair of baffling works confusing Sigourney with the British poet Felicia Hemans. This peculiar doubling of Sigourney's feminine writing subject is seen by some as relegating her to the so-called obscurity of Hemans and other nineteenth-century sentimental women. But from a rhetorical perspective, Sigourney as "the American Hemans" takes heart from this mix-up, using it to assert a writing persona not only forcible but also public—and at the same time properly feminine. Next, two poems discussed in the middle of this chapter cloak Sigourney as a man. The male-masked female self of "Sentiment in a Sermon" demonstrates the poet's expertise with conventions of the rhetoric of sentiment. Likewise, a masculine poet-prophet dominates most—but not all—of Sigourney's long poem "Imitation of Parts of the Prophet Amos."

These three personae exemplify dangers and advantages of metonymy, or substitution of terms, in a rhetoric of sentiment under the rubric of Enlightenment rhetoric. Sentimentalism is based on sensationalist epistemology preferred for 150 years both as a basis for perception and science and as fundamental to the psyche. George Campbell lays it out in his 1776 *Philosophy of Rhetoric*, recommending metonymy over other rhetorical figures as a means to lively discourse. To him, metonymy is "most various of the tropes" because liveliness or "vivacity" is crucial to reproduce sensory experience in a text or speech. Metonymy trumps any new metaphor because the latter risks "impropriety" and "obscurity." In contrast to metaphor (a switch in categories), metonymy slides between terms, where the second term depends on "causes, effects, or adjuncts" of the first. Metonymy is superior to metaphor, Campbell claims, because of more direct reference between the terms of the comparison (294). That "strong mind" in the first epigraph illustrates such metonymy. Sigourney refers to the dead woman by her intellect, a dimension of character evident to all who knew her. The poet need not mention the woman by name, but invokes this "adjunct" of herself. By metonymy, Sigourney's trope has even more "vivacity" than Shakespeare's familiar reference to a dead person as "this mortal coil," which, as metaphor, requires a greater stretch of the imagination to connect the term to the remembered human being.

From antiquity, metonymy has been understood as one species of metaphor. Aristotle's sense of metaphor sounds quite like later specific definitions of metonymy: it "consists in giving the thing a name that belongs to something else; the transference being either from genus to species, or from species to genus, or from species to species, or on grounds of analogy" (1457b:8–10). The *Encyclopedia of Rhetoric* calls metonymy a switch of names by "substitution of contiguities . . . in terms of a causal, a local, or a temporal relationship" (Nate 496). Metonymy as a switch in terms, Richard Lanham writes, is not separate from metaphor, but "the central instance of the transforming power of metaphor" (103). The problem and the promise of metonymy both occur because its two terms get confused: the substituted term may skew the first past recognition, even erase all sense of it, or the substituted term can lend strength to the original. Sigourney's use of metonymy suggests that the antebellum woman poet contrives a powerful metonymic ethos gaining strength from identification with forebears. Metonymy enables a woman poet to speak to an American scene that remains resistant to women's voices.

Finally, I consider a fourth appearance of Sigourney as antebellum sentimental poet, an oddly inspiring performance of this poet's rhetorical ethos narrating the 1858 mixed-genre work, *Lucy Howard's Journal*.[2] The journal's last entries indicate that Sigourney's protagonist dies as a pioneer woman in childbirth. But the writer confounds death to rise from the grave and close the text herself. Lucy's disappearance and return remind readers this is an ethos no less constructed or fictive than Sigourney's masculine masks. Lucy's voice from the dead makes trouble for today's readers. This resurrected self challenges our views of the poet Sigourney and of all sentimental women writers, and so we must adjust notions of "true womanhood" articulated by Barbara Welter in 1966. Lucy's performance marks the metamorphosis of an unashamedly female author writing about herself in a manner not very pure, pious, domestic, or submissive. The poet rises from the dead by a trick of narration, but also by her links to forebears and by her hold on readers' memories. The writer's resurrection in *Lucy Howard's Journal* typifies a recovery Sigourney might inspire in our imaginations every time we read antebellum women poets' texts.

### *Birth of the American Hemans*

In 1828, Sigourney's reputation suffers its first fortunate error—or perhaps tragedy—when New Haven editors mistakenly place Lydia Huntley Sigourney's "Death of an Infant" in a collection of works by the British poet

Felicia Hemans (Haight 78). On one hand, this mistake becomes impetus for Sigourney's popularity as "the American Hemans." On the other hand, the editors' mistake reinforces, for some, the small worth of sentimental writers—Hemans and Sigourney especially. They are two from masses of antebellum popular writers that Edgar Allan Poe acidly referred to as "animaliculae" who generate an infectious mass of "microscopial works" (qtd. in Haight 79). What about Sigourney makes her for Poe a carrier of the sentimental pandemic? Poe feared, perhaps, that some sentimental infection would make the public ill disposed toward his poems. Effects of a metonymy identifying Sigourney with Hemans include not only drowning by the British poet's fame and sentimentalism. It is also possible that riding apron strings of Hemans' posthumous fame, Sigourney can persuade readers to grant her a like measure of immortality.

Lydia Sigourney's writing about Hemans demonstrates the power of sentimental metonymy. One of several poems in memory of Hemans ends Sigourney's 1836 collection, *Zinzendorff, and Other Poems*. A central topic of this piece is the unquenchable flame of Hemans' life and works. Near the end, Sigourney asserts this rather conventional doctrine with peculiar force:

> We say thou art not dead. We dare not. No.
> For every mountain stream and shadowy dell
> Where thy rich harpings linger, would hurl back
> The falsehood on our souls. Thou spak'st alike
> The simple language of the freckled flower,
> And of glorious stars. God taught it thee.
> And from thy living intercourse with man
> Thou shalt not pass away, until this earth
> Drops her last gem into the doom's-day flame.          (299)

Packing two sentences and three denials of Hemans' death into the first iambic pentameter line is no mean feat. Together, these lines say the earth and all its creatures have been changed by Hemans' poetry: everything on which "thy rich harpings linger" protests the poet's death. Her words live after her, so she and every topic of her texts will never die. Sigourney's negatives in somber blank verse mark her forebear's death, commemorate Hemans' life and significance, and situate Sigourney among those inspired by Hemans' verse. Because Sigourney lavishes praise on the famous poet, this piece puts the American woman in "contiguity" with the British (reiterating one of Nate's conditions for metonymy). The mantle of Hemans' fame thus can slide from her shoulders to Sigourney's emerging ethos.

In success, Hemans is always one step ahead of Sigourney. Hemans' life in Wales thus marks a path for her American devotee. At the start of their careers, Hemans and Sigourney each win a poetry prize against well-reputed men. In 1819, Hemans wins acclaim at twenty-six for best poem in competition with others all over the British Isles (Trinder, 19). Sigourney reads of Hemans' prize from U.S. print coverage of the famous poet. In 1828, Sigourney herself shares with N. P. Willis an award of $100 in a competition sponsored by *The Token*, America's first successful annual (Haight 77), a gift book featuring a collection selected from newspaper and magazine poetry and other genres, akin to today's volumes of the year's best poetry, fiction, or essays.

Hemans' determination to keep writing despite her husband's disapproval also helps Sigourney persist in the face of spousal complaints. Hemans publishes two collections of poetry before she marries, and unlike thwarted sister writers like Jane Welsh Carlyle, Hemans keeps up the pace of publishing after she weds (Clarke 112), producing three more books in the first six years of her marriage and before 1818, when her husband permanently sails away from Britain and his family to live in Italy. The poet, meanwhile, gives birth to five sons (Trinder 15). Sigourney's memorial poem emphasizes Hemans' egalitarian appeal as it denies the British poet's death. She is born to a family of distinction, but she uses both the "simple language of the freckled flower, / And of glorious stars," Sigourney notes. Hemans' father was the imperial and Tuscan consul in Liverpool; her mother's father was the Venetian Republic consul (Trinder 4). Yet the British poet's readers include hundreds of thousands—as Sigourney doubtless hopes for herself—from every class on both sides of the Atlantic.

"The American Hemans" likewise determines to publish though she is hardly as well born. Sigourney was born in 1791, only child of a groundskeeper on the Norwich, Connecticut, estate of Jerusha Talcott Lathrop, an ailing widow who provides the girl's education (Haight 1). Lydia Huntley publishes one volume, *Moral Pieces in Prose and Verse* (1815), before her marriage in 1819. But she becomes known from magazine poems printed under her name during her first ten years of marriage. In bound poetry collections over those same years, her work appears anonymously. Charles disapproves of any public appearance by his wife, even in print. These objections require Lydia to make "elaborate arrangements" to publish secretly two 1832 collections of biographical sketches, textbooks for her students (Haight 34). Only after his financial collapse in 1833 does Charles agree to Lydia's publishing openly (Haight 37). In all, she publishes over fifty volumes of verse. Women

writers who publish most of their work under their own names, Hemans and Sigourney both enjoy great popular success, enough to support five children each—and more to support charitable causes. Except for differences in lineage, these poets' lives are remarkably parallel. Similar too are Hemans' and Sigourney's chosen topics of nature and domestic matters, their use of poetic convention drawn from sentimentalism, and their often overlapping readership.

Sigourney as follower of Hemans is an issue for Gordon Haight, who in 1930 publishes a hostile biography of the American poet. He calls Sigourney a pale copy, labeling Hemans the sentimental "prototype" of Sigourney (37), which indeed she was. Haight accepts the judgment of Sigourney's contemporary Edgar Allan Poe, whose 1836 review of Sigourney's poems claimed he "grieved" over the "almost identity between" Mrs. Hemans and Mrs. Sigourney (113). Poe abhorred the rhetoric of sentiment as "mannerisms of a gross and inartificial nature"; these are no mark of artistry in Hemans' poems. To Poe's mind, this sentimental repertoire becomes "in Mrs. Sigourney . . . mannerisms of the most inadmissible kind—the mannerisms of imitation" (113). No matter that eighteenth-century rhetoricians advised imitation as key to fluency with poetic forms familiar to contemporary readers. To Poe, a theorist of so-called spontaneous romantic expression, Sigourney's imitation of Felicia Hemans ought to doom the American to obscurity. Poe's ban on "inadmissible" sentimental convention stands virtually unchallenged among U.S. academics well into the twentieth century.

Critical opinion has come full circle to honor Felicia Hemans again, although many still ostracize her American counterpart. The University of Oregon's Knight Library, which has large holdings by nineteenth-century popular writers, has preserved eight copies of Hemans' nineteenth-century texts versus only five of Sigourney's more than fifty volumes, and it also displays the full array of Hemans' 1978 reissued works. Lately, several of Sigourney's poems are back in print, even in Norton anthologies, and *Letters to Young Ladies* (2008) and *Lucy Howard's Journal* (2007, 2013) have appeared as facsimile reprints.[3] Nevertheless, Hemans is almost a household word again. Not quite yet her American follower.

What happens to early public opinion of both writers when, by rhetorical metonymy, Sigourney effectively takes Hemans' name? Apparently the identification serves Hemans well. Most of her works are posthumously reissued in the United States and snapped up by an antebellum public who read both poets. In *Ambitious Heights*, a 1990 study of British women sentimentalists, Norma Clarke suggests Hemans' enthusiastic U.S. following

may have exceeded British readership.[4] There is no evidence Sigourney feels threatened by Hemans. One reason may be Hemans' death in 1835 just as Sigourney's star begins to rise (Trinder 2). The lines above from one of several "Felicia Hemans" poems indicate Sigourney writes admiringly, making Hemans a patron saint and familiar spirit for nineteenth-century women. Here are final lines of the same poem:

> Therefore, we will not say
> Farewell to thee; for every unborn age
> Shall mix thee with its household charities.
> The sage shall greet thee with his benison,
> And Woman shrine thee as a vestal-flame
> In all the temples of her sanctity,
> And the young child shall take thee by the hand
> And travel with a surer step to heaven. (299)

Sigourney insists public acclaim can last forever when someone like Hemans both touches the hearts of "the sage," or elderly, and does not forget women and children. As long as in kitchens and parlors they "mix thee with . . . household charities," all those readers will be blessed. Sigourney's optimism seems borne out. People keep reading Hemans. Sigourney writes two biographies honoring Hemans, one an early sketch and the other a long introduction to Hemans' collected works. Is Sigourney looking at herself dead or alive—or both—in such mirror images of Hemans' life? It seems clear one rhetorical goal of Sigourney's memorials to Hemans is to place her name in a metonymic slide linking herself in the popular mind with the ethos of the more famous, well-born British poet, eliding differences such as nationality and social class while banking on her popular appeal. Sigourney hopes to continue the rest of her life and live on after death exactly as Hemans has—beloved and widely read by an American public.

Resonance between personae of the two women intensifies in a second major mix-up occurring in an 1849 annual, *The Young Ladies' Offering; or, Gems of Prose and Poetry*, a collection reissued with little change in the United States for eight years after it appeared. This annual prominently announces on its frontispiece that its "gems of prose and poetry" are "by Mrs. L. H. Sigourney; and others." In twelve years after Hemans' death, Sigourney's reputation grows to the point where she receives top billing. One expects her poems will dominate the collection. However, the table of contents lists Hemans more often than Sigourney. Given the frontispiece announcement, it is peculiar the first title attributed to Sigourney is fourth in the table of

contents, while a Hemans entry tops the list. The fourth-listed piece said to be by Sigourney actually appears on page one of the book. Leafing through this annual, you find that no author's name appears beside any separate piece. Such labeling, shuffling, and masking of authors make a reader wonder who wrote what. Did Hemans write everything in this book? Or is it all Sigourney's work, with nothing by Hemans?

Whether accidental or intentional, because of sloppy editing or deceit, this second mix-up between the two poets reinforces metonymy between personae of Hemans and Sigourney. Parentage is thematically at stake in two pieces attributed to Sigourney: "The Father" and "The Patriarch." She emphasizes paternity, but a reader is left wondering about form—not topic—because of a scrambled format retracing the maternal role played by Hemans in Sigourney's professional life. The ambitious poet who is pathfinder, double, and comfort to Sigourney both makes the American Hemans what she is and threatens to engulf her sense of self, thanks to this follower's own deliberate rhetorical metonymy.

An otherwise friendly contemporary review describes Sigourney's association with Hemans as an "almost invidious" threat to Sigourney's fame—which the 1855 *Ladies Repository* critic hastens to reassure readers "will be as hearty and enduring" one day as is Hemans' reputation at the moment ("Literary Women" 67). Sentimental metonymy does melt these writers into one another, but solidarity and satisfaction are also apparent in the association. Replying to Poe's charges of imitation in a letter to the *Southern Literary Messenger*, Sigourney protests:

> I would not . . . admit the idea that there is ought of equality between my writings, and that of the most gifted poet of the age. . . . The resemblance, which my friends have imagined to exist, I have resolved into their partiality. (qtd. in Haight 83–84)

Sigourney carefully notes that no less than three collections of her own poems were published before she "had enjoyed the pleasure of perusing any of [Hemans']—[and] can therefore not be classed as imitations of that pure model" (qtd. in Haight 84).

Sigourney's distinction between "imitations" and "pure model" anticipates C. Jan Swearingen's discovery of "possible selves" recovered when rhetoric as a heuristic analyzes historical texts. One might say Sigourney has found, as Royster and Kirsch recommend, that "more dialogic and reciprocal . . . relationship between past and present" than scholars of rhetoric usually expect (14). More than casual links between lives and works of the British

and the American Hemans show that Hemans as a "pure model" does more than offer a format for Sigourney's poems to follow. Other woman readers of poetry are drawn into the cloud of Hemans/Sigourney identity and embrace both poets as models of opportunity. As Hemans raises Sigourney's hopes as a poet, so both poets encourage other women. Both fit Swearingen's characterization of effective historical "models for seeing and participating in both knowledge and experience, and for interacting with others" (236). In effect, confusion between Hemans and Sigourney "engage[s] in an exchange" (Royster and Kirsch, 14) that can address and overcome political and cultural barriers faced by antebellum would-be writers, barriers too often still with us. Such double readings and provocative models might even give heart to women writers today.

### *Metonymy as Bridge of Public-Private*

Before turning to other examples of Sigourney's metonymy that enhance her rhetorical ethos, it is worth pausing to reemphasize one other double function of this trope. Such displacement becomes one means of antebellum American women's "mediating the boundaries between masculine and feminine codes of behavior," as Carla L. Peterson writes. She reports, contrary to conventional wisdom:

> Much sentimental literature . . . illustrates the extent to which the public comes to infiltrate and inhabit the domestic, thereby politicizing it, and . . . the degree to which metaphors of domesticity are appropriated to express the political, thereby domesticating it. (126)

By metonymy, woman writers enter forbidden zones from what was considered the safe haven of home. Carol Mattingly observes that thus they can remain private women and yet go public (*Appropriate[ing]* 2002). A few women rhetors, conversely, do become public figures yet claim a domestic side. One might say that despite cultural, ethical constraints upon her person, what an antebellum woman wants, sentimental metonymy gets her.

Displacement of this kind is a necessity for the ethos of black woman orator Frances E. W. Harper, who makes sentimental metonymy work for her in the second way: to go public but seem domestic. In Harper's hands, this trope is a means for "negotiating the public exposure of the black female body," says Peterson (119). For Harper does speak in public—with a mission to fuel antislavery sentiment until it is a nation-changing flame—yet Harper

maintains a demure "womanly" presence and often refers to domestic topics: women's choice of a marriage partner, wifely duties, raising children. Reference to homely topics and presenting a meek persona allow her to identify with tropes of feminine discourse, thus she appears proper yet stands bold at abolitionist podiums. In chapter 2, I elaborated on Harper's emphasis on the fugitive slave mother's attachment to her children—a culturally sanctioned, revered feminine sentiment. She calls on white women to sympathize, as mothers, with slave women whose ethic of protective maternal love should exculpate Margaret Garner for her "illegal" flight and even the murder of her infant.

Sigourney's assertive textual personae echo Harper's defense of the fugitive mother, and they dramatize Peterson's and Mattingly's observation on metonymic displacements in literary sentimentalism. But Sigourney's ethos and arguments on public issues exemplify the first half of the neat reversal, Peterson's chiasmus on how antebellum sentimentalism works. Political issues and aggressive stances in lines of poetry allow Sigourney to identify with tropes of public masculine authority yet remain at home, "properly" out of the public eye.

### *Sigourney as Sentimental Preacher*

Such radical, savvy metonymies of ethos act through one of Sigourney's most innocuous poems, "Sentiment in a Sermon." If this 1842 piece were merely an exposition of religious feeling, its third-person speaker might be the woman of Barbara Welter's twentieth-century construct of womanhood: pious, pure, submissive, domestic. Instead, this devout writing persona marches straight through Welter's parameters. The sentimental trope works here as Peterson maintains it will, to let domestic and political spheres infiltrate and inhabit one another. With a voice unmarked by gender, this sixteen-line ode in effect challenges conventions of "true womanhood" by locating its poet in identity with professional rhetoricians who teach sermon composition to the clergy. She slides boldly into the position occupied in her day by a male professor teaching homiletics to some of the culture's highest authorities. Prevailing common sense asserts that ineptness in public affairs indicates women's calling to domestic duties only. This woman writer will have none of it. Demonstrating her own rhetorical qualifications by deploying a rich repertoire of sentimental strategies, Sigourney shows in this poem she is no meek homebody. The poem demonstrates that nineteenth-century women are capable in every respect.

SENTIMENT IN A SERMON

"Piety flourishes best, in a soil watered by tears,
and often succeeds, where harvests of temporal good have failed."

HOPE's soft petals love the beam
    That cheer'd them into birth;—
Pleasure seeks a glittering stream
    Bright oozing from the earth;—
Knowledge yields his lofty fruit
    To those who climb with toil,
But Heaven's pure plant strikes deepest root
    Where tears have dew'd the soil.

Hope with flow'rets strews the blast
    When adverse winds arise;
Pleasure's garlands wither fast
    Before inclement skies,
Knowledge often mocks pursuit,
    Involv'd in mazy shade,
But Piety yields richer fruit
    When earthly harvests fade.     (*Poems* 194)

The poem's title announces its topic, sentimental discourse, but Sigourney's ode also demonstrates by form that it engages strategies from the rhetoric of sentiment. According to Campbell's contemporary Hugh Blair, "Sentiments, of one kind or other, form . . . the subject of the Ode" (2:354, lecture 39). In contrast to romanticism's lyric verses, understood to express a poet's emotions, the ode (from the Greek *aedein*, "to sing; to chant") meditates on public issues. The *New Princeton Encyclopedia of Poetry and Poetics* describes odes as "the most formal, ceremonious, and complexly organized" of short poems, "frequently the vehicle for public utterance on state occasions" (Lloyd 855). In addition to its title and poetic tradition, the poem reveals itself as classically sentimental in its intent to shape moral affect—or sentiment—through faculty psychology. It engages what the eighteenth-century rhetorical theorist George Campbell labels the new "science of the human mind," appealing consecutively to faculties of understanding, imagination, passions, and the will (lxxiv). Implicit is a message that the poet of "Sentiment in a Sermon" is a top practitioner of sensationalist epistemology, modeling a virtuoso performance of its sentimental persuasive power.

Sigourney's vision of women's prospects authorizes her to teach sensationalist epistemology to clergy. Introducing *Letters to Young Ladies*, Sigourney neither recognizes a gender-based limit to young women's education nor accepts pedestals for feminine virtue. "No . . . interdict continues to exclude them [women] from the temple of knowledge, and no illusion of chivalry exalts them to an airy height, above life's duties, and its substantial joys" (10). With faith in the spirit of the times, Sigourney sees herself and her students as more advantaged than "our grandmothers," whose "simple training" fit them only for "household-good." There is life beyond the household, says Sigourney. Yet she does not see herself or her students rising to the eventual status of "our grand-daughters," who, if granted time to study, one day "may have an opportunity of becoming professors" (60). Sigourney insists women are equals of men, and although women's achievements lag behind, she asserts this is only for lack of access. The professor she might have been would describe and demonstrate to her class, in terms much like this poem's, how to reach a congregation's mental faculties.

Thematically, Sigourney's rhetoric in "Sentiment in a Sermon" considers the worth of three human virtues: hope, pleasure, and knowledge—exuberantly personifying them, then transforming them into spiritual fruit borne by plants grown tall from sun, water, and careful tending. While these virtues have analogues in plants and streams, the poet reverses the comparison in the last two lines of the stanza to conflate plant life with faith. She emphasizes what cultivators of the spirit must do to prepare hearts for roots of faith. A preacher's job, to Sigourney, is to make people know their shortcomings, their need for God. Lines of this first stanza support the thesis of the poem's epigraph: "Piety flourishes best, in a soil watered by tears, and often succeeds, where harvests of temporal good have failed." Religious conviction takes hold best in a heart moved to weep. Yet not just title, form, flowers, and tears signal the poem's sentimental rhetoric.

The poem also showcases Sigourney's mastery of rhetorical convention in a striking resemblance between the virtues—hope, pleasure, knowledge, faith—and those mental faculties laid out by George Campbell. His version of sensationalist psychology maintains that the ends of rhetoric "are reducible to four . . . to enlighten the understanding, to please the imagination, to move the passions, or influence the will" (1). Rhetoric must captivate the common faculty psychology of its hearers. The poem's first stanza on "hope" suggests what lies ahead, a disposition produced not only by its speaker's religion but also by the faculty of imagination. Her reference to "pleasure" is linked to the faculty of the passions, which would register this feeling.

One easily links "knowledge" with the faculty of understanding. "Faith," or the conversion sought by a preacher, can be produced only by persuasive appeals to the first three faculties, which together pressure a fourth faculty, the will. The professor narrating Sigourney's poem follows Campbell's lead, insisting effective discourse will enlighten, please, move, and compel action from the faculties taken for granted in the new mental science.

The second stanza continues this display of sentimental tactics by the professor's ethos, underscoring a version of the Puritan doctrine of afflictions. It assumes that earthly hope, pleasure, and knowledge wither in the wind, heat, or "mazy shade." This teacher of preachers maintains that a mind moved to assent only by means of deductive logic will be shaken in its resolve when trouble comes. Appeals to faculties of passion, will, and imagination must accompany any appeals to intellect. As an evangelical during the second and third Great Awakenings in America, the preacher ethos of this poem asserts that ordinary impressions on the faculties of understanding, imagination, will, or passions will eventually grow dim. "But," concludes the poem with a new version of the epigraph, "Piety yields richer fruit / When earthly harvests fade." Faith alone—but not unreasonable faith—will endure. Durable faith springs from the inevitable human experience that mortal pleasures cannot last. Disappointment is inevitable, but it can be transformed by an act of will—conversion. The rhetorician maintains that only sadder but wiser piety impresses a human mind forever. In topic, the poem's sentimentalism works to conventional ends, but in disposition, the woman poet appropriates a tone and ethos traditionally masculine. The speaker's showy display of sensationalist strategies exceeds the culture's boundaries for women. At stake in "Sentiment in a Sermon" are not methods of conversion, but a cross-gendered figure instructing preachers how to move their congregations.[5]

Plant husbandry joins rhetoric and religion as topics of this poem. Sigourney exhibits ease with all three. From the poem's agricultural metaphors—soil, petals, roots, harvest—its writer's seminary students will serve country churches. From the same humble trope, the ethos of the poet is also likely well acquainted with growing things. She might even be the gardener's daughter who has married up—so goes the historical account of Lydia Huntley Sigourney. Ann Douglas has called Sigourney a social climber, a "determined intruder" from Connecticut's working class who marries "well above herself" ("Sensibility" 165). Douglas fails to mention Sigourney's "catch" was a financially inept widower thirteen years older than she, with three children (Haight 15–16, 21). For ten years after Charles Sigourney's death, she uses her pen to support her stepchildren and her own two

offspring. The role of professional writer is a pleasure to her—for the freedom from a domestic role it gives her, for its recognition, and for the public power it allows (Collin 20). Writing is also an economic necessity for Sigourney.

### *Criticism from an Upscale Neighbor*

"Determined intruder" is a view of the poet's ethos that draws attention to Sigourney's material circumstances, and if Douglas' account suggests a self-interested Sigourney, it also indicates class bias on the part of those attempting to keep this poet within the bounds of "true womanhood." Another is Professor Timothy Dwight of Yale, co-editor of the *New Englander* in 1866, whose mean-spirited review of Sigourney's work backhandedly praised her "true womanly character" (347). Sigourney dies the year before Dwight's review. In light of critics' concern about her rise in social status and her dedicated readership, Dwight's faint praise seems designed to constrain the ethos of this woman writer to conventional roles.

Within gendered boundaries, Dwight spoke favorably of the years Sigourney spends before gaining literary fame, for they are

> marked, like every woman's life with so little that can be told of to the world, and yet with so much that is noble and pure,—with so much that is full of kindness, and is quite as essential to the world's happiness as any of the more conspicuous works on which men pride themselves. (352)

The purpose of a woman's domesticity, according to Dwight, is to make her world happy—that is, to live for a man and his household, to serve a husband who ventures out to perform "more conspicuous works." No wonder Dwight also damned with faint praise a curriculum Sigourney designs for neighborhood schools founded for young women. According to Dwight, lessons in needlework or homemaking address "those amiable dispositions so essential to the true womanly character" (347).[6] He was critical of Sigourney's lesson plans for history, bookkeeping, and continual entreaties that young women read and write at every stage of life. Her curriculum is "not one," he insisted, "that could be universally adopted in larger schools or among all classes of children" (347). Universal literacy, the poet's moral imperative for working class women, was not a goal for Dwight.

He criticized altogether Sigourney's connection to women, her "generous commendation . . . of every one of her own sex." Her poems honor both society women and twenty-five years of "heart-service" from a black

housemaid. Today's reader can be uncomfortable with condescension in Sigourney's description of the black woman, but Dwight was most uncomfortable with Sigourney's description of the Lathrop grounds as if "they were all alike the property of Mrs. Sigourney's own family." Her father was Lathrop's gardener, but Dwight dismissed the girl's pride in her father's work (336). Dwight selectively endorsed those bits of this poet's ethos reflecting his view of "womanly character," but he charged that when a successful writer, she not only violates womanly norms but also encroaches on the territory of her betters.

This editor seemed bent on relegating the woman poet to some properly domestic role. As wife or parlor schoolteacher, Sigourney poses little threat to the male literary establishment. As professional poet, Sigourney competes with men for column space, readership, money, and status. To the end of the twentieth century, putting Sigourney in her place met mostly with success. More recently, some have looked closely enough to imagine she can return to critical acclaim.[7] For others, however, even the poetic voice of seminary professor will not dislodge her from "her place."

### *Amos: Sigourney's Prophet of the Poor*

Obscurity may have been Sigourney's fate in Dwight's neighborhood of Norwich, Connecticut, but it is hardly so in Hartford, which in 1862 names a street after the woman writer and reformer (Haight 169). Lydia Huntley Sigourney once sighs, "I have no other claim to the title of prophet, save the absence of honor in my own country" (Collin 21). Dwight's attack and Sigourney's lament take on significance from a long piece in her 1842 collection *Poems*. "Imitation of Parts of the Prophet Amos" is 186 lines of energetic heroic couplets where the first-person rhetor invokes the full force of biblical prophecy. Sigourney's Amos, like the Bible's prophet, exhorts complacent wealthy readers—for sins against the poor and fatherless, for idolatry, for waste of material goods, and for holding slaves. The woman celebrated as "sweet singer of Hartford" is no comfortable prophet to her hometown of Norwich.

Pressing her case against the wealthy, Sigourney slides from a first-person male voice of Amos to an apparently female stance, then back to the masculine prophet's role. The poem's style fully exploits a sentimental repertoire, and its primarily masculine ethos assaults readers with all the force the discourse can muster. For this rhetorical study of ethos, "Amos" is important for shifts between gendered personae. Such "discordance," says theorist Julia Kristeva, demonstrates relationships of power in a culture more clearly than

thematic statements. Textual "*discordance* in the symbolic function and consequently within the identity of the transcendental ego itself," she says, point to ethical dimensions of discourse more reliable than topics for "establishing meaning" ("Identity" 140; italics in the original). As Norma Clarke observes of nineteenth-century British women poets, "Cultural meaning attached to writing is not a single meaning that women or men participate in by the act of becoming writers." Sigourney's "Amos" shows that denial of single meanings applies also to American poets. "Discordance" between masculine and feminine narrators resonates with the "complex mixture of permission and prohibition" faced by all nineteenth-century "women with ambitions to become writers," says Clarke (6). Alternating male and female faces, the "Amos" narrator also dramatizes Peterson's and Mattingly's insight on interplay of public and domestic spheres in women's writing. In two distinct voices, Sigourney's "Amos" exploits both permissions and prohibitions of antebellum sentimental discourse.

Given resistance to the upstart Sigourney, the uppity working-class male voice that starts and ends her Amos poem may be a mouthpiece for attacks on those casting themselves as Sigourney's betters. The first four lines repeatedly point out the speaker's working-class background:

> I from no princely stock, or lineage came,
> Nor bore my sire, a prophet's honor'd name,—
> But 'mid the Tekoan shepherds' manners rude,
> My speech was fashion'd, and my toil pursued.   (lines 1–4)

Except for the "Tekoan" reference, Sigourney's lines depart from first verses of the book of Amos in the *King James Bible*; she calls attention five times to humble parentage, and her prophet alludes to familiarity with hard work in "shepherds' manners rude" and "toil." By contrast, class and status are relatively unimportant for the *King James* Amos, who simply states he comes from "among herdsmen of Tekoa."[8]

Although the Bible's prophet shouts in verse two that "the LORD will roar from Zion," it takes the versified ethos of Amos longer to warm up. Sigourney's writer first explains why, at this moment in the antebellum United States, a working-class prophet must speak out against injustice—God commands it. In fact, Sigourney puts words into God's mouth: "Shepherd, forsake thy flock, and be the seer of God" (line 41). Sigourney's writer must abandon former duties to announce God's word. After a hundred lines, Sigourney's Amos finally attains white heat: "Repent! Repent!—ye rebel race!" (line 104). From a searing blast in the poem's last seventy lines,

one imagines that just as the Almighty roars through the Bible's prophet, God roars through Sigourney's. Here is one stark, accusing stanza of her prophet's final tirade:

> Ho!—ye, who sink on couches, soft with down,—
> And all your crimes in wine and music drown,—
> Who snatch the garment from the shivering poor,
> And wrest his pittance, to increase your store,—
> You, first, the plagues and wants of war shall vex,
> The captive's yoke shall cling around your necks
> And you shall groan, in servitude and scorn,
> Like the slave sorrowing o'er his dead first-born.
> Ah sinful nation!—of thy God accurst,
> Thy glory stain'd, thy crown defil'd with dust,
> Go,—hide thee in Mount Carmel,—dive the deep,—
> Plunge in the slimy cells where serpents creep,—
> Make through the earth's dark dens, thy secret path,—
> Yet canst thou shun the purpose of His wrath?   (lines 120–33)

This nineteenth-century prophet forces wealthy Americans to face what they deny: their luxury causes the poor to have less and enslaves innocent people. Sigourney's God and prophet scrutinize and expose such sins; both claim the "accurst" wealthy shall "groan" in "servitude and scorn." Even if the well off flee God's wrath, they will suffer for their greed.

The angry persona of this poem's Amos ranges far from the ethos of a woman writer Nina Baym claims nineteenth-century reviewers prefer. Baym says the approved narrator is gentle and loving, pronounces "healthy" values, and in contrast to this prophet, is "not egotistical about the narrator's self-presentation" (*Woman's* 254–58).[9] Instead, Sigourney's Amos aggressively engages all the power of sentimental rhetoric with sensationalist appeals—exclamations, vivid sensory detail, apostrophe (direct address to the reader)—strategies that press home the need for a complete turnaround in morality and behavior.

Part of the buildup, however, involves a remarkable shift into a feminine and maternal voice, but not a conventional representative of "true womanhood." Sigourney's Amos poet by this momentary shift underscores a distance between the poem's dominant figure and some preferred narrator of women's discourse. The shift suggests the writing persona of a woman enthusiastic about a vocation of letters yet conscious of leaving her home flock unattended.

This turn from masculine to feminine voice comes at a maternal moment when Sigourney's suddenly feminine prophet weeps over who will tend her lambs. But it occurs only once, and only briefly, when Amos first turns from pastoral life to respond to God's call.[10] In order to follow this vocation, a resolute Amos lays down her shepherd's crook and begins to ford a rushing stream dividing the new self from the old.

> But pressing on my path, I heard with pain,
> The approaching footsteps of my cherished train,—
> And wept, as gazing on their fleecy pride,
> I thought who now their wandering steps would guide.
>
> Yet still, within, the hallow'd impulse burn'd,
> And soon, its answering thoughts my heart return'd;—
> "My tender lambs, my unfed flock, adieu,
> My God, a shepherd will provide for you,
> One kind as I have been, whose care shall guide
> You, where fresh pastures smile, and fountains glide;
> A hand unseen, a voice and purpose true,
> Divide you from my charge, and me from you."   (146–57)

The shepherd-prophet says she leaves her "tender lambs" to preach and write as God insists. But until she tearfully shoos her flock home and turns to follow her vocation, the sheep come pattering after her like children. A shift between personae and a show of maternal sentiment might be judged lapses of form or a stumble in Sigourney's resolve as a professional writer. We might also read such a turn and display of feeling as strategies of persuasion. While clergy tend their flocks and preach, the ethos of this prophet apparently cannot both tend her "sheep" and enter the public sphere. This passage may show Sigourney acknowledging and exploiting criticisms women must expect if they follow a vocation to write.

Readers would have linked the weeping, "feminine" prophet with the rhetorician's stock "beauty . . . in tears." Campbell's *Philosophy of Rhetoric* advises student rhetors, "Distress to the pitying eye diminishes every fault," and "beauty is never so irresistible as in tears" (133). In other words, tears should move readers to embrace a protagonist's cause. With this appearance as a weeping woman, the prophet-poet-rhetorician of Sigourney's "Amos" shows again that the poet knows rhetorical conventions and will use them boldly. With tears, she demonstrates awareness of social norms for women and her choice to violate them. Women are supposed to cry, so this woman

assuming a public role of prophet, coded masculine, also weeps. If she cries over her children, she must be a proper woman—right? One message may be that her hearers' sins are so egregious that to root them out, a woman is forced away from her "natural" calling. Another message could be that by invoking tears, the poet-prophet gains her audience's assent to a woman's speaking about moral and social reform. Despite the stinging rebuke she calls down on oppressors, the tears locate Sigourney's prophet within acceptable feminine discourse. Her violation of convention marks and emphasizes the seriousness of her hearers' transgressions.

The prophetess leaves her little flock to spread a doomsday warning. Thus Sigourney belies a call—perhaps from her own conscience—to some notion of "true womanhood." At the same time, the prophet shrewdly employs tears to persuade contemporaries they must change their behavior in gender relations, as well as in commerce and racial oppression. Through sympathetic identification wrought by tears of a feminine figure, Sigourney has "insinuated" into her readers' minds activist sentiments of her speaking subject (Campbell 96). More openly than as homiletics professor, Sigourney's shifting ethos of the "Amos" poem could be momentarily a woman rhetor—one who both gestures toward and thwarts her culture's gendered expectations about who is qualified to preach an American jeremiad.[11]

Sigourney's Amos in final exhortations matches the force of the biblical figure. Amos of the *King James Bible* wails, "Woe to them that are at ease . . . ! . . . For, behold, the LORD commandeth, and he will smite the great house with breaches" (Amos 6.1, 11). Sigourney's Amos wallops readers with sixteen rhetorical questions, interrogations silencing any remaining question of the prophet's authority:

> Say,—whose strong arm compos'd this wondrous frame?
> Who stay'd the fury of the rushing flame?
> Who made the mighty sun to know his place?
> And fill'd with countless orbs yon concave space?
> Who from his cistern bade the waters flow
> And on the spent cloud hung his dazzling bow?
> Who drives thro' realms immense his thundering car
> To far Orion and the morning star?
> Who light to darkness turns?—and night to death?
> Gives the frail life and gathers back the breath?
>
> Who gave this ponderous globe, with nicest care
> To balance lightly on the fluid air?

> Who raised yon mountains to their lofty height?
> Who speeds the whirlwind in its trackless flight?
> Who darts thro' deep disguise, his piercing ken
> To read the secret thoughts and ways of men?
> Who gave the morning and the midnight birth?
> Whose muffled step affrights the quaking earth?
> Who curb'd the sea? and touch'd the rocks with flame?
> Jehovah, God of Hosts, is his tremendous name.
>
> <div align="right">(lines 166–86)</div>

Sigourney's Amos demands evil-doers acknowledge both the authority and "tremendous name" of "Jehovah, God of Hosts." In the same gesture, this poem's ambivalently gendered ethos demands they acknowledge a woman in the prophet's role.

These last heated rebukes serve to remind readers it is because Sigourney's prophet echoes the masculine voice of a biblical prophet she can get away with blasting powerful people. In her day, when women preachers did attempt to speak in public, most did not fare well. Christine L. Krueger's study of Victorian women preachers refers to *"ad feminam* attacks on the prophet as fallen woman." Such attacks brought the weight of popular opprobrium against women who asserted themselves before "promiscuous" mixed-gender audiences (19). Despite biblical subject matter and masculine cover, despite careful allusions to motherhood, Sigourney's forceful prophesying likely strikes readers as an affront.

Alongside textual personae violating class and gender boundaries, historical records construct a Sigourney nearly as formidable as any ancient prophet. She is a dedicated contributor to abolitionist periodicals (Baym, "Reinventing" 386). She crusades for temperance (Douglas, *Feminization* 131). She co-writes petitions against removal of Cherokees from traditional lands (Miles 225). She starts at least two schools for young women and supports others. She is a founding member of the Willard Association for the Mutual Improvement of Female Teachers (Walker, "Lydia Sigourney" 80). Sigourney overcomes loss of a son and takes in aging parents. In final years, despite reduced circumstances, she corresponds with a wide circle of friends, visits the sick, and feeds hungry people at her door (Collin 20). Haight records her Episcopalian priest's comment that he rarely visited an invalid's bedside where the poet had not ministered before. Sigourney's moral stature in life embodies the prophetic stance she assumes in "Amos."

The poet's male persona is one reminder women in the antebellum United States enter a male-dominated field of letters hostile to women, hostility with intensity surprising even feminists who lately chart that gendering. Nineteenth-century women find "the identity of the writer, the authorial position, has been defined as the property of the male sex" (Clarke 6). For Sigourney to deepen her voice is to admit, as Paula Bennett aptly puts it, "Nineteenth-century women's poetry was . . . thought of as . . . an 'anonymous' Art. That is, it functioned as a craft, where making—not being—was the dominant mode" (*American Women Poets* xl). Making poetry that gets read is important to antebellum women even when being a known poet is next to impossible. With exceptions like Frances Harper, many go undercover venturing into the public eye only anonymously, or wearing men's garb. For a mission overstepping social convention, Amos offers near invisibility. Sigourney puts on the mask so she can express outrage on issues of reform and get taken seriously. While a poet in drag underscores rhetorical construction of ethos or subjectivity, and her textual personae shape-shift to suit situations and persuasive aims, Sigourney does not write anonymously when she can get away with using her own name and voice. She intends to reap the rewards of publishing under her own name. With the poet's aims in mind, shifts among "Amos" personae together remonstrate against a woman writer's having to hide herself away—or to play dead behind a double.

### *Life after Death in* Lucy Howard's Journal

An unashamedly female writer narrates Lydia Sigourney's 1858 work, *Lucy Howard's Journal*. The book presents the coming-of-age story of a woman poet and sets a number of her poems in context, thus providing more context for Sigourney's rhetorical ethos. This self too is set apart from piety, purity, meekness, and domesticity assigned in Barbara Welter's "true womanhood." Sigourney's own rhetorical theory (excerpted in Donawerth, *Theory*) provides commentary on gender conventions without which, Welter claimed, "all was ashes" for antebellum American women (171). In chapter 1, I discussed the *Journal*'s meditation on what poetry does for antebellum women, the logos or rhetorical aim of Sigourney's campaign to get women reading and writing poetry. Here Sigourney's *Journal* reveals "true womanhood" as one more exigency she and contemporary female poets have to negotiate, not the sum of women's lives.

Take, for example, Welter's term "domesticity" and its apotheosis in midnineteenth century: motherhood. Welter cited Sigourney as chief advocate of accommodation to what Welter mocked as the "increase of power" gained from bearing children (171). The narrator of Sigourney's *Lucy Howard's Journal* is quick neither to marry nor to have children. Before Lucy gets pregnant, she establishes a "dame school" for poverty-stricken girls—one teaching enough reading, writing, arithmetic, and needlework that these girls could make a living. Lucy's Henry supports his wife's efforts in this grassroots "needle reform movement" (Monaghan 55).[12] With another couple, Lucy and Henry establish a weekly book discussion group. Far from stifling Lucy's "taste for writing poetry," Henry claims that "he could not forgive himself should he be the means of destroying any gift or attainment [Lucy] might have possessed in earlier years, but would feel it his privilege . . . to add to their number" (*Journal* 226). While much of *Lucy Howard's Journal* was probably lifted from Sigourney's diary, this supportive husband is pure fantasy. Charles Sigourney did not share Henry's views.[13] When an infant comes into her already full life, she rejoices over baby Willie, writes a poem for his birthday, and worries about him. Taking a cue, however, from concern the protagonist's mother shows when helping with Willie's difficult birth, Lucy tells her journal, "Methinks this maternal love hath ever an element of anxiety" (*Journal* 230).

Not long after the child's first birthday, the toddler comes down with a fever. Lucy soon writes this poem for Willie's headstone:

>     Released without a sorrow,
>         Exhaled without a stain,
>     We, on whose hearts that angel lay
>     A little while, to cheer our way,
>         Give God his own again.          (*Journal* 316)

Much gave a woman pause about the joys of motherhood: lack of birth control, death in childbirth, high infant mortality, certainty of infection, not to mention the sheer hard work of raising a family. Such risks become occasions inspiring Lucy Howard's poems about childhood lessons and dame school classrooms, holidays and birthdays, specifics of a family recipe, reflections on the turn of seasons, and—indeed—remembrances of loved ones after death. Lucy's poems aim to persuade hearers to value everyday events by writing about them, remembering life's mileposts, pondering their significance, and trying to make sense out of an existence that can prove overwhelming for mothers, and for anyone.

Sigourney's comment on that "increase of power" Welter insisted the nineteenth century conferred on motherhood admits more ambivalence than Welter allowed. "If in becoming a mother, you have reached the climax of your happiness, you have . . . taken a higher place in the scale of being," Sigourney writes in *Letters to Mothers* (9). I detect a sigh of resignation in this admission that women aspiring to be mothers may perhaps achieve elevation "in the scale of being." Women will get pregnant in Sigourney's day, whether aspiring to that state or not. Women will nurse babies, and mothers will bring up children. Sigourney's words on "the climax of your happiness" hardly constitute a ringing endorsement of motherhood as the epitome of joy. Her "if" leaves open the possibility that some will not be satisfied with the job of mother. Sigourney rejoices to take up other roles.

Explaining that finances require she often write poetry "more as a trade" than for "recreation or solace," Sigourney enjoys her ethos as successful author and crows in this letter to her editor:

> It is now considerably more than a year, since I have supplied all my expenses of clothing, charity, literature &c, beside paying the wages of a woman, who relieves me a part of the day from household care, and I take great pleasure in doing it. (qtd. in Haight 36)

Sigourney will no longer be defined exclusively as mother and housewife. Yet with one eye on critics, and taking joy in teaching, she assures her publisher it is still her pleasure to "educate my little children" (qtd. in Haight 36). Sigourney delights in publishing poetry, a lot of it, partly because it purchases a measure of freedom from domesticity. It also marks her rise from the working class. In sum, Sigourney's texts show her at best a part-time devotee in the cult of "true womanhood."

Answering Welter's principle of piety, Sigourney makes Lucy devout, but she obliquely promotes an expansive heresy ducking narrow doctrine espoused by most Christians of the nineteenth century. There is more than one way to the God Sigourney reveres. Lucy records "a beautiful legend of the Turks" in which angels record good deeds and "faults." In this story, no fault is forever sealed, giving the sinner a chance to repent and cry, "O Allah! I have done wrong!" If one subsequently does a good deed, the recording angel "washes out" the error and plants on the believer's forehead "the kiss of peace." Lucy observes, "I am sure we Christians might be made better, if we would, by this Moslem moral" (*Journal* 43). Lucy as a pioneer woman also endorses spirituality of American Indians. Orra, an orphan adopted

by Lucy's family, brings her tribal chief to meet the woman and son Willie. After a meal Lucy serves him, the chief "reached his hands for the child." The mother hesitates, "but Willie settles the matter by determining to go to this tall old lord of the forest." Before handing the child back, the chief lifts the boy overhead with a "deep intonation and in a devout manner," blessing him "in the name of the Great Spirit" (according to Orra's translation) and declaring eternal peace between his and Lucy's kin (*Journal* 280). The little boy's warmth signals readers that racial bigotry is not "natural" to any woman's ethos, but cultural and learned.

Lucy's hospitality to the chief and adoption of Orra appear to be gestures of atonement for what Sigourney characterizes elsewhere as Europeans' sins against American Indians. Her last two stanzas from "The Indian's Welcome to the Pilgrim Fathers" (collected often among Sigourney's poems) indict the "pilgrims" for greed and elevate Natives' faith and generosity to early Europeans:

> That *welcome* was a blast and ban
>   Upon thy race unborn.
> Was there no seer, thou fated Man!
>   Thy lavish zeal to warn?
> Thou in thy fearless faith didst hail
>   A weak, invading band,
> But who shall heed thy children's wail,
>   Swept from their native land?
>
> Thou gav'st the riches of thy streams,
>   The lordship o'er thy waves,
> The region of thine infant dreams,
>   And of thy father's graves,
> But you to yon proud mansions pil'd
>   With wealth of earth and sea,
> Poor outcast from thy forest wild,
>   *Say who shall welcome thee?*
>                     (*Zinzendorff* 48; italics in the original)

Sigourney's apology signaled in Lucy's good deeds is not obscured by inaccuracies in the poet's take on Native and white interactions. Natives in Sigourney's day and today's field of indigenous literature present themselves as fallible mortals—not "noble savages" that romanticism and Sigourney's words would make them. As a matter of course from first arrival, white

people seized Native territory; these regions were not handed over to the Europeans. Yet Sigourney does indicate in Lucy's journal and her poetry a respect for spirituality in traditions other than Christianity. This woman's ethos is pious, but with qualifications. She is not particularly orthodox.

Sigourney's Lucy as elegist also approaches from an angle the purity and meekness of "true womanhood." Cheryl Glenn clarifies "that we each have an angle." Thus, she observes, feminist historians of rhetoric, aware of omissions from traditional lineage of the field, "have taken to measuring and charting territory by means of *angles*" (5; italics in the original). Walling off any but the narrowest perspective on nineteenth-century women, Welter's "true womanhood" remains the most powerful "totalizing narrative," which Judith Fetterley has complained "excludes writers who do not fit the story being told" (604–5). "True womanhood" ignores aspects of women's lives challenging its straightforward stories. But "through angular lenses," Glenn asserts, "we catch . . . glimpses of . . . unconsidered 'irregularities' . . . smoothed over by the flat surface of received knowledge" (5). The pioneer woman elegist who will not stay in her grave demonstrates such an angle on purity and meekness, and on the rhetorical ethos of Sigourney as elegist.

### *A Defense of Elegy*

A stranglehold of prejudice against "Sigourney as elegist" has benumbed responses to this delightful and disturbing journal. Ignoring implications of Lucy's schooling, her directions for a dame school, and her pioneer adventures, Ann Douglas has claimed Sigourney's *Lucy Howard's Journal* "is fascinating in its inability to work up an incident." Douglas maintained even Lucy's religious conversion was without trauma. "She did not know it was happening," Douglas said, "a description which could cover the whole of her life." Douglas morbidly characterized Sigourney's own story as "extinguished," lived by the "sentimental songstress" in "calm hypnosis" ("Sensibility" 174). This twentieth-century critic may take permission for her acerbic tone from Dwight's cutting 1866 retrospective, claiming Sigourney's "life that had already opened itself in a whole volume of obituaries might properly show, at its close that it was itself one obituary volume" (331). Dwight's critique seems an early attempt to bury Sigourney's reputation alive in the mind of a public that eagerly reads her poems. Among later critics, Loeffelholz seems content to inter Sigourney with her elegies (*Difference* 64), and Virginia Jackson imagines seeds of modernist lyric eclipsing this poet's robust

sentimentalism (54–75). These reinforce Welter's and Douglas' attempts to undermine the poet's memory at a moment when feminist analysis might resurrect her. Yet the indefatigable woman poet of *Lucy Howard's Journal* springs up to face her adversities and Sigourney's adversaries.

One of Lucy's elegies is a feisty variation on the ethos of rhetorical practice midcentury thirteen-year-old girls likely did perform. Lucy perhaps recites this poem as part of year-end school exams in elocution; elocution handbooks of the day might well have included this Sigourney piece.[14] Hardly conducive to notions of female purity and meekness, this poem projects Lucy's ambitions and accomplishments. Though its subject is elegiac (remembering war dead), the poet seizes the occasion to shake her fist at William the Conqueror and Norman warriors for devastating Saxon homes several centuries before:

> Those Norman kings! those Norman kings!
>     With their stern and haughty port,
> They crush'd the life from a thousand homes
>     For the sake of their savage sport.
> For the sake of hunting the boar and hare,
>     With uproar of horns and cries,
> They put out the fire from a thousand hearths,
>     That thickets and dells might rise.
> No more those humble roof-trees smiled,
>     Nor the mead like amber flow'd
> But the conquer'd Saxon shuddering wept
>     O'er the wreck of his loved abode. (*Journal* 73)

Lucy records the "savage sport" motivating Norman attacks upon Britain, leaving a "wreck" of Saxon homes. This "sport" included rape and torture, as well as looting. This is not the verse we have been led to expect from an antebellum thirteen-year-old sentimental woman writer.

A promising student at eleven, Lucy is sent to "a man's school" (*Journal* 8). Her benefactress and family thereby put themselves in the company of a few broad-minded educational thinkers who believe coed learning environments best challenge young women's abilities. At this school, Lucy not only thrives but excels. She becomes a writer who protests, at least to her journal, taunts from fellow students: "I only hesitated once to-day in a long lesson in Philosophy, and yesterday in the conjugation of a French verb, and heard them whisper to each other, 'There! that's a'most a mistake.' It was not, neither [*sic*]." Her persecutors are the "Scribes and Pharisees,"

"Judges . . . without any jury" (*Journal* 10–11), "the pedantic bench of wiseacres" expecting to win a medal for best scholar. Their taunts pique Lucy's ambition, and she retorts, "Let's see a little to that, though!" (*Journal* 14). The schoolgirl goes off to bed with her books, preparing for the next day's lessons, which go without a hitch. The following spring, she wins top prize in final examinations, perhaps with recitation of her Norman kings poem.

The Saxon elegy is not a speech, the preferred genre of male rhetors in the long tradition of rhetoric. It could be Sigourney recites her own poem as a bit of bourgeois "parlor rhetoric," which Nan Johnson chronicles in *Gender and Rhetorical Space in American Life, 1866–1910*. Parlors are venues crucial to nineteenth-century women's rhetorical practice. Given its topic, likely Sigourney used this poem as a model for study in her classrooms. In the journal, Lucy is thrilled to witness debates in Congress during a visit to Washington, D.C., and this would-be woman preacher makes a list of sermons that need preaching (*Journal* 144–45). Recall that "Sentiments in a Sermon" and "Amos" indicate Sigourney's desire to make public statements on issues of gender and justice.[15] Lucy's verse on the Norman invasion presents a young woman who excels in a "man's school," embraces a political position, and trumpets a call to arms. Her elegy for conquered Saxons shows off the scholar Lucy has blossomed into although her arena of performance is a venue some say compromises her purity: a "promiscuous" or coed classroom where she learns elocution, among other subjects reserved for men.

It is no accident that, contrary to "meekness," the youngster of Lucy's journal presents herself speaking up in "a man's" classroom and in the public school exam. If elegies in Lucy's journal are read alongside Sigourney's rhetorical theory, they exemplify the full life and experience of a sentimental woman poet played out just inside the boundaries of "pure," with little attention to "meek" or "submissive." For the rhetorical theory in Sigourney's conduct books supports open discourse between men and women. In *Letters to Young Ladies*, Sigourney advises:

> Daily intercourse with a cultivated mind is the best method to rivet, refine, and polish the hoarded gems of knowledge. Conversation with intelligent men is eminently serviceable. For after all our exultation on the advancing state of female education, with the other sex will be found the wealth of classical knowledge and profound wisdom. (qtd. in Donawerth, *Theory* 145)

According to Sigourney, "natural" differences between the sexes do not account for gaps between what young men and women know. In her lifetime, girls and boys usually study in separate schools whose curricula differ drastically in depth and quality.

Beyond such "promiscuous" conversation, Sigourney straightforwardly advocates public speaking. She writes, "In the zeal for feminine accomplishments, it would seem that the graces of elocution had been too little regarded" (qtd. in Donawerth, *Theory* 143). She cites the Rev. Mr. Gallaudet, advocate of women's education and father to the founder of Gallaudet University for the deaf, who underscores the social, not natural, practice of banning women from public speaking.[16] "I cannot understand why it should be thought . . . a departure from female delicacy to read in a promiscuous social circle, if called upon." If a woman could sing or play the piano in such company, why should she not speak? "Nothing but some strange freak of fashion can have made a difference," according to Gallaudet (qtd. in Donawerth, *Theory* 143). By showing up the boys in their own schoolroom and in the male domain of public address, Lucy exhibits neither the purity nor meekness of "true womanhood." Rather, she "test[s] domestic ideology's myths against women's 'life world' experience," as Paula Bennett puts it, and breaks "the Angel's grip on middle-class women's subjectivities" (*Public Sphere* 116). Lucy embodies Sigourney's aim to persuade real women to challenge gender restrictions imposed by their culture.[17]

Two other examples of elegy in the journal suggest a related aim, even more ambitious. The more disturbing of these coincides with death of the journal writer three pages before the end of the book. You have to comb through Lucy's final entries to discern that her earthly life leaves off with this six-line ode:

> The homeless child, the unshelter'd guest,
>    Whom thou on earth didst cheer,
> Perchance, when cares no more infest,
> Shall rise in Heaven among the bless'd
> And greet thee to that realm of rest
>    Which sorrow comes not near.     (*Journal* 341)

The "homeless child" and "unshelter'd guest" appear to be needy people mourning the death of a benefactor (*Journal* 341). Because Lucy's newborn twins no longer have their mother-benefactor, we are left to infer that Lucy has passed into that "realm of rest," leaving her children orphans. Lucy dies in childbirth in the "great West," but death in childbirth is not news in her day.

### Voices of Un-dead Sigourney

What is strange in Sigourney's account is that Lucy's death occurs before the end of the book. Curiously, Lucy's journal continues for some pages post mortem, as if Lucy still describes the scene from an out-of-body vantage. This spectral voice conflates religious devotion with a husband's adoration of the dead woman. For the bereaved man is described "as one amazed—one whom God hath forsaken" (*Journal* 342).[18] The narrator depicts Lucy's mother cradling two newborns at the dead woman's bedside. From this scene, we understand a grandmother will raise Lucy's children. If this narrator is indeed Lucy, her departing spirit assures in an elliptical way that earthly life and love continue without her. Finally, the disembodied voice reports Lucy's days are at an end: "She lingered not" (*Journal* 343). But her spirit abides—in her mother, in her earthly children, and in the voice of the journal. The parallel is blasphemous but unmistakable: the miraculous life of Jesus did not end with crucifixion, nor can death keep a good woman writer down.

The book's final words from disembodied Lucy are one unsettling aspect of her textual ethos. But in retrospect, this ending makes another passage foreshadow Lucy's passing and at last performs a textual resurrection. Earlier, Lucy remembers two relatively famous poets, and she reiterates the metonymy that so often characterizes Sigourney's own rhetorical ethos. The process of remembering and associating herself with the two poets illuminates one final time what elegy and metonymy mean to Sigourney.

Four pages before her death and resurrection, Lucy paraphrases a conversation about the death of German poet, Johann Gottfried Herder (1744–1803). Herder, like Sigourney, rises from a working-class background, an autodidact who becomes a pastor and theologian, to be appointed court preacher (Forster). Herder dies "composing a hymn to the Deity," Lucy comments, "every thought uplifted and absorbed." She contrasts his passing to that of Poliziano, an Italian poet who dies "fitting to his harp some elegiac verses" on the death of Lorenzo de Medici (*Journal* 336). Poliziano dies in obscurity, Lucy writes, "inasmuch as the grief and gratitude of earth are inferior to the aspirations of saintly piety." The worth of a poet who writes lines of worship is relative to the object of adoration. That writing produces immortality is a commonplace for poets from the writer of *Beowulf* to Shakespeare to Henry David Thoreau.[19] One way a poet's value persists is to memorialize subjects the world deems great. Lucy exclaims of Herder's death, "What a sublime transition! The last theme of earth caught up and

finished in heaven" (*Journal* 336). It is an end devoutly to be wished not only by young Lucy, soon to die in childbirth, but also by Sigourney seven years from death when the 1858 journal comes to print.

Elegy places Sigourney's ethos in sympathetic metonymy with a person who has died, reflecting on her "strong mind," as in the epigraph of this chapter, or taking pride in Herder's rise to recognition and great faith. While Sigourney will never step into public arenas, she can savor the fame of her heroes. She shares their immortality and carries it into the future by articulating her predecessors' influence on readers, in effect keeping past poets alive. In elegies Sigourney cannot alone "survive herself," to insist on outliving "her own literary moment," in Loeffelholz's view ("Difference" 94). Rather, asserting Hemans' life after death in her poetry, Sigourney wants readers to declare at her own funeral, "We say not thou art dead. We dare not. No!" Whatever critics say, as elegist Sigourney cannot ensure a long life in print after death. Yet metonymy, Sigourney's favorite strategy for reviving forebears, illustrates Suzanne Clark's point that a degree of the sentimental is with us yet: "Sympathetic personification gives a face to the audience we address, marking the juncture of rhetoric as figure and rhetoric as persuasion" ("Social Construction" 102). Sigourney's rich memorials and all discourse that imagines readers involves sympathetic identification.[20] The discourse of sentiment only more dramatically foregrounds the "I" and "you" implicit in any text. Thus Sigourney's elegiac metonymy only more boldly reaches for life beyond the page.

Since language and the self are social constructs, readers' own selves get drawn into discursive webs like *Lucy Howard's Journal*, and we are changed by the writer's shifting ethos. The journal's title page epigraph is attributed to Webster: "We want a history of firesides." This line should give advance warning that the book has designs on readers' atrophied domestic sentiments. Lucy's readers identify with the "I" of every entry, and the reader becomes "herself" with undone housework. The book inflicts guilt because the topics of its self-searching entries model "inner habitudes" of a mostly domestic life that today's readers may not share (*Journal* 296). But readers also become the bright, ambitious young woman who competes successfully in a boy's school. While we may resist domestic passages working like a narrative conduct book, we can admire powerful, ambitious, assertive personae appearing in other parts of *Lucy Howard's Journal*, each of whom "*makes* history by convincing the people of the world that [her] description of the world is the true one," as Jane Tompkins wrote of sentimental rhetoric (*Sensational* 141; italics in the original). Readmitting Sigourney to scholarly discussion

reminds us that sentimentalism and other constructs such as rationality and gender are rhetorical and not always stable. Today's sympathetic identification and personification differ from the "O!" and shape- and genre-shifting Lydia Sigourney used. But current practice reveals itself too to be rhetorical and persuasive—and in some ways complexly sentimental.

If we cannot shake the ghosts of sentimental epithets, we can recognize the sentimental craft that connects an implicit "I" in Sigourney's discourse to "you"—that is, to *us* who now read her text more than 150 years after Lucy would have died.[21] In our own day, we could take to heart a woman writer who disappears and reappears in the curious finale of *Lucy Howard's Journal*, trumpeting profound and resilient power of sentimental discourse. Such sentimental connections are no easy task. For if Sigourney's body of poetry, her tirades, her advice, and her entries in Lucy's journal sometimes arrange themselves thematically inside parameters of nineteenth-century convention, current notions of "true womanhood" cannot contain the ethos of a restless antebellum woman poet who still reaches out through Sigourney's texts.

# 4. Julia Ward Howe's "I—s" and the Gaze of Men

> There is a difference in our I—s.
> —Julia Ward Howe, "The Lyric I"

> That men learned language in the same way, from the same women, is a well-kept secret . . . , but the repressed is never altogether absent: the mother turns up as muse, and poetry, with its ahs and las, its embrace of physical and emotional as well as intellectual truth, is perhaps the place where even the most patriarchal language has continued to reveal its origins.
> —Martha Collins, "Reclaiming the Oh"

In a deft move some years ago, Mutlu Konuk Blasing first describes, then erases a tradition that read American poetry through the eyes of Ralph Waldo Emerson. Similarly, but without erasure of the dominant poets, this chapter offers rhetorical analysis of the shifting poetic ethos, or the "I—s" traceable in lines by Julia Ward Howe (figure 4.1) in contrast to antebellum men's poetry, particularly by John Greenleaf Whittier and Henry Wadsworth Longfellow. Howe's "I—s" are not visual organs, but dispositions of Howe's first-person pronoun suggesting her multi-valenced ethos.

### Howe's Many "I—s"

There are many selves of Julia Ward Howe we no longer know. Three versions appear in the fifth stanza of "The Lyric I," introducing her second collection, *Words for the Hour* (1857): a fact-collecting empiricist, a reader of German romanticism, and a day-to-day pragmatist might each represent a different

Fig. 4.1. Julia Ward Howe in an engraving from a photograph done about 1860. PHOTOGRAPHED BY JOHNSON HAWES AND ENGRAVED BY CAROLINE AMELIA POWELL. LIBRARY OF CONGRESS.

type in Howe's upper-class circle of antebellum Boston. Sixth and seventh stanzas, however, foreground contrasts between Howe's selves closer to the bone: "The philosophic I, is not / The I that any man may meet . . . Or hold to greetings in the street." Moreover, she frets:

> The I that cannot choose but stand
> Great rights and wrongings to assert,
> Is not the I that wastes the meal,
> And leaves hiatus in the shirt. (*Words* 6)

Howe articulates a gulf between the reformer plunging into political causes and her not very domestic self. The poet sums up her plural, fragmented personae: "There is a difference in our I—s" (*Words* 5). She is not particularly domestic, pious, or submissive, this sentimental woman poet. Knowing something of Howe's selves could help us better assess her contemporaries in sentimental discourse. Before reading more of Howe's

poetry, however, I will first look at what compels comparison of hers to men's poetry.

Despite Blasing's thoughtful moves, by that erasure her study nevertheless reasserts a later predictable canon of American poetry. She acknowledges tremendous effect of Emerson's essays on such poets as Emily Dickinson and Walt Whitman and searches out ways of reading others' work through "the play of rhetoric, . . . the play of language," by what Blasing calls a "typology of the generic rhetorics" characterizing main tropes of American poetry since Emerson's mid-nineteenth-century poetic manifesto (2–3). Yet poetry other than Emerson's she chooses to read must fit standard modernist criteria. Truly American poetry, she asserts, only becomes so by abandoning English literary tradition and, with it, "assumptions underwriting the very idea of a legitimate historical authority" (1). Skepticism toward authority and Blasing's views on tropic threads of rhetoric take their cues from modernist poetics. Her schema omits thousands of nineteenth-century poets, however, many of them women, who achieved fame for texts using then ascendant literary and rhetorical conventions.

Following twentieth-century conventions, Blasing reiterates Harold Bloom's belief that even Emerson only "sang, after all, in prose" (2). Long-held views elevating antebellum prose and simultaneously dismissing most antebellum poetry can hinder making sense today of widely read verse, not to mention sharing it with students. Compare this view with earlier takes on Emerson: in her 1899 *Reminiscences*, Julia Ward Howe judges Emerson's poems "divine snatches of melody," pronouncing, "I think that in the popular affection they may outlast the prose" (291). For a time, Howe's assessment holds sway; in my parents' old house, a crumbling collection of Emerson's poetry, not essays, sat on the shelf. During Howe's lifetime, Emerson and William Dean Howells, among others, hail her, in Nathaniel Hawthorne's words, "beyond all comparison the first of American poetesses" (qtd. in Freibert and White 355–56). Howe's verse spans both sensationalist rhetorical codes and European traditions of sentimentalism. To unlock what nineteenth-century readers find in poems on their own terms, finding subjectivities in lines by the poet Julia Ward Howe can be key.

Multiple selves in Howe's poetry challenge men's sentimental poetry in two respects. First, I argue in this chapter, her poems underscore specific constructions of a poet's ethos from belletristic rhetorical codes, tactics used by both Howe and many men, including Whittier. These strategies are meant to produce sympathetic identification with a generalized reader, today's empathy urging readers to act on pressing social ills. It is now painfully obvious that in

developing reformist sympathy, both these celebrated poets at times obscure the selves of nondominant others. Both Howe and Whittier nevertheless spin out webs of sentimentalism, drawing the country toward a break with slavery. Second, Howe's version of sentimental ethos differs from the strong woman figure appearing in Longfellow's short poems, and I contrast the two by extending discussion of Howe's affinity for European romanticism.

Once again in an antebellum woman's poetic texts, we discover Howe's personae mismatched with conventional views of "true womanhood." A woman's eyes confronting the rhetorical dispositions of two male poets may inspire for us broad visions of how "serious sentimental" rhetoric affected American antebellum culture—and how that culture and sentimentalism still influence literary imaginations. This project adds a framework for reading sentimental poetry to such fine research as Gary Williams' *Hungry Heart: The Literary Emergence of Julia Ward Howe* (1999) and his 2009 reconstruction of Howe's unpublished novel *The Hermaphrodite*; both show us complications in the lives of sentimental poets. Also, Paula Bennett's *Poets in the Public Sphere: The Emancipatory Project of American Women's Poetry, 1800–1900* (2003) finds nineteenth-century women writers "peculiarly open to their own differences, . . . their need *not* to be fully absorbed by the genteel lyric's homogenizing voices or by . . . bourgeois gender values" (xii; italics in the original). On male sentimentalists generally, substantial critical work is under way, with room for much more beyond this chapter, especially on Emerson's and Henry David Thoreau's poetry. Here I limit the men contrasting with Howe's "I—s" to a few poems by Whittier and Longfellow emblematic of women's sentimental personae represented in male discourse.

### A "Battle Hymn" Recruiter

Lines of "The Battle Hymn of the Republic," written by Julia Ward Howe in 1861, bring home the rhetorical force of this sentimental poet's ethos shaped by sensationalist codes. As a girl, Howe read the Scottish professor Hugh Blair's *Lectures on Rhetoric and Belles Lettres*, using literary models to popularize both sensationalist psychology and eighteenth-century rhetoric for oratory and writing. Years later Howe recalls, "'Blair's 'Rhetoric,' with its many quotations from the poets, was a delight to me" (*Reminiscences* 57). One need not accept faculty psychology to understand the explosive potential of Blair's "useful" deployment of written discourse, including poetry (1: 361, lecture 40), for isolated, gifted young Julia Ward and thousands of other antebellum American poets, women and men, who read Blair and set out to change the world.

Howe sees poetic ethos in Blair's rhetorical scheme to be a disposition tailored to cultural expectations of audiences or readers. Resonant with contemporary rhetorician George Campbell's audience-driven scheme, Blair professed, "Nothing is more necessary" than exhibiting "sentiments which will ever be most powerful in affecting the hearts of others." The audience must see a speaker as "a virtuous man" who would move hearers "to refine and improve their moral feelings, . . . possess generous sentiments, warm feelings, and a mind turned toward admiration of those great and high objects, which men are by nature formed to venerate." Blair emphasized exposure to tasteful literature to shape a rhetor's (especially a poet's) self-presentation, but he tempered elegant style with an exhortation to the rhetor: "adapt your style to the subject, and likewise to the capacity of your hearers" (1:406, lecture 19). Moreover, "with the manly virtues, he should possess strong and tender sensibility to all the injuries, distresses, and sorrows of his fellow creatures" (2:230–32, lecture 34). Like Campbell, Blair's gender references were masculine, contradicting common misconceptions that only women write sentimental discourse. Perhaps style makes the man—or woman— but in the sensationalist codes, the rhetor and his or her style are shaped by contemporary culture. A sense of audience determines a sentimental writer's ethos and style, in turn molding the reader's sentiments.

Long after Howe moderates strict youthful piety to become a devoted follower of transcendentalist preacher Theodore Parker, the last rousing stanza of her "Battle Hymn" shows she reaches her audience for the Union cause by activating codes of dominant evangelicalism. Assuming the stance of inspired prophet—like Sigourney's seminary professor unmarked for gender, thus presumably male—Howe shares a persona with Frances Harper, Whittier, and dozens of others called to shape abolitionist sentiments:

> In the beauty of the lilies Christ was born across the sea,
> With a glory in his bosom that transfigures you and me:
> As he died to make men holy, let us die to make men free,
>   While God is marching on.
>     (qtd. in Walker, "Julia Ward Howe" 149)

Pronouns in the second line invoke listeners or readers with a generalized "you," insisting they identify with "me," the poet, in common religious devotion. In the third line, poet and reader collapse into the plural "us," called by identical placement in parallel syntax to identify with Christ and crucifixion.

Howe's rhetorical ethos challenges readers to face a redemptive death like "he" did, Christ-like martyrdom to free the black slaves. Merging a

call to arms with Christian iconography, Howe's pronouns offer slippery poetic sites where personae of writer and reader combine. We can imagine how a poet posing as a military recruiter "insinuates" sentiments into her audience (Campbell's term). When her audience stands to sing, Howe's words resonate in their bodies. By apostrophe, this sentimental woman poet masks her gender and constitutes a reading, speaking, singing subject ready to march in Lincoln's army.

The song still marshals us to higher causes, for it is often sung at civil rights gatherings. But too often we have ignored its lyricist along with its sentimental system. Host of NPR's *Mountain Stage* radio program introduces a guest singing the "Battle Hymn," ruefully recalling an age that honored poets. Howe receives just five dollars for it from the *Atlantic Monthly* in 1862, but thousands read the poem in the following months, and it is widely sung in public (Clifford 147). An elderly Howe capitalizes on the song's success and the forceful, passionate ethos of its writing subject, foregrounding the reformer over others in "The Lyric I": a self who could not "choose but stand / Great rights and wrongings to assert." She often recites the "Battle Hymn," recalling in print and public appearances the story of how its words came to her.

One morning in November 1861, the poet lies awake and, as she describes it, "the long lines . . . began to twine themselves in my mind." To remember them, Howe "sprang out of bed," scribbling its five stanzas "in the dimness . . . almost without looking at the paper" (*Reminiscences* 275). She creeps back to bed, trying not to wake her husband and baby sleeping in the same room. Soldiers' campfires in her lines recall scenes viewed at dusk from a train crossing fields outside Washington, D.C., weeks before, when Howe enters the city. Her words also draw force from a short trip the previous day with other dignitaries to review the Grand Army of the Potomac. Howe's family stays several weeks while her husband, famous for social and hospital reform, serves on a commission for "interests of the newly freed slaves" and on the Union Sanitary Commission (*Reminiscences* 269). Sung to "John Brown's Body," Julia's lyrics grow popular among northern regiments. Reportedly, the first time President Lincoln hears the "Battle Hymn," tears run down his face and he shouts, "Sing it again!" Seven years later, Emerson refers to Howe's lines in his journal: "I honor the author of the Battle Hymn. . . . We have no such poetess in New England" (qtd. in Clifford 147). The "reformer" is often Howe's public ethos of choice.

Looking back from her sixties, seventies, and eighties, Howe's stance of universally admired reformer, poet of the "Battle Hymn," proves expedient for a widow who breaks with convention to write, travel, and lecture for a

living. Two full chapters of her *Reminiscences* elaborate on inspiring details of the "Battle Hymn" lyrics. The 2011 *Cambridge Companion to Nineteenth-Century American Poetry* allows only this persona for Howe (Larson 113–14). Her own memoir, however, connects that 1860s abolitionist not only to the promoter of women's clubs as arenas for women's influence and oratory, but also to the woman preacher of pacifism in late nineteenth-century New England and British Unitarian congregations, as well as to the lobbyist who would stump for women's suffrage to the end of her life in 1910 (Clifford 218–80). This sentimental woman poet's ethos fits that passionate, reformist "I" who shapes abolitionist and suffrage sentiments.

Evident in the army recruiter Howe becomes in the "Battle Hymn," sentimental personae grow increasingly ambiguous in gender and identity as more antebellum women among others figure themselves as writers. With increasing literacy, the generalized audience of "all men in general" no longer is exclusively white men. Emboldened by Blair to shape rhetors to the audience, a multitude of various unexpected writers assume the stance of poet to address all of "you"—multiples of such dispositions in Julia Ward Howe's work alone.

### *Emergence of Other Julias*

Exhibiting the flexibility of Howe's ethos, a further bit of wit in multiple self-exposures of that introductory poem from *Words for the Hour* also reveals Howe's affinity for contemporaries' transcendentalist wordplay. She figures herself to be

> the lyric I,
> The poet's *eye* that finely rolls,
> And holds convertible domain.      (5; italics in the original)

The poet's eye (perhaps not Thoreau's eyeball), her language, material demands of her circumstances, and her male audiences discussed later in this chapter not only convert the domain she surveys but also again and again transform Julia Ward Howe's demeanor into romantic poet, wit, scholar, philosopher, reformer, and absentminded domestic.

This "lyric I" is shaped in part by adjustments to a childhood filled with men of power and influence. From birth in 1819 in New York City until twenty-three, Julia Ward lives in her banker father's wealthy household as headstrong first of three daughters, middle child of five, bent on living up to the wild reputation of her red hair (Richards, Elliott, and Hall 1:57–59).

At eleven, the budding poet hands her schoolmarm verses instead of the prose assignment. This woman does not encourage Julia's literary ambitions (Clifford 23). The poet's mother dies when Julia is small, and her father in grief turns to his wife's severe Episcopalian piety, part of a widespread evangelical movement (Clifford 15). During this time, Julia Ward first reads Blair's *Lectures*, and although forbidden attendance at public productions, the ambitious girl and her brothers compose and produce plays in verse for family gatherings (Richards, Elliott, and Hall 1:29). At sixteen, when Julia's female seminary education is replaced by exacting private tutors at home, the girl's social circle shrinks to her father's extended family, happily a merry, inquisitive clan (Howe, *Reminiscences* 18–19).

Closest in temperament to her brilliant and mercurial older brother Sam, Julia reads widely in his library from university studies at Columbia University and later in Europe. Sam supports publication of Julia's poems; several appear in the *New York American* when she is fourteen (Clifford 23). Finding Goethe's *Faust* among Sam's books, the poet's father scolds Julia: "I hope you have not been reading this wicked book" (Howe, *Reminiscences* 59). Long before, however, she likely read it in the German. Of this enclosed world, Julia later writes, "I seemed to myself like a young damsel of olden time, shut up within an enchanted castle" (qtd. in Richards, Elliott, and Hall 1:49).

Julia Ward Howe's first childhood book-length manuscript, called *Poems*, is dutifully dedicated "to Samuel Ward esq. By His affectionate daughter" (qtd. in Richards, Elliott, and Hall 1:33), but early on Howe senses, especially for women, verse could be a great mission—as Emily Dickinson writes, that "letter to the World / That never wrote to me" (216). Julia chides her little sisters one day for playing a nursery game, bidding them to "turn their thoughts to graver matters, and write poetry" (qtd. in Richards, Elliott, and Hall 1:35). "Serious sentimentalist" fits young Julia Ward as it does Mrs. Holmes, the philosophical recluse given this moniker in William Hill Brown's 1789 novel, *The Power of Sympathy* (35).

Mourning her father's death in 1839 and her brother Henry's the following year, the twenty-one-year-old Julia becomes as zealous and pious as her father. Her daughters recount a time she "enforced her Calvinistic principles" on her siblings with a heavy hand. "The family were allowed only cold meat on Sunday, to their great discomfort; the rather uninviting midday dinner was named by Uncle John 'Sentiment'; but at six o'clock they were given hot tea, and this he called 'Bliss'" (qtd. in Richards, Elliott, and Hall 1:66). Neither temporary asceticism, however, nor evangelicalism of her "Battle Hymn" definitively locates for us the sentimentalist Julia Ward Howe. Her

selves are at least as various as the Lucys in Sigourney's *Lucy Howard's Journal*. For if, as theorist Emile Benveniste writes, "the instance of discourse is . . . constitutive of all the coordinates that define the subject" (730–31), different discourses—different poems in Howe's case—give us different poets. I return to other personae she shapes for herself after providing a contrast to Howe's smoothly crafted recruiter persona shaped—with a few lapses—by John Greenleaf Whittier.

### Whittier's Illustrated Abolitionist

Whittier as abolitionist presses his case to a unitary audience in the American rhetoric of sentiment through his complex *A Sabbath Scene*. This remarkable tract, comprised of verses plus line drawings, suggests sentimentalism's power to shape rhetors' and readers' personae, and also abolitionism's participation in conflicted race and gender practices. While exhorting northern men to repeal fugitive slave laws, the poem again represents a kind of failure for sentimental rhetoric's unitary self, "all men in general," in George Campbell's words (133). A woman trips over the Bible (or racist interpretations of it), and a northern congregation returns her to a slave hunter (figure 4.2).[1] The runaway exemplifies what the sentimental code calls "distress to the pitying eye," a handy figure Campbell said "diminishes every fault" (133). Campbell's *Philosophy of Rhetoric* recommended a personified "beauty . . . in tears" as "one main engine" to attach reader sympathy to a cause (96).

Racial implications of Whittier's poem and its pictures can be read with help of Roland Barthes' arguments about a "denoted" message or an obvious "analogon," which can be undercut by a "connoted message" from "a period rhetoric, in short, . . . a stock of stereotypes (schemes, colours, graphisms, gestures, expressions, arrangements of elements)," images from the particular "historical" common sense ("Old" 17–18, 22). Barthes' observations on overt versus inadvertent historical rhetoric may help today's reader decipher mid-nineteenth-century racial codes.

With the tract's series of pictures, the connotative rhetoric of Whittier's text lies not in one image, but in what Barthes calls "the suprasegmental level—of the concatenation" ("Old" 24). Furthermore, the text-plus-image format balances stanzas and line drawings on the page, producing at least two textual planes of signification. Picture illustrates text, but the text also, in Barthes' words, "loads the image, burdening it with a culture, a moral, an imagination . . . ; there is amplification from the one to the other." Text and picture may duplicate one another, producing an apparent "naturalization of

Fig. 4.2. "A wasted female figure." FROM *A SABBATH SCENE*, BY JOHN GREENLEAF WHITTIER. ILLUSTRATIONS BY BAKER, SMITH, AND ANDREW.

the cultural," as Barthes says, but they may also contradict on the plane of the "ideological . . . or ethical connotation, that which introduces reasons or values into the reading of the image" ("Old" 29). For sentimental rhetoric, both the construction of ethos and its contradictions are finally what stand out in Whittier's text.

After the poem's first picture of a runaway slave, there is her pursuer, arrogant chin up, with his whip, a symbol of his power, strategically placed against his crotch (figure 4.3). The 1850s are a pre-Freudian decade, but sometimes today we recognize an inscription of phallic power. Next, the fleeing woman throws up her hands with "a keen and bitter cry" while the crowd places itself between runaway and slave hunter (figure 4.4). Whittier's text evokes the "natural" response of "manhood's generous pulses" and "woman's heart" in response to the fleeing slave's cry. According to Whittier and his illustrators, it should be as Campbell said: "Everybody acknowledges that beauty is never so irresistible as in tears" (133). Perversely, the minister bows to the whip-holding "lord and master" (figure 4.5) to support the hunter's

ownership. "Of course I know your right divine / To own and work and whip her." The minister orders his deacons to "throw the Polyglot / Before the wench and trip her!"

> Plump dropped the holy tome, and o'er
> Its sacred pages stumbling,
> Bound hand and foot, a slave once more,
> The hapless wretch lay trembling.        (*Sabbath* 13)

An enormous Bible lands in front of the fleeing woman. In Whittier's abolitionist tract, the Bible literally becomes her stumbling block, and the slave is recaptured right there in the church.

This page is the narrative climax of Whittier's short discourse, for it dramatizes—in a way that might be comic if its subject were not horrific—antebellum racist interpretations of the Bible set out to justify the bigotry of northern churches that support fugitive slave laws. Sentimental codes, which insist on "vivacity" or liveliness and "perspicuity" or concise delivery, are fully engaged. In lively pictures and the compressed story of Whittier's lines, we see, we hear, we sense with all our faculties the deep contradictions of antebellum legal codes as they clash with conventional religious codes.

Fig. 4.3. "A lank-haired hunter." FROM *A SABBATH SCENE*, BY JOHN GREENLEAF WHITTIER. ILLUSTRATIONS BY BAKER, SMITH, AND ANDREW.

Fig. 4.4. "A keen and bitter cry." FROM *A SABBATH SCENE*, BY JOHN GREENLEAF WHITTIER. ILLUSTRATIONS BY BAKER, SMITH, AND ANDREW.

Fig. 4.5. "Plump dropped the holy tome." FROM *A SABBATH SCENE*, BY JOHN GREENLEAF WHITTIER. ILLUSTRATIONS BY BAKER, SMITH, AND ANDREW.

Faith otherwise would exhort church folk to "love thy neighbor as thyself" and let the woman go, but some congregations do not.

Near the end of Whittier's tract, "the wind of summer lifted" pages of a Bible on a windowsill (figure 4.6). Whittier's ideological or ethical message is that nature interprets the Bible better than the minister, representative of entirely wrongheaded institutional church politics. Correct alone are natural impulses of Whittier's crowd defending the woman. A good antinomian Quaker, Whittier testifies to the Inner Light or Holy Spirit to be trusted over human dogma. This picture may also resonate with natural theology in 1850s transcendentalism, which trusts the soul of each person.

Problems arise, however, not only from the pastor and his theology but also from Whittier's take on the minister's moral conflict. One page after the preacher's order to throw down the Bible, the planes of text and illustration collide. The text presents Whittier's narrator transformed from passive mouthpiece of the story to active agent of change:

Fig. 4.6. "The open window sill." FROM *A SABBATH SCENE*, BY JOHN GREENLEAF WHITTIER. ILLUSTRATIONS BY BAKER, SMITH, AND ANDREW.

My brain took fire: "Is this," I cried,
   "The end of prayer and preaching?
Then down with pulpit, down with priest,
   And give us Nature's teaching!

"Foul shame and scorn be on ye all
   Who turn the good to evil,
And steal the Bible from the Lord,
   To give it to the Devil!"            (*Sabbath* 21)

Fiery words from this devout Quaker poet! Most readers would applaud his transformation of stance and sentiment. It seems the whole aim of Whittier's tract is to fire readers' imaginations, so they too jump out of their pews to become active, politicized agents of change.

Odd dissonance occurs between these lines and their illustration (figure 4.7). Readers interpolated by the "I" of Whittier's poem should rise to stop the slave hunter. Yet a dark-skinned devil whispering in the minister's ear tellingly reinscribes "the status of persons" in antebellum abolitionism. "Status of persons" is Emile Benveniste's phrase signaling that power relations

Fig. 4.7. "To give it to the Devil!" FROM *A SABBATH SCENE*, BY JOHN GREENLEAF WHITTIER. ILLUSTRATIONS BY BAKER, SMITH, AND ANDREW.

may be implicit, not explicit, in rhetorical practice (730). Juxtaposition of a black devil with the first textual appearance of the narrator's "I" underscores persistence of racial prejudice not only in the minister's mind but also for the narrator and antebellum culture. The gap between representations in text and illustration also underscores "the implacable violence . . . which," Julia Kristeva says, "constitutes any symbolic contract" ("Time" 203). Perhaps the social contract of language necessarily elides particularities, but Whittier's inattention to clashing iconographies of evil has reasserted racist hierarchies and undercut his own ethical message.

The rhetor of this poem, tailoring his ethos to generalized "Hearers as Men in general" (from the title of Campbell's chapter on audience), does violence to particularities of race, gender, and material circumstances. Although Whittier supports women and their writing, no woman in this text has any words; they cry out and weep, but nothing more, least of all the fugitive woman, whose fate gets lost in ruminations by the narrator.[2] This American champion of abolition asserts the humanity of black people, exhorts passive northerners to action, and dramatizes the hypocrisy of institutionalized religion. In other venues, as African American scholar Shirley J. Yee writes, the nineteenth-century abolitionist movement provided an "opportunity for . . . both races to work together for a common cause." Yet textual subjectivities in Whittier's *A Sabbath Scene*, along with much abolitionist discourse, "also replicated the racial and sexual tensions of the larger society" (Yee 1).[3] The more fervent the cause, the more vulnerable it may be to contradictions.

Whittier and Howe became expert antebellum wordsmiths of the rhetoric of sentiment transforming northern morality and passions about race. Their sympathetic "I" and generalized "you" exploited dominant religious discourse and white middle-class masculine norms to reach sensible men, mostly, who had the power to change those norms. Both wrote politically charged abolitionist verse: Howe's "Battle Hymn" recruits soldiers, while Whittier's *A Sabbath Scene* unsettles church leaders' hypocrisy on fugitive slave laws.[4] For all their expansive motives, however, Howe and Whittier exclude from speakers and audiences many voices who could complicate the rhetorical situation. In either poet's work, nondominant folk, people of color, and women are not often enough given voice. Although conventional facelessness of eighteenth-century rhetoric allowed a bold woman like Howe to speak up, the same generalized self of sentimentalism might obscure others dispossessed. Nevertheless, her project to breach masculine literary barriers produced an antebellum feminine ethos quite aware of sexual tensions.

## *Daring Flirtation with the Master*

The seductive version of Howe's "I—s" draws less on the Scottish Enlightenment than on European sentimentalism whose poems, Blasing agrees, are ironic and "'sentimental'—In Friedrich Schiller's sense of 'self-conscious'—representation of the 'naive' modes of other tropes" (7). If "romantic sentimentalism" is an oxymoron now, the term underscores a gap in most current interpretations of nineteenth-century discourse.[5] We are not positioned to read what few besides Paula Bennett today recognize as "sophisticated erotic awareness" (*Public Sphere* 33) in the subjects or subjectivities of Julia Ward Howe's poetry.

This seductive self, I argue in chapter 7, produces a dialogue to woo male readers, a format central to Howe's pathos or audience appeal. Outside of Howe's *Passion-Flowers* dialogue, three daring stand-alone poems profile her writing personae. In contrast to the woman of Howe's "Master" dialogue, coy on literary ambitions, these selves strike poses overtly announcing a desire for recognition.

Howe's first "Master" poem in the 1854 *Passion-Flowers* collection presents a demure voice invoking one who has encouraged the fledgling poet. An ode in two eight-line stanzas, it is part two of three sections in the longer opening "Salutatory" poem, subtitled "To My Master." Of several possibilities for Master, she likely has in mind Henry Wadsworth Longfellow, who, she wrote her sister, edited the *Passion-Flowers* volume, suggested its name, and recommended it be published anonymously (Richards, Elliott, and Hall 1:139). It is fitting for this study to reiterate rhetorician Blair's report: "Sentiments, of one kind or other, form, almost always, the subject of the Ode" (2:354, lecture 39). Readers will find sentimentalism's passionate reasoning in this poem. Its first four pentameter lines begin with more trochees and spondees than the commonplace iambs expected in an ode; the poet's unusual stresses suggest the initially meek woman now urgently solicits her Master's approval:

> Thou who so dear a medation wert
> Between the heavens and my mortality,
> Give ear to these faint murmurs of the heart,
> Which, upward tending, take their tone from thee.
> Follow where'er the wayward numbers run,
> And if on my deserving, not my need,
> Some boon should wait, vouchsafe this only meed,
> Modest, but glorious—say, 'Thou hast well done.' (5)

In prayer-like "murmurs," the poet modestly decries her halting meter (those "wayward numbers"), and she protests in the second stanza not work, but "pleasure was my task" to write this book. Intensely hoping to please her Master, she ends the second stanza:

> Of all Earth's crownings, I would never one
>   But thine approving hand upon my head
>   Dear as the sacred laurels of the dead,
> And that high measured praise, 'Thou hast well done.'   (5)

Piously eschewing economic reasons for her book, this rhetor still earnestly desires "Earth's crownings." Both stanzas end with a refrain putting approval into her reader's mouth and echoing a Christian's hope for an approving judgment after death: "Well done, thou good and faithful servant." In the Bible, the Lord of "the kingdom of heaven" thus commends servants who use their talents well (Matt. 25.21). Secular talents and achievements can get heaven's nod, but such favor rarely includes "Earth's crownings." Weaving together devotion and ambition in a hymn to a godlike Master locates this woman poet precariously on the border of heresy.

Howe crosses that line in another "Master" poem, near the end of *Passion-Flowers*. "The Master" raises another paean to the singular man who will look deeply at her work with generous condescension:

> Sometimes, in the brilliant strife
>   Of the wise and witty,
> One who pleads not for himself
>   Breathes divinest pity.                    (173)

Following this encomium to her benefactor, the poet points out things of this world he does not stoop to: "denunciation, . . . rapturous swelling, . . . busy haunts of men, / Mid their festal dances" (173–74). Blatantly appealing to his heart, his pity, the woman imagines this visionary man has the wisdom to recognize her even before she knew her own talents.

> When his eye detected me
>   In the world's vain glitter,
> And his look said: 'Here is one
>   Whose garments do not fit her;
>
> 'She who stakes an hour on cards
>   Risks a holier treasure;

> She who scatters shining words
>> Gathers pain for pleasure.' (175)

He sees past the veneer of her life to recognize her artistic ability. He also sees through polished lines to feel her stressful circumstances, perhaps a troubled marriage. To end, the poet moves her seer into full identity with God:

> Then my world-enfrozen heart
>> Faster beat, and faster;
> As I looked upon the Man,
>> I beheld the Master. (175)

When "Man" becomes "Master," the poet perhaps commits blasphemy in orthodox Christianity, but she also locates herself and him in transcendentalist thought and neo-Platonic longing for truth beyond materiality. Simultaneously, she prettily compliments the power of her mentor's teaching and begs help for her career.

Religious diction suggests the women poets of these "Master" poems stand enthralled by divine visions, but this same spirituality makes Howe's case for fame. Whether or not her reverence is sincere, it is a charming rhetorical strategy. A last "Master" poem stands out for its persistent, complex ethos or writing subject who deliberately and artfully, perhaps obsequiously, mixes religion with literary discourse and displays her poetic craft.

This other address to the Master adds to Howe's proliferating selves, for it electrifies the spirituality of the first two poems with frank eroticism and an out-of-wedlock pregnancy. Mixing eros, faith, and motherhood, the woman writer figured in "Mother Mind" cues readers to draw parallels between Howe's *Passion-Flowers* and Bettine von Arnim's popular nineteenth-century epistolary novel, *Goethe's Correspondence with a Child*. Letters in von Arnim's semiautobiographical novel connect intellectual intercourse to physical when she writes her Master, "Art valiantly spiritualizes sensual life. . . . The intercourse between thee and me forthbrings spirits. Thoughts are spirits, my love is the hatching warmth for the spirit's offspring" (586–87). Likewise, for an American woman poet, Howe's "Mother Mind" establishes erotically charged connections to groom male readers for complete seduction several pages later.

The "Mother Mind" narrator responds to a question on how she writes, protesting she makes no poems on request, only by inspiration:

> I never *made* a poem, dear friend—
> I never sat me down, and said,

> This cunning brain and patient hand
> Shall fashion something to be read. (91)

She is no hack, writing for anyone who asks. This Howe—locating herself squarely among romantics—claims inspiration comes only after the male muse beckons, gives the sign.

> But not a word I breathe is mine
> To sing, in praise of man or God;
> My Master calls, at noon or night;
> I know his whisper and his nod. (92)

The poet claims as audience this intimate muse and Master. However, putting "My Master" just after "man or God" allows poetic ambivalence about who this is. A deity? A secret lover? The Master himself fosters and encourages the poems welling up within her. Perhaps he also actually fathers her literary offspring. Since he keeps asking how she writes her poems, she finally answers:

> 'Tis thus—through weary length of days,
> I bear a thought within my breast
> That greatens from my growth of soul,
> And waits, and will not be expressed. (92)

Gestating thought into poem takes reflection and self-culture, she writes, just as American romantics, those transcendentalists, say. Worrying as had Anne Bradstreet two hundred years before about sending out a defective poetic brainchild, Howe's poet next equates her work to physical labor of childbirth:

> It greatens till its hour has come;
> Not without pain, it sees the light;
> 'Twixt smiles and tears I view it o'er,
> And dare not deem it perfect, quite. (92)

This woman seeks attention and approval of her male mentor-Master-muse, an unconventional woman ready to shock readers into riveting attention on her and her poetic offspring. Outrageous allusions to pregnancy and childbirth also indicate she cannily reads power relations of her day. Howe's poetic rhetor fashions a racy weave of maternal domesticity with erotic and religious discourses to snare her Master.

To end "Mother Mind," the poet rather disingenuously asserts, "These children of my soul I keep / Where scarce a mortal man may see" (92). How

is it the poet's issue of a rendezvous with her Master can be hidden while she parades her poems before the world? The woman unfolds a breathtaking, devious ploy. "Yet not unconsecrate, dear friend," she gracefully notes of her poems, turning the full force of erotic, religious, and maternal discourses upon her hapless Master in a final apostrophe. They may be bastard poems, but they will not go unrecognized: "Baptismal rites they claim of thee" (92). Not only an enthusiastic hymn of praise to friend and muse, this collection has specific, urgent claim upon her Master's goodwill. "Do you like these poems?" the sentimental poet asks. "Good." This sly woman poet may blackmail the Master into acknowledging his own progeny: he inspired the poems; his conversations with her produced them. She says, in effect, he is responsible for her brainchildren. He must support them. The woman poet demands the Master admit his part and provide patronage for her poems.

## *Mother Nature in Longfellow and Contrary Howe*

Finally, consider Howe's known mentor among her contemporary male poets. In light of her oeuvre, his work takes a rather misogynist cast. Henry Wadsworth Longfellow's sonnet "Nature" resonates strongly with Howe's work, not only because Longfellow was involved with Howe's career, but also because, like hers, this poem conflates religious and domestic discourses while presenting a striking female figure. Moreover, for this study it is important that Longfellow suffered like Whittier the same twentieth-century modernist dismissal wrought upon Howe and other women sentimental poets.

Blasing cites at length Poe's searing indictment of Longfellow's "plagiarism" of historic poetic forms; in her own more moderate words, he "quite earnestly adopts the tradition" (20). Yet Blasing repeats Ezra Pound's backhanded compliment that when the nation "wanted a tradition like other nations, . . . [it] got Longfellow's 'Tales of a Wayside Inn' and 'Hiawatha' and 'Evangeline'" (qtd. in Blasing 124). To Pound's ear and Blasing's as well, Longfellow's veneration of a so-called dead tradition rang dully in contrast to the "live tradition" Pound endorsed in Whitman's lines. For Whitman sounded "our American keynote," according to Pound (qtd. in Blasing 140–41). I suggest that we must reread Longfellow not to get nineteenth-century white males back into circulation now that African Americans and women poets "are starting to receive their due," as Laurence Buell argued in his introduction to a collection of Longfellow's work (xxxii). Rather, we need Longfellow for the sake of nineteenth-century sentimentalism as a discourse and for its women poets in particular. Recovering sentimentalism's men

could neutralize misogyny poured upon its women. Thus we find, as E. H. Underwood remembered Longfellow, how the rhetoric of sentiment with "sympathy boundless . . . addressed the hearts of all" (242). Sympathy may be a connection worth relearning.

Longfellow's sonnet "Nature" is no philosophical treatise like Emerson's 1836 essay by this title, nor is it like Howe's "Master" poems designed to woo the literati. It is one of many reflections on "advancing years," as Edward Wagenknecht in 1986 characterized several later poems by Longfellow (*Henry* 137). With thoughtful meditative layering—here of both domestic and religious discourse—this sonnet achieves the epitome of German theorist of sentimentalism Friedrich Schiller's self-conscious, artful naivete.

> As fond mother, when the day is o'er,
>   Leads by the hand her little child to bed,
>   Half willing, half reluctant to be led,
> Still gazing at them through the open door,
>   Nor wholly reassured and comforted
>   By promises of others in their stead,
>   Which, though more splendid, may not please him more;
>
> So Nature deals with us, and takes away
>   Our playthings one by one, and by the hand
>   Leads us to rest so gently, that we go
> Scarce knowing if we wish to go or stay,
>   Being too full of sleep to understand
>   How far the unknown transcends the what we know. (376)

A feminine gender is assigned throughout to the inexorable force who "takes away / Our playthings one by one." An omniscient third-person narrator introduces "Nature" "[a]s fond mother" in the octave, and because the phrase lacks the article "a," it produces an identity between "Nature" and "mother." Perhaps consonant with transcendentalism's neo-Platonic idealism, any "mother" to Longfellow is an instance of transcendent "Nature," and effects of old age in anyone are likewise appearances of the same force. Even if it echoes transcendentalism, Longfellow's maternal trope may seem cloying to today's taste. We, like Poe, may want to criticize Longfellow along with Sigourney for an "invincible inclination to apostrophize every object, in both moral and physical existence" ("Critical Notices" 113).

This poem does not address the woman in classic apostrophe, using second-person "you." Yet extending this single personification throughout

the single long sentence of the sonnet, Longfellow provides evidence of his poetic craft, at the time a formal sign of any poet's imaginative capacity. Longfellow and Sigourney obey Blair's dictum that "in the descriptions of a poet, who has a lively fancy, everything is animated" (1:330, lecture 16). In Longfellow's conceit, Mother Nature "leads" a child who at first resists. Then she "promises," "deals," "takes away" toys, and finally manages to get the little boy to bed.

On a level perhaps obvious to early readers, Longfellow's mother and reluctant child constitute a touching, almost comic metaphor of stubborn anxiety humans feel as the body ages—when pleasures, activities, and friends of youth are less and less available, death is near. This poet's audience was likely the rhetorician's vague, ubiquitous "men in general" like him, finding one after another element in their world changing, friends dying off, faculties waning. Longfellow gets accused of predictable accommodation to Victorian anxieties, but graying baby boomers may find Longfellow's representation of death and aging affecting. Noting the poet's ambition to write poetry, biographer Lawrance Thompson reports that "stubbornness was a subtle power in Longfellow—a kind of spoiled child way he had, of setting his heart on something and refusing to be denied" (281). Determined as the boy of "Nature," holding on to life despite declining bodily force, Longfellow remains throughout a long life the poet he as a child hoped to be.

Not an elegy for a particular person, yet the poem in tone reminds us that collections by Whittier, Emerson, Thoreau, and Longfellow include many commemorative poems. Their works reveal that elegy, a branch of epideictic rhetoric, occupied many poets of the nineteenth century. To some it may seem morbid, yet commemorative poetry faces death in a manner more sturdy than some of today's denials. In days after such events as those of September 11, 2001, the space shuttle Columbia disaster, Sandy Hook elementary school shootings, or death of the revered Nelson Mandela, we are all audience to poems about those who die. Our own popular discourse reminds us we are not immune to comforts of sentimentalism and its commemorative verse. Longfellow's "Nature" as remembrance of death demonstrates that not only Lydia Huntley Sigourney and Mark Twain's Emmeline Grangerford write and receive solace from nineteenth-century verse elegies.

Turning to the woman from Longfellow's boy ethos in "Nature," I find she evokes associations with "The Wife," a fantasy short story by one of Longfellow's favorite writers, Washington Irving. Flowers in her hair, offering strawberries to her man dragging home from work, Irving's "wife" proves that "though all abroad is darkness and humiliation, yet there is still a little

world of love at home, of which he is the monarch" (760). More straightforwardly than Longfellow's Mother Nature, Irving's character is recognizable in Barbara Welter's 1966 sketch of "true womanhood." Female readers may be offended that once again Longfellow's paragon of womanhood is made to soothe and comfort a weary man at the end of the day. Frankly, the sexy, dangerous, prolific woman writer of Howe's "Master" poems is more interesting. Given complex women writers variously sketched in Howe's poetry and in other erotic verse by Rose Terry Cooke, Frances Sargent Osgood, and Sarah Piatt—not to mention interesting particularities about other early- to midcentury women poets such as Harper and Sigourney—one wonders, *who but men* strictly observe Welter's parameters for women of the nineteenth century? The depiction scarcely fits women then.

### Sentimental Mothers of Language

One can link this woman in "Nature" with a quite different dimension associated with the feminine, a disposition whose power may still be accessible. Longfellow, as Blasing said, "earnestly followed the tradition," a tradition presenting this woman who, unlike the little boy, does "understand / How far the unknown transcends the what we know." This does not mean women know all and men know nothing. Linking the "unknown" to Longfellow's woman does not suggest the gender of God is female (or any other gender) although the suggestion may be pleasant. This womanly metaphor resonates with postmodern semiotic registers of language—that is, the dimension of words drenched in ineffable pleasures of the body, a register theorist Julia Kristeva says precedes the words we learned in our mothers' arms ("Time" 190), a realm still overturning diction, syntax, and social order whenever it can, especially when we are tired like this poem's little boy.

In "Reclaiming the Oh," one of many short pieces by women on literary tradition collected in Sharon Bryan's *Where We Stand*, Martha Collins reports at last recovering a "mother tongue" when she read women's works, including those "largely forgotten women poets of nineteenth-century America." Collins describes her pleasurable shock of discovery: "Unavailable as a model of achievement—or, if we happened to be heterosexual, as loveobject—our first love returned to some of us with an almost overwhelming force" (33). She found herself reconsidering primal connections to her mother in lines of these women's poems. But, she found, not only women poets and writers thrill to ineffable semiotic power. Convention connects the semiotic register with women, but it cannot be only women whose language taps it.

"That men learned language in the same way, from the same women, is a well-kept secret," Collins observes.

> But the repressed is never altogether absent: the mother turns up as muse, and poetry, with its ahs and las, its embrace of physical and emotional as well as intellectual truth, is perhaps the place where even the most patriarchal language has continued to reveal its origins. (34)

Longfellow's poetry as well as Whittier's—like Howe's and Sigourney's and Harper's—has as its matrix the nineteenth century's rhetoric of sentiment. Longfellow's Mother Nature celebrated in "Nature" shows he too learns his "ahs and las" in the lap of sentimentalism. For us now attempting to glimpse selves produced by lines of men's and women's sentimental poetry, Longfellow's "Nature" and Whittier's abolition verse—seen through "I—s" of Julia Ward Howe's insouciant, irrepressible woman poet—indicate this cultural discourse is both more complex than we imagined and more pervasive.

If the sentimental and its rhetoric, moreover, have been the unconscious of American nineteenth-century literature—unknown to us until recently—its poets have been doubly obscured. Like the semiotic so often linked to the feminine, constructs of sentimental poetry have lost a multiply gendered sense of the discourse. We restore complexity to sentimentalism, its writers' rhetorical ethos, and gendering in both the nineteenth century and the twenty-first if we take Julia Ward Howe's invitation to look more closely into sentimental poets' "I—s."

PART 3

Pathos: Who Reads Sentimental Poetry?
And Who Cares?

# 5. Slave Market Matrix of Harper's Critical Pedagogy

*'Tis yours to banish from the land*
*Oppression's iron rule;*
*And o'er the ruin'd auction-block*
*Erect the common school.*
—Frances Ellen Watkins Harper,
"Words for the Hour" (ca. 1863)

Shall we not hope, that the mental and moral aspect which we now present is but the first step of a mighty advancement, . . . that ere long we may present . . . a people to whom knowledge has given power, and righteousness exaltation?
—Frances Ellen Watkins Harper, "The Colored People of America" (1857)

[In] African American women's literate practices . . . rhetorical action becomes visible as a site of continuous struggle in response to an ongoing hermeneutic problem. . . . They use language to envision a world as crafted by their own minds and hearts.
—Jacqueline Jones Royster, *Traces of a Stream*

She did not read books, but Sojourner Truth asserts, "I read men and nations" (qtd. in Taylor 74). A sister nineteenth-century black speaker, Frances Ellen Watkins Harper, acknowledges the already critical literacy of those like Sojourner Truth, to whom slavery had denied formal education:

"Human faces were the scrolls from which they had been reading" (*Day* 303). Harper's lifelong rhetorical aim—inspired by Truth and others—is to cultivate similar critical literacy in readers of her poetry. Drawing on radical Christianity and Unitarianism, Harper exhorts black and white people alike in her audiences to diligently read both people *and* texts—and to change culture. This chapter considers the slave market, both as a historical site and in readers' imaginations, as the location where Harper chooses to "[e]rect the common school," as she puts it in "Words for the Hour" (*Day* 185). Thus African American poet Frances Harper teaches audiences to transform the locus of degradation into a matrix of spiritual and cultural rebirth.

## *Schoolhouse Footings in Critical Pedagogy*

"What happened here? What will happen here?" These questions ground the critical pedagogy by which Harper instructs student audiences. The two questions also guide my rhetorical analysis of pathos or audience appeal for Harper's antebellum poetry. The first question helps us recover Harper's coursework on actual slave markets and their effects before and during the Civil War. The second lets us reconsider audiences' response to a vision Harper aimed to inspire: how to heal the wounds of slavery. This chapter focuses on Harper's antebellum poetry; other, later texts suggest post–Civil War change she enjoins her audience to enact as they seek healing for wounds inflicted by slave markets.

The two questions on what locations mean grow from David A. Gruenewald's critical pedagogy of place.[1] He wants to incorporate environmental issues into all twenty-first-century curricula. Teaching in what Gruenewald calls a place-based "situated context" with "the goal of social transformation" is also central to Harper's race-based instruction from the slave market (323, 309). Harper's racially aware pedagogy of place uses strategies of pathos that insist only by careful reflection on slave markets can black and white audiences act to change the lives of African Americans. Black and white readers must articulate and cut ties to the political economy of slavery.

Strategies of pathos in Harper's lessons on antebellum slave markets presage place-based educational theory and also anticipate principles set out in African American educator Lisa Delpit's critical pedagogy. Like Delpit, the poet practices a branch of critical pedagogy known for race-conscious teaching and learning. With designs on changing students' minds about oppressive structures, both Gruenewald's and Delpit's branches of critical

pedagogy manifest rhetorical overtones. If you substitute the language of nineteenth-century slave markets for terms of traditional classrooms challenged by Delpit, you have elements of Harper's prescient course of study. Here are Delpit's tenets:

1. Issues of power are enacted in classrooms.
2. There are codes or rules for participating in power; that is, there is a "culture of power."
3. The rules of the culture of power are a reflection of the rules of the culture of those who have power.
4. If you are not already a participant in the culture of power, being told explicitly the rules of that culture makes acquiring power easier.
5. Those with power are frequently least aware of—or least willing to acknowledge—its existence. Those with less power are often most aware of its existence. (282)

Through Delpit's lens, Harper's abolitionist project clarifies how power gets wielded in slave markets. My analysis of Harper's slave auction metaphor for pathos follows Delpit's tenets to trace the poet's argument challenging white society's monopoly. Place- and race-based frameworks for pedagogy together reveal how Harper's poetry appeals to pathos, to her readers black and white. Gruenewald's large questions query place in pedagogy, how slave markets figure in the poet's texts. Delpit's analysis of power traces racial dimensions of Harper's place-based lessons, and when Delpit's assertions are applied to the poetry, learning goals emerge for Harper's classroom.

### *Harper's Lessons for White Readers*

What does happen in antebellum places where black people are sold? Harper's 1854 poem "The Slave Auction" and her advocacy of education for African Americans both respond to this first question from a critical pedagogy of place. Likely written to accompany speeches to mostly white audiences on the abolitionist circuit, "The Slave Auction" may be Harper's first extant text that teaches about race from such markets. What she shows is power deployed in ways long entrenched in a racist culture. The poem exposes conventions established and reiterated by Europeans over centuries of buying and selling Africans. In the first four stanzas of the poem, the poet dramatizes to unschooled white northerners previously unarticulated codes of power:

> The sale began—young girls were there,
>   Defenceless in their wretchedness,
> Whose stifled sobs of deep despair
>   Revealed their anguish and distress.
>
> And mothers stood with streaming eyes,
>   And saw their dearest children sold;
> Unheeded rose their bitter cries,
>   While tyrants bartered them for gold.
>
> And woman, with her love and trust—
>   For these in sable forms may dwell—
> Gaz'd on the husband of her youth,
>   With anguish none may paint or tell.
>
> And men, whose sole crime was their hue,
>   The impress of their Maker's hand,
> And frail and shrinking children, too,
>   Were gathered in that mournful band. *(Day 64)*

Recognizing and undoing codes of unchecked power top the poet's lesson plan. Harper assumes that issues of power are enacted in slave auctions—just as Delpit points out for all classrooms. The poet's reference to white sellers and buyers labels them as "tyrants" who "bartered [black people] for gold." White people dominate the trade, and Harper testifies such abuse of power warps human relations, extinguishes human sympathy, and shatters families. If you have eyes to see, Harper teaches, you may undo the damage of unbridled power.

Codes or rules of power are embedded in slave market language, and Harper takes it on directly. An exchange of people for money labels those sold as "beasts" or "property." But the poet dismisses this vocabulary from the beginning of her first stanza. It is "young girls," "mothers," "dearest children," and "husband[s]" on sale. Instead of using commercial diction for slavery, she starts with terms of family, human feeling, and compassion. Such elemental terms aim to bind Harper's subjects to her white readers, a bond of pathos.

Readers of this poem must realize that people cannot be considered property. Showing not objects, but human beings, Harper enacts philosopher Immanuel Kant's dictum: "Love people. Use things." Except for the title's noun, *auction*, from a commercial lexicon, along with *slave* as its modifier, the poet avoids any other language of commerce. She refuses to wrangle about black people's humanity as some contemporary white poets do. John Greenleaf Whittier's "On a Prayer Book" argues that Christians who support

slavery not only deny black people's humanity but lack it themselves (*Works* 408). Harper agrees but chooses instead to demonstrate that souls standing on auction blocks possess feeling and virtues. Human faculties live in "sobs" and "cries" and "anguish" of the black people for sale, and such capacities are also implicit in what she places at risk here: the humanity of her white audience.

From her first 1850s stump speech, as I have noted, Harper acknowledges her day's rhetoric of sentiment meant to shape every person's mental faculties. Speaking carefully to a mostly white northern audience, she aligns herself with terms of this discourse, assuming literary works might "cultivate the intellect, enlighten the understanding, give scope to the imagination, and refine the sensibilities" (*Day* 98). Harper addresses mental faculties of her audience according to a new "science of the human mind" incorporated into eighteenth-century rhetorical theory by academics such as Scotland's George Campbell (lxxiii–lxxiv). Yet she challenges the neutrality of this Enlightenment code. You must have a sense of right and wrong, she instructs her white audiences, for this engine of persuasion to work well.

Evoking moral sentiment with the mental faculties, Harper harmonizes with passages in which Campbell barely admits one may "evince the truth" with logical syllogisms (71). Campbell instead recommends "sympathy" (today's empathy) as "one main engine of persuasion" (80), and he emphasizes for pathos righteous identification of hearers with speakers, not mere deduction. Harper clashes with Campbell, however, when faculties of the human psyche are played upon without regard for alleviating oppression, a reform impulse she associates with religious sentiment. "Philosophy and science may bring their researches and revelations—Literature her elegance—but they are idle tales compared to the truths of Christianity." Well-crafted, worldly discourses address the faculties, but "they open not . . . our dim eyes and longing vision. . . . One is important here, the other of infinite and vital importance both here and hereafter." Alluding to a tenet of prevailing natural theology which holds that God made nature to fit human need, she reminds her listeners, "As this material world is adapted to man's physical nature, so the word of eternal truth is adapted to . . . moral nature" (*Day* 98). That "word of eternal truth," for Harper, refers not only to the Bible but also to a living prophetic spirit of reform.

To be true to itself, Harper says, rhetoric must have a spirit that "has changed the moral aspect of nations." Persuasion must not only increase knowledge but also serve human need. Scientific method becomes a rhetoric producing truth and moral sentiment only if, in its wake, "fetters have been broken, and men have risen redeemed from dust, . . . and freed from

chains" (*Day* 97). Enlightenment rhetoric shapes language and gives insight, but with no heart the best-crafted text is cold and narrow. Harper invokes faculty psychology only to direct a white audience's attention past it. Her goal is full identification of readers and listeners with black human beings. The poet presumes black humanity in "The Slave Auction" rather than using syllogism or cold faculty psychology because the teacher-poet's choice is a rhetorical move of identification, shaping a new community of sentiment from her subjects and her audience.

Harper presents black people at the slave sale as "one of you," family whose grief should wrench every reader's heart. In ancient Greece, Aristotle advised rhetors that for hearers to identify with and act to change others' terrible circumstances, "we must obviously be capable of supposing that some evil . . . might . . . befall ourselves or some friend of ours, and moreover to befall us soon" (2:8.14–15, 16–17). As an Aristotelian rhetor, Harper does not chop logic about black humanity. Rather, "The Slave Auction" displays immediate passions of countless anguished black women and men bartered away in slave trades. These people have feelings and morals. Harper shows that black people on the auction block know this scene is wrong. They sob knowing they will be torn from loved ones.

Beginning the poem with those "daughters," Harper appeals to a growing northern awareness of slavery's moral outrage. In any slave auction, Harper says, heartbroken mothers "stood with streaming eyes," dreading the future of female children sold into sexual bondage. Husbands and little ones as well, innocent of everything but being black, know full well their families are under assault. She demonstrates African Americans, like everyone else, are equipped with feeling, imagination, intellect, and understanding. Thus, replacing market language with familial terms and recasting mental science in a moral framework, Harper articulates the codes of the slave system. She undercuts the institution that labels black human beings as goods by countering white people's vocabulary of power with African Americans' capacity for dignity. What is at stake in this poem, finally, is not the "new mental science" or family. It is race.

> Ye who have laid your love to rest,
>     And wept above their lifeless clay,
> Know not the anguish of that breast,
>     Whose lov'd are rudely torn away.
>
> Ye may not know how desolate
>     Are bosoms rudely forced to part,

> And how a dull and heavy weight
> > Will press the life-drops from the heart. (*Day* 64–65)

Any whose family members die feel that loss, but white people who sympathize with slaves in Harper's poem cannot know the bitterness of loss by sale. Like Linda Brent, Harriet Ann Jacobs' pseudonymous narrator in *Incidents in the Life of a Slave Girl*, Harper distrusts white sympathizers. Jacobs recalls holding her son close when he is freed, crying, "Can you imagine . . . ? No, you cannot, unless you have been a slave mother" (261). Pointing out mental faculties common to all races is a partial goal for Harper, but it is never sufficient in her race-conscious critical pedagogy.

Sentimentalism sets more profound goals than either to teach mental faculties or to arouse free-floating emotion. George Campbell reassures consumers of eighteenth-century sentimentalism, "What is addressed solely to the *moral* powers of the mind is not so properly denominated the pathetic [or passionate] as the *sentimental*" (80; brackets and italics in the original). Harper appropriates Campbell's sentimental tactics to shape people's sentiments in race-conscious ways. Guidelines in a late speech mirror those in Harper's 1854 speech seeking to inspire black people to be "ere long . . . a people to whom knowledge has given power, and righteousness exaltation" (*Day* 100). This black teacher's commitment to link knowledge to power anticipates Michel Foucault's twentieth-century connection. He would use the first three words of this line from Harper's later piece: "Knowledge is power, the great mental lever which has lifted up man in the scale of social and racial life" (*Day* 275). As with Harper, Foucault's equation of knowledge to power never involved mere facts. Critical knowledge deals with webs of power spun by cultural institutions, power that can be resisted by people who articulate such webs. Harper's poetry carries a promise of "exaltation" for black people, and education for her becomes a footing from which they can rise above the worst circumstances. Her poem "The Slave Auction" begins building that market into a site of instruction, exemplifying the way she would interrupt white cultural indifference toward slavery and injustice.[2]

## *Harper's Challenge to Convention*

Harper rarely takes common parlance for granted. As her language challenges the discourse of slavery, so too does it work as a strategy of pathos to overturn oppression. In virtually every poem, Harper has audiences take a critical second read of nineteenth-century culture. Frances Smith Foster

writes, "Harper's innovations were in the particular interpretations that she gave to familiar subject matter" (*Day* 54). Indeed, Foster maintains, "Harper chose to use her words as weapons in the battle to save humanity" (*Day* 29). The poet starts a piece with familiar terms, then resituates them in particular historical and material circumstances. Examples from Harper's 1854 *Poems on Miscellaneous Subjects* illustrate the strategies of her pedagogy and various cultural effects on readers of the critical literacy she wants to demonstrate.

A remarkable call to undercut and appropriate terms of power appears in the poem "Free Labor." Harper advocates boycotting clothes made from slave-grown cotton or flax because that clothing is a sign of oppression. A dress of the right material makes a political statement:

> And from its seams and folds shall rise,
>   No voice to pierce the sky,
>
> And witness at the throne of God
>   In language deep and strong,
> That I have nerv'd Oppression's hand
>   For deeds of guilt and wrong.      (*Day* 81)

To Harper, "free" does not mean one pays next to nothing for products—nor that employers are free to exploit people to sell at the cheapest price. Touring the abolitionist circuit in 1854, she writes Underground Railroad conductor William Still about inconsistencies between activists' talk and lifestyles dependent on slave labor. "Oh, could slavery exist long if it did not sit on a commercial throne?" No, she insists. But toppling this tyrant of commerce requires sacrifice. "I have reason to be thankful that I am able to give a little more for a Free Labor dress, [even] if it is coarser," she tells Still. "If the liberation of the slave demanded it, I could consent to part with a portion of the blood from my own veins" (*Day* 45). In the folds of one's own clothes, any rightly educated person will read either injustice against people discounted as property or the dignity of "free labor." Anyone with clothes has the power to choose and act on behalf of hands that earn fair wages for fair work. The poem "Free Labor" uses the pathos of Frances Harper's slave market critical pedagogy to reveal how coded practices of place and race can be read and revised, so reader-students can affect their historical context.

"The Soul," in Harper's 1854 collection, argues similarly against corrosion by antebellum industrialization. Surprisingly, Harper tells pious readers, "Heap high the gems, pile up the gold," accepting how important

material wealth is to black people long impoverished by slavery. Yet however high riches rise, Harper maintains, "the weight of the balance would still be light" measured against the "immortal worth" of either "a spotless name / [Or of] the robes, the wreaths, and gems of thought" (*Day* 56–57). This poem speaks on behalf of virtues and education to a materialistic culture and the slave system. Both devalue people while piling up material wealth.

Two poems later, Harper reworks a troubling biblical dialogue between Jesus and a woman petitioner who is a gentile outcast in Israel:

> "Lord!" she cried with mournful breath,
> "Save! Oh save my child from death!"
> But as though she was unheard,
> Jesus answered not a word.                    (*Day* 58)

God has something to learn, Harper suggests in "The Syrophenician Woman." He does learn—from this woman—to value people of another ethnic group. The poem argues for sympathy toward "the humblest, meanest," who in nineteenth-century America comprise a burgeoning urban population gathering to run factories. Sympathize, the poet pleads, or everyone's humanity may be lost. Two poems on, Harper instructs readers to scan with "recognition" the anguish of a child whose father is an alcoholic, and then to act on the child's behalf (*Day* 63). The very next piece exhorts readers to scrutinize the corruption of a culture reveling in technology with no thought of "the simple sons of earth" who produce but do not share profits of a booming economy (*Day* 65).

In "The Contrast," Harper scolds the public for harsh judgment of a prostitute; the self-righteous took no pity, yet "scorned her for her sinning." Rather, judges must read in the woman's shame callous brutality on the part of the men who use her:

> Where was he, who sullied
>    Her once unspotted name;
> Who lured her from life's brightness
>    To agony and shame?                         (*Day* 73)

Harper's arguments shock all but Woman's Christian Temperance Union (WCTU) marchers and Methodist activists, who know prostitution is neither victimless nor solely perpetrated by women. Men who pay for sex are liable. This poet is always alert to teach readers how to let go of prejudice and find stories of the spirit in human circumstances.

Harper advises young men and women to read prospective partners critically: young men should value the "woman of truth" whose

> ... habits be frugal,
>    Her hands not afraid
> To work in her household
>    Or follow her trade.          (*Day* 67–68)

A working woman is the mate to prize. "Just open your mind, / And make her your wife," Harper tells young men. She offers similar instruction to young women:

> Wed not a man whose merit lies
>    In things of outward show,
> In raven hair or flashing eyes
>    That please your fancy so.
>
> But marry one who's good and kind,
>    And free from all pretence;
> Who if without a gifted mind,
>    At least has common sense.         (*Day* 68)

Partners who read for qualities of character and spirit and not just good looks, Harper insists, will root out deception and find virtue. Such wide-ranging topics show, as Frances Smith Foster points out, Harper was "never simply an abolitionist poet" (*Day* 33). Yet Harper always engages pathos to instruct readers to discern humanity in the faces of people dismissed by prevailing common sense. Both black and white people enlightened in the "common school" of Harper's poetry can read most any aspect of culture to glimpse troubled souls, human potential, glimmers of good. Read the needs of people who have nothing, she directs. Life will teach us if we reread its "facts" for significance.

### *A Critical Reread of "Race"*

Whatever other required topics this teacher assigns, undercutting racial bias is central to her 1854 collection. Among race-conscious poems is her "Bible Defense of Slavery." In it Harper registers "holy horror" that while "rocks and stones" of creation grasp spiritual truth, slaveholders maintain that Christianity supports slavery. Thus, she rails, so-called "masters" "insult . . . God's majestic throne / With th' mockery of praise" (*Day* 60). A few pages later, a woman narrator of "The Fugitive's Wife" says:

> I noticed on his brow a shade
>   I'd never seen before;
>
> And in his eyes a gloomy night
>   Of anguish and despair;—
> I gazed upon their troubled light
>   To read the meaning there. *(Day* 72)

The wife knows the "slave-pen" is crushing life out of her man. A loving wife understands and forgives his flight north, although she and her children are left behind. With other topics and always with race, Harper recasts destructive commonplaces to unsettle them.

This teacher's goal is to revise readers' conventional wisdom through poetry. Poetic language may best accomplish the internal task of "pulverizing the polished surface of ideas, and beliefs," to borrow Julia Kristeva's description of Roland Barthes' work. For the language of poetry may "reveal all that is left unsaid" (*Sense and Nonsense* 18). In her early verse, Harper advances a grammar of values to counter the deadly patter dominating her culture. She inculcates in reader-students a broader, deeper vocabulary of family and human capacity.

Jacqueline Jones Royster says one way to grasp African American women's "bridging" to reach white readers is to see such appeals to pathos as constructs of identification and consubstantiation. Rhetorical and poetic, Kenneth Burke's "both / and" dynamic at play in "identification" may sum up this poet's lesson for white people on what happens in slave auctions. In *Rhetoric of Motives*, Burke explains that while

> A is not identical with his colleague, B, . . . insofar as their interests are joined, A is identified with B. . . . Here are ambiguities of substance. In being identified with B, A is "substantially one" with a person other than himself. Yet at the same time he remains unique, an individual locus of motives. Thus he is both joined and separate, at once a distinct substance and consubstantial with another. . . . "[I]dentification" is . . . to confront the implications of division. . . . Identification is affirmed with earnestness precisely because there is division. (21–22)

Harper wants to move every reader toward active cultural critique. While she holds to distinctions between audiences, she also points out ways black and white lives coincide.

Some see engaging universal faculties of mind as an appeal solely to dominant-culture, white audiences. If Harper accomplishes only this, the

code of power might be seen to swallow her. Yet the reverse can also be argued. In studies of nineteenth-century African American publishing, Frances Smith Foster finds something other than imitation in sentimental conventions used "by African Americans for African Americans." Harper models for nondominant readers and would-be writers a familiarity with the available means of persuasion. Foster maintains Frances Harper and other "African American writers were about the business of creating and reconstructing literary subjects, themes, and forms that best suited their own aesthetics and intentions." The poet instructs black readers about white codes and also demonstrates "inversions, improvisations, and inventions" that could inspire subversions by other black writers (Foster, "Gender" 51).

## Harper's Lessons for Black Readers

The poet does aim to teach psychological and rhetorical codes of power to fellow black people, just as Delpit directs teachers in today's classrooms, but Harper would extend Campbell's rhetorical project beyond the white male middle class. Then sentimental black and white women's poetry on occasion could and did turn convention on its head. The poet Harper's curriculum is founded on the premise that such codes, once laid out, may be turned by savvy black students to acquire power.

She reveals how such visions have guided her sentimentalism from its inception in her 1885 essay on pedagogy, "A Factor in Human Progress." Harper is sixty years old. Since before the Civil War, she had taught white and black readers to address implications of both races' human capacities. She invokes sentimentalism to awaken both black and white people to African Americans' full potential and their path to power. Rather than move the faculties by sensationalism, however, Harper will reshape them in a moral framework: her version of sentimentalism. Responding in her essay to a question from a previous writer, "How shall we educate?" Harper wants black teachers to ask instead, "How can we best utilize this education? The culture of the moral and spiritual faculties is destined to play the most important part in our future development" (*Day* 275). She takes for granted teachers do engage the day's "mental science." The question for her is, to what end? Harper's explanation of teaching connects knowledge and power, supported by the rhetoric of sentiment:

> Education of the intellect and the training of the morals should go hand-in-hand. The devising brain and the feeling heart should

never be divorced, and the question worth asking is not simply, What will education do for us? but, What will it help us to do for others? (*Day* 276)

Faculties of "intellect" and "heart" signal it is moral sentiment she is after. Her reversal of syntax or chiasmus echoes in John F. Kennedy's challenge of 1961, "Ask not what your country can do for you, but what you can do for your country." Black readers have these capacities, she assumes. Her lesson: "Use them for good."

To end "The Slave Auction," Harper overtly identifies with black readers, instructing them on "rules of the culture." Two points illuminate the poem's final appeal to African Americans' pathos. First, she puts her own convictions on the line, speaking as one of the nineteenth century's handful of black "public intellectuals" (Foster, "Press" 24), a courageous spokesperson for oppressed people who "desperately needed positive black role models" (Mary Helen Washington qtd. in Foster, "Gender" 49). Twentieth-century black critics often failed to "appropriately historicize both the attitudes and art" of writers like Harper, scolds Frances Smith Foster. They forgot "that the public presentation of an African American woman who took clear positions on issues that were politically and socially controversial" reworked roles that dominant culture would never assign to black women. Second, this writer, by means of sentimentalism, springs from a "church militant," which promulgates "the same Christianity that produced Nat Turner and John Brown," Foster observes ("Gender" 54). Led by black people, the African Methodist Episcopal denomination, founded in 1816, embodied that militant movement and published much of Harper's work in journals such as the *Christian Recorder*.

In concluding stanzas of "The Slave Auction," this poet dramatizes radical Christianity at work. Some have made being black a crime, so this black woman models a way to oppose the indictment. If her people's "sole crime was their hue," she proposes that it is God who commits the offense, reminding all readers that everyone's skin color is "[t]he impress of their Maker's hand." Black readers of Harper's poem might feel that hand on their own heads. Harper's phrase is close to the 1960s Black Power pronouncement that "black is beautiful." Familial terms, likewise, for black audiences may be more than a way to dismiss the intent of white people's commercial language. They may advance Harper's reappropriation and reconstitution of family life shattered by slave sales. Her appeals to pathos call free black readers, moreover, to identify as she does with sisters and

brothers in bondage. Describing the scene theologically, she affirms the right of any black believers to use—to their own ends—codes and conventions of dominant culture.

White people aim in antebellum slave markets to incapacitate black people, convincing them of white rights to their persons. But self-possession is Harper's rhetorical and educational goal. With herself as prime example, Harper dismisses white possession and invokes past models of black self-assertion. Norms of "true womanhood" are on Harper's mind when, in "The Slave Auction," she refers to "woman, with her love and trust— / For these in sable forms may dwell." The poet uses diction from Phillis Wheatley, reaching beyond cultural commonplaces to a poet most black readers would recognize.

Pathos of "The Slave Auction" echoes appeals to eighteenth-century readers from slave poet Wheatley. This young woman published more than eighty years before Harper a piece defending black virtue, "On Being Brought from Africa to America":

> 'Twas mercy brought me from my Pagan land,
> Taught my benighted soul to understand
> That there's a God, that there's a Saviour too:
> Once I redemption neither sought nor knew.
> Some view our sable race with scornful eye,
> "Their color is a diabolic die."
> Remember, Christians, Negros, black as Cain,
> May be refin'd and join th' angelic train.     (160)

Harper's phrase "sable forms" signals sisterhood with Wheatley's astonishing self-possession. Wheatley demonstrates black people could "be refin'd" as any white folks. Karla Holloway writes that Wheatley's "challenge to the boundary conditions of Christianity was as essential a part of her language as were the rhythm and flow of her metrical patterns." Holloway urges on today's teachers that same dynamic of challenge and convention exploited by Wheatley: "The language we use in our classrooms has both text and subtext" (615). Harper taps into Wheatley's mix: significance beyond surfaces, meaning requiring a second read and change of heart. Harper tells her black pupil-readers: Learn from your heritage of writers such as Phillis Wheatley, Ann Plato, Maria Stewart—and me. Slavery cannot constrain us.

What happens in antebellum slave auctions? Worse than their market lexicon denying people's humanity is a spell of despair. Philip Fisher claimed

white people's nineteenth-century fiction instantly establishes the humanity of black people as "hard fact" (1985). But Harper's poetry advances the difficult work of African Americans changing their own status and power.[3] Royster insists black people of that century do conduct their own readings and analyses to write about black culture. She explains that in

> African American women's literate practices . . . rhetorical action becomes visible as a site of continuous struggle in response to an ongoing hermeneutic . . . problem. . . . They use language to envision a world as crafted by their own minds and hearts. (*Traces* 72)

At stake is self-definition of the race. Harper's 1850s reference to Wheatley would bring to black readers' minds the wide "matrix of relationships" Royster points out is then already available in texts by African Americans, a sisterhood and brotherhood bent on "survival of the race" (86). Frances Ellen Watkins Harper, teaching about the slave pen, is one of many Royster still puts on reading lists of works by "African American women [who] transform the world they perceive into the worlds that they desire through the use of language" (70). Harper's readers take heart because other black writers also flourish in adversity to shape a future hope.

Urging education for African Americans, the poet turns readers back to the "slave pen" to resist and undo meanings reinforcing white people's status over black people. Social contexts, Harper declares early in her speaking career, not genetics, cause black "disability" and despair:

> Born to an inheritance of misery, nurtured in degradation, and cradled in oppression, with the scorn of the white man upon their souls, his fetters upon their limbs, his scourge upon their flesh, what can be expected from their offspring, but a mournful reaction of that cursed system which spreads its baneful influence over body and soul; which dwarfs the intellect, stunts its development, debases the spirit, and dwarfs the intellect, and degrades the soul? Place any nation in the same condition . . . , fetter their limbs and degrade their souls, debase their sons and corrupt their daughters, and when the restless yearnings for liberty shall burn through heart and brain—when, tortured by wrong and goaded by oppression, the hearts that would madden with misery, or break in despair, . . . let them, when nominally free, feel that they have only exchanged the iron yoke of oppression for the galling fetters of . . . public opinion . . . and tell me, reviler of our race! Censurer of our people! If there

is a nation in whose veins runs the purest Caucasian blood, upon whom the same causes would not produce the same effects; whose social condition, intellectual and moral character, would present a more favorable aspect than ours? (*Day* 99–100)

Harper's critical instruction from the slave pen matches bell hooks' goal in *Teaching to Transgress*: "to 'read' the dominant social system ... against itself by finding, in the folds, seams, and fault lines of its ideologies, spaces in which to oppose oppressive modes of social and economic domination" (*Day* 95). Anyone without options would appear as debased as black slaves, but learning can turn the tables.

African Americans' day will come, Harper promises; if despair is socially constructed, it can be revised and rebuilt. "Shall we not hope," she asks fellow African Americans, "that ere long we may present to the admiring gaze of those who wish us well, a people to whom knowledge has given power, and righteousness exaltation?" (*Day* 100). Her hope is her people's own knowledge of power codes will spin a strong sense of self. Here Harper turns to Gruenewald's second question for pedagogy of place: What will happen here? What can African Americans do to transform the legacy of slave auctions?

Frances Harper's pathos makes the slave market a matrix of power, arming students with transformed consciousness of that place, so they reflect on their circumstances and reshape their own selves. Critical pedagogy is "not just a skill, but an act of emerging consciousness," writes Suzanne Clark ("Discipline" 125), tracing pedagogy's connection to rhetorical practice. Both teacher and student must reach beyond bits of information, argue Mas'ud Zavarzadeh and Donald Morton, and find "enabling conditions for production of meaning in culture" (99). Postmodern educational theories reiterate Harper's sense that material and institutional circumstances affect people's learning. A critical learner in Harper's slave market classroom grows into "a critical subject who knows that knowledge is a social product with political consequences and is therefore willing to 'intervene' in the way knowledge is produced" (93). Harper's strategies of pathos would persuade black students to reinvent themselves and their world.

### Poetry's Power of Change and Faith

How does poetry accomplish such a thing? Harper answers this question about her verse in a series of "Fancy Etchings" essays in the *Christian*

*Recorder*. Aunt Jane puts a similar question to young Jenny, just home from college. "Do you think by being a poet you can best serve our people?" The aunt represents prevailing African American views just after the Civil War, but Harper reveals her lifelong goals in Jenny's response: "I think, Aunty, the best way to serve humanity, is by looking within ourselves, and becoming acquainted with our powers and capacities." Jenny mentions the stir created by a poem of her own: "That poem was a revelation. I learned from it that I had the power to create, and it gave me faith in myself, and I think faith in oneself is an element of success." Jenny's faith in her power to cause cultural change constitutes a new, positive sense of self. "I want to learn myself and be able to teach others to strive to make the highest ideal, the most truly real of our lives" (*Day* 225). Harper roots her faith in radical Christianity of the African Methodist Episcopal (AME) Church, which published her work, but also in application of her own Unitarian principles.

Just how poetry in Harper's day can accomplish such marvels is suggested by Emerson's canny remark in "The Poet." A Unitarian from the 1830s on, Emerson brushes aside nitpicking about standard poetic meter to concentrate on the "metre-making argument, that makes a poem" ("Poet" 200). Shrewd experience in the material world and ideals of book learning blend in Harper's Unitarian definition of education. Her aim to convince readers they have "power to create" and "make the highest ideal, the most truly real of our lives" rises above notions of dry pedagogy of the nineteenth century. Frances Smith Foster traces the poet's association with the black church from the AME archives, along with Harper's emergence as an American public intellectual.[4] However, Carla Peterson makes much of these Unitarian principles:

> Although Frances Harper assiduously participated in activities of the AME Church throughout her life, . . . Evangelical Unitarianism enabled Frances Harper to envision herself as a poet-preacher whose faith in . . . Christ empowered her to promote social engagement. (124)

Over poetry and pedagogy, Peterson emphasizes this poet's oratory, but she is right that Unitarians are among the earliest to support the call of women to preach, write, and be active as public persons.

Peterson focuses on specifically Christian roots of U.S. Unitarianism, ascribing to it the traditional view that "Jesus Christ is the ultimate source of salvation" (125). In this way, she may seek to make tame Harper's membership

in an overtly unorthodox denomination that eventually embraced both transcendentalism and Universalism. Harper's vision for black people's education, however, is not conventional. She couples idealism and pragmatism in poetry with an edge, which, Royster says, "adds complexity" to cultural views of black people. A rhetorical approach centered on distinctives of black audiences "resist[s] simplification, stereotyping, . . . [and] value systems that would render their knowledge and experiences irrelevant . . . , or that would erase the specificity of their material conditions" (*Traces* 72). Material conditions for black people in Harper's day appear in excruciating detail in her verse, difficult accounts that redeem, Jenny tells Aunt Jane, only if they activate resources of "the ideal." Imagination and spirit together, Harper believes, can project and enact real change. "Physical forces have their limitations," this poet admits, "but who can fix the boundary line of the ideal and impalpable forces?" (*Day* 275). Unitarian principles supply Harper with a well of power that could overwhelm African Americans' material barriers with a flood of learning.

Harper makes a case for human potential and change in a poem that may seem distant from slave auctions. "I Thirst" appears in the poet's collections between 1865 and 1875, but Foster suggests it comes to print before or during the Civil War (*Day* 136–37). The poem challenges commonsense language again with cultural context when two voices set out first an orthodox, then a progressive take on spirituality as it affects human agency. The poem transforms bondage into a well of hope.

FIRST VOICE

I thirst, but earth cannot allay
    The fever coursing through my veins;
The healing stream is far away—
    It flows through Salem's lovely plains.

The murmurs of its crystal flow
    Break ever o'er this world of strife;
My heart is weary, let me go,
    To bathe it in the stream of life

For many worn and weary hearts
    Have bathed in this pure healing stream
And felt their griefs and cares depart,
    E'en like some sad forgotten dream.

SECOND VOICE

"The Word is nigh thee, even in thy heart."

Say not, within thy weary heart,
    Who shall ascend above,
To bring unto thy fever'd lips
    The fount of joy and love.

Nor do thou seek to vainly delve
    Where death's pale angels tread,
To hear the murmur of its flow
    Around the silent dead.

Within, in thee is the living fount,
    Fed from the springs above;
There quench thy thirst till thou shalt bathe
    In God's own sea of love.     (*Day* 208–9)

Not quite giving up notions of a God who reaches down to earth, Harper nevertheless expounds on limitations of a belief that the deity dwells only in heaven. The first voice of "I Thirst" says heaven and God are too far away. During the Civil War, a black poet might well feel that distance when economic and racial inequities continue to fall on "worn and weary hearts" even after Lincoln's 1863 Emancipation Proclamation. Such a view implies "the healing stream" is distant; it does not flow in the material world where one stands tired and thirsty. If God is fully accessible only "[w]here death's pale angels tread," then death is welcome.

Oddly, the second voice of Harper's "I Thirst" begins with an epigraph from the Bible that might reinforce an orthodox view but might also undercut it: "The Word is nigh thee, even in thy heart." The New Testament book of Romans adds "of God" after "Word." The verse usually tells readers: don't look to yourself, to heaven, or to the dead for how to live. Orthodoxy claims "the righteousness that comes from faith" arrives only through Jesus, who died for humanity and rose again by God's power (*King James Bible,* Rom. 10.5–9). Look then for strength to Jesus, the Son of God—made mystically equivalent to "the Word," according to familiar doctrines based on other verses (John 1.1, 14). For many, the presence of Jesus as the Word eventually comes to mean that lines of the Bible will divinely come to mind in times of stress.

Without erasing the traditional view, Unitarians layer "the Word" with a pragmatic interpretation of immanence, divine presence here and now.

Unitarianism asserts the divine resides on earth, not just in heaven.[5] Jesus soon became for nineteenth-century Unitarians, not the savior from sin, but a model to which all humans could aspire. Taken to its logical extreme, Unitarian doctrine places divinity inside each person. This second half of the poem might then announce spiritual potential is immanent, not distant. In the dynamic of Harper's sentimental pathos, say the word and it can happen.

This expansive spirit will transform Unitarians' understanding of God and humanity, salvation and holy living. Theodore Parker, the daring radical, begins to talk about God's embrace of male and female genders; Howe delightedly reports that from the pulpit, Parker refers to God as "Father and Mother of us all" (*Reminiscences* 167). Salvation for Unitarians comes to center on a process of "self-forming" born of "self-searching" (Robinson, 16). Orthodox injunctions based on the Bible's call to "work out your own salvation with fear and trembling" (*King James Bible*, Philippians 2:12) will preach sinners need a conversion, which mortals can only timidly articulate, since we can never completely know the God we seek to please. For Unitarians, salvation as "self-culture" gains momentum.[6] Faith in individuals along with deliberate self-cultivation to draw out their potential fit neatly into Harper's schema of sentimental pathos, which values education for the sake of social change.

Illustrating Unitarianism's impact on "salvation" as an educational process, David Robinson refers to Emerson's typically provocative statement "God is the substratum of all souls" (19). In this generative soil, Harper cultivates downtrodden hearers' own "power to create" the world and themselves, in Jenny's words to Aunt Jane. If a root of divinity lies within, Harper reasons, what can prevent any of us from "mak[ing] the highest ideal, the most truly real of our lives" (*Day* 225)? Harper assures readers there is no limit to the spiritual immanence and earthly possibility planted squarely in the final stanza by the second—Unitarian—voice.

The poem's final stanza embraces views that reinterpret all previous orthodox references in the poem. To do this, Harper uses multivalent terms. The mystery and wonder to which all cultures look for the "living fount" might be a distant God watching over our world. It might also be a single deity given various names by different cultures. But it might indeed be, according to Harper, that immanent human power and capacity to create, the same power Jenny discovers when she publishes a poem and that Sojourner Truth draws on to "read" nations and men.

Harper encourages student-readers: If you drink from the spirit within, drawing divinity from a pool that is substratum of all souls, then you surely will "quench thy thirst." By this means, she promises, "[T]hou shalt bathe /

In God's own sea of love." In the orthodox framework, these lines assert that in life, one draws on insight given only by God, and after death, one draws directly from God's presence in heaven. Harper as Unitarian allows for this but simultaneously argues that to the degree one cultivates inner spirit, one's inner self expands and gains power. At some point, the mortal self and the divine are identical, "coeval" to use a term from Thoreau's *Walden*. If your spirit thirsts, Harper tells readers, do not look up and out—look within. That is where spiritual power abides. Each person can develop the capacity to critique and change her world.

What will happen if a slave market gets transformed into a classroom? Harper imagines four outcomes in the martial poem "Words for the Hour." Like others published in her 1871 collection titled simply *Poems*, it is "obviously written during the Civil War," says Frances Smith Foster (*Day* 185). Here are stanzas one, five, seven, eight, and ten:

> Men of the North! it is no time
>    To quit the battle-field;
> When danger fronts your rear and van
>    It is no time to yield.
> . . . . . . . . . . . . . . . . . . . . . . .
> The foe ye foiled upon the field
>    Has only changed his base;
> New dangers crowd around you
>    And stare you in the face.
> . . . . . . . . . . . . . . . . . . . . . . .
> 'Tis yours to banish from the land
>    Oppression's iron rule;
> And o'er the ruin'd auction block
>    Erect the common school.
>
> To wipe from labor's branded brow
>    The curse that shamed the land;
> And teach the Freedman how to wield
>    The ballot in his hand.
> . . . . . . . . . . . . . . . . . . . . . . .
> True to your trust, oh, never yield
>    One citadel of right!
> With Truth and Justice clasping hands
>    Ye yet shall win the fight!           (*Day* 185–86)

What "danger fronts" the United States despite the Union's imminent victory? The country might lose the virtue it fought for. To her readers, Harper declares that victors of Civil War battles have no trivial responsibility. The slave market at stake in this war is not to be turned into any old "common school," says the poet, using "common" to make a pun on language of democratic school reform crafted by her contemporary Horace Mann. Harper's slave market classroom makes four uncommon demands. Each one exchanges creativity and choice for denial of black humanity in the slave auction. First, the North must "banish . . . [o]ppression's iron rule." Accomplishing this will take longer than for Lincoln to sign the Emancipation Proclamation. Freedom for African Americans means laws, behaviors, and attitudes must change. Second, if the Union "erect[s] the common school" where the "auction block" now stands, it fulfills America's promise to all, including black people: to overturn the "peculiar institution" at the very site where human beings were treated as chattel. I take this to be Harper's call for universal public education. New schools must educe, draw forth human potential, renewing hearts "ruin'd" by slavery. Along with freedom of the body, black people require freedom of the spirit. Third, former slaves must receive respect as they labor beside white people. Workers paid nothing must receive just pay for fair labor. Fourth, black people must be accorded full citizenship, to be supported in those schools, including the right to "wield [t]he ballot."

Carla Peterson sums up the transformative goals of Harper's critical pedagogy, noting she used verse to "create character in the reader." White readers were not only to end slavery but also to commit to programs of social support for freed slaves. Black people were not only to take heart and demand their rights but also to imagine the future and vote. For Harper, explains Peterson,

> sentimentality became a mode whose purpose was not to unleash an excess of emotion in the reader but rather to channel feelings toward benevolent and moral ends, develop Christian character, and forge social bonds that would commit the reader to work to better society. (125)

Lessons taught by poetry have the power to rearrange how people think, Harper knew. With rhetorical strategies of pathos, her classroom would shake up readers and teach them to act justly.

### Outward and Inward Learning Outcomes

Transforming slave auctions into schools will be both exterior and interior in Harper's vision, manifested outwardly at Jefferson Davis' plantation. After

the war, the poet travels in the South, speaking for education of freed slaves, and she finds a school for black people on the grounds of the Confederate president's plantation. Arguably the most important slave pen of the South has become a school. Seeing her vision fulfilled must have been immensely satisfying: "A school will spring up there like a well in the desert dust" (*Day* 132). Harper writes about other people rising from scattered ashes, human exemplars nurturing black readers' hopes. Among them, a freed woman whose "hunger and cruelty and prostitution" might have "left her a wreck for life," except that "freedom came" and with it "opportunity for work and wages. . . . She went to work, and got ten dollars a month. She has contrived to get some education, and has since been teaching school." Piecing together her shattered self, this woman passed on what she knew. Even the woman's former mistress had "been to her for help," Harper writes (*Day* 131). A woman utterly degraded rises to teach others, the poet demonstrates. Surely her audience can do the same.

What happens inside the poet's readers is as revolutionary as what happens outwardly, and inward transformation is the harder part. Long before Freud, African Americans come together in black churches to encourage restoration of what Hortense Spillers has described as "interiority" or "ethical self-knowing" (Haslett).[7] Spillers explains that her psychoanalytic research responds to an ongoing challenge for black people. Echoing Harper's question near the end of the Civil War, Spillers asks, "How do you increase human agency under conditions that are not ideal, even though they are a lot better than they were?"

In the same way Harper invokes pathos, so Spillers maintains transformations are possible if black people can come to see the "psychoanalytic as a political category." The AME Church is born in resistance to a white hierarchy barring black people from the pulpit. Spillers notes church always has provided a "dimension of the spiritual . . . which made [black people] critical of themselves and others." She urges a return to more overtly political talk. She would have churches "place more emphasis" on tackling the "political problem[s]" black congregations face, problems among black people and with white culture. For Spillers as for Harper, grappling with repercussions of slavery is central. The church provides an ideal site for talking over such topics: "People speaking in small groups . . . that's where agency starts," Spillers explains. "Freedom to achieve mobility" should lead to "verbal agility," she asserts, "and that is intellectual agency." African Americans with circulating texts and talk, Spillers envisions, could virtually "swim in language" (Haslett).[8] Not incidentally, a leader of the Black Lives

Matter movement in Washington, D.C., advocates "emotional emancipation circles" strikingly similar to Spillers' small groups: "All churches should have an antiracism . . . and white dominant culture training," declares Erika Totten. "They need to have these hard conversations. And not be defensive. Just listen and stand up" (Barnett 47). In short, swim in a sea of your own and others' words, and you'll gain a sense of power and vision.

Note how Spillers' recommendation follows Harper's multivalent challenge in the peroration of her Unitarian poem "I Thirst." A swim in the language of a black church family that nurtures the spirit is one place to fulfill Harper's poetic injunction to "bathe [i]n God's own sea of love." If this ocean is within each person, as Harper believes, then a voluble, noisy gathering is a sea swell drawn by the tide. Nineteenth-century African Americans should gather, Harper argues, in discussion groups where they come to grips with community and cultural issues such as how to think about ongoing effects of slavery. As Spillers would nurture and educate psychic potential in the black church community, so Harper would band readers together to draw out that resource until it wells up on its own.

Toni Morrison portrays a similar creative "matrix" in ritual "clearings" of her novel *Beloved*. Linda Krumholz has claimed of these gatherings—as the poet Harper does for slave pens become schools—that the impact of such clearings on the imagination has "potential to construct and transform individual consciousness as well as social relations" (396). "Gathering" or "meeting-place" appears to be Harper's word for such crucial sites. Even without a building, the poet writes to friends from her travels at the end of the Civil War, freed slaves have gathered in a hopeful place:

> Do you know what the gathering means? It is a school, and the teacher, I believe, is paid from the schoolfund. . . . They have a church; but somehow they have burnt a hole, I understand, in the top, and so . . . they gathered around the fire outside. Here is another—what shall I call it?—meeting-place. It is a brush arbor. And what pray is that? Shall I call it an edifice or an improvised meeting-house? . . . It is a kind of brush house with seats, and a kind of covering made partly . . . of branches of trees, and an humble place for a pulpit. I lectured in a place where they seem to have no other church. . . . But amid all this roughing it in the bush, I find a field of work where kindness and hospitality have thrown their sunshine around my way. And Oh what a field of work is here! (*Day* 134)

School, church, and "gatherings" blend together in this letter. Harper must have known that one meaning of the New Testament's Greek word for church, *ecclesia*, is "gathering." For southern black people, Harper's northern readers, and Morrison's readers today, great power resides in such company. "Clearings" mark sites and events where, with support, slaves and freed black people's "rememory" of past horrors can foster "cleansing and rebirth" (Krumholz 398). Harper's "gatherings," like Morrison's "clearings," make a space for black people haunted by slavery and allow nineteenth- and twenty-first-century black readers "to relive it with a difference" (Krumholz 403). What happens here, Harper promises, can "make one's life a living . . . force to help men to higher planes of thought and action" (*Day* 134). In a curriculum played out in transformed classrooms, Harper offers a chance for redemption. Readers and students can make slave markets a birthplace of free hearts and minds.

In sum, the five tenets of Delpit's race-based critical pedagogy are enacted in what Gruenewald might call the critical space of Harper's slave auction schools. African Americans identify and enact issues of power at the site, literally and psychically, where slaves were denied all capacity for thought. This nineteenth-century black woman's lessons in sentimental poetry establish the critical dynamic at work in curricula of courageous black women who in the 1960s taught at segregated Booker T. Washington School. It was not as open and free as Harper envisioned. Yet one of their students, Gloria Watkins, would become bell hooks, and she reflects on the same critical question: What would happen here? Lessons that black women teachers insisted on, bell hooks reports, fit Harper's goal to rise beyond what you are, to transcend the school's boundaries:

> They were committed to nurturing intellect so that we could become scholars, thinkers, and cultural workers—black folks who used our "minds." We learned early that our devotion to learning, to a life of the mind, was . . . a fundamental way to resist every strategy of white racist colonization. (*Teaching to Transgress* 2)

"Common schools" at the site of segregation and slave auctions are Frances Harper's "counter-hegemonic act," a reversal at the site of oppression, designed to work healing at the site of the wound. In such environments, black people reclaim their potential and worth and a sense of agency. Students learn to decode the culture of power, including rhetorical moves necessary to debunk hierarchy. Harper's black reader-students are equipped to walk their own, more ethical path to power, redrawing the terrain.[9]

Seeds planted in Harper's poems take root and blossom in a scene published in *Iola Leroy* after the war. Harper's insight into ongoing ignorance of former oppressors presages Delpit's final principle of classroom power: "Those with power are frequently least aware of . . . its existence" (282). The poet's fictional classroom shows retrenched postwar racism among white people. The scene also shows her frank upstart students have learned their lessons. A well-educated, mixed-blood former slave, Iola Leroy has opened a school for students in the basement of a black church.

> One day a gentleman came to the school and wished to address the children. Iola suspended the regular order of the school, and the gentleman essayed to talk to them on the achievements of the white race, such as building steamboats and carrying on business. Finally, he asked how they did it?
>
> "They've got money," chorused the children.
>
> "But how did they get it?"
>
> "They took it from us," chimed the youngsters. Iola smiled, and the gentleman was nonplussed; but he could not deny that one of the powers of knowledge is the power of the strong to oppress the weak. (*Day* 304)

Soon after, the school becomes "a smouldering ruin," touched off by resentful white people. But students have "too much elasticity in their spirits . . . to be crushed out by unreasoning malice" (*Day* 304). Iola's students express a truth that the southern "gentleman" has yet to imagine: his part in economic inequity. This teacher engenders power of knowledge beyond oppression, born of her critical pedagogy. This power, Harper claims in prose and poetry, can be a "great mental lever . . . in the scale of social and racial life" (*Day* 275). The poet writes that "where they had trodden with fear and misgiving, freedmen walked with light and bounding hearts. The school-house had taken the place of the slave-pen and auction block" (*Day* 307). No fire consumes lessons learned in the sentimental pathos of Harper's slave pen become a school.

Those who burn down Iola's school are still imprisoned by the slave system. They take for granted discourse that appropriates power and keeps black people from economic and educational advantages. Iola's school works to different ends. Her classroom exercises growth of mind and spirit for all classes and races open to learn. In *Teaching to Transgress*, bell hooks instructs:

> We have the opportunity to labor for freedom, to demand . . . openness of mind and heart that allows us to face reality even as we . . . imagine ways . . . to transgress. This is education as the practice of freedom. (207)

No boundary is beyond challenge, Frances Harper's slave pen school demonstrates. Reader-students are expected to do their homework, show up, participate in discussion, and apply the lessons.

# 6. Problems for Sigourney's Readers of Sentimental Rhetoric and Class

> The life that had already opened itself in a whole volume of obituaries might properly show at its close, that it was itself one obituary volume.
> —Timothy Dwight, review of Sigourney's memoir, *Letters of Life*

> We may sometimes forget that the distinctions in society are no certain test of intrinsick merit, and that we "all have one Master. . . ." Yet admitting that the ranks and stations are not very clearly defined, and that the lower classes sometimes press upon the higher, this is in accordance with the spirit of a republick, and all should be willing to pay some tax for the privileges of a government, which admits such a high degree, and wide expansion of happiness . . . to moderate our wants.
> —Lydia Huntley Sigourney, *Letters to Young Ladies*

In an 1865 retrospective, Catherine Beecher insists that readers dismissing Lydia Huntley Sigourney underscore issues of class. Beecher as critic and educator puts her finger squarely on aesthetic aversion to the poet—and laughs. "It has been so often claimed that Mrs. Sigourney was not a poet of a high *class*, that as a matter of justice," Beecher decides to level the scales. She claims the "vivid painting, vigorous style, and poetic sentiment [are] surpassed but by very few of our highest *classics*" (561; italics added). Beecher then inserts the full text of Sigourney's long poem "Return of Napoleon from St. Helena." To Beecher, this poem's sentimental moves are positive.

It is an elegy for the reburial of Napoleon in Paris in 1840 upon his body's return from exile. Sigourney's poem also constitutes a memorial for all who died at his command:

> A requiem for the chief,
>    Whose fiat millions slew,—
> The soaring eagle of the Alps,
>    The crushed at Waterloo:—
> The banished who returned,
>    The dead who rose again,
> And rose in his shroud the billows proud
>    To the sunny banks of Seine. (561)

Napoleon was a symbol of resilient ambition and success and the object of criticism. Yet after his death, the French king and vast crowds would welcome Napoleon home. Sigourney shares Napoleon's resilience and a degree of the same conflicted public reaction. If Beecher's pun on economic "class" and "classics" brings Sigourney fans together, the reviewer's laughter also splits the topic of discussion. Quality is beside the point, the joke suggests, in critics' dismissal of Lydia Huntley Sigourney. Beecher maintains that at issue for this poet's readers are conventions of the rhetoric of sentiment—and class.

Sigourney's strategic use of sentimental conventions such as agitated typography and especially apostrophe should not tag her as vulgar; they make a way for her to speak in privileged masculine sentimental discourse. Yet the woman poet and gardener's daughter received a cool welcome among critics. For while it gets her into the conversation, the apostrophe does mark her entry as popular, disruptive, and feminine. Using heuristic frameworks of sentimental rhetoric and class, my aim in this chapter is to recover her work with a sense of the class-conscious, often misogynist public Sigourney spoke to. Turning barriers into interpretive frames can help retrace dimensions of Sigourney's poetry, lost outlines of her audience, and readers of other sentimental poetry. Recent scholars who do not dismiss Sigourney rarely consider rhetorical and formal matters designed to appeal to readers. Jane Donawerth, a notable exception, includes Sigourney with influential women theorists of rhetoric before 1900 (*Theory*). Few consider discourses of the body or postmodern semiotics to support Sigourney's recovery.[1] Before considering the audience of Sigourney's day, I want to shed light on omissions by more recent critics. Their issues, as Beecher prophesies, often turn out to be matters of class.

## Class Criticism and Apostrophe

Gordon Haight, author of a critical biography (1930), focused on mistakes in Sigourney's Latin. Haight made much of one "classical, scholarly" detractor who, finding a mistake in her suffixes, professed, "A lady was not expected to be acquainted with Latin." The scholar scolded, "If . . . she choose to introduce words of a language she does not understand, she is not entirely free from blame, if she neglect to procure . . . advice of persons better qualified." Haight adds, "Why had she not procured the advice of Mr. Sigourney, whose rare classical attainments were so well known?" (105–6). Sigourney's husband attempted to prevent her from writing at all; she is unlikely to check her Latin with him.

Yet Haight had to acknowledge the poet's popular appeal. He was probably correct that "her readers, neither scholarly nor critical, were more concerned with sentiment than with Latin" (106). Much poetry by men in Sigourney's day failed to attract a public precisely because of those "Latin quantities," Catherine Beecher explains. "Some of our modern poets will fail of . . . popularity, because their involved sentences . . . demand a previous exercise in parsing, or the dictionary, to be understood" (560). By 1865, Sigourney's "popularity" includes millions of women. Haight identified Sigourney's appeal to sentiment almost exclusively with what he called her attempt to comfort bereaved women settlers of the frontier, those "mute millions . . . too busy with their household tasks to have much time for thought" (107). Haight could imagine only thoughtless, unschooled working women as Sigourney's readers, reason enough for him to dismiss her work. Following Haight's lead, Ann Douglas in 1972 characterizes Sigourney as a "determined intruder" in the Norwich, Connecticut, society where the poet grows up ("Sensibility" 165). Douglas indicted the poet's publishing career as the "seamy underside of Mrs. Sigourney's life," accusing her of "vicarious public prostitution" because she ignores her husband's appeals to give up writing ("Sensibility" 166). Such animus seems apart from any assessment of Sigourney's sentimental poetic form.

When literary critics consider Sigourney's works for form, even such thoughtful scholars as Elizabeth Petrino and Barton Levi St. Armand focus on what they call Sigourney's profligate appeals to pathos, in negative contrast to Emily Dickinson's works of canonical density. Mary Loeffelholz in 2004 resists narrow takes on Sigourney's poems as "partial and reductive creation[s]" (*Salon* 34), but in 2008 she reiterates without comment Sandra Gilbert and Susan Gubar's 1979 dismissal of Sigourney's "lucrative genteel

verse," implicitly accepting modernist preferences for a very few nineteenth-century poets ("Mapping" 139). When charges against Sigourney may not be linked to class, at issue seem to be shifts in critical taste.

An exception to the negative response was Nina Baym's 1993 "Reinventing Lydia Sigourney." However, Baym emphasizes thematic concerns of elegy and the nation over sentimental form. Baym may have been unfamiliar with specific rhetorical dimensions of the discourse, for she concludes Sigourney's poetry is aesthetically "weak, sentimental" (68). More recently, Paula Bennett defends Sigourney as poet and not Poetess, the "empty figure" criticism makes her, yet Bennett repeats Mark Twain's snarky joke, labeling Sigourney "foremother of an entire century of Emmeline Grangerfords" (*Public Sphere* 283). Recovery of nineteenth-century women's texts owes much to Baym and Bennett, so their mistaken identity of terms is not a lapse in judgment, but a sign of persistent gaps in the field. The problem no longer is recovery of texts, nor a lack of biographical information, but what we do with texts and cultural contexts once we have them. I take seriously Cheryl Walker's assertion that Sigourney is "one of many women poets we now know something about. The problem is we don't know how to read their poems" (*Burden* 1).

This study responds to calls for a heuristic allowing us to read Sigourney and other sentimentalists well into the twenty-first century. I join other workers in the nineteenth-century vineyard "in the interests of expanding the critical vocabulary and refining the critical methodologies," as Joanne Dobson puts it in "Reclaiming Sentimental Literature" (263). I do not add modernist criteria by which to evaluate sentimental poetry as "products of individual imagination, talent, and agency" (Dobson, "Reclaiming" 268)—in other words, only as precursor to the later lyric form (Jackson 68). Nor do I add historical information constructing only "a pathos occasioned by helplessness and weakness rather than by heroic strength" (Mikhail Bakhtin qtd. in Dobson, "Reclaiming" 272). Either claim could reassert heroic or victim status for particular sentimentalists and reinstate the familiar but narrow role of evaluator either for today's readers generally or for critical researchers.

### *Process and Rhetorical Context in Sigourney's Pathos*

This chapter attempts a "process analysis" of Sigourney's appeals to pathos, an approach considering textual "structure and language" for its historical context. We can reimagine this context only by attending to rhetorical issues of pathos in a text's "narrator/narratee contracts." These "contracts" are rhetorical exchanges viewed through the researcher's "retrospective"

position, which seeks "traces of changing consciousness." I here add to what Susan Harris recognizes as "building blocks for an ideologically self-conscious literary history" and also rhetorical history ("'Any Good?'" 275). Self-consciously rhetorical frameworks can support textual recovery in the field of English studies, texts recognizable as both literary and rhetorical.

Annie Finch is one of few critics to take Sigourney seriously enough as a poet to trace romantic and sentimental traditions in her lines, unfolding multiple reader identifications in Sigourney's "sentimental attitude." This attitude for both poet and reader "bind her to her society in a nonindividuated, nonegotistical way like the emotions of Christian faith and parental or filial love" ("World" 12). Finch finds the apostrophe one of Sigourney's most effective appeals to pathos, attracting and holding an audience. Paula Bennett likewise enjoins us to find Sigourney's "subtextual narrative of a woman's (sexual) unfolding" in flower imagery ("Critical" 244). Such erotic traces could draw an audience not generally recognizable in today's notions of nineteenth-century "true womanhood." More recently, Mary Louise Kete compares Sigourney's verse to Longfellow's in service of national unity, concluding that because her format invites both praise and critique, "in Sigourney's hands, sentimentality is a subtle and powerful tool" that "foster[s] an emotional connection to the material" (*Collaborations* 122; "Reception" 24). My study extends insights by Harris, Finch, Bennett, and Kete to consider not only Sigourney's "sentimental attitude," nationalism, and imagery but also specific rhetorical strategies of agitated typography and her remarkable apostrophes that forge sentimental links to dimensions of pathos. A rhetorical approach foregrounds such means employed by the poet to reach her audience.

Admitting there is a code in play to reach audiences begins the work of disentangling women writers from some "natural" association with so-called vulgar readers or the feminine from sentimental convention. As I have argued, a code of sensationalist rhetoric did not anticipate working-class or women interlocutors. It was constituted by male professors to reach "Hearers as Men in general," implying identification between a (male) college-educated rhetor and his (male) college-educated audience. Paradoxically, rhetorical constructions of universal, anonymous sympathy between rhetor and audience allowed antebellum women—with other nontraditional hearers and speakers—not only to eavesdrop but also to break into men's conversations.[2] Still, we find that agitated typography—and those many apostrophes! Blair ranked high these dramatic sentimental conventions typical of sentimental poetry, placing them barely "a degree lower than personification"

to engage hearers (1:338, lecture 16). Yet Sigourney's extravagant apostrophe and exuberant typography make it obvious this woman poet is an interloper in an elite, masculine literary discourse.

Sigourney's commemoration of Lady Jane Grey offers an example of both conventions in play. Notice strategic use of typography in these lines:

> LADY JANE GREY
>
> On seeing a picture representing her engaged in the study of Plato.
> *So early wise!* Beauty hath been to thee
>    No traitor-friend, to steal the key
>      Of knowledge from thy mind;
>   Making thee gorgeous to the eye,
>   Flaunting and flushed with vanity,
>      Yet inly blind.
>
>   Hark! the hunting-bugle sounds,
>     Thy father's park is gay,
>   Stately nobles cheer the hounds,
>     Soft hands the coursers sway,
>   Haste to the sport, away! away!
>   Youth, and mirth, and love are there,
>   Lingerest thou, fairest of the fair,
>   In thy lone chamber to explore
>     Ancient Plato's classic lore?
> . . . . . . . . . . . . . . . . . . . . . . . . . . .
>   Doubtless the sage doth marvel deep,
>     That for philosophy divine
>      A *lady* could decline
> The pleasure 'mid yon pageant-train to sweep,
> The glory o'er some five-barr'd gate to leap,
>   And in the toil of reading Greek
>     Which many a student flies,
>   Find more entrancing rhetoric
>     Than Fashion's page supplies.    (*Zinzendorff* 63)

Sigourney emphasizes with italics her first exclamation and only one other word in this part of the five-stanza poem. From these, the poet wants readers, probably young women, to remember British history lessons on Lady Jane Grey, who was "*So early wise.*" Lady Jane was only eleven when wrangling politicians involved her in a scheme to make her queen to Henry VIII's

son Edward. When that plan failed, she returned home to continue her education. By age fifteen, Lady Jane apparently had become "gorgeous to the eye," but she concentrated on filling her head with "more entrancing rhetoric / Than Fashion." She was skilled in influencing audiences; read and wrote Greek; knew Latin, Italian, French; and was studying Hebrew. Then a second plot emerged that did marry her to Edward, ensuring strategic succession. After Edward's death, she held the throne for nine days before surrendering the crown to Mary, Edward's sister (Morrill). This serious girl had been Britain's first female monarch. She pioneered the literate status nineteenth-century girls of the new republic could admire, if not aspire to.

The *lady* did not respond to shouts of the hunt marked by three exclamation points; she did not go after elusive foxes, men, or honors. When Jane concentrated on improving herself, these things came to her as Sigourney implies they will to readers. From this look at Sigourney's typography, I am impressed with its judicious placement, not its profligacy. Poets use typography in different ways today, but this poet has not shouted at us. She leans in to emphasize her point: young women can and have learned to read and write well. Her apostrophes supplement typography to underscore Sigourney's theme: if Lady Jane learned rhetoric, you can, too.

Context for such typography—italics and exclamations, with accompanying ellipses and dashes—and for poetic apostrophe, provides a way to read them. Remarks from Janet Todd on conventions of eighteenth-century sentimentalism recapture the significance of agitated typography for its readers: "The poet's feeling becomes all important" as a model of audience response, since sentimental rhetoric assumed "the most potent force for community . . . [was] emotional ritual or the display of sensibility" (53, 83). A display of sensibility in the text should heat up readers' emotional temperature to match the poet's concern.

Elegies for Napoleon and Lady Jane Grey show how sentimentalism in Sigourney's hands is Kete's "subtle and powerful tool." One hundred eighty-six lines of heroic couplets in "Imitation of Parts of the Prophet Amos" suggests why some have called Sigourney's approach overwrought.

The piece begins by recounting the poet's call from God to a ministry of verse prophesy. Forty-six dashes are scattered throughout the piece—several within the pentameter line. These with sixteen rhetorical questions in the poem's last twenty lines suggest Sigourney's confidence in her vocation, like that of Amos, to challenge a "rebel race" of thoughtless wealthy people, "sons of pride" who have oppressed the poor and helpless. Here are the poem's last eight lines:

> Who raised yon mountains to their lofty height?
> Who speeds the whirlwind in its trackless flight?
> Who darts thro' deep disguise, his piercing ken
> To read the secret thoughts and ways of men?
> Who gave the morning and the midnight birth?
> Whose muffled step affrights the quaking earth?
> Who curb'd the sea? and touch'd the rocks with flame?
> Jehovah, God of Hosts, is his tremendous name.     (179–86)

The poet's charge or vocation is not at issue. At stake are grounds of any who challenge the prophet through whom God demands repentance and reform. God and poet-prophet are angry, these lines say both topically and typographically. Sigourney wants to ignite her readers' ire.

Elaborating on Todd's discussion of typography to read Sigourney, I underscore the sense made by typography in this poem within a code that purposely urges rhetors to show and elicit passion. Codes of rhetoric published in the 1770s and 1780s by George Campbell and Hugh Blair were devised to prepare upper-middle-class male lawyers and preachers, and according to Lynee Lewis Gaillet, also businessmen and doctors (*Scottish Rhetoric* 40). They followed the new science of John Locke's sensationalist epistemology. The best way to move the heart of a reader or audience, Blair claimed, is to "set before me the distress suffered by the person for whom he would interest me. Then . . . , my heart begins to be touched" (2:192, lecture 32). The discourse most vividly representing a passionate speaker will be the text most likely to reproduce a similar passion in its audience.

### *A Semiotic Sentimentalism with Limits*

Postmodern theories of semiotics recover something akin to eighteenth-century connections between text and affect: disrupted textual surfaces gesture toward domains of feeling, the passions evident in typography of nineteenth-century texts. Julia Kristeva has called the intersection of print and feeling part of the dialectic of symbolic and semiotic registers in language (*Revolution* 91). While a smooth textual surface may signal rationality, it also belies pathos and connection always conveyed by discourse. Suzanne Clark argues that assertion of any such "well-known and gendered opposition of reason and emotion is misleading." For Sigourney's day, the sentimental codes articulate "how emotion falls under the domination of cultural conventions, but how reason and emotion participate in the irrational"

(Clark "Social Construction" 96). The broken surface of sentimentalism's typography exaggerates a dynamic persisting between text and feeling in language, and between intellect and emotional appeal. Clark argues the rhetoric of sentiment emphasizes these intersections.

Empiricism's rhetoric of sentiment presses the experience of writer or speaker upon readers and audience. Disrupted textual surface is sentimentalism's calculated appeal to pathos, to arouse moral feeling in its audience. Todd indicates that for sentimental discourse, agitated typography is not a sign of bad form; it is one strategy in a repertoire that highlights audience appeal, a sign system dominant for nearly two hundred years in Britain and the United States. In both sensationalist and semiotic terms, Sigourney's textual surface does not suggest some hysterical woman. It marks a prophetic sensibility in "Amos" seeking to produce morally outraged readers who will join her to challenge slaveholding and greed.

Pertinent to Sigourney's "Amos" are gendered implications of this style. Todd writes that agitated typography characterizes Lovelace, the rake in Samuel Richardson's eighteenth-century fiction. She concludes Richardson's broken textual surface could be associated with "men's power of free social expression and with ebullient sexuality." Agitated text, explains Todd, "becomes a difficult style for women" because in their texts, "the style expresses sexual horror and social impotence" (86). Letters of frightened working-class women come to mind, fleeing advances from the likes of Lovelace. Sigourney and other American sentimental women poets are not Todd's horrified, helpless women. Nevertheless, Todd observes that from early on, sentimentalism itself was not coded feminine—it was written for men. Therefore, its conventions scanned variously for gendered audiences, depending on whether writers and narrators were men or women.

There is no sexual aversion or helplessness about Sigourney's "Amos." Instead, a powerful, confident woman prophet assumes a masculine role in conventions of the discourse, typographically and thematically deploying its strategies of pathos. A cross-dressing Sigourney inhabits the "Amos" persona and calling of the Hebrew prophet, throwing her voice like a ventriloquist into his exhortations. This poet's forceful punctuation does not signify a helpless overflow of feeling. Sigourney's typography conveys a demand for immediate and radical reform.

A note of caution on sentimentalism's agitated typography: European American sentimentalism was wrong to assume every reader would respond with identical "common sense" to its cues. Eighteenth-century rhetoricians built their codes on assumptions of a universally applicable "mental

science," a map of each brain's faculty psychology. If, as they presumed, everyone did think alike, rhetors could be sure everyone would respond predictably. But these rhetoricians did not anticipate in their audiences the women and others unlike themselves, audiences who would take up the pen themselves.

In 1861, African American Harriet Jacobs writes pointedly to white women, "O reader, can you imagine? . . . No, you cannot" (261). At one time, Robyn Warhol suggested that a universal feminine sensibility might be revived by women writers' return to disruptive texts like those in antebellum sentimentalism. Based in part on this passage from Jacobs—one with broken syntax and typography first enacting the commonsense rhetorical apostrophe and then withdrawing it—Warhol has since retracted her suggestion.[3] Too often, orators bank on the electorate's desire to exhibit "common sense." Appeals for "commonsense" tax cuts, for more national defense, for particular kinds of assessment in education, or for other broad social programs often elide gaps between writers' and readers' cultures and backgrounds: Who would not want common sense? Who would not vote for my agenda? While sentimentalism as an inclusive project brought both change and diversity to dominant nineteenth-century discourse, its strategies also did, and still do at times, violently elide differences among people and groups.

Apostrophe is recognizable today as sentimental convention, second in familiarity to agitated typography. In *A Handlist of Rhetorical Terms*, Richard Lanham traces this disruptive figure to its Greek roots, translating it as "turning away." This strategy, he says, marks a "breaking off [of] discourse to address some person or personified thing" (20). Today's readers of Sigourney's verse might be tempted to turn away from her apostrophes.

## *Apostrophe's Convocation in "The Lost Sister"*

The work of apostrophe in Sigourney's poem "The Lost Sister" typifies both intrusions and inclusions of pathos enacted by a nineteenth-century woman poet to turn toward her contemporary audience. The poem intrudes on orthodox Christianity by placing a woman at the center of a worshipful domestic circle. Using an extended apostrophe in a final passage, "The Lost Sister" imposes a women's network onto the formerly masculine discourse of sentiment. Both interruptions trace murmurs of a feminine conversation between a nineteenth-century mother, child, woman writer, and her audience.

## THE LOST SISTER

They wak'd me from my sleep, I knew not why,
And bade me hasten where a midnight lamp
Gleam'd from an inner chamber, There she lay,
With brow so pale,—who yester-morn breath'd forth
Through joyous smiles her superflux of bliss
Into the hearts of others. By her side
Her hoary sire, with speechless sorrow, gazed
Upon the stricken idol,—all dismay'd
Beneath his God's rebuke. And she who nurs'd
That fair young creature at her gentle breast,
And oft those sunny locks had deck'd with buds
Of rose and jasmine, shuddering wip'd the dews
Which death distils.
                    The sufferer just had given
Her long farewell, and for the last, last time
Touch'd with cold lips his cheek who led so late
Her footsteps to the altar, and receiv'd
In the deep transport of an ardent heart
Her vow of love. And she had striven to press
That golden circlet with her bloodless hand
Back on his finger which he kneeling gave
At the bright, bridal morn. So, there she lay
In calm endurance, like the smitten lamb
Wounded in flowery pastures, from whose breast
The dreaded bitterness of death had pass'd.
—But a faint wail disturb'd the silent scene,
And, in its nurse's arms a new-born babe
Was borne in utter helplessness along,
Before that dying eye.
                      Its gather'd film
Kindled one moment with a sudden glow
Of tearless agony,—and fearful pangs,
Rocking the rigid features, told how strong
A mother's love doth root itself. One cry
Of bitter anguish, blent with fervent prayer,
Went up to Heaven,—and, as in a dream
I seem'd to move. The certainty of loss
Fell not at once on me. Then I wept

> As weep the sisterless.—For thou wert fled,
> My only, my belov'd, my sainted one,—
> Twin of my spirit! and my number'd days
> Must wear the sable of that midnight hour
> Which rent thee from me.  (*Poems* 58–59)

Sigourney's first-person narrator records the nineteenth-century ritual of dying, administered by a feminine group who upstage the old husband's role in a death watch. The narrator is first "wak'd" from her sleep, probably by other women, to attend a young mother after childbirth (lines 1–3). The poet observes the woman's own mother, now sponging death "dews" from her daughter's "brow" (lines 9–13). Next, the fading young mother attempts "to press" a wedding ring back onto the finger of her aged husband (lines 19–21). Then a nursemaid carries in "the new-born babe" whose "faint wail" rallies the young mother a last time (lines 26–27).[4] This rite would be familiar to women readers caring for ailing family members at home.

Sigourney's readers will notice the poem displaces Jesus with the dying woman, for the poet portrays the woman, not Christ, as the "stricken idol" who "lay . . . like the smitten lamb / Wounded in flowery pastures" (lines 23–24). The woman as the "lamb" lying "wounded" at the center of a tableau resonates with Christ, the Lamb of God, who (Christian orthodoxy says) was stricken for humanity's sin. She is not stricken for her or others' sin, however, unless "God's rebuke" upon the husband hints her sin is having displaced God as object of worship. With a double shift away from Christ—first to the metaphor "lamb," and then to the woman—Sigourney might hint at a parallel between her readers' attachment to poetry and to the maternal body, a rivalry between loving poetry and mothers also competing for a believer's love of God. Kristeva touches on this rivalry in her double-voiced "Stabat Mater," where she connects a "love of God" and "artistic, literary, or painterly accomplishment" to a person's "freedom with respect to the maternal territory" (162–63). The more an artist identifies with the mother, the more abandon that artist may express in her craft. "Freedom" may also be associated with a lack of conflict between these loyalties. Relax, Kristeva implies, in poetry you can have the best of all worlds: stay close to the mother even when she is gone, and though you risk losing the deity, you keep a kind of spirituality.

Perhaps these rivalries constitute a danger in poetry the old mother-in-law snipes about in Fanny Fern's 1855 novel *Ruth Hall*. Snooping in Ruth's backyard, she sniffs, "What have we here? a book . . . Poetry, I declare? the

most frivolous of all reading; all pencil marked;—and there's something in Ruth's own hand-writing—*that's* poetry, too: worse and worse" (32; italics in the original). For all nineteenth-century women, sentimental poetry threatened conventional loyalties of life, religion, and home.[5] This mother's death marks a traumatic separation from her conventional place, yet her sweet, calm passing—like Christ's passion—gathers the devout to recall the lost One.[6] Sigourney's Christ-like dying woman invokes a Christian community, redefined with a woman at the center.[7]

## *Critical Asides on Women's Apostrophe*

I want to expand on implications of apostrophe for women writers before further consideration of Sigourney's deathbed convocation. In an essay detailing gender distinctions linked in history to apostrophe, Barbara Johnson names this figure as one of "a great many poetic effects [which] may be colored according to *expectations* articulated through the gender of the poetic speaker" (198; italics in the original).[8] For women, Johnson asserts, the hue of apostrophe continues to be disruptive and passionate.

Rhetorical tradition adds background to Johnson's discussion, showing how apostrophe and personification in a double strand weave a backdrop for sentimental poetry of the past two centuries. Eighteenth-century rhetorician Hugh Blair said of personification that "all poetry . . . abounds in this figure" (1:324, lecture 16). And of its twin figure, apostrophe, Blair said that because it is "prompted by passion," like personification, apostrophe is to be expected in poetry, especially when it addresses the dead (1:338, lecture 16). Personification and apostrophe "are indeed the life and soul" of poetry, Blair asserted, for the work of poetry in the eighteenth-century sentimental tradition was to make inanimate objects move the passions and haunt the conscience. The rhetorician of *belles lettres* practically defined poetry by this twin gesture, a formal sign of the poet's imaginative capacity, claiming, "in the descriptions of a poet, who has a lively fancy, everything is animated" (1:324, lecture 16). According to accepted codes, personification and apostrophe are required marks of poetic sensibility.

In this vein, Sigourney, from early on, announces her qualifications to audition on the stage of professional antebellum verse. In the *Zinzendorff* collection (1836), her apostrophes animate a host of inert objects, such as a lady's gold chain, which Sigourney calls "thou graceful toy" (214). The evening star is hailed as "Pure Planet!" (196). Most apostrophes appear deliberate, strategic, like those of the Napoleon poem. Some do exhibit

exuberance expected of sentimental apostrophe; "Parting Hymn of Missionaries to Burmah" begins fourteen of its thirty-two lines with insistent apostrophes calling out good-bye to such worthies as "Native land! . . . Home! . . . Haunts! . . . Church! . . . Mother! . . . Father! . . . Friends!" (239–40). Creation is alive to Sigourney. By apostrophe she rouses readers to experience the vibrant world with her.

While apostrophe is to be indispensable for poets of Sigourney's day, belletristic codes also link apostrophe to intense feeling, women's feeling in particular. Blair's *Lectures* endorsed links among feeling and apostrophe and women. He offered Eve's farewell to Paradise in Milton's epic *Paradise Lost* as a model of personification and apostrophe. "This," Blair generalized, "is the real language of nature and of female passion" (1:333, lecture 16). With Blair's sanction, sentimentalists can properly use apostrophe to announce themselves as poets, to signify the natural world, and to mark the presence of a passionate woman.

Blair endorsed one other use of apostrophe for writers of elegies like "The Lost Sister." He observed, "To address the corpse of a deceased friend is natural" (1:334, lecture 16). Aristotle, too, supported heightened language in elegies; his example personified the Greek nation mourning at a hero's grave: "It is fitting that Greece should cut off her hair beside the tomb of those who fell at Salamis" (3.10.1411a.32–34). Historians of rhetoric recognize the effect of New York mayor Rudy Giuliani's apostrophe in December 2001 on the public viewing platform at the World Trade Center ruins: "We will always remember what you did here—you our heroes—to save America. God Bless You, Rudy Giuliani, 12-29-01" (Hajela). Coming from a leader in a difficult time, Giuliani's apostrophe was never questioned. The last five anniversaries of an AIDS victim's death, my local newspaper ran the photo of a young man with this apostrophe as caption: "We love you, Marcus. We miss you so very much" ("In Memoriam"). In Sigourney's day, consider the popularity of Whitman's apostrophe to the assassinated President Lincoln, "O Captain! My Captain!" Every poet's use of apostrophe for elegy is deemed appropriate. For male poets, all these uses of apostrophe—making vivid one's experience, spotlighting features of creation, addressing the dead, emphasizing women's passion—are expected and encouraged as "natural." For women sentimentalists, however, cautions against apostrophe loom large.

Though, as a strategy of pathos, Blair encouraged the poet's animation of everything, he warned against apostrophe to represent "inanimate objects . . . not only as feeling and acting, but as speaking to us, or listening, while we address them." This warning questions Sigourney's address to such objects as the lady's chain, a planet, and home haunts a foreign missionary may yearn

PROBLEMS FOR SIGOURNEY'S READERS

for. Blair cautioned that either personification or apostrophe "should never be attempted, except when the mind is . . . heated and agitated" (1:332, lecture 16). Since apostrophe attributed to any woman signals her passionate state, even careful use of the figure by a woman could deepen readers' impression of her feeling's intensity. For women, Blair's warning about hyperbole fits apostrophe too: "What is the proper measure and boundary of this figure cannot . . . be ascertained by any precise rule" (1:332, lecture 16). Even a male writer will have trouble telling when apostrophe may intervene and when it trespasses. Apostrophe from a woman will recall links of passion to the female, increasing difficulty for male critics to accept her literacy as natural. It will be virtually impossible for a woman not to exceed boundaries drawn by male arbiters of "good sense and an accurate taste" (1:332, lecture 16). Because eighteenth-century codes did not anticipate female writers, apostrophe from a woman rhetor cannot signify a self-evident message. The female poet's apostrophe makes an overtly rhetorical use of the figure, signaling the rhetorical construction of language itself.

When a woman sentimentalist addresses the collective self, her apostrophes represent both a discursive opportunity, and a problem. Apostrophes do open the door for antebellum American women poets, but by then they also serve as a catch-22 tracer for women writers entering masculine literary domain. A woman's apostrophe shifts the ground for a major aspect of writing and reading, Suzanne Clark notes, "introduc[ing] a wobble into the structure of a rhetorical agreement that is based on an identification of subject and reader" ("Social Construction" 102). Identification ensures that a reader loses track of the process of reading, forgetting the work of text as metaphor in our imaginations. But nineteenth-century men, taking up a text where they see themselves to be invoked by feminine conventions, will likely be aware of the writer's gender.

### *A Final Call to Community*

Key to belletristic apostrophe for this chapter is its work to gather audiences into like-minded communities like that in Sigourney's "The Lost Sister." It is worth reiterating Todd's comment that sentimental rhetoric assumes that "the most potent force for community... [was] emotional ritual or the display of sensibility" (53, 83). As more women enter print and their consumption of women's writing is commonplace, the rhetoric of sentiment eventually grants permission for women to speak apostrophe, *to* other women, *about* a woman's feeling. In "The Lost Sister," the rhetorical effect of apostrophe

infuses a whole community of women readers with like sentiments. This is not to say Sigourney writes only for women. The poem "Amos" is one vibrant testimony among many to the contrary. Readers invoked by "The Lost Sister" and other Sigourney poems, however, do not constitute a collective of "man in general," as George Campbell characterized readers. Invocations in her poetry generally draw an audience of women, and women do assemble in the remarkable pronouns and apostrophe that end this poem.

The most dramatic moment in "The Lost Sister" is staged by the final apostrophe. The last ten lines' final wail powerfully enacts a convocation of the dying woman, the child, the woman poet, a female relative, a servant, and Sigourney's women readers. The "[o]ne cry" in these lines goes up just after the newborn's "faint wail." Because this cry is not clearly attributed, it could signal the baby's wail, the mother's final utterance before death, or perhaps the poet's anguish reporting the scene. In effect, the child's keening is indistinguishable from both the mother's and the poet's laments. I focus initially on a link between the cry of the infant and the poet, and then on connections between the poet and others assembled by these lines.

A disruptive figure like apostrophe can be associated with both newborn and poet because each laments separation from the young mother. This conflation of infant and writer parallels an effect Barbara Johnson observes in her analysis of more modern verse apostrophes:

> If apostrophe is structured like demand, and if demand articulates the primal relation to the mother as a relation to the Other, then lyric poetry itself—summed up in the figure of apostrophe—comes to look like the fantastically intricate history of endless elaborations and displacements of the single cry, "Mama!" (199)

A follower of Lacan, Johnson uses psychoanalytic terms to note human language is acquired when an infant separates from its "primal relation" to the mother's body. A child learns to speak and gains consciousness as a separate person in the phase when she or he is weaned and potty trained—and moves away from dependence on the mother. Language in this scheme may trace the loss of a primal mother, and Sigourney's last few lines combine an infant and a writer crying out for her. One way of reading apostrophe is as the work of language to mark the separation of each human being from relations with the maternal body.

Sigourney's poem, however, does not register absence only. Like a mourner's garb of "sable" clothes, the final apostrophe testifies to both separation from and connection with the dead "sister." Calling up dead loved ones

reiterates both loss and connection. Apostrophe in Sigourney's poem does not just mark some romantic gulf between an absent mother and those who miss her. Her lines record connections among its personae, women figured in the text and those invoked as readers. Identities of poet, infant, and audience all converge when the final pronouns "thee" and "me" pick up distinct threads to braid separate personae into one another. As Emile Benveniste says of personal pronouns, indeterminate words blend the subjectivities of their referents (729). Because it is hard to tell personae of Sigourney's poem apart, their connections are finally underscored by the text. Both "thee" and "me" draw the lost sister close once more to her infant and to the poet narrator, invoking the dead woman with the very words representing loss.

Sigourney's final apostrophe in "The Lost Sister" "refuse[s] to settle into a single voice," as Johnson says of apostrophe for women writing about abortion (199). Rhetorical apostrophe weaves a connection among Sigourney's nineteenth-century women. The baby's "faint wail," the dying mother's "[o]ne cry," and the poet's multivalent "thee" and "me" come together in connection and separation all human beings share. This intersection recalls the presence of what Kristeva calls "the immeasurable, unconfinable maternal body" ("Stabat Mater" 177). Here life is conceived; its pleasures constitute the backdrop language plays against—poetic language with its power to move and unsettle gestures toward such force fields of human sociality. In its disruption, passion, urgency, and association with the feminine, Sigourney's poem could be read as a sign of both the rupture and the connection between every speaking subject and a primal mother.

Apostrophe is always an urgent figure in the sentimental code. Notwithstanding Blair's nod to apostrophe in the craft of a poet, I cannot imagine "The Lost Sister" apostrophe as anything but disturbing even 150 years ago. Sigourney's apostrophe dramatizes a woman poet's desire to connect with the dead—and to connect the lost one and herself to her readers. Sigourney's apostrophes are rhetorical gestures, in this case gathering a feminine audience.[9] As an impassioned poet, by this code, Sigourney uses apostrophe to animate poetic subjects, but also by this code, male critics would read her poetry as excessively emotional.

## *Common Marks of Gender and Class*

Sigourney's popular embrace of apostrophes—gaining entry, but marking gender and a too-common audience—bothered Edgar Allan Poe, who attacked them directly as flaws, not powers. His 1836 review, as I have noted, criticized

the *Zinzendorff* collection for Sigourney's "inclination to apostrophize every object, in both moral and physical existence" ("Critical Notices" 113). To Poe, a true poet no longer uses the apostrophe, a tenet in what becomes modernist criteria for canonizing the "best" literature. Quality work shall be "entitled to be called *great* from its power of creating intense emotion in the minds of great men" ("Critical Notices" 112; italics in the original). Poe advocated dense, concentrated works that resonate with sensibilities of those cultivated sufficiently to appreciate literary distinction. It is a closed system. Sigourney's scattered apostrophes disrupt Poe's desired "unity of totality of interest," a principle of poetry he draws from the German romantic Friedrich Schlegel. Poe advocated this rule to achieve his famous "totality, or unity of effect," which "intensely excites by elevating the soul" ("Philosophy" 1461). This soul inhabited only a select few.

Apostrophe, Sigourney's in particular, cannot unify in Poe's sense. Instead, hers split and spread a sense of subjectivity and audience. Thus the woman poet's popularity is suspicious to Poe, who placed himself in the European romantic tradition of the lone male artist, seeking to create a single effect. Note how Poe's complaint slid into issues of class. Poe made himself the jealous guardian of literary discourse, the one to prescribe criteria for entry that will exclude Lydia Huntley Sigourney and her readers.

Poe obviously hoped to benefit less popular elite writers, including himself. To Poe, a "great" but narrowly appreciated writer was too easily eclipsed by

> another writer of very moderate powers [who] may build up . . . little by little a reputation equally great—and this, too, merely by keeping continually in the eye, or by appealing continually with little things, to the ear, of that great, overgrown, and majestical gander, the critical and bibliographical rabble. ("Critical Notices" 112)

The uncritical "rabble" are gendered male. But the "silly goose" one hears gabbling in Poe's line is female. It is a feminine characterization Poe applied to the "gentle charities and lofty pieties of life" that suffuse Sigourney's verse. ("Critical Notices" 113).[10] Poe's gibe about the goose was cut from the same envious cloth as Hawthorne's complaint against the "mob of scribbling women," enormously popular poets and fiction writers who steal his readership. Poe and Hawthorne equated with ignorant mobs the women writers who draw a readership of "bibliographical rabble," asserting neither group knows enough to write or recognize fine work.[11] Poe articulated gendered and class tensions straining the fabric of poetic discourse, tensions later setting modernists against imitation and apostrophe as "feminine" strategies of popular appeal.[12]

Despite critics' dismay, women's literary circles thrive midcentury in Sigourney's name. Their existence testifies to the broad appeal of a feminine sensibility invoked by the poet's apostrophes. Records of two such groups indicate how Sigourney's apostrophes encourage women to speak up and enter male-dominated rhetorical practice. An *Atlantic Monthly* writer transcribes into a 1907 column the "vinegary ink" of an old record book belonging to a Chichester, Vermont, "Sigourney Circle" that meets many decades before. The Chichester bluestockings read and discuss not only others' poems but also their own, along with essays and songs. The secretary's book depicts in verse one "small and breathless" woman in "haste to flee" center stage after reciting her work ("Sigourney Circle" 573–74). However timidly, the woman has followed Sigourney's lead to rise and speak to a feminine audience.

Sigourney's legacy moved nineteenth-century Butler University women to take more aggressive action to enter masculine rhetorical practice. Heidemarie Weidner reports that one of Butler's first women undergraduates, Lydia Short, initiates a Sigourney Society in the late 1850s. Short is critical of male students' poorly delivered orations (258) and reasons that with practice, women can do better. Butler's early literary societies are social and academic gatherings where male students practice assigned speeches and other rhetorical exercises. Until Short remedies the lack, no literary societies admit women. If others question verse as a strategy of rhetorical persuasion, Lydia Short does not. Her salutatorian speech at Butler's commencement in 1860 is "The Power of Verse" (259). Short is publicly recognized and defends poetry as rhetoric in part because she has rallied women rhetors in Sigourney's name. Sigourney's apostrophes raise a curtain on the stage, and Butler University women march to the podium.

In spite of Sigourney's importance to women of all classes, however, it is a class-motivated critique that long proved deadly to her literary reputation. This blow was aimed by Yale professor (later president) Timothy Dwight, who grew up after Sigourney in the same region of Connecticut. His 1866 review of her posthumous autobiography became the definitive text on which twentieth-century critics base their dismissals. The review was snidely critical of Sigourney's neighborhood literacy classes. This schoolteacher's homey pedagogy was "not one, indeed," he sniffed, "that could be universally adopted in larger schools or among all classes of children" (347).[13] Dwight likewise carped about Sigourney's "generous commendation" of women up and down the ranks, from a society woman who was once her student to a black housemaid who rendered the poet "heart-service" for twenty-five years. The reviewer was incredulous of Sigourney's grateful eulogy of the servant,

"She was to me as my own flesh and blood" (355). Dwight was most alarmed by Sigourney's description of the Lathrop grounds her father groomed when she was a girl, as if "they were all alike the property of Mrs. Sigourney's own family." It seemed to Dwight that by admiring the Lathrop estate, "the kindly heart of the authoress appropriates them all to herself" (336). He made a final cut: "The life that has already opened itself in a whole volume of obituaries might properly show at its close, that it was itself one obituary volume" (331). Though she writes fifty-six books, not all poetry and not with death as their sole topic, Sigourney never completely shakes this identification with elegy. Considering his slant on class and gender, Dwight's contempt for Sigourney's poetry suggested he feared that this upstart gardener's daughter might not only move into the estate of her benefactress, Mrs. Lathrop, but also take over the professor's literary domain.

It makes sense Dwight should worry about the literary reputation of a poet from the Connecticut River Valley. His grandfather, also named Timothy Dwight, was likewise a professor who became president of Yale. The earlier Dwight staked out poetic territory as one of the Connecticut Wits, writing conservative political verse during the early republic. Perhaps it was the elder Dwight's writing the critic seeks to defend. In spite of Catherine Beecher's defense of Sigourney, Dwight's criticisms prevailed for almost a hundred years.

Not much stylistic difference distinguishes poetry by Sigourney from lines by the elder Dwight. Kenneth Silverman's characterization of Dwight's poetry in a foreword to the 1969 edition of *The Connecticut Wits* could fit Sigourney's:

> It is the . . . work of a man wanting humor, wit, playfulness, artistry, grace, lacking subtlety and suggestiveness, but with a shrewd common sense, a great vigor and a certain grandiose imagination. . . . He was always inviting majestic effects. . . . [So much thunder rolled in one poem] that Trumbull suggested he ought to furnish a lightning rod. Such a man could not move easily in narrow spaces. An epic was none too slight to contain his swelling fancies or satisfy his rhetoric; he walks with huge strides; he is prodigal of images; one canto finished, other cantos clamor to emerge upon the page. His ready versification, one often feels, runs like a water pipe with the faucet off. There is never a pause to pick or choose; his words flow in an unbroken stream from his inkwell. Yet even in his amazing copiousness there is vigor; a well-stocked mind is pouring out the gatherings of years. (vii–viii)

Except for the compliments, these lines exactly describe Sigourney.[14] Weaknesses and strengths suggested in Dwight's verse are hers as well: "lacking subtlety . . . , but with shrewd common sense, versification [that] runs like a water pipe . . . , great vigor . . . , amazing copiousness . . . , a well-stocked mind." This characterization did not damage Dwight's reputation, nor did it prevent his verse from being read and anthologized into the twentieth century. Some significance of the Wits persists in twenty-first-century critical discussions and anthologies.[15] Sigourney, however, is no president of Yale. She has no ancestors of stature. She is a woman writing about women, and her strategies—not Dwight's—get linked to a pejorative sense of the sentimental.

What is at stake in critical arguments denying access to print and honor for antebellum working-class poets? In *Letters to Young Ladies*, Sigourney's own tart response to the commonplace treatment of "lower classes" suggests that in such attacks, the status of persons is on trial:

> Complaints of the errors of domesticks are very common, and with none more so than with those who are least qualified to direct them. Perhaps too much is expected of them; perhaps we neglect to make due allowance for their causes of irritation, or to sympathize in the hardships of their lot. Possibly we may sometimes forget that the distinctions in society are no certain test of intrinsick merit, and that we "all have one Master, even Christ." Yet admitting that the ranks and stations are not very clearly defined, and that the lower classes sometimes press upon the higher; this is in accordance with the spirit of a republick, and all should be willing to pay some tax for the privileges of a government, which admits such a high degree, and wide expansion of happiness. If our domesticks draw back from the performance of what the spirit of feudal times, or aristocratick sway might exact, a remedy still remains; to moderate our wants, and study simplicity in our style of living. (86)

Knowing the poet's working-class background, a reader can imagine that a woman trained by Sigourney would "sympathize in the hardships" of working women's "lot." Sigourney was a "domestick" as a girl, serving at the bedside of the Dwights' kindly, ailing neighbor, Mrs. Lathrop. At stake in Sigourney's advice about the household is what life should be in the new "republick" and who has access to "aristocratick sway." For households and for aesthetics dismissive of Sigourney's poetry, what is at stake may be "to moderate our wants, and study simplicity" in the lines of sentimental poets.

## *An Elegy for the Elegist*

John Greenleaf Whittier is another working-class poet accused of sentimentality—a charge eventually damaging to his reputation although he is a committed abolitionist—and as a critic, he welcomes women writers. Whittier writes constructive reviews of women's texts and also publishes poetry by and about women poets. Like them, he seeks to shape readers' attitudes and so to reform his culture. Whittier does not hide his indebtedness to Lydia Sigourney, who introduces him to Hartford literary society in 1831.[16] I found these affectionate lines in Whittier's 1888 printing of his collected works:

> She sang alone, ere womanhood had known
>    The gift of song which fills the air to-day:
> Tender and sweet, a music all her own
>    May fitly linger where she knelt to pray. (585)

Whittier writes this elegy for an 1887 memorial tablet placed in Sigourney's honor near the organ of Christ Church at Hartford, twenty-two years after her death (Haight 173–74). What Whittier misses is that she never does sing quite alone although she stands out as perhaps our first professional American woman poet who makes a living in print. She establishes the key. She gives the downbeat. Yet her "song" always includes grace notes—those indeterminate apostrophes—which invite the audience of women readers and writers to join in.

Lydia Huntley Sigourney and her kind enter empirical sensationalist rhetoric as intruders. Their acceptance by antebellum literati is provisional and fleeting; their fame among popular audiences is vast. To read their poetry well, we must reconsider nineteenth-century woman poets' strategies of pathos, engaging sensationalist epistemology and specific rhetorical strategies to shape readers' sentiments. These include agitated typography and apostrophe, showing us aspects of Sigourney's culture and courage we can value today if we respect her context. Doing so, we reimagine something of the world sentimental poets try to change, dimensions of discourse they influence. Sigourney's poetry speaks for affect and rationality, for working people, for connection across class boundaries, and for women. To these ends, for readers of the twenty-first century, as Grace Collin argued in 1902 for the twentieth, "Has not the work of Mrs. Sigourney its significance in the literary history of our country?" (30). A working knowledge of sentimental rhetoric can help us answer yes.

# 7. Howe's *Passion-Flowers* Dialogue with a Master

> It was a timid performance upon a slender reed, but the great performers in the noble orchestra of writers answered to its appeal, which won me a seat in their ranks.
> —Julia Ward Howe on publication of *Passion-Flowers* fifty-five years later, *Reminiscences*

> Is not rhetoric itself sentimental, with its codes and conventions certainly, but also with its location of meaning in the situation, in the connectedness between an *ethos* represented by the subject and the *pathos* of the audience, arising in dialectical response?
> —Suzanne Clark, "Rhetoric, Social Construction, and Gender: Is It Bad to Be Sentimental?"

A lone voice in Julia Ward Howe's 1854 *Passion-Flowers* collection echoes hollowly in contrast to the women's chorus of Lydia Sigourney's poems. This anonymous volume offers no one overtly sounding a key, no downbeat, no harmony. In the book's first half, a veiled persona speaks almost hypnotically offstage, like mythology's Echo, whose rhythmic waves of sound mark her distance from Narcissus. Suddenly the stage has two on it. In three poems at the center of her collection, the poet of *Passion-Flowers* introduces alternating voices measuring a seductive woman's distance from her hesitant lover. Thus she constructs an intimate dialogue with a reader she calls "Master."

### Sentimental Semiotics and Desire

This chapter spotlights how Julia Ward Howe draws her contemporary audience into erotic conversation with a poet. The exchange occurs in a three-poem

sequence exemplifying not only specific workings of Howe's pathos or audience appeal but also a dialogic process characteristic of rhetoric. In the epigraph above, Suzanne Clark challenges those setting rational discourse against sentimentalism to reconsider rhetoric itself for its sentimental dimensions. Central to Howe's book is its woman poet, rolling out cultivated line after line, obviously familiar with poetic "codes and conventions." Howe's strategy is not exhausted, however, by our discovery the poet may talk to herself or to offstage echoes in literary language, nor by locating sentimental codes in the exchange. Rather, reading her rhetorical situation requires accounting for an audience whose pathos is aroused, as Clark says, "in dialectical response" to Howe's invitation—as is all sense of audience in rhetorical practice.

Other figures in *Passion-Flowers* allude to Julia Ward Howe's readers, and she writes other erotic poems, some discussed in chapters 1 and 4. Yet Howe's poetic dialogue in this sequence constructs a distinctive "connectedness" between rhetor and audience because as seductive conversation, the three poems perform the "psychagogy" of Plato's dialogues. Roland Barthes translates psychagogy as "formation of souls by speech," claiming particularly that in Plato's *Phaedrus*, "the basic mode of discourse is the dialogue between teacher and pupil, united by an inspired love" ("Old" 19). The text works like the teacher; readers and students take on affections of the text. Barthes articulates from Plato's dialogue what seems natural about Socratic method and about texts generally. My purpose in this chapter and this project is to articulate what seems natural about a rhetoric of sentiment and so reclaim its art and audience appeal for the twenty-first century. Foregrounding Julia Ward Howe's audience appeal or pathos, I focus on her construction of an erotic conversation between three adjoining poems and its effect on readers.

Alternating a woman's flirtatious advances with her partner's tentative responses, Howe's poems also recall the dialogue in the Bible's "Song of Solomon" by enacting a dance of desire in a charged absence. As for those lovers, Julia Ward Howe's appeal arises from the intimacy of question and response in an imaginary clandestine courtship. Plato's appeal too stems less from the victory of one logic over another than from intimacy springing up in a dynamic between interlocutors, speakers alternately figured in the text. Roland Barthes sums up Plato's approach: "Rhetoric is a dialogue of love" ("Old" 19). In the context of Howe's rhetorical situation, moreover, her seductive exchange may move readers today, as Suzanne Clark urges, to "reclaim the status of the gendered other" and so to "confront the political unconscious" to which sentimentalism was so long consigned ("Social Construction" 104). Students of rhetoric and literature, Clark implies,

should reconsider limits on worthy objects of research. As a female poet, Howe underscores the status of her *Passion-Flowers* writer as an outsider who wants in. The even broader context of rhetoric reveals for Howe's dialogue the politics of literary discourse that long dismissed all women's poetry as sentimental and so not literary. With dialogue her fundamental trope, this poet persuades nineteenth-century American men to admit her to their closed circle of literary elite.

## *Nods to Standby Readers*

Unlike Sigourney's choir of women, Howe's collection before and after the dialogue only hints thematically at a circle gathered outside the book's pages. For example, friends including "Brother and sister poets dear" as well as her Master are honored in the "Salutatory" poem for loving support. Howe suggests people and relationships elsewhere by metaphors just as charged as the Master figure, but with different relationships to the poet. One is an angry miller trying to control a roiling "Mill-Stream" (*Passion-Flowers* 80–84):

> A miller wanted a mill-stream,
>     A mild, efficient brook,
> To help him to his living, in
>     Some snug and shady nook.
>
> But our Miller had a brilliant taste,
>     A love of flash and spray;
> And so, the stream that charmed him most
>     Was that of brightest play.
>
> It wore a quiet look, at times,
>     And steady seemed, and still;
> But when its quicker depths were stirred,
>     Wow! but it wrought its will. (*Passion-Flowers* 80)

As a pair, miller and stream stand for a troubled marriage, very likely Howe's own. In *Hungry Heart: The Literary Emergence of Julia Ward Howe*, Gary Williams thoughtfully unfolds the depths of the "flash and spray," turmoil in the Howes' relationship. In Howe's poem "The Heart's Astronomy," discussed later in this chapter, a wandering star is emblem of a restless mother speaking to her children (*Passion-Flowers* 100–102). Metaphors like these for Howe's audience and context evoke Paula Bennett's "women of wit and fashion" (*Public Sphere* 32), whose "ingenuity" Jane Donawerth observes

"turn[s] . . . restrictions into possibilities" (*Conversational* 3). Despite the "quiet look" of Howe's "brook," "conventional" wife and mother do not fit.

In addition to the Master and figures of speech, the anonymous *Passion-Flowers* poet uses poetic style to allude to readers, such as the Longfellow-like trochees of a short poem "Stanzas":

> Of the heaven is generation;
> Fruition in the deep earth lies;
> And where the twain have broadest blending,
> The stateliest growths of life arise.
>
> Set, then, thy root in earth more firmly;
> Raise thy fair head erect and free;
> And spread thy loving arms so widely,
> That heaven and earth shall meet in thee. (149)

A tree is one of nature's "stateliest growths," but it also suggests a transcendental consciousness that matches Howe's report to her sister she had shown single poems to Unitarian minister Thomas H. Peabody, poems edited by friend and Harvard professor Henry Wadsworth Longfellow before *Passion-Flowers* went to press (Richards, Elliott, and Hall 1:139). With her husband, Samuel Gridley Howe, these men founded the Transcendentalist Club, which met on occasion in Julia's sitting room.

Not even "Handsome Harry," however, a frankly suggestive poem toward the end of the book, gives the poet's intimate admirer a voice:

> His hand upon the wheel, his eye
> The swelling sail doth measure:
> Were I the vessel he commands,
> I should obey with pleasure. (169)

While these textual clues allude to readers, they do not define Howe's audience quite the way Harper's slave market as common school makes students of her readers, nor as Sigourney's "thee" and "me" gather and invite women to join in. Looking primarily for each woman poet's antebellum pathos or audience as a dimension of sentimental rhetoric, I maintain that characteristic tropes in works by Harper, Sigourney, and Howe shape three distinct audiences. Howe's erotic dialogue in *Passion-Flowers* moves her lover and Master to let a woman join his circle, but the few personal references outside the dialogue that interrupts *Passion-Flowers* deflect and spread out—rather than lock in—positive identification of the poet's audience.

## Cultural Context of Howe's Coquette

A reader therefore stumbles by surprise into an intimate three-poem sequence halfway through *Passion-Flowers* (116–20). This dialogue introduces a bold couple, at first oddly direct for such a coy poet. But the intimate, baffling play of this erotic conversation is finally not surprising; it can be read as typical of how this elusive antebellum poet appeals to a nineteenth-century masculine audience.

Poetry as rhetoric may surprise some, but an erotic sentimental woman poet of 1850s America was until recently an even greater shock. If modernist scholars valued nineteenth-century women's personal correspondence as did Karen Lystra for *Searching the Heart* (1989), they would have seen that real women included a sensual self. In her 1992 anthology, *American Women Poets of the Nineteenth Century*, Cheryl Walker introduces Rose Terry Cooke and Frances Sargent Osgood as frankly erotic sentimental women poets. Likewise, Joanne Dobson delightfully expands on Osgood's "private" erotic poetry addressing "the extreme power imbalance of erotic love in a patriarchal world" ("Sex" 640). Perhaps most provocative, Paula Bennett's 1993 study reveals imagery's "latent sexual potential" in nineteenth-century American women's poems. Bennett argues, "Failure by present-day commentators to decode [this sexual potential] in women's writing has led to major misunderstandings of nineteenth-century bourgeois women's sexuality and of the sexual content of their poetry" ("Critical" 243–44). Overt in Howe's and Osgood's poems, implicit for many others, eroticism now acknowledged in the once enormously popular genre of nineteenth-century women's poetry should loosen strict, pejorative interpretations still limiting antebellum womanhood. Even in a newly racy crowd, Howe's dialogue viewed only as seduction might miss the point. She wanted something from her sentimental lines: a place in the mostly male literary scene.

Few influential readers lately who notice Julia Ward Howe is lyricist of "The Battle Hymn of the Republic" find her an erotic poet.[1] Early on, the 1988 *Columbia Literary History of the United States* (Elliott 487) and Lawrence Buell in *New England Literary Culture* (1986) both mention Howe only in relation to this one poem.[2] Gary Williams' provocative *Hungry Heart* is rare for its emphasis on Howe's painful relationship with her husband, Samuel, placing erotic poems such as "Handsome Harry" in that context.

Most who note a woman wrote the "Battle Hymn" lines assume Howe always fits common notions of the sentimental. Chapter 4 elaborates on

ways the poem shows that Julia Ward Howe knew and used discourses of religion and human rights in service of the Union cause. Lyrics rallying the Union army hardly hint at a collection like *Passion-Flowers*.[3] Perhaps this is why Howe's large corpus beyond the "Battle Hymn" lay virtually unread until a few poems turned up in Walker's and Bennett's anthologies of the 1990s. The American canon missed an erotic Howe. In contrast to audiences' ignorance of Harper or Sigourney, their problem with Julia Ward Howe is misreading her. Until the late twentieth century, audiences were quite sure they knew more than enough about nineteenth-century women and the sentimental, so Howe was dismissed with the rest.

### Dialogue in a Rhetoric of Sentiment

Pious rhetoricians Hugh Blair and George Campbell might well have resisted claiming Howe's sensual dialogue as progeny. But seeing Howe's poetic exchange as rhetoric is to agree with Nan Johnson's assertion, "There has always been a discipline of rhetoric, but . . . it has never been exactly the same one" (*Rhetoric* 7). Rhetoric, in other words, looks different with changing times and places. In eighteenth-century rhetorical codes, dialogue was a format recommended for philosophical debate, well within the pale of traditional rhetoric. Howe's verse exchange hardly matches the "conversation as a model for republican discourse" Jane Donawerth identifies as one culturally approved rhetorical practice for pre–Civil War women (*Conversational* 57). Rather, it comes close to Blair's view of philosophical texts in dialogue that might be considered literary. Philosophy, Blair said in his lectures, occasionally "mingles more with works of taste, when carried on in the way of dialogue and conversation" (2:293, lecture 36).

Aristotle long ago associated dialogue with both philosophical and literary discourse because "the Socratic dialogues do depict character . . . being concerned with moral questions" (1417a.19–20). Consequently, texts with dialogue invite readers to take roles among the *dramatis personae*. In this, dialogue differs sharply from mathematical discourse, which, according to Aristotle, "depict[s] no character" (1417a.17). Howe follows Blair's—and by extension Aristotle's—instructions for a lively exchange, for she gives each speaker "that peculiarity of thought and expression" Blair prescribed for different voices (2:293, lecture 36).[4] "Moral questions" Aristotle alluded to, however, not only are issues of good and evil but also involve "purpose of the agents, i.e. the sort of thing they seek or avoid, where that is not obvious" (1450b.8–9). Framed by Blair's and Aristotle's rhetorics, Julia Ward Howe's

*tête-à-tête* is not philosophy—though she touches profound issues. Instead, more than other poems in *Passion-Flowers*, her dialogue underscores the rhetorical situation of a woman poet's desire. By design, what she seeks is nowhere as obvious as here: she wants the attention of male readers who can grant entry into their literary domain. What she apparently wants to avoid is naming either her lover or herself.

Popular reading for mid-nineteenth-century young American women includes another dialogue paralleling Howe's. This earlier exchange occurs between a Master and his young friend in Bettine von Arnim's epistolary novel, *Goethe's Correspondence with a Child*. When the book is published in 1835, von Arnim claims it is autobiography, three years after her German Master Goethe is gone and four years after her husband dies (Waldstein 44). She translates the *Correspondence* for a British edition in the late 1840s, and it creates a sensation among American women readers. Fluent in German, Howe could have read it in the original, but once the book is widely available, many imagined themselves interlocutors in such a correspondence. The seventeen-year-old Louisa May Alcott finds von Arnim's book in Emerson's library, and in her self-described "Sentimental Period," she writes undelivered letters to him as her Master (*Life* 58). Helen Hunt Jackson in *Mercy Philbrick's Choice* (1876) tells of a young woman's attraction to a middle-aged professor she calls Master. Emily Dickinson's Master letters and poems may allude to von Arnim's book. Historical context again belies our notions of nineteenth-century propriety once we realize von Arnim intended intellectual intercourse to suggest physical intimacy with her Master: "Art valiantly spiritualizes sensual life.... The intercourse between thee and me forthbrings spirits. Thoughts are spirits, my love is the hatching warmth for the spirit's offspring" (586–87). Goethe's family claims von Arnim's book is fiction, insisting he had been cool to her advances. We cannot investigate, but the young woman writer's language does take the initiative. Howe's verses to her hesitant Master are charged with sentiments echoing von Arnim's.

### A Coquette's Appeal

A reader only gradually realizes, nevertheless, the woman poet and her lover are distinct personae in Howe's exchange. Repeatedly reading the three poems, one senses in the second a man interrupts the woman's voice recognizable in the rest of the book. Her words begin and end the three-poem sequence. The first, in six quatrains, is titled "Coquette et Froide"

(loosely translated, "flirtatious and cold, or reserved"). Its stanzas alternate six- and five-syllable lines in a halting mixed meter of trochees and iambs, with only the second and fourth lines rhyming. Using elevated deferential second-person pronouns, "thee," "thou," and "thy," a woman speaker quite brazenly insists her partner, an educated man, state his sexual intentions. In the woman's voice, here are the first three stanzas initiating the exchange:

> What is thy thought of me?
> What is thy feeling?
> Lov'st thou the veil of sense,
> Or its revealing?
>
> Leav'st thou the maiden rose
> Drooping and blushing?
> Or rend'st its bosom with
> Kissing and crushing?
>
> I would be beautiful,
> That thou should'st woo me;
> Gentle, delightsome, but
> To draw thee to me.            (lines 1–12)

The woman ponders this relationship, and her poem's halting form also signals uncertainty. Still, her "gentle, delightsome" diction shows this "maiden" does not spurn his attention. She seeks it. "Thou should'st woo me," she tells the Master.

Formal features in the replying poem are much more strictly methodical than the woman's. A masculine voice in *"Coquette et Tendre"* ("flirtatious and tender," "soft," or "warm") is clearly fascinated by "thy woman's art." He would "censure none" of her advances, yet his reserved response is five quatrains of invariable trochaic tetrameter in eight- and seven-syllable lines that rhyme *abab* throughout. Similar enough in title, meter, and rhyme scheme to make it obvious the two poems are paired, their pronoun references and formal qualities vary sufficiently to indicate a change of speaker from one to the next. Still, it is only crystal clear well into the second poem that a reader is eavesdropping on the poet's intimate dialogue.

Here are first and second stanzas in the man's voice:

> To mine arm so closely clinging,
>   Looking, lingering in mine eyes;

> Say, what hidden thought is bringing
> >  Change of cheek and smothered sighs?
>
> Oft I think thine hands caress me
> >  With each object that they yield,
> > And the glances that repress me
> >  Sidelong lure me to the field.   (1–8)

References to her "hands [that] caress me" and "[s]idelong" "glances" are powerful, but fewer than her previous sensual evocations of "thy longing eye" and "quickened Fantasy," or of a "maiden rose" whose "bosom" is kissed and crushed. The woman's thematic foreplay has initiated an exchange between this couple. Her erotic strategies outnumber his. Invitation constrained by hesitation in her poetic structure suggests she pursues by indirection. He flees. His distant demeanor may produce her longing and is likely the occasion for her verse. Perhaps, as Julia Kristeva notes for the amorous couple of the Bible's "Song of Solomon," these are "lovers who do not merge but are in love with the other's absence" ("Holy" 89). That is, lovers appear together in Howe's text, but even when his words follow hers, the two figures are separate, distinct in stance and tone.

Solomon's "Canticles" may be a composite of older separate Hebrew love poems,[5] but they appear today in all versions of the Bible as an exchange between lovers, a conversation steeped in desire. Both Socrates' appeal to young Phaedrus and the longing of Howe's woman writer in *Passion-Flowers* produce a conversation something like Solomon's, one initiated by the absence of fulfillment. A Shunamite maiden in King Solomon's court initiates this ancient exchange from a "reserve of incompleteness" between lovers, says Kristeva ("Holy" 88): "Let him kiss me with the kisses of his mouth" (*King James Bible*, Song of Sol. 1.2). He is not with her, but her third-person pronoun conjures "him." The woman at last addresses her lover, Solomon, directly: "For thy love is better than wine" (*King James Bible*, Song of Sol. 1.2). Interspersed with her invitations, Solomon's voice in her imagination responds with equal longing, fancying eager anatomies of the maiden's body. In effect, the Bible's dialogue endorses remarkably frank expression of a woman's sexual desire.

The voices of the "Song of Solomon" constitute a flickering promise of erotic fulfillment—the aim of dialogue, "the sort of thing they seek," as I have noted above in Aristotle's words (1450b.8–9). The power of this erotic longing builds despite—or perhaps because of—distance between the writer and her lover. That woman's longing gets called "excessive" in a text may

suggest, according to Suzanne Clark, a discourse influenced by something other than reason: "perhaps personal experience, a desire to appeal to the personal experience of others, or the violence and desire of the body's fluctuating life" ("Social Construction" 101). Mathematical discourse notwithstanding, Aristotle says that every discourse has its passions; every passion has its reasons.[6] Text may symbolize both presence and rationality, but print and electronic pages twenty-first-century readers scan also fundamentally remind us presence and reason are projections of solitary imaginations. Dialogue therefore effectively dramatizes and intensifies longing between amorous personae—present to each other solely by means of a text ("Holy" 87). Thus Howe's dialogue brings its remarkable exchange to the text, one like the "Canticles" producing two amorous, distinct speaking subjects.

Differences between the man's poem and the second from Howe's coquette occur this time in spatial arrangement rather than prosody. Part three of the dialogue, "Answer," returns to the feminine persona. He asks at the end of his piece, "Come—what would'st thou of thy friend? . . . Fathom thine own doubting heart" (lines 16, 20). In this third poem, she responds obliquely, half apologizing while holding his attention:

> 'Tis a trick of ancient learning
>    Riper age effaceth not;
> Youth's warm impulses returning,
>    Sage-eyed prudence is forgot.                (lines 1–4)

The next two stanzas of "Answer" continue her ambivalent apology. I forget myself because you mean so much to me, she coos. At my age, I should know better. Metrics of her lines now exactly mimic the second poem. Though her alternate lines indent, they now rhyme precisely as his, *abab* in all five quatrains. Whether the publisher's or the poet's choice, the third title is in a smaller type size than the first two, and also unlike those poems, each of which begins on its own page, this third one responds below his on the same page (120–21). The third poem relates to the previous, but it is also subordinate. Such a shift from second to third poem differs sharply from the move from first to second. For the man, that change required a new page and a title of equal boldness. When she responds in the third poem, the woman poet has bent her demeanor to match his. She now seems eager to be correct, a good follower—in form.

She only half withdraws, however, her "fond, instinctive clinging / To the helpful arm of love" (lines 11–12). Formally, she is proper. Thematically, she seems chagrined but unrepentant. Here are the third poem's last two stanzas:

> If there's evil in my bosom,
> > Aid thou me to keep it down;
> Show the worm within the blossom,
> > I, like thee, will shrink and frown.
>
> Is our jesting, then, so fateful?
> > I'll be colder, if I must;
> Do not chide that I am grateful,
> > Dare not mock my childish trust. (lines 13–20)

The effect of this dialogue on an unwary reader is to make him go back and read Howe's *tête-à-tête* again. He wants to know what is going on. Why this intricate interlace of poetic form? Who is this direct, seductive woman? Who is the man of Longfellow's trochees? A reader finds almost no clues among lines of these three poems. It makes a kind of sense that the third poem, "Answer," does not appear in the collection's table of contents. In the whole book, indeed, there is no final answer to questions invited by the surprise dialogue. The exchange occurs unannounced, almost imperceptible in a casual read. This conversation would be noticeable only to very careful readers, discernible in subtle formal strategies, not in any general sense of the volume.

### *Rhetoric of Howe's Intrigue*

Nevertheless, because the sequence gives voice to a targeted audience with its distinctly erotic tone, I argue this dialogue of charged absence is characteristic of Howe's rhetorical appeal.[7] After furtive whispers from beyond an almost empty stage, the performance of these poems draws the poet's audience into an erotic relationship that not only presses past boundaries of how we have imagined the sentimental woman poet but also repositions readers as potential suitors. She coyly teases men with a physical intimacy she imagines they want. Yet her desire—for something else—upstages theirs. A rhetorical approach to Howe's poetry helps us rediscover readers of her day who would have read carefully, men educated to understand her intricate prosody and powerful rhetorical appeal. This approach, furthermore, helps us recognize the poet's covert rhetorical goal.

Howe remembers "Blair's 'Rhetoric,' with its many quotations from the poets" as a "delight" (*Reminiscences* 56–57), and at first glance, few poems in her *Passion-Flowers* fall outside this rhetorician's preferred "ultimate end of poetry, indeed of every composition"—namely, to "make some useful

impression on the mind" (2:361, lecture 40). The classical dictum from Horace that art should delight and instruct arises often in eighteenth- and nineteenth-century literary discussion (Bigelow 36). Useful and proper parameters of moral sentiment would govern Blair's definition of poetry as a genre of persuasive discourse, but the erotic dialogue of *Passion-Flowers*? Delightful, yes, but useful? Howe's *Passion-Flowers* dialogue bears a likeness to Blair's definition of sentimental discourse, but in format and tone the sequence strongly resembles the Continental branch of nineteenth-century sentiment.

Erotic dialogue is not commonsensically "useful" to the woman poet. That is to say, Howe's dialogue neither conveys information nor turns its readers to moral rectitude, both goals the Scottish rhetoricians endorsed. The *Passion-Flowers* exchange instead serves the poet because of its imaginary relationship. Discussions of dialogue underscore the manner in which this form works—by strategic effect on an audience, rather than by thematic content.[8] Omitting a response to the "you" of an artful 2014 *New York Times* column, Ehud Havazelet in "Second Person" toys with such strategic effects. "Dialogue" in *The New Princeton Encyclopedia of Poetry and Poetics*, B. Ashton Nichols writes, involves "more than one speaker" in lines of popular ballads to "heighten dramatic tension or suspense" (799).[9] Tension and suspense produced by this format are enhanced by its undecidability and eroticism; they move toward resolution only if a *Passion-Flowers* audience reads the poems in sequence and then reflects. Recursive structure of the *tête-à-tête* invites a second glance, and that is part of what Howe wants, her rhetorical aim. Her audience hungrily rereads the whole sequence.

Many readings pleasurably combing the poems for hints, however, cannot pin down the couple's banter to one meaning. The woman's early question, "Lov'st thou the veil of sense, / Or its revealing?" ("Coquette et Froide" lines 3–4), is unintelligible until her Master tosses the question back at her in the second poem: "Say, what hidden thought is bringing / Change of cheek and smothered sighs?" ("Coquette et Tendre" lines 3–4). On one level, she asks what he thinks about transcendentalism's tenet of rejecting material appearances for truth in Platonic forms. On another level, she asks whether the Master is interested in an elegant fan dance. Does he want her clothed or naked? By returning the topic to an issue of "thought," does the Master scold her for making their serious philosophical discussion trivial, fleshly? Or by referring to her body, its "[c]hange of cheek and smothered sighs," does he instead flirt right back? Does he perhaps say, given a choice of body

or soul, that he will take the woman naked? After his response, her query reveals both its own doubleness and a multivalent effect of the conversation. At issue in the whole sequence and the book itself is not *who* is this poet. At stake for this study is *how* subtle changes and blank spaces set between feminine and masculine voices ensnare readers of Howe's *Passion-Flowers*. In its baffling recursiveness, Howe's dialogue is indeed useful to her. In it the woman poet's craft becomes perfectly evident to literary critics caught up in its spell.

A nineteenth-century audience under this woman poet's spell would link her flirtatious conversation not only with von Arnim's tell-all novel but also with a European philosophical tradition of sentimentalism, recalling Friedrich Schiller and Johann Wolfgang von Goethe, as well as Johann Gottlieb Fichte and Georg Wilhelm Friedrich Hegel. Critics knew that Schiller's influential *Naive and Sentimental Poetry* (1795) grew out of conversations and correspondence with Goethe. Schiller articulates four divisions of poetry, each with its own parts: satire, elegy, idyll, and naive. For Schiller, the naive is charmingly unconscious expression; he considers the first three categories "sentimental" for coinciding with all sorts of deliberate, formal, conscious art. This notion of the sentimental is moral in the aesthetic sense: art should consciously adhere to formal criteria. Schiller's "sentimental" art makes sense within "mores" of its various forms. In this vein, Annie Finch successfully distinguishes between Sigourney's sentimental and romantic forms, arguing for both a romantic and a sentimental Sigourney in the "The Sentimental Poetess in the World." In contrast, because of Continental influences on Howe's writing, sentimental and romantic attitudes coincide in her verse. The point here is not to articulate American and European thought, but to suggest how Howe's link to Continental sentimentalism would have situated the mostly male audience educated to recognize that link.

One woman contemporary, Lucia Gilbert Calhoun, superimposes the two attitudes, sentimental and romantic, in a biographical essay on Howe in *Eminent Women of the Age* (1868).[10] Calhoun piles up adjectives describing Julia Ward Howe at age twenty as "sentimental, romantic, longing for the actual vivacity of life" (623). Calhoun avoids comment on Howe's eroticism and represents the Master's influence in terms of wealth and duty, reflecting that the "shining inheritance of German literature . . . seemed to create in her new faculties of comprehension. Goethe and Schiller were her prophets and kings" (622). Placing the words "sentimental, romantic" side by side, this nineteenth-century critic equates the two, producing a metonymic exchange between adjectives. Of late, Howe's audience has not listened carefully to

hear a contemporary Romantic resonance in the transcontinental sentimentalism that antebellum American poetry is part of. We have failed to imagine Howe's persuasion of her contemporary audience.

## Finding Howe's Followers

Poems before and after the dialogue, as I have noted, allude to intimacies with her mentor more physical than spiritual. Chapter 4 details other assertive women personae in Howe's *Passion-Flowers*, contrasting sharply with the settled wives and mothers ubiquitous in contemporary men's sentimental poetry. I underscore here peculiar diction in "Mother Mind" paralleling von Arnim's erotic appeal to her mentor. The "Mother Mind" poet claims a Master as audience who is father to the thought "I bear . . . within my breast / That greatens from my growth of soul" (*Passion-Flowers* 91). Earlier, in "To My Master," she invokes the Master with a less suggestive apostrophe: "Thou who so dear a mediation wert / Between the heavens and my mortality" (*Passion-Flowers* 5). The *Knickerbocker*'s 1854 reviewer speculates on that mediator of Howe's "religious sentiments": "a great New England mind, . . . one of the foremost reformers and strongest men of the age." The reviewer admits his guess might be "in error" and declines to name the personage ("Passion-Flowers" 359).

It is not the poet's husband, Samuel Gridley Howe. Is it Thomas H. Peabody, the revered Unitarian minister? One of her publishers, William Davis Ticknor or James Thomas Fields? Emerson? Bronson Alcott? One of the Channings in transcendentalist circles? Or was it Longfellow, whose metrical scheme appears intermittently in the collection? Howe wrote her sister Louise that Longfellow ("Longo" to the Ward sisters) had read parts of her manuscript, advised her on the title, and recommended she publish it anonymously (Richards, Elliott, and Hall 1:139). Finally, Howe's indeterminate text allows readers to fill in the Master blank. Perhaps every man who reads it finds himself called to intervene for her.

After earlier tantalizing hints, what must it have been like for the eager male critic to discover lines where the Master speaks for himself? Except for his single speech, the book is the woman writer's space. Here the author offers the discerning man a moment to speak up about a woman poet's entrance onto the scene of American letters. If she succeeds in wooing him with "simple wiles" and "jesting," as her part in the dialogue protests, then he may "not chide" or "mock [her] childish trust," a trust the poet exhibits by humbly following his literary lead (*Passion-Flowers* 119–20). If she convinces

him she is innocent as a girl, then she poses no threat, and as protégé she needs his help. Perhaps she spurns Sigourney's brash working-class apostrophes breaking into antebellum poetry on their own. Instead, "clinging / To the helpful arm of love," clinging to her Master, this lady poet may elegantly infiltrate his domain (*Passion-Flowers* 120). Indeed, whether male readers identify as Master, ready to take up the *Passion-Flowers* dialogue, seems a litmus test of their approval both of the book and of Howe's success as a major poet.

Contemporary reviews of *Passion-Flowers* indicate smitten men in Howe's audience quickly move to champion the collection. H. T. Tuckerman in *Southern Quarterly Review* finds himself "too much impressed with the ability, the earnestness and the intensity of the writer" to quibble with the volume's "inaccuracies." He protests he wants nothing more than to speak "words of cordial recognition" to the woman poet. He concludes by waxing plural: "We hail her advent," ushering in both poet and her verse (191). The *Knickerbocker* reviewer likewise exclaims of the collection, "We hail with joy its appearance," willingly extending his arm. This critic's first-person pronoun early on expands to the plural, broadening at last to include all citizens. He praises *Passion-Flowers* not only for introducing "us to a poet of power and originality" but also for revealing its poetess as "a true American woman" ("Passion-Flowers" 362). Persuaded by the dialogue to assume the role of suitor Howe offers men, these reviewers not only give her keys to the literary club but also march out like Union armies to do battle on her behalf.

Eagerly leaping to identify as Howe's champion, the excited *Knickerbocker* writer exemplifies the sympathetic response of Howe's masculine audience to the Master role. Aroused by thinly veiled erotic diction in her "sense revealing" fan dance passage of the dialogue, he observes emphatically:

> In every line you feel the fiery meaning burning through the veil of words. Indeed . . . it is not so much the words which attract notice . . . but somehow the vivid thought *behind* the words forces itself upon your attention. ("Passion-Flowers" 356; italics in the original)

Clearly the poet's Continental brand of sentimentalism excites him not so much by its reference to a higher plane, but by its come-hither sensuality.

Even Nathaniel Hawthorne warms to these "admirable poems of Mrs. Howe's," though previously he has placed her among that "damn'd mob of scribbling women" (Frederick 231). Although Hawthorne imagines for Reverend Dimmesdale in *The Scarlet Letter* dire consequences if a man should

succumb to a woman's passion, now his shock is overwhelmed by delight at the poet's frank sensuality. To his publisher Ticknor, who sent him *Passion-Flowers*, Hawthorne writes he would gladly step into the Master's role and escort her into the masculine poetic realm: "I for one, am much obliged to the lady, and esteem her beyond all comparison the first of American poetesses."[11] Hawthorne nevertheless cannot resist asking Ticknor about that single glaring exception to the mass of Howe's masculine admirers: "What does her husband think of it?" (qtd. in Freibert and White 355–56).

Her husband did not approve. Neither Howe's *Reminiscences* nor her daughters' later biography mentions Samuel Gridley Howe's displeasure over this book, but in their "Passion Flowers" chapter, the girls recall their mother often quoting Thomas Garrett of the Underground Railroad, "If I told no one what I intended to do, I should be enabled to do it" (qtd. in Freibert and White 151). Julia Ward Howe was neither the first nor the last woman to embrace that dictum. The daughters excerpt letters from Whittier, Emerson, and Oliver Wendell Holmes praising *Passion-Flowers* (138–41). Of Mr. Howe's reaction, Deborah Pickman Clifford reports in her 1978 biography that Julia confided to her sister Annie:

> We have been very unhappy. The book, you see, was a blow to him, and some foolish and impertinent people have hinted that the Miller was meant for himself—this has made him almost crazy. . . . We have had the devil's own time of it. (121)

Howe's husband was not the intended reader of the book.

Hawthorne's delicious horror upon reading Fanny Fern's *Ruth Hall* may apply to men's most common reaction to Howe's *Passion-Flowers*:

> Generally women write like emasculated men, and are only to be distinguished from male authors by greater feebleness and folly; but when they throw off the restraints of decency, and come before the public stark naked, as it were—then their books are sure to possess character and value. (qtd. in Freibert and White 357)

Hawthorne responds as did the *Knickerbocker* reviewer to Howe's "veiled" or "unveiled" query about the fan dance: he prefers his woman poet bare. Conflicted male reactions to female writers in one respect parallel old Mrs. Hall's alarm when, in Fanny Fern's novel, the woman expostulates on the effect of her daughter-in-law's reading and writing verse. "Poetry, I declare? the most frivolous of all reading; all pencil marked;—and there's something in Ruth's own hand-writing—*that's* poetry, too: worse and worse" (32; italics

in the original). Hawthorne's and Mrs. Hall's comments indicate the woman writer's relationship to a feminine ideal is at issue for American antebellum readers. Judgments on "character and value" of women's texts, as Hawthorne put it, will be gender specific. Nineteenth-century men enjoyed fantasies of transgression; women like Mrs. Hall are horrified. Male critics welcomed Howe's erotic verse. Female readers criticize *Passion-Flowers*, either ignoring it or revising its erotic appeal.

## *No Appeal to Women*

Nineteenth-century women's contempt for the *Passion-Flowers* appeal may be explained in a letter not long before the collection appeared; Howe complains to a male correspondent she has "no woman friends" (Clifford 116). She does, however, have men friends addressed in *Passion-Flowers*. Howe seeks approval by men despite growing numbers of women readers and writers in 1854. In Howe's mind, men direct the performance of poetic discourse, not women. In *Reminiscences*, Howe lists those "highest literary authorities of the time" who review her book positively—virtually all men (229–30). In the memoir, one lone woman's name makes Howe's list: novelist Catharine Sedgwick approvingly cites a descriptive line from *Passion-Flowers*' longest poem, "Rome." Sedgwick's praise comes to the poet, Howe says, through "a mutual friend" (228). Thomas Wentworth Higginson's biography of Margaret Fuller reports that she too wrote a piece

> upon the Passion Flower, whose petals had just fallen from her girdle, she says, while all her other flowers remained intact; and with which she connects a striking delineation of human character, as embodied in some person not now to be identified. (96)

Fuller's "delineation of human character" might well indirectly and negatively refer to Howe's collection.[12] More pointedly, Caroline May's otherwise inclusive 1869 anthology, *Pearls from the American Female Poets*, omits Howe's work entirely.[13] Howe typically ignores women readers; their general silence on her collection returns the favor.

At least two contemporary women readers, however, do respond in some depth to the seductive *Passion-Flowers* collection. Because the book does not invoke them as audience, their view of its purpose takes surprising turns. In Lucia Gilbert Calhoun's 1868 essay on Howe in *Eminent Women of the Age*, she jealously minimizes the stir Howe's book caused, saying it was "powerful, pungent, and unripe. Its personalism was terrible" (621). Calhoun

insists, "Not many copies were sold" (621). Yet Howe's daughters report *Passion-Flowers* "passed rapidly through three editions" (qtd. in Freibert and White 137). Calhoun nevertheless honors Howe's 1861 "Battle Hymn" as "the Marseillaise of the war" (626). This woman critic may covet the coquette's masculine audience, but she casts the one famous poem as exceptional and heroic. Because of those lines, Howe would stand out for Calhoun among simpering women as a lone, strong, extraordinary poet. Calhoun sets Howe against others like Sigourney, the "Sweet Singer of Hartford," to construct a Howe who was "not an echo, nor a shadow, nor a sweet singer of nothings" (621). Yet to establish Howe as a Civil War heroine, Calhoun must dismiss the book's sensual *Mädchen* and her Master, the two echoing German sentimental discourse. She revises the poet to fit an ideal.

Howe is herself the second woman revisionist, for in old age she alters her own characterization of *Passion-Flowers* to underscore Calhoun's revolutionary logic. Now the poet too deflects attention from the temptress of the Master dialogue and directs readers instead to the book's overtly political topics. After all, poems in it address "wrongs and sufferings of the slave" and "the events of 1848," a struggle for independence in Italy and Hungary. She would have readers remember "the most important among my '*Passion Flowers*' were devoted to these themes" (*Reminiscences* 229–30). Howe's emphasis on political topics recalls Nina Baym's attempt at "reinventing Lydia Sigourney." Together Howe and Baym underscore the tendency of readers to misread and dismiss political implications of sentimental discourse, particularly in poetry by women. And Howe did write about politics. But Howe's masking of the erotic also reflects the passage of nearly half a century between *Passion-Flowers*' publication and Howe's 1899 memoir. She is eighty years old when she advances a geopolitical frame for *Passion-Flowers*. Near the end of her life, Howe will shape a respectable heritage, not elicit her Master's second glance.

After her death, a Julia Ward Howe trimmed to fit in also appears in A. Wylie Mahon's 1921 retrospective on Howe in the *Canadian Magazine*, titled "The Queen of Hearts." Mahon's Howe is more subdued than the *Passion-Flowers* poet and no longer even a political reformer. Mahon foregrounds a sunny poet telling "jocular" childhood stories, resembling Queen Victoria, sharing with the popular queen "a joy at being alive and at being girl babies" (349). Howe's troubled mother from "The Heart's Astronomy" in *Passion-Flowers* (101–2) becomes for Mahon a happy mama "watching in . . . delight to catch a glimpse of her babies." Mahon's version, however, is scarcely recognizable in the pacing wanderer of Howe's lines:

> While round and round the house I trudged,
> Intent to walk a weary mile,
> Oft as I passed within their range,
> The little things would beck and smile.
>
> They watched me, as Astronomers,
> Whose business lies in heaven afar,
> Await, beside the slanting glass,
> The re-appearance of a star.
>
> Not so, not so, my pretty ones,
> Seek stars in yonder cloudless sky;
> But mark no steadfast path for me,
> A comet dire and strange am I.   (lines 5–16)

To conclude the poem, she rather frantically requests of the baffled children:

> ... when ye know
> What wild, erratic natures are,
> Pray that the laws of heavenly force
> Would help and guide the Mother star.   (lines 33–36)

Instead of a distraught unreliable poet, the 1920s critic presents an uncomplicated, domestic Howe, whose "every good cause never weaned her heart from home, and never made her less of a wife and mother" (Mahon 350).

Reducing the *Passion-Flowers* collection to a tract on Continental politics, bending its verses into quips from a jocular mother, or most significantly, making no comment at all, women in Howe's audience show they have been excluded from the poetic gesture fundamental to Howe's dialogue between the coquette and Master. Their disavowal of her tactics makes them "resistant readers," in Judith Fetterley's terms, of Howe's poems with male-identified audience appeal. The flirtatious exchange of *Passion-Flowers* seems precisely shaped to a female poet and her male reader. This is not to say that a writer can precisely shape a discourse to fit her desired audience.[14] Still, readers excluded by a writer react in surprising ways.

### *Success of Howe's Seduction*

For the nineteenth century, it appears Howe successfully takes the measure of literary men.[15] Looking back in 1899 on her first volume of poetry, the poet at last makes explicit the rhetorical aim of *Passion-Flowers*, now muting its sexual overtones:

> It was a timid performance upon a slender reed, but the great performers in the noble orchestra of writers answered to its appeal, which won me a seat in their ranks. (*Reminiscences* 229)

Gendered allusions to the intimate *Passion-Flowers* couple still shape the elderly poet's musical metaphor for her rhetorical goal. Relative dimensions of a feminine "slender reed" and a masculine "great . . . noble orchestra" give away the poet's intent. Howe admits the purpose of her *Passion-Flowers* was to gain entry into the performance hall of nineteenth-century poetry. To use the coquette's ambiguous metaphor, a strategic dialogue was indeed her "veil of sense," since it both masks and offers a way to publish her poems. At last the poet could find words for her seductive stratagem's complete "revealing." She could confess *Passion-Flowers* had been a successful appeal to men only—for the purpose of joining their artistic ranks. And it worked.

It is not only for Julia Ward Howe that seduction works in the nineteenth century, for the woman poet in Howe's dialogue is as anonymous as her lover. Brave women who do not turn away like Mrs. Hall could imagine themselves in the bold coquette's role. Phillis Wheatley, Mercy Otis Warren, and poets back to Anne Bradstreet only with difficulty managed to publish before 1854. Yet Howe's seduction of the male literary establishment is emblematic—along with Harper's activist pedagogy and Sigourney's downbeat for a chorus—of an army of women writers who successfully campaign in the mid-nineteenth century to enter the antebellum public sphere in different roles with different aims on different fronts. Everyone knows it is hers, but Julia Ward Howe anonymously publishes her erotically tinged *Passion-Flowers*, likely in order to salvage some respectability for a Boston matron with children to raise. The amorphous identity of the *Passion-Flowers* poet nevertheless is also a blank where women who read Howe may write their names to seek their own suitors. If this is not Howe's purpose, it is one effect of her anonymous poetic dialogue.

Concluding this study of Howe's readers, I return to Suzanne Clark's words at the head of this chapter. Her insight that "rhetoric itself" is "sentimental" by extension contends all discourse has sentimental dimensions. Ours does too. My research is one voice in a convocation of investigators into nineteenth-century and sentimental discourse, hardly finished with opening remarks. Women's poetry of the antebellum United States has overtly sentimental codes and conventions, a point significant for demystifying attacks on a body of work only now returning to print. Yet looking for textual codes or logos alone, even adding women rhetors' own textual

personae or ethos, may miss the third dimension of sentimental poetry (and all discourse), which is the audience and writers' tactics to reach it, or pathos. Audience analysis shows that the barriers Howe sails through at her Master's elbow are walls of a male literary institution supporting the Master's powerful status. Paradoxically, his strength as Master weakens in the very gesture of wielding influence on her behalf. Not by logic, but by sentimental positioning—the coquette's poetic rhetoric persuades him and nineteenth-century literary culture to go beyond itself.[16] The Master forsakes an exclusively male literary performance by escorting the coquette into his world, irrevocably extending the discourse of poetry to women.

Full-orbed rhetorical analysis lets us glimpse such political power of sentimental poets' language long after literary preferences change and these women poets go missing. We could, this analysis suggests, consider other dimensions of twenty-first-century discourse with like evocative effects. In other words, an emphasis on nineteenth-century women writers' audience might unfold for us the ongoing politics of reaching our own readers. Who knows? With our own rhetoric of sentiment at work, we too could change the world.

# Conclusion: Sentimental Rhetoric's Poets and Prospects

Serious sentimentalism and its poetry in antebellum America do not come out of nowhere. Shifting conversations about what humans are, what we can know, how we know it, and how to share insights—that is, about humanity and rhetoric—make their way toward an understanding of self and consciousness and methods of discovery that the Scottish Enlightenment and Continental Romanticism call "sentimental" as a matter of common sense.

Taking up sentimental rhetorical conventions, folks who ill fit the common sense will bend cultural traditions out of all recognition to those in antebellum America who take convention and culture for granted. Women and poets and women poets are some of these newcomers, along with people of color and foreigners, unconventionally gendered souls and waves of newly literate poor folks. Earnest to take up conventional prosody, sentimental poets reach unanticipated hearers eager to respond with heart and mind. Yet the rhetorical codes these poets employ with such energy are less significant than their visions and the complexities of their struggles to reach readers and hearers. These poets paradoxically embrace convention and wreak havoc on the status quo.

Listen closely to Frances Watkins Harper's past voices revived, and you catch her joy in poetic ventriloquism's magic as well as the force of her pedagogy insisting we learn from these lives. Listen to Lydia Huntley Sigourney's elegies and cheerful metonymies, and you trace dark days in her apostrophes that bear witness to many who suffer loss of schooling, status, and loved ones. Listen and learn from the transcendentalist Julia Ward Howe that her shell games of multiple poetic selves may slow a spiral of despair, spur Civil War recruitment, and stop a Master reader in his tracks. Like familiar elder relatives' stark old stories that suddenly start to make profound sense and then trail off, these women poets' goals and lives and audiences start making sense and then point down the road at so much more that even rhetorical

logos, ethos, and pathos have not articulated. There is much more to find, to imagine, to ponder.

Once you glimpse these women among vast numbers new to U.S. print literacy and its sentimental poetry before the Civil War, you do not love less the handful long considered literati among American Renaissance poets, writers, and speakers, nor others still famous such as Dickinson, Stowe, Frederick Douglass, and Lincoln. You just begin to wonder what happened to all the others. You think hard about how few are the topics we pay attention to in their vast world; you ponder unspeakable dimensions of language that escape their pages and any page—and you start digging through old library catalogues and online archives, wandering down the long end of quiet stacks, poking through historical society attics, and settling in to read what antebellum folks read. You imagine what they saw in a fireplace mantel now housed in that attic, in newspapers and magazines—fashion, street scenes, shocking photographs of oppression—and how their lives changed in revisions of economic production, of scripture, of the Constitution, of family life, of education, of clothing, of race, of gender. You sense far more than archives can record, and you find we do not know much yet about their world, much less about our own.

If we attend to only a narrow register of known knowns, our twenty-first-century ears will not be tuned to the pitch of unknowns like these poets. The lives and lines of sentimental poets and visionaries—in the nineteenth century or today—do not fit our preconceptions, rigid views of feminine and masculine conventions, or proprieties of race and class. We do justice to nineteenth-century women poets only by imagining them in motion between the conventions of their day and lines of their own texts. Lives and minds in motion are not bound by rules or stereotypes.

More women, more poets, more rhetorics and discourses, more communities and cultures, and many more dynamics of complex power stand yet unarticulated for today's readers in nineteenth-century archives both in the United States and elsewhere. Lifetimes of work continue to reward workers in these vineyards, and the implications of past women's lives begin to press on our own when we take these women seriously and reimagine their exchanges with one another and their worlds.

I am drawn into further research on sentimentalism and dialogue by Jane Donawerth's work on "women's gendered experience in conversation as a model for all discourse" that we consider in "women's tradition of rhetoric" (*Tradition* 1). Moreover, insistent calls in Royster and Kirsch's *Feminist Rhetorical Practices* urge that we connect our historical studies to today's

rhetorical exchanges; this encourages my curiosity about contemporary conversations in the most difficult circumstances. Bearing ongoing fruit, American scholars cultivate new insights into rhetorical and sentimental dimensions of rhetorical listening, racialized oppression and resistance, silence, and material culture, along with myriad discourses and peoples still unfamiliar to academe. More Europeans, especially French and Turkish writers, such as Orhan Pamuk, are overtly discussing the "sentimental" in literature and in public exchanges. Chinese literary scholars ambivalently apply the modifier "sentimental," perhaps to permit their study of sometimes unsanctioned historical texts. Closer to home, in communities torn by racialized violence or by conflict between entrenched opponents, I discover a kind of sentimentalism at work in structured dialogues guided by such groups such as Black Lives Matter and the Public Conversations Project. They seek not consensus, but acceptance and understanding through rhetorical dynamics that echo the logic or logos, the personae or ethos, and audience appeals or pathos of sentimental women poets.

Calls for equitable, structured conversations come from school communities in chaos after violence, university factions advocating distinctive faith traditions and free speech, teachers involved in difficult classroom dynamics, faith communities internally at odds on openness to gay and transgendered members or on abortion rights and euthanasia, environmentalists and loggers, and scholars who collaborate across disciplines, among many others. Out of the limelight, Palestinian and Jewish parents bereaved of children by violent conflict are talking, as are Nigerian tribes formerly locked in battle.

Tactics of transformative dialogue, I find, involve such sentimental strategies as identification or transference (sympathy in sentimentalism), metonymy allowing slides between disparate lexicons of those at odds, invocations of lost martyrs' voices that (like apostrophes and ventriloquism) make the past live, and perhaps the most significant strategy: interlocutors' deliberate efforts to imagine partners' contexts and contemplate the impact of their own next words.

The nineteenth century's sentimental strategies resonate for me not only with Royster and Kirsch's "critical terms of engagement" (19), intended to drive scholarly research in the annals of rhetoric, but also with dynamics of today's civic dialogue that may allow deeply divided people to hear one another.

Whether in archival research, interdisciplinary collaboration, classroom discussion, or gatherings in church basements, agreement is not the goal. Hearing deeply is.

Notes

Works Cited and Consulted

Index

# Notes

INTRODUCTION

1. This project sides with some, like Paula Bennett, who find the "Poetess" sobriquet "deeply problematic" when the lives and textual practices of women poets exceed the bounds of that label. Sharing the goal of Virginia Jackson, Eliza Richards, and Mary Loeffelholz to "read history back into" our views of nineteenth-century women poets, yet I argue the rhetoric of sentiment explains why contemporary men share the women's poetic form and audiences.

2. Molly Meijer Wertheimer's 1997 collection of critical essays, *Listening to Their Voices: The Rhetorical Activities of Historical Women*, expands the range of women's rhetoric by many centuries and voices. Poetry is noted several times. Barbara S. Lesko briefly addresses women's lyric love poems in the reign of Egyptian pharaohs as one genre of "colloquial speech forms" worthy of more notice (106–7).

3. Landmark studies in rhetoric lay the groundwork for this project, including Nan Johnson's *Nineteenth-Century Rhetoric in North America* and *Gender and Rhetorical Space in American Life, 1866–1910*; Winifred Horner's *Nineteenth-Century Scottish Rhetoric: The American Connection*; Jacqueline Jones Royster's *Traces of a Stream: Literacy and Social Change among African American Women* and her foundational textbook written with Gesa E. Kirsch, *Feminist Rhetorical Practices: New Horizons for Rhetoric, Composition, and Literacy Studies*; Shirley Wilson Logan's *"We Are Coming": The Persuasive Discourse of Nineteenth-Century Black Women* and "Black Speakers, White Representations: Frances Ellen Watkins Harper and the Construction of a Public Persona"; Carol Mattingly's *Well-Tempered Women: Nineteenth-Century Temperance Rhetoric* and *Appropriate[ing] Dress: Women's Rhetorical Style in Nineteenth-Century America*. An outstanding new analysis of Harper's work is Michael Stancliff's *Frances Ellen Watkins Harper: African American Reform Rhetoric and the Rise of a Modern Nation State*. Collected essays have gathered several scholars' research, including Gregory Clark and C. Michael Halloran's *Oratorical Culture in Nineteenth-Century America*, Catherine Hobbs' *Nineteenth-Century Women Learn to Write*, and Lynee Lewis Gaillet's *Scottish Rhetoric and Its Influences*. Foundational to these in the broader field of rhetoric are C. Jan Swearingen's *Rhetoric and Irony: Western Literacy and Western Lies*, Susan C. Jarratt's *Rereading the Sophists: Classical Rhetoric Refigured*, and Cheryl Glenn's *Rhetoric Retold:*

*Regendering the Tradition from Antiquity through the Renaissance.* Again, collections gather several projects; these include Andrea Lunsford's *Reclaiming Rhetorica: Women in the Rhetorical Tradition*, Joy Ritchie and Kate Ronald's *Available Means: An Anthology of Women's Rhetoric(s)*, and Christine Mason Sutherland and Rebecca Sutcliffe's *Changing Tradition in the History of Rhetoric*. Linda Ferreira-Buckley and C. Michael Halloran's 2002 edition of Hugh Blair's *Lectures on Rhetoric and Belles Lettres* is crucial to recover the discourse of many nineteenth-century texts, including women's. Other recent studies expand on specific areas of rhetoric, such as women's roles in writing instruction.

In literary studies, certain books set a precedent for both critical and supportive analysis of nineteenth-century women's texts. These include Nina Baym's oeuvre beginning with *Woman's Fiction: A Guide to Novels by and about Women in America, 1820–1870*; Judith Fetterley's *Resisting Reader: A Feminist Approach to American Fiction*; Jane Tompkins' *Sensational Designs: The Cultural Work of American Fiction, 1790–1860*; Carol Smith-Rosenberg's *Disorderly Conduct: Visions of Gender in Victorian America*; Cathy N. Davidson's thorough studies, beginning with *Revolution and the Word: The Rise of the Novel in America*; Hazel Carby's *Reconstructing Womanhood: The Emergence of the Afro-American Woman Novelist*; Nancy Armstrong's *Desire and Domestic Fiction: A Political History of the Novel*; Karen Lystra's *Searching the Heart: Women, Men, and Romantic Love in Nineteenth-Century America*; Robyn R. Warhol's *Gendered Interventions: Narrative Discourse in the Victorian Novel*; Frances Smith Foster's *A Brighter Coming Day: A Frances Ellen Watkins Harper Reader* and *Written by Herself: Literary Production by African American Women, 1746–1892*; Barbara Leslie Epstein's *The Politics of Domesticity: Women, Evangelism, and Temperance in Nineteenth-Century America*; Margaret J. M. Ezell's *Writing Women's Literary History*; Carla L. Peterson's *"Doers of the Word": African-American Women Speakers and Writers in the North, 1830–1880*; and studies such as Gary Williams' *Hungry Heart: The Literary Emergence of Julia Ward Howe*, Mary Louise Kete's *Sentimental Collaborations: Mourning and Middle-Class Identity in Nineteenth-Century America*, Elizabeth Maddock Dillon's "Sentimental Aesthetics," Annie Finch on sentimentalism in both Sigourney's and Phillis Wheatley's poems, and Hortense Spillers' work, including essays collected in *Black, White, and in Color: Essays on American Literature and Culture*. Two recent studies demonstrate research using complex historical frames for sentimental discourse: specific religious denominations' influence in Claudia Stokes' *The Altar at Home: Sentimental Literature and Nineteenth-Century American Religion* and the use of popular ballads in Michael C. Cohen's *The Social Lives of Poems in Nineteenth-Century America*. Many feminist studies make a case for aesthetic qualities of women's sentimental poetry; few conduct rhetorical analyses. A recent exception is Faye Halpern's *Sentimental Readers: The Rise, Fall, and Revival of a Disparaged Rhetoric*, which showcases the process of text and oratory's appeal to readers but does revert to an identification of "sentimentality" with women's bodies. Suzanne

Clark's *Sentimental Modernism: Women Writers and the Revolution of the Word* and *Cold Warriors: Manliness on Trial in the Rhetoric of the West* are model analyses of literature and culture as rhetorical.

4. In the only extended study I have found to date on both rhetoric and early national poetry, Gordon E. Bigelow boldly considered intersections between poetry and persuasion. If poetry were reckoned as a subcategory of argument, Bigelow reasoned, how would the field of rhetoric change? Bigelow pointed out what Hugh Blair, the most popular rhetorician of *belles lettres*, knew: "It is hardly possible to determine the exact limit where eloquence ends, and poetry begins; nor is there any occasion for being very precise about the boundaries" (2:313, lecture 28). Since eighteenth-century rhetoric located poetry as a subcategory of persuasion, verse could be distinguished from rhetoric only as a variety and not as a distinct species. George Campbell's assertion in *Philosophy of Rhetoric* (1783) paralleled Blair's: poetry was "one mode of oratory" (3) or one of several "suasory discourses, or such as are intended to operate on the will" (5). Bigelow recognized "the rhetorico-poetic tradition stretching back some 1500 years to late classical antiquity" did not sharply distinguish verse and rhetoric; he admits "absolute or categorical distinctions between the two modes cannot be made." Even Aristotle's separation of *Rhetoric* and *Poetics* is more a function, Bigelow claimed, of two arbitrary titles than two distinct topics. Elsewhere, since it is high modernism's heyday, Bigelow took pains to draw distinctions between rhetoric and poetry (1–3).

5. Martha L. Henning's *Beyond Understanding: Appeals to the Imagination, Passions, and Will in Mid-Nineteenth-Century American Women's Fiction* is notable for its explicit use of rhetorical frameworks to analyze women's fiction. Nan Johnson has analyzed several genres of parlor rhetoric in *Gender and Rhetorical Space in American Life, 1866–1910*. Rhetorical studies of conduct books include Jane E. Rose's "Conduct Books for Women, 1830–1860: A Rationale for Women's Conduct and Domestic Role in America" in Catharine Hobbs' collection *Nineteenth-Century Women Learn to Write*. See also Wendy Dasler Johnson's "Cultural Rhetorics of Women's Corsets" and Wanlin Li's "Towards a Sentimental Rhetoric: A Rhetorical Reading of Rebecca Harding Davis' 'Life in the Iron Mills.'"

6. Citing the likes of John Steinbeck, William Saroyan, and James Jones, Edmund Fuller insisted that "the most vindictive writers" were "sentimental about incorrigible antisocial and criminal types and whores"; they were at fault for a sentimentality threatening literary morality as a whole and tragedy in particular, tragedy being a more respectable genre representing the fall of great men (59). His sort of good folk lived in "another world of respectable and economically stable people who [to sentimentalists] vaguely are not nice, not right, compared to the ineffable and intransigent 'little people'" (57–58).

7. Carol Mattingly's essay "Telling Evidence: Rethinking What Counts in Rhetoric" (2002) elaborates on the significance of finding hundreds of thousands of nineteenth-century women were active in rhetorical practices and topics beyond the

field's conventional favorites, oratory and suffrage. Mattingly first sets out those discoveries in *Well-Tempered Women: Nineteenth-Century Temperance Rhetoric* (1998).

8. Today's wayward sense of "sentiment" overlooks Ralph Waldo Emerson's equation of "moral sentiment" to "pure sympathy with universal ends" and remarkably to "an oath from the Most High" or "unlimited power." In the essay "Fate," published in 1860 after his son's death, Emerson wrote that "moral sentiment" and "thought" remain the sole "noble creative forces" allowing freedom for human will in the face of uncontrollable events and inherited tendencies (355–57).

9. Joy Ritchie and Kate Ronald's *Available Means: An Anthology of Women's Rhetoric(s)* includes the text of Harper's speech at the Eleventh National Woman's Rights Convention in 1866. Jane Donawerth's *Rhetorical Theory by Women before 1900: An Anthology* includes excerpts on reading aloud, handwriting, memory, literary societies, and conversation from Sigourney's *Letters to Young Ladies* (1833) and *Letters to My Pupils* (1851).

10. Henry David Thoreau wove commemorative verse for his dead brother into prose of *A Week on the Concord and Merrimack Rivers*, instructive as a counterpart to Lydia Huntley Sigourney's elegiac verse. One poem begins, "Lately, alas, I knew a gentle boy . . ." (193). Poetic structure and topics of both poets draw on sentimental conventions.

11. We forget that codes of sentimental discourse apply John Locke's skeptical epistemology where knowledge stems from impressions on the five senses, not from eternally existing a priori ideas. Though it would overturn millennia of faith in deductive logic, sensationalist rhetoric born of Locke's system applied empirical knowledge to moral and useful ends. Enlightenment rhetoric pressed poetry to contain skepticism implicit in such words as "empirical" and "the Scottish Enlightenment." Poetry might manipulate the "mental faculties" and "common sense," terms familiar in the rhetorical system of American antebellum poetry. Nevertheless, I argue in chapters on audience or pathos that to some, mixing unpredictable effects of poetry with Locke's epistemology was a cause for alarm.

12. So many editions and various abridgments of Hugh Blair's work have been published that I refer to volume, chapter, and page numbers from the earlier definitive 1965 reprint from Southern Illinois University Press, which since has published a new edition edited by Linda Ferreira-Buckley and S. Michael Halloran (2002). Citations of George Campbell's *Philosophy of Rhetoric* are by page number from Lloyd F. Bitzer's 1988 edition.

13. Sentimentalism as constriction is evident in Lauren Berlant's essay "The Female Complaint," arguing women's antebellum novels work only as a "genre of containment." Berlant maintains only "the strictly sentimental deployment of family discourse" is open to women (246).

14. As an empiricist, Campbell favorably and at length contrasted inductive "natural logic" to "the scholastic art of Syllogizing . . . , the dialectic of the schools, . . . now fallen into disrepute" (61+).

15. Gregory Clark and S. Michael Halloran once worried that the widespread snare of sentimentalism in nineteenth-century discourse hastened death of traditional syllogistic oratory, to which they credited a "public moral consensus" ("Nature"). They challenged an individualistic "rhetoric of identification," which thereafter subtly corrodes American ideals (Frederick Antczac, qtd. in Clark and Halloran, "Nature"). However, a generous 1994 collection from Clark and Halloran, *Oratorical Culture in Nineteenth-Century America: Transformations in the Theory and Practice of Rhetoric*, offers an ample range of sentimental rhetorical practice.

16. As dominant discourse, sentimentalism worked on both sides of the Mason-Dixon line and sometimes against progressive causes. Mary Henderson Eastman's *Aunt Phyllis's Cabin; or, Southern Life as It Is* (1852) is one example of pro-slavery sentimental fiction. *Balcony Stories* is a collection of southern tales by Grace King first printed in the New Orleans *Century* magazine after the Civil War and reprinted in 1994. On poetry, the remarkable text of Sidney Lanier's lectures at Johns Hopkins University, *The Science of English Verse*, was published after the Civil War. It nevertheless applied sentimental conventions to nineteenth-century verse generally. A penciled note on the frontispiece reads, "This volume embodies Lanier's two courses of lectures at Johns Hopkins University. He was a Confederate and the hardships of camp and prison life contributed to his early death. He was the poet of 'the warm South'" (1880).

17. In "Education and Psychoanalysis: Teaching Terminable and Interminable," Shoshana Felman elaborates on a similar sympathetic transference and countertransference between students and teachers.

18. I adapt questions Jacqueline Jones Royster applies to Alice Walker's essays, previewing an approach Royster uses throughout her study *Traces of a Stream: Literacy and Social Change among African American Women*. Royster asks two questions of Walker's essays:

> 1) By what values does Walker define her task as an essay writer? And
> 2) What are the distinguishing characteristics of her way of seeing and expressing in this form that would suggest a pattern of action that might be instructive for the examination of other African American women writers? (26)

## 1. ANTEBELLUM AMERICAN WOMEN POETS

1. William Cullen Bryant, John Greenleaf Whittier, the Connecticut "Wits," Walt Whitman, Ralph Waldo Emerson, and others called for distinctively American literature.

2. An early modernist aesthetic may be at work in the 1923 anthology *American Poetry*, where just seven of sixty-four poets are women and none have three poems; Louise Imogen Guiney is the only woman with two. Harper, Howe, and Sigourney are missing.

3. Three important anthologies of women's verse (1842–69) are *Pearls from the American Female Poets*, edited by Caroline May; *The Female Poets of America*, edited by Thomas Buchanan Read; and *The Female Poets of America*, edited by Rufus Griswold. For male poets, see Griswold's *The Poets and Poetry of America* (1842). Charles A. Dana's *The Household Book of Poetry* (1859) includes verse by both women and men.

4. For explorations between humanist values and middle-class women, see Joyce Warren's *The American Narcissus: Individualism and Women in Nineteenth-Century American Fiction*.

5. Warren does concede that with her contemporaries, Fern embraced a maternal role and exhorted readers from that stance:

> Because a woman can appreciate a good book, or even write one . . . , is she to disdain to comb a little tumbled head, or to wash a pair of sticky little paws, or to mend a rent in a pinafore or a little pair of trousers? I tell you . . . she will never, never disdain it. (*Fern* 214–15)

Fern's refusal to deny domestic and the maternal discourses positioned her within them. Doubtless, as for other women writers of the day, references to a child's "little tumbled head" added moral weight to her persona and to her contemporary appeal. With Warren, I praise Fern's courage, but many will hesitate over demands made by maternal discourse. Should modern women readers and writers "never, never disdain" the role of motherhood? Not Fern's audacity but her insistence on maternal conventions may give us pause today.

6. Economic necessity required Lydia Sigourney, like her fictional Lucy, to leave school at thirteen after stints in at least eight schools (Collin 16–17).

7. Jane Tompkins' analysis of Susan Warner's *Wide Wide World* as an "education in submission" has implications for Lucy's submissiveness (*Sensational* 182), but Warner's training of Ellen proves more severe than Sigourney's. Ellen's journal is such a threat to her mentor and fiancé that he takes it from the girl.

8. Bradstreet's stanza concludes:

> For such despite they cast on female wits:
> If what I do prove well, it won't advance,
> They'll say it's stol'n, or else it was by chance.     (lines 28–30)

Her use of maternal metaphors both to excuse and to write poetry would have served as a model to nineteenth-century women. In "The Author to Her Book," an extended apostrophe scolds what she calls the bastard "offspring of my feeble brain," while she lovingly revises her text for a second edition (221). My helpful last best Southern Illinois University Press reader, Jane Donawerth, recommends the 1997 anthology of early modern writing by British women, *Lay By Your Needles Ladies, Take the Pen: Writing Women in England, 1500–1700*, edited by Suzanne Trill, Kate Chedgzoy, and Melanie Osborne.

9. When Howe has children, she tries to learn to cook from Lydia Maria Child's *The American Frugal Housewife* (1836); her first attempts became a family joke, but she writes in *Reminiscences*, "I got on better after that" (102). In girlhood, Julia Ward was surely "pampered" (Walker, *American Women Poets* 142), especially as Howe's privileged childhood contrasts brutally to hundreds of thousands of African Americans' early years before the Civil War. Howe's education likewise outstrips that of working-class children like Sigourney or Watkins Harper, who after their early teens have little access to formal education. Years after leaving a girls' day school, Julia shares exacting private tutors with her brothers. Doubtless, all her life she has domestic help whose labor give her time to write. Yet Walker might now agree "pampered" can be one of those marked terms too easily applied to antebellum white women poets. It is a term rarely applied to male elites—Emerson for one—who, like Howe, inherits family money. Howe, Sigourney, and Harper typify a range of antebellum women poets called to Howe's "sense of literary responsibility which never left me" (Clifford, 32).

10. Parker's Unitarian sermons lack sufficient "impressions of reverence" for their children, said Howe's husband. Yet "it was a grievous thing for me to comply with his wishes," Howe reports, when to keep peace she left Parker's church for more traditional preaching under Christian transcendentalist James Freeman Clarke (*Reminiscences* 244). Howe says Parker "insisted . . . upon the claim of the sex to equality of education and opportunity"; he invited to his pulpit feminists Lucretia Mott, Mrs. Seba Smith, and Rev. Antoinette Brown Blackwell, the first woman minister "regularly ordained" in the United States. "I am almost certain that Parker was the first minister who in public prayer to God addressed him as 'Father and Mother of us all,'" Howe writes (*Reminiscences* 166).

11. Howe's first child, Julia Romana, is born in Rome and baptized there by Theodore Parker (*Reminiscences* 161). Perhaps Parker is one of those Howe looks to as "Master" and patron of her poetry.

12. Howe will not part with any child, invoking maternal discourse against her husband's threats to leave and against disastrous social and economic consequences for a wife. With little legal status and no birth control, one price of Howe's reconciliation is bearing two more children.

13. Baym admits Sigourney's verse has more a sense of "other-directedness" than the "narcissistic woman's tradition" overall ("Reinventing" 389).

14. Women's feeling is not a different species of affect from that sustaining men's poetry of the day. Howe at the end of the nineteenth century believes sentimental poetry will endure in the American canon. She says in 1898 of Emerson's poems, "In the popular affection, they may outlast his prose" (*Reminiscences* 291). Howe's own contemporary success in print shows that she, like Emerson, had a finger on the pulse of "popular affection."

15. Shirley Wilson Logan uses Alice Walker's term "womanist" for the gulf between Frances Ellen Watkins Harper's discourse on domestic and writing chores and white

women's worry about managing both: "Womanist," Logan says, is "Harper's consistent identification with and articulation of the ways in which Black women's experiences were different from those of their White contemporaries" ("Speakers" 24).

16. Sigourney's view of interwoven sound and sense anticipated Julia Kristeva's argument that "discourse is *dialogue*: its organization, rhythmic and intonational as well as syntactical, requires two speakers in order to be completed" (*Sun* 41; italics in the original). Sigourney has no verse dialogues, but inchoate sound and articulation are distinct yet interwoven in her work. Her poetry thus embodies Kristeva's "'semiotic' and the 'symbolic' [as] the communicable imprints of an affective reality" (*Sun* 22). Diction and syntax may separate subjects and subjectivities in language, but poetic sound connects.

## 2. FRANCES ELLEN WATKINS HARPER, BLACK POET VENTRILOQUIST

1. Carla Peterson argues that new poems ending Harper's second edition frame the rest by illustrating "how from biblical times to the present women within the supposedly protected domestic sphere have been made to suffer as a consequence of male political actions" (131).

2. Melba Joyce Boyd reports the poet's original gravestone has the 1824 date but 1825 was the date of birth reported in Harper's lifetime (*Legacy* 234).

3. Laura Mulvey, E. Ann Kaplan, Theresa de Lauretis, and others influenced by these critics discuss implications of women onscreen in American cinema. Their take on women objects of "the gaze" is complicated by audiences' identification with a male or female protagonist, by gendered identification of the watcher as that crosses or reinforces conventional gender roles, by relative power or authority of women in the gaze or cast as watchers—and of course, by race.

4. I am grateful for comments from Dorene Ames, communicated to me by e-mail on 27 December 2003. Ames' dissertation in American Studies at Washington State University–Pullman was defended in 2010.

5. As a Unitarian, Harper would likely have seen women in the pulpit. In her *Reminiscences*, Julia Ward Howe notes that Thomas Peabody's Unitarian pulpit in 1840s Boston was the first to host women preachers. See also chapter 5 on Harper's activist Unitarian connections as they inspired her teaching.

6. Belletristic rhetorician Hugh Blair reiterated that pulpit oratory should follow a mixed format advocated by Dennis. Blair placed a specific appeal to emotion, "the great spring to human action," just before a sermon's conclusion (2, lecture 32). In this same location, Harper's poetic ventriloquism would consequently arouse passions precisely before she calls hearers to rise up against slavery. It cannot be accidental that the eminent African Methodist Episcopal Zion minister Bishop J. W. Hood (North Carolina state administrator of education and an author), Harper's contemporary, inserted a brief poem just before the final appeal of his sermon "The Soul's Anchor." The poem supplements Hood's scheme of deductive logic with "analogic" or "poetic logic," both of which Paul A. Minifee found throughout

this famous preacher's sermons (2001; used with permission). Placement of Hood's poem just before concluding fits the Enlightenment logic of arrangement according to mental faculties that makes nineteenth-century oratory, including Harper's, so effective in shaping public sentiment.

Not all nineteenth-century sermons include poems, but many have a distinctly poetic feature in the next-to-last phase. Lyman Beecher, Harriet Beecher Stowe's famous preacher father, includes a poem, an analogy, or an extended second-person apostrophe at this point in all four sermons collected in *Lyman Beecher and the Reform of Society: Four Sermons, 1804–1828*. Henry Ward Beecher uses these tactics and sometimes a story or a letter in the same phase of eleven orations collected in *Lectures and Orations by Henry Ward Beecher* (Hillis). Researching sermons by African Americans, Cleophus J. LaRue in *The Heart of Black Preaching* includes several nineteenth-century sermons as examples. Both pieces by Francis J. Grimke (an abolitionist orator contemporary to Harper) include poems in this crucial next-to-last spot (154–55, 167). Daniel Alexander Payne, in a sermon just after the Emancipation Proclamation, included an exclamation at this point: "O, that God may bring them . . ." (178). Sermons from Jeremiah A Wright Jr. and Fred C. Lofton, early nineteenth- and twentieth-century ministers, respectively, both included poems or lyrics from hymns in this spot (196, 219, 221). In sermons to this day, something poetic (imaginative, heart-stirring, stylistically and rhetorically unusual), often a poem, occurs at the moment of high passion just before the conclusion.

7. Reading this, Jane Donawerth reminds me Harper's "household wreaths" recall nineteenth-century women's funerary art that wove hair of departed relatives into circles of memory.

8. I am indebted to Wendy Olson's insight that Harper both omits and adds implicitly racialized markers to deepen white readers' identification with the slave mother. Wendy Olson is an associate professor of English and the director of writing at Washington State University Vancouver.

9. For an extended discussion of Harper's ballad strategies, see Carla Peterson's analysis (128–30). My thanks also to Wendy Olson for noting this structure in Harper's Ohio slave mother poem.

10. Campbell began chapter 1 of his *Philosophy of Rhetoric* by defining rhetoric "in its greatest latitude" as "'that art or talent by which the discourse is adapted to its end.'" He reiterated common faculties of the "new mental science." Discourse must be shaped "to enlighten the understanding, to please the imagination, to move the passions, or to influence the will" (10). While the term "speech" appears in this passage, when he earlier introduced his theory of rhetoric, Campbell agreed with Aristotle that "poetry indeed is properly no other than a particular mode or form of certain branches of oratory" (lxxiii).

11. Harper fights long and hard for women's issues—and sometimes against white women when debating the Fifteenth Amendment, which in 1868 recognized black men's right to suffrage. Shirley Wilson Logan (*"We Are Coming"* 44–69) and

Carol Mattingly (*Well-Tempered Women* 75–95) both thoughtfully analyze Harper's speeches on the Fifteenth Amendment and her frank exchanges about race with white leaders of national women's groups. These organizations would have passed resolutions against the amendment, stifling Harper's support of black men's suffrage. White women deserve the vote first, they argued, advancing a position no less racist than it was thoughtless of African Americans among the ranks of women suffragists.

12. In context of the imagination, Connor discussed the frenzied Oracle of Delphi and an uncanny accurate prophesy from the Bible's Witch of Endor among ancient ventriloquists. These two women mediums are emblematic of disempowered regimes, Connor argued. They act like marionettes, the puppets of outside powers. In addition to frenzy and necromancy, moreover, there is violence. There is sex. The overpowered female *engastrimyth* (or belly-speaker) must attribute substance and power to a male deity speaking through her (47–101). By the seventeenth century, a critical shift then seeks to explain how the *engastrimyth* manages to project a voice. Connor identified Casserius' 1601 *Anatomical History of the Organs of Voice and Hearing* as an early book explaining ventriloquism in physical terms rather than theological. Casserius and others wrenched ventriloquism out of antiquity where the trick had produced ontological messages male deities transmit to hearers. Enlightenment studies redefine the discourse as a repertoire of technologies, a rhetoric, a means to suspicious moral and political ends sought by powerful and almost always male opportunists.

13. Discussions of "voice" today in writing instruction often appeal to "authenticity": "true," "real," and "natural" impulses in textual voice. Yet Connor called such a tone the "phallic" voice; it insists that "What I Say Goes," the title of Connor's first chapter (3–43). This voice forces itself on others' views of the world, muffling their voices. It is a desire for an integrated self, for a voice emanating solely from some human body, that produces any sense of "voice" in texts. The same hope produces a semblance of wholeness about my texts and myself. My imagination rebels when a voice seems to come out of nowhere. I want to attach a body to it. Every mother's voice had such a body. At first an infant's wails and later her death articulate a chasm that opens between oneself and that mother-body—so Julia Kristeva's theories argue.

14. Nan Johnson responds to an H-RHETOR e-mail question about whether "the Big R rhetoric" can still be taught, "I would say to this crucial question, now more than ever . . . now more than ever students need to learn to be rhetorical critics, to see how the discourse around them uses them and constructs them." She continues, "How can [students] hope to intervene in the cultural arguments that shape their lives if they do not know how one composes arguments?" We see historical subjects, and our own selves, differently if we invoke rhetorical frames for study.

15. I am indebted to Jerzy Axer, who connected rhetorical history to the present in his presidential address at the 2001 Warsaw conference of the International Society for the History of Rhetoric. Having survived decades of Poland's upheaval, Axer remarked on obstacles to cultural change, "How hard it is for the dumb to regain

the power of speech, and the deaf to regain their hearing." Our work, Axer said, is to reanimate voices of the past in tones today's ears can hear.

## 3. REVIVING LYDIA HUNTLEY SIGOURNEY

1. For many twentieth-century critics, Lydia Huntley Sigourney's elegies eclipse other issues in her work. Introducing Sigourney in a 1991 anthology of women poets, Cheryl Walker defends the woman, "much maligned as a sentimentalist," and calls for more work on her, yet she emphasizes Sigourney's reputation for "moralistic sentiments and her poems about death" (*Burden* 1). Barton Levi St. Armand claimed Sigourney was chief evangelist of the "Sentimental Love Religion," which he said centered on obsession with dead loved ones, especially children (43). For St. Armand, Mark Twain's Emmeline and Sigourney share the camp of "duplicitous popular culture" whose "sedulous imitation" Huck Finn could not bring himself to perform (43). Emily Dickinson's funeral crowns St. Armand's chapter comparing Sigourney and Dickinson. In a study celebrating Emily Dickinson's elegies, Elizabeth A. Petrino likewise used Sigourney's commemorative verse as a foil. Nina Baym's thoughtful study "Reinventing Lydia Sigourney" takes Sigourney's "elegiac project" seriously (70), categorizing the obituary verse by various topics and acknowledging her power "to make suffering people feel better—and make them feel better fast" (69). Even in Baym's "reinvention," Sigourney comes off as a dispenser of bromides. Baym's criticism is surprising, since she earlier challenged conventional use of the modifier "sentimental" as too "often a term of judgment rather than of description, and the judgment it conveys is of course adverse" (*Woman's* 24). Among other recent reviewers, however, Mary Louise Kete in *Sentimental Collaborations* (2000) expands on Baym's category of nationhood to consider how Sigourney's elegies participated in discussions of what the early republic could be. These and other critics provide useful information about Sigourney as elegist, but many reinscribe a partial view. This rhetorical study extends Paula Bennett's long-standing class-based, gendered, and psychological analyses of Sigourney's work.

2. The personae crowding Lucy's poetry are enlivened by a mixed bag of other genres. My favorite Lucy among these writes a sensationally comedic recipe for her own novel, an outline clearly drawn from potboilers of the day—though a pious Lucy claims, "I have never read one." She directs would-be novelists to mix "Earls and Countesses, and several singular people, and beauty and love, and dangers and escapes, and perils and quarrels, and shake all up together, and the end would be matrimony." Lucy summarizes her story: "A great deal of uncommon action to arrive at a common condition. And then, I understand, all the romance vanishes" (*Journal* 76). The wife Lucy becomes will not question the continuing romance of marriage, for she simultaneously adores and teases her husband as "a being quite above me; something to look up to and be afraid of, like the Grand Mogul" (*Journal* 179). But the girl Lucy who writes the potboiler can't help challenging "happily ever after" endings. Lucy's comment on marriage as the end of romance may have hit closer to

home for Sigourney. Verse in another tale moves a self-righteous Lucy to relent and join in what she imagines her mother would call the "bold and hoydenish" play of girls and boys sliding hand in hand down a snowy slope. One girl flying past taunts fussy Lucy Howard with a couplet parodied from Pope: "What can ennoble slaves or cowards? / Not all the blood of all the Howards" (*Journal* 21). Unable to keep from laughing, Lucy herself then lets admirer Henry grab her hand for a slide down the hill. In more serious poses, Lucy includes lines from famous poets and hymns, verse summaries of lessons, birthday poems, and even recipes set to rhyme and meter. Nevertheless, a playful Lucy also fools around with puns like this child's slip on the prayer, "Now I lay me down to sleep. . . ." The child innocently asks, "Mamma, I'm awful tired of always saying 'Now I *lama*;' won't it do once in a while to say, 'Now I *camel* down to sleep'?" (*Journal* 66; italics in the original).

3. Although Annie Finch, Laura Mandell, and Peggy Davis collaborated on a collection titled *Poetess Poetics: A New Look at a Lyric Tradition* (now the online *Poetess Archive*) that includes Sigourney among British and American poets honored, the Modern Language Association index shows many more approving titles on Hemans than about her American avatar. To scholars of British women's poetry, Hemans has become something of a broad cause célèbre; Nanora Sweet at the University of Missouri has edited a selection of essays from the boom of recent work exclusively on Hemans. As perhaps a more popular measure of Hemans' reemergence, Garrison Keillor read the poet's "Evening Song of the Weary" on National Public Radio's *Writer's Almanac* in July 1997.

4. Clarke writes of Hemans, "American readers in particular, were relentless in pursuit of her; . . . she lived and worked in a 'constant excitement, homage' [Hemans' words] which made her profoundly uneasy" (50).

5. Jane Donawerth reminds me that long before 1842, John Wesley had licensed Methodist women to preach, and Quaker women led congregations from the first. According to *Conservapedia* ("United Methodist Church"), however, the first Methodist woman preacher, Helenor Alter Davisson, was not ordained until 1866.

6. Dwight's "compliment" recalls similar backhanded praise in James Nathan's 1873 Prefatory Note to a supposedly tell-all collection, *Love Letters of Margaret Fuller*, asserting that notes between himself and Fuller reveal "that great and gifted as she was as a writer, she was no less so in the soft and tender emotions of a true woman's heart" (5).

7. In addition to Baym, Bennett, and Kete, Patricia Okker notes that Sigourney's poetry, "rather than focus on women's passivity as the genteel tradition prescribes, . . . repeatedly insists on women's strength" (37). When Sigourney addresses topics on the West, she stands out in contrast to Alice and Phoebe Cary, says Steven Olson; he notes briefly, "Unlike the Carys, Sigourney does not stress the role of white women in the West. Rather, she emphasizes the difficulties faced in the wilderness by Indian women" (82). "Furthermore," Olson continues, "unlike Bryant, whose 'Monument Mountain' remains purely romantic, she focuses on some real hardships confronting native women" (83).

8. The biblical version gives more space than Sigourney to historically situate the prophet's message, noting contemporary kings and the eruption of a volcano.

9. Baym does try to counter Ann Douglas and others following Gordon Haight's sarcastic caricature of Sigourney in the 1930s as "the most private and domesticated of antebellum women authors," for Baym elaborates on the broader "moral republicanism" of Sigourney's political verse (*Woman's* 403–4). Moreover, Baym emphasizes the "public arena and . . . practical goal" of even the poet's consolatory verse (*Woman's* 389) over "any immediate occasion of death," even in her most poignant *memento mori* poems (*Woman's* 388).

10. In other texts, Sigourney sounds more consistently like a mother. The adviser-narrator in *Letters to Young Ladies* often takes that maternal tone. Numbers of poems and stories also speak to mothers; these, as expected, appeal to familiar feminine conventions of the nineteenth century. However, Sigourney advocates traditional aspects of womanhood less than one might suppose. Of more than a hundred titles in the 1842 *Poems*, fewer than twenty refer to wives, sisters, or mothers or include names of women.

11. Eighteenth- and nineteenth-century proto-feminist traditions of women preachers among British Methodists and Quakers are the subject of Christine L. Krueger's 1992 book, *The Reader's Repentance: Women Preachers, Women Writers, and Nineteenth-Century Social Discourse*. Krueger says of women novelists, a "paradoxical relationship of female speakers and writers to patriarchal discourse cannot be overemphasized." Krueger sees a "dialectic and opposition" in sermons by women who "mounted vigorous resistance to domestic ideology on the basis of scripture and evangelical teaching" (6–7).

12. Lucy's dame school curriculum aims to teach indigent neighbor girls a literacy considered appropriate to their status: no writing (though the poet's own schools emphasized writing), but first sewing so that they could make their own clothes and a meager living, and only then some reading. Indeed, Lucy's steps for setting up her school are written out in such detail they could easily guide readers who might teach classes in their own neighborhoods. A star pupil, Lucy undertakes this neighborhood project at fourteen as a way to continue her education though her grandfather insists that she quit her own schooling to learn "the domestic science of making home happy" (*Journal* 62).

13. Among Lydia Huntley Sigourney's papers at the Connecticut Historical Society, Charles' pocket notebook lists her faults, frequently referring to insubordination. Also in Charles' script is a four-page complaint against her writing and publishing that reads like a legal indictment.

14. Angela Sorby observes that in a "schoolroom canon," poems "accrued cultural power through repetition"; they "established affective bonds between individuals, institutions and the nation." However, Sorby argues that late nineteenth-century school recitation of American popular poetry, including "child-voice" poems by Emily Dickinson, links them all to a "discourse of infantilization and pedagogy" she sees as still dominant (62).

15. Song lyrics requested of the poet for her hometown Norwich Academy's fiftieth anniversary were not sung but recited at this celebration and printed in a commemorative volume. Haight reports this as an insult to Sigourney (169).

16. Edna Edith Sayers and Diana Gates wrote one of several recent studies (2008) linking Sigourney to founding of the Gallaudet school for the deaf and blind.

17. I do not mean to overstate the case for a rebellious Lucy Howard—or a rebellious Lydia Sigourney. The poet makes this girl sometimes undeniably priggish. Two-thirds of one long entry consists of a dialogue between Lucy and a little friend who wishes that she "could have [her] own way sometimes." Lucy asks, "Can't you make your own way the same as your mother's? Then you'd always have your own way" (*Journal* 25). The last third of that day's entry is written by a quite insufferable little Lucy announcing she is always completely obedient to her mother, asserting, "If I were thinking how I might rule her, or hide things from her, I should be miserable." The day's dreary catechism concludes, "I would have repeated the fifth commandment [Honor your father and mother . . .] to my school-mate if she had not got so angry and flown away" (*Journal* 26). This goody two-shoes forgets that a few pages back, Lucy's secretive self worried about the propriety of writing "piles" of poetry, saying, "I hope mother will not find them. I never tried to conceal any thing from her before" (*Journal* 15). Evidently, the not-so-pure Lucy is of two minds on secrecy and obedience.

18. This conflation of veneration for a dead woman with worship of God also appears in "The Lost Sister," a powerful elegy among Sigourney's works discussed in chapter 6.

19. Many consider Thoreau's *A Week on the Concord and Merrimack Rivers* an elegy for his brother, John, who dies in 1839 after the two travel the length of these streams. Thoreau scholar William Rossi jokes that this book may be the only way Henry Thoreau could get a collection of poems published, many in memoriam of John.

20. Anne Frank's diary, for example, reveals a strong-minded twentieth-century writer with designs on our sentiments, exceeding her own text to rise again in the imagination. On the fiftieth anniversary of Anne Frank's death, a National Public Radio report ("Anne Frank Remembered") concludes with various teenage voices reading excerpts from *Anne Frank: Diary of a Young Girl*. The last was a young woman refugee from Bosnia, whose own displaced sense of self multiplies the textual personae-in-process and power of Anne's words. It also extends the life of Frank's text. Anne Frank writes:

> It's really a wonder that I haven't dropped all my ideals, because they seem so absurd and impossible to carry out. Yet I keep them, because in spite of everything I still believe that people are really good at heart. I simply can't build up my hopes on a foundation consisting of confusion, misery, and death. I see the world gradually being turned into a

wilderness, I hear the ever approaching thunder, which will destroy us too, I can feel the sufferings of millions and yet, if I look up into the heavens, I think that it will all come right, that this cruelty too will end, and that peace and tranquility will return again. In the meantime, I must uphold my ideals, for perhaps the time will come when I shall be able to carry them out. Yours, Anne. (237)

"I must uphold my ideals," Anne Frank insisted just days before German forces arrest all the occupants of her Amsterdam "Secret Annexe" (243).

21. Samuel McChord Crothers wrote *The Gentle Reader*, an affectionate 1903 book on the audience of sentimental discourse. Interestingly, Crothers still describes this reader as a masculine lover of books: "There is no one in all the world so careless of the distinctions between Meum and Tuum," he claims (vii).

## 4. JULIA WARD HOWE'S "I—S" AND THE GAZE OF MEN

1. Whittier's illustrations turn up in a five-by-seven-inch tract on general shelves of University of Oregon's Knight Library. Bound in light green cardboard, this handsome booklet may have been handed to churchgoers entering a Sunday service. Figure 4.2 reproduces the first page of the tract.

2. Whittier showed deference to women writers and collaborators. He saluted Lydia Maria Child, "O woman greatly loved!" for a commemorative poem (*Works* 252–53). As noted in chapter 6, he described Sigourney's poetry as "tender and sweet, a music all her own," now on a memorial plaque in her Hartford church (*Works* 585). Whittier wrote his colleague in "To Lucy Larcom," requesting a review he does not have time for:

> Pray give the "Atlantic"
> A brief unpedantic
> Review of Miss Phelps' book.                (*Works* 628)

Jacqueline Jones Royster reminds me that Whittier also published poetry by the Grimke sisters and other black women poets.

3. Howe's poem "The First Martyr," a dialogue between a northern mother and child about John Brown's death (*Later Lyrics* 12–14), shows how slowly the poet came to abolitionism. She does not share her husband Samuel Gridley Howe's convictions until after the Harper's Ferry plot failed.

4. Marjorie Jane Trapp's 2010 study "Sentimental Poetry of the Civil War" places poetry central to description and reports of the war. In verse, "the radical upheaval and violence of the war becomes a poem. . . . This verse made meaning of the war by translating the inexplicability of the war into bounded and (largely) explicable texts."

5. Nobel Prize–winning Turkish novelist Orhan Pamuk takes from Schiller his title and inspiration for *The Naive and the Sentimental Novelist* (2011), emphasizing

a spectrum from "unaware" or naive writers and readers to the "more reflective," sentimental sort. To show the merge of writer, reader, and the text's hero, he describes an identification nineteenth-century sentimentalists engaged to convince readers of their agency; as a boy reader, he claims, "I felt a breathtaking sense of freedom and self-confidence."

## 5. SLAVE MARKET MATRIX OF HARPER'S CRITICAL PEDAGOGY

1. To stress a respectful ecology of the natural world (nature), Gruenewald expands on a foundational scene of instruction sketched by educational theorist Paulo Freire: "Human beings *are* because they are in a situation. And they *will be more* the more they not only critically reflect upon their existence but critically act upon it" (qtd. in Gruenewald 310; italics Freire's). Being fully human, in other words, requires critical reflection and action on behalf of the place where you find yourself.

2. Harper's poem "The Slave Auction" appears on a Cherokee Nation educational website in 2011.

3. Establishing such a "hard fact" has required repeated discussion: in court, through a Civil War, by amendments to the Constitution, and in ongoing struggles to protect civil rights for people of color. Humanity and citizenship were still at stake in Rick Perry's 2002 successful gubernatorial campaign as champion of "real Texas values" against an African American candidate. In 2016, laws limiting voting rights provoke the same arguments.

4. Two essays record Frances Smith Foster's research into nineteenth-century AME Church publications that give context for Harper's and other black writers' work: "African Americans, Literature, and the Nineteenth-Century Afro-Protestant Press" provides a broad sketch of early African American presses, and "Gender, Genre, and Vulgar Secularism: The Case of Frances Ellen Watkins Harper and the AME Press" resituates Harper as a force in the specifically sentimental discourse the AME presses were part of, organs specifically "designed to speak to, about and for African Americans" (51).

5. *The Transcendentalists*, an anthology edited by Perry Miller, recorded controversies that led to Transcendentalists' leaving the Unitarian church, and so clarified theological positions of both. Unitarianism expanded to embrace Universalism's assertion that true divinity occurs in many faiths, and likewise to include transcendentalism's understanding of spiritual inklings in every material object. The denomination's principles eventually transfer a messianic optimism from Jesus to the potential of each human being. Unitarianism's immanent view of divinity and its upbeat view of humanity contrast, for example, with bleaker Calvinist views of God's distaste for human depravity based on original sin. These points of Calvinist doctrine assume people on their own have no power to change; a sovereign God alone can deliver mortal beings from their failings. But Unitarian optimism, as I have discussed for Julia Ward Howe's poetic personae, borrows from European romanticism some philosophical underpinnings and its faith in human capacity to

learn and do good. Useful outlines of Calvinist doctrine are accessible online. "The Five Points of Calvinism," an article on the *Calvinist Corner* website established by Matthew J. Slick, elaborates on TULIP, a mnemonic acronym for Calvinist doctrines: Total depravity, Unconditional election, Limited atonement, Irresistible grace, and Perseverance of the saints.

6. When Unitarianism later merges with transcendentalist thought, Robinson reports, a process of self-examination and self-improvement that orthodox Christians believed was "a *means* becomes an *end* in itself" for Unitarians (29; italics added). According to a list furnished by the Michael Servetus Unitarian Fellowship of Vancouver, Washington, the first source of Unitarian teaching is not the Bible, but "direct experience of that transcending mystery and wonder, affirmed in all cultures, which moves us to a renewal of the spirit and an openness to the forces which create and uphold life." A second source of the church's teaching is the "words and deeds of prophetic women and men which challenge us to confront powers and structures of evil with justice, compassion, and the transforming power of love." Those words and deeds from human prophets include the Bible, but the Unitarian list adds other teachings on equal footing from Jewish, Christian, humanist, and "earth-centered traditions." According to this precept, seekers of spiritual truth on any path share the same divinity. Significant for Harper's goal of critical pedagogy, especially on issues of race, Unitarian goals underscore "the inherent worth and dignity of every person" and each one's right to "a free and responsible search for truth and meaning" within a "world community with peace, liberty, and justice for all." The "Unitarian Universalist Principles and Purposes," along with other information about the denomination, can be found on the Unitarian Universalist Association website.

7. Hortense Spillers is interviewed online in 1998 by Tim Haslett from the *Black Cultural Studies* website, who asked her to elaborate on implications of her groundbreaking article "All the Things You Could Be by Now If Sigmund Freud's Wife Was Your Mother: Psychoanalysis and Race."

8. Writer bell hooks' flood of accessible, provocative books may be designed for such church, community, and reading circles. Four evocative titles from hooks' long list of publications suggest these are just the audience she seeks: *When Angels Speak of Love, Rock My Soul: Black People and Self-Esteem, Salvation: Black People and Love*, and *Sisters of the Yam: Black Women and Self-Recovery*. Preservice teachers find her books useful to discuss classroom issues; one of the latest is *Teaching Critical Thinking: Practical Wisdom* (2009). All three women—Harper, Spillers, and hooks—insist black people should read and talk more together on provocative subjects.

9. Michael Stancliff persuasively argues that all Harper's "major questions of policy, leadership, and affiliation" have to do with "rhetorical instruction and pedagogical politics," thus positioning herself as teacher and all readers as students in her transformed classroom.

## 6. PROBLEMS FOR SIGOURNEY'S READERS OF SENTIMENTAL RHETORIC AND CLASS

1. Joanne Dobson mentions Mikhail Bakhtin relative to a critique of Sigourney's weakness and helplessness ("Reclaiming" 272), and Mary Loeffelholz cites Pierre Bourdieu to discuss Sigourney's self-construction as a teacher in "a larger field of cultural possibles" ("School" 35). In the most sophisticated of these analyses, Paula Bennett argues that "resituating the Gransci-Williams concept of hegemony within" an understanding of the "Habermasian public sphere allows us to honor the power of domestic ideology's 'intimate discipline' while still making room for agency and change" (*Public Sphere* 114). My study often fits Bennett's analysis, which, however, ascribes even more power to conventional domesticity than I find in these poets' lives.

2. In "Writing in Circles," Nicole Tonkovich likewise argues that anonymity is both helpful and limiting to novelist Harriet Beecher Stowe and other women in literary circles such as the Semi-Colon Club.

3. Robyn Warhol carefully articulates a genealogy of critical response to the "narrative 'you'" and direct address in Victorian novels in her 1989 *Gendered Interventions: Narrative Discourse in the Victorian Novel*. There she emphasizes a "feminine presence behind the narrative 'I,'" which asserts "female influence over the moral condition of the reading audience" (205). However, in an unpublished paper delivered at the 1993 MLA convention, "'Reader, Can You Imagine? No, You Cannot': The Narratee as Other in Harriet Jacobs's Text," Warhol revises her earlier views on powers of female virtue.

4. Sigourney's poem paints a deathbed scene emblematic of the intimate homosocial feminine world Carroll Smith-Rosenberg finds in middle-class women's diaries of the American 1760s to 1880s. The intensity and ardor of this world may unsettle gender proprieties for post-Freudian heterosexual readers, Smith-Rosenberg notes, but its cosmos may be accessible to those taking into account sometimes distant emotional relations between Victorian American men and women (*Disorderly* 75–76).

5. See Mary Kelley's *Private Woman, Public Stage* for a discussion of nineteenth-century American women's agony at going public, and also Glenn Hendler's complication of the writing woman's "stage" in "The Limits of Sympathy: Louisa May Alcott and the Sentimental Novel."

6. Barton Levi St. Armand, in "Dark Parade: Dickinson, Sigourney, and the Victorian Way of Death," distinguished the "Sentimental Love Religion" from orthodoxy by a new call to center on one's own trials as Christ-like rather than to have faith in Jesus' death for human sin (42).

7. For all its apparent unorthodoxy, "The Lost Sister" shows up in two contemporary collections of Sigourney's verse published eleven years apart. In *Zinzendorff* (1836), it appears among other unsettling poems grieving deaths of women. A poem on Queen Elizabeth's death comes before it; one on the death of a minister's wife

follows. By contrast, in *Poems* (1846), any heresy from lack of solace in "The Lost Sister" is immediately patched up by a more proper next poem, "Mistaken Grief," which conventionally reminds mourners to be at peace because faithful dead go to heaven. Nevertheless, in both collections, "The Lost Sister" competes with God for the focal point of mourners' grief.

8. Without noting rhetorical or sentimental traditions specifically, Johnson points out a profound contrast in gender implications for the apostrophe. Apostrophes by men to dead children, she claims, cannot be read the same way as apostrophes by women.

9. For many contemporaries, male-to-male identification between writer and reader is taken for granted; not so for women writers and their readers. Whittier's verse foregrounded a constructed, not self-evident, sense of its rhetorical links, and yet purpose, strategy, and person of this male sentimental poet were received as "positive," "earnest," and "objective" (Ballou 146). Without worry about gender, Whittier's contemporary reviewers admit that the effect of his identification with the writer will nurture readers' moral sentiments. On one hand, Robert Allyn writes that the "Yankee poet" loves everything in nature "as tenderly and as dearly as a mother loves her suffering, . . . disconsolate child" (89). On the other hand, notwithstanding Whittier's passionate sentiments, Robert Collyer describes him as the poet who "stands and sings for *man manly* and *manful*" (290; italics in the original). It is significant that the same *Universalist Quarterly* reviewer who writes of Whittier, "no man deals more in sentiment," then says that the poet's noble purpose "prevents him from ever descending to the sentimental" (Ballou 146). Nineteenth-century men embrace the rhetoric of sentiment as fully as do women, but there is already a pejorative sense of the "sentimental" reserved for what is considered distastefully feminine, or perhaps for what some think displays excessive emotion.

10. Poe allowed that "the versification of *Zinzendorff* is particularly good," but then looks long and hard to find that "at page 160 is an error in meter" ("Critical Notices" 115). Moreover, he criticized Sigourney's diction ("Thou wert their friend") as "*not* English," but he also acknowledged, "The burden of [her] song finds a ready echo in our bosoms" ("Critical Notices" 116; italics in the original).

11. Beecher calls these difficulties "the faults of the age in which she lived—a period in which the desire for distinction and originality betrayed literary men into strange vagaries of language and style." In an appeal to the afterlife, Beecher imagines, "Where love rules supreme [Sigourney] may form a different estimate, and rejoice that a desire for admiration and fame was subordinated to tender sympathy and far-reaching benevolence" (560).

12. It likely gives Sigourney some satisfaction when, a few weeks after Poe's review, the publisher of the *Southern Literary Messenger* pressures him into soliciting a contribution from this popular woman poet for a special edition to be composed, Poe's letter of request says, "entirely of articles from our most distinguished *literati*" (Haight 84; italics in the original).

13. Ken Parille, researcher of children's literature, usefully complicates Dwight's take on Sigourney's pedagogy:

> Acutely aware of... ways that cultural expectations... limited the lives of women, Sigourney argues that boys' reading... often advocates a repressive pedagogy and sanctions what she sees as harmful norms of boyhood masculinity. (15)

Sigourney thought deeply not just about curriculum for girls but also broadly about cultural effects of children's pedagogy.

14. Catherine Beecher concedes: "Prolixity and haste were the faults of [Sigourney's] literary career; and that her fifty volumes would have been wisely reduced to half that number" (560).

15. Mary Loeffelholz, for example, set the early Dwight's 1794 "prospect poem" on New England life, *Greenfield Hill*, against Sigourney's 1834 "Connecticut River," which the critic posited to be "antebellum domestic elegy," claiming this term sums up all later history poems by Sigourney ("School" 61), as well as *Lucy Howard's Journal*.

16. A twentieth-century Whittier biographer, John B. Pickard, acknowledged in *John Greenleaf Whittier* that in 1831,

> Whittier had been welcomed into the best homes and became a member of the cosmopolitan literary circle that revolved about Mrs. Sigourney, who was just then gaining recognition for... poems which were to make her the most popular writer of pre–Civil War days. (15)

A chronology at the front of Pickard's book elaborated on this comment, recording that in his Hartford days, Whittier "greatly widened his social, political, and literary acquaintances under the influence of Mrs. Sigourney" (*Whittier* xi). Nevertheless, the same Pickard struggled to distinguish Whittier from sentimental Sigourney, who for him is "representative of the host of pre–Civil War newspaper versifiers and gift book writers whose trite moralizing, diffuse rhapsodic style, and vague unrestrained imagery corrupted American popular taste." In the high modernist days of 1961, Pickard insisted that that "imitating Sigourney," for Whittier, "was only a passing fad" (*Whittier* 20).

7. HOWE'S *PASSION-FLOWERS* DIALOGUE WITH A MASTER

1. In a 2004 book for young readers, Elizabeth Raum adds Howe's women's suffrage work to the abolitionist poetry, but this writer like others before her is tailoring Howe for a particular audience.

2. Scott Michaelsen cautions against "violent, murderous" sentimental strategies used by Howe in her "Battle Hymn" and by Harriet Beecher Stowe in *Uncle Tom's Cabin*, sending millions of Civil War soldiers to their death. He likens these tactics to Michael Griffin's prolife sentiments, which, Michaelsen says, motivated the 1993 slaying of abortion clinic doctor David Gunn.

3. A PBS DVD collection for its 2002 *American Civil War* TV series by Ken Burns includes the "Battle-Hymn," and for a September 1993 National Public Radio broadcast of "The Mountain Stage" variety program, Howe's lyrics are sung with special notice that the nineteenth-century honored its poets. Martin Luther King Day celebrations, other civil rights' gatherings, and Fourth of July concerts still include this song.

4. Because Blair offered dialogue as a means of instruction, it is interesting that Howe writes of learning chemistry as a girl through "Mrs. B.'s 'Conversations' . . . which I studied with great pleasure, albeit that I never saw one of the experiments therein described" (*Reminiscences* 56–57).

5. My thanks to Paula Bennett for this composite view of "Song of Solomon" in her e-mail comments on an early version of this chapter.

6. I am inspired by Dylan Evans' use in *Emotion: The Science of Sentiment* of a similar phrase to discuss what he called evolutionary reasons for certain emotions: "Not only are there passions within reason, but there are reasons within passion" (177).

7. I refer in chapter 4 to similarly disruptive poetic dialogues in Howe's third collection, *Later Lyrics* (1866). There, in "Bargains," a man and woman converse as in the coquette sequence, this time exchanging jewels, perhaps emblems of sexual favors; the woman's suggestive reply about "the gift you had from me" intimates a return to the female eroticism of Howe's 1850s dialogue (194).

8. Tullio Maranhao, in *The Interpretation of Dialogue*, asserted this procedural view even in the case of Plato's more philosophical dialogues: "The question of *how* the discussants arrive at a certain conclusion becomes more important than *what* that conclusion is" (7; italics added). Julia Kristeva, like Maranhao, emphasizes the process of dialogue over its semantic content, but she applies Mikhail Bakhtin's work on dialogic narrative to poetic language. In *Tales of Love*, she titles her study of King Solomon's dialogue "A Holy Madness: She and He." Kristeva moves through a range of orthodox, feminist, and erotic readings of "Song of Solomon" to argue for its undecidability. It is not, finally, the Shunamite maiden's words to the king preventing a single interpretation; rather, it is how their love is represented. "The very enunciatory pact" constitutes an erotic dialogue placed in holy writ, a pact loading each word with "semantic polyvalence" that at last "becomes undecidable connotation" (91).

9. The *New Princeton Encyclopedia of Poetry and Poetics* offers several ways that dialogue lures its readers: the form "reveal[s] a wider range of ideas, emotions, and perspectives than would be possible with a single voice." Moreover, "the form lends itself to powerful emotional or philosophical exchanges, as in love lyrics and intellectual debates" (798, 800).

10. Significantly, *Eminent Women of the Age*, on lives and accomplishments of nineteenth-century women, was compiled by James Parton, novelist Fanny Fern's lover and domestic partner, not incidentally a man who published texts by many ambitious women.

11. Later, Hawthorne has harsher criticism for Howe, writing to Charles Ticknor in 1857 that the "*Passion Flowers* were delightful; but she ought to have been soundly whipt for publishing them" (qtd. in Freibert and White 456).

12. My thanks to Albert von Frank for sharing in a personal communication Fuller's comment on "passion flowers," which may refer to Howe's book.

13. May's 1869 *Pearls* volume lists nearly eighty women poets, many from her 1848 six-volume set, titled *American Female Poets*, but also many first published during the twenty years between the two collections. I have not learned whether any of Howe's poetry appears in the first multivolume edition.

14. Gayatri Spivak, asked by Ellen Rooney about "exclusions that fragment one's audience," explains that "the audience is not an essence, the audience is a blank. An audience can be constituted by people I cannot even imagine." On anticipating patently unpredictable readers, Spivak says, "Derrida calls this a responsibility to the trace of the other." She then discusses an eager audience something like Howe's escorts: "When an audience is responsible, responding, invited, in other words to coinvestigate, then positionality is shared with it. Audience and investigator: it's not just a binary opposition. . . . An audience is part of one" (22).

15. After the Civil War, Howe does speak to women audiences, famously founds women's associations, and stumps for women's suffrage. *Julia Ward Howe and the Woman Suffrage Movement* (1913) is a collection of her speeches on voting rights for women. A facsimile of the book is back in print. On 19 May 2013, a New Jersey Episcopal church reprints Howe's "Mother's Day Proclamation," a poem urging women to spread pacifist sentiments.

16. The notion that culture can "forsake . . . itself, in order to go beyond itself" comes from Kristeva's "From One Identity to an Other," where she reflects on how writers' and readers' sense of self is both knit up and unraveled in text.

# Works Cited and Consulted

*The African Americans: Many Rivers to Cross.* Writ. and pres. Henry Louis Gates Jr. PBS, 2014. DVD.
Alcott, Louisa May. *Life, Letters, and Journals.* Boston: Roberts Brothers, 1889. Print.
Allyn, Robert. "Whittier's Poems." *Methodist Quarterly* 40 (1858): 72–92. Print.
*The American Civil War.* Dir. Ken Burns. PBS, 2002. DVD.
Ames, Dorene I. "Re: Voice." Message to the author. 27 Dec. 2003. E-mail.
———. "Wandering Souls, Wounded Spirits, and the Disoriented Self: American Indian Pedagogies in Modern Contexts." Diss. Washington State University, 2010. Print.
"Anne Frank Remembered." *All Things Considered.* National Public Radio. WNYC, New York. 15 Mar. 1995. Radio.
Apthorp, Elaine Sargent. "Sentiment, Naturalism, and the Female Regionalist." *Legacy* 7 (1990): 3–22. Print.
Aristotle. *The Rhetoric and Poetics of Aristotle.* Rhetoric trans. Rhys Roberts. Poetics trans. Ingram Bywater. Ed. Edward P. J. Corbett. New York: Modern Library, 1984. Print.
Armstrong, Nancy. *Desire and Domestic Fiction: A Political History of the Novel.* New York: Oxford UP, 1987. Print.
Austin, Gilbert. *Chironomia; or, A Treatise on Rhetorical Delivery: Comprehending Many Precepts, Both Ancient and Modern, for the Proper Regulation of the Voice, the Countenance, and Gesture.* London, 1806. Print.
Axer, Jerzy. "President's Address." International Society for the History of Rhetoric. Warsaw, Poland. Aug. 2001. Address.
Ballou, H. "Whittier's Poems." *Universalist Quarterly* 6 (1849): 142–60. Print.
Barnett, Jenna. "Short Takes: Erika Totten." *Sojourners: Faith in Action for Social Justice* (June 2015): 47. Print.
Barthes, Roland. "Chateaubriand: *Live of Rancé.*" *New Critical Essays.* Trans. Richard Howard. New York: Hill and Wang, 1980. 41–54. Print.
———. "The Old Rhetoric: An Aide-Mémoire." *The Semiotic Challenge.* By Barthes. Trans. Richard Howard. Berkeley: U of California P, 1988. 11–94. Print.
———. "The Plates of the *Encyclopedia.*" *New Critical Essays.* Trans. Richard Howard. New York: Hill and Wang, 1980. 23–40. Print.

———. "Rhetoric of the Image." *Image, Music, Text*. Trans. Stephen Heath. New York: Hill and Wang, 1977. 32–51. Print.

Bator, Paul. "The D.[avid] B.[aynes] Horn Collection: Unpublished Papers on the History of the University of Edinburgh." *Rhetoric Society Quarterly* 26.1 (Winter 1996): 69–83. Print.

———. "The Edinburgh *Belles Lettres* Society (1759–1764) and the Rhetoric of the Novel." Rhetoric Society of America Convention. May 1992. Reading.

Baumlin, James S. "Ēthos." *Encyclopedia of Rhetoric*. Ed. Thomas O. Sloane. New York: Oxford UP, 2001. 263–77. Print.

Baym, Nina. "The Madwoman and Her Languages: Why I Don't Do Feminist Literary Theory." *Feminism and American Literary History*. New Brunswick: Rutgers UP, 1992. 199–213. Print.

———. *Novels, Readers and Reviewers: Responses to Fiction in Antebellum America*. Utica: Cornell UP, 1984. Print.

———. "Reinventing Lydia Sigourney." *The (Other) American Traditions: Nineteenth-Century Women Writers*. Ed. Joyce W. Warren. New Brunswick: Rutgers UP, 1993. 54–72. Print.

———. "Rewriting the Scribbling Women." *Legacy* 2 (1985): 3–12. Print.

———. *Woman's Fiction: A Guide to Novels by and about Women in America, 1820–1870*. Ithaca, NY: Cornell UP, 1978. Print.

Beecher, Catherine E. "Mrs. Lydia H. Sigourney." *Hours at Home* 1.6 (Oct. 1865): 559–65. Print.

Beecher, Catherine E., and Harriet Beecher Stowe. *The American Woman's Home; or, Principles of Domestic Science; Being a Guide to the Formation and Maintenance of Economical, Healthful, Beautiful and Christian Homes*. Boston, 1869. Print.

Beecher, Lyman. *Lyman Beecher and the Reform of Society: Four Sermons, 1804–1828*. Ayer Company Pub., 1972. Print.

Bell, Michael Davitt. The Development of American Romance: The Sacrifice of Relation. Chicago: U Chicago P, 1980. Print.

*Beloved*. Dir. Jonathan Demme. Perf. Oprah Winfrey, Danny Glover, Thandie Newton, and Kimberly Elise. Harpo Productions, 1998. Film.

Bennett, Paula Bernat. "Critical Clitoridectomy: Female Sexual Imagery and Feminist Psychoanalytic Theory." *Signs* 18 (1993): 235–59. Print.

———, ed. *Nineteenth-Century American Women Poets*. London: Blackwell, 1997. Print.

———. *Poets in the Public Sphere: The Emancipatory Project of American Women's Poetry, 1800–1900*. Princeton: Princeton UP, 2003. Print.

———. "Re: Composite view of 'Song of Solomon.'" Message to the author. 26 Jan. 1998. E-mail.

———. "Was Sigourney a Poetess? The Aesthetics of Victorian Plenitude in Lydia Sigourney's Poetry." *Comparative American Studies* 5.3 (2007): 265–89. Print.

Bennett, Paula Bernat, and Karen L. Kilcup. "Rethinking Nineteenth-Century American Poetry." *Teaching Nineteenth-Century American Poetry*. Ed. Paula Bernat Bennett, Karen L. Kilcup, and Philipp Schweighauser. New York: Modern Language Association, 2007. 1–10. Print.

Benveniste, Emile. "Subjectivity in Language." *Critical Theory since 1965*. Ed. Hazard Adams and Leroy Searle. Tallahassee: Florida State UP, 1986. 728–32. Print.

Bercovitch, Sacvan. *The Rites of Assent: Transformations in the Symbolic Construction of America*. New York: Routledge, 1992. Print.

Berlant, Lauren. "The Female Complaint." *Social Text* (Fall 1988): 237–59. Print.

Berlin, James. *Rhetorics, Poetics, and Cultures: Refiguring College English Studies*. Urbana, IL: NCTE, 1996. Print.

———. *Writing Instruction in Nineteenth-Century American Colleges*. Carbondale: Southern Illinois UP, 1984. Print.

Bhabha, Homi K. *The Location of Culture*. New York: Routledge, 1994. Print.

Bigelow, Gordon E. *Rhetoric and American Poetry of the Early National Period*. University of Florida Monographs: Humanities 4. Gainesville: U of Florida P, 1960. Print.

Bitzer, Lloyd F. Introduction. *The Philosophy of Rhetoric*. By George Campbell. Ed. Bitzer. 1776. Carbondale: Southern Illinois UP, 1963. vii–lii. Print.

Bizzell, Patricia, and Bruce Herzberg, eds. *The Rhetorical Tradition: Readings from Classical Times to the Present*. Boston: Bedford, 1990. Print.

Blair, Hugh. *Lectures on Rhetoric and Belles Lettres*. 2 vols. 1776. Ed. Harold Harding. Carbondale: Southern Illinois UP, 1965. Print.

———. *Lectures on Rhetoric and Belles Lettres*. 1776. Ed. Linda Ferreira-Buckley and S. Michael Halloran. Carbondale: S Illinois UP, 2002. Print.

Blasing, Mutlu Konuk. *American Poetry: The Rhetoric of Its Forms*. New Haven, CT: Yale UP, 1987. Print.

Bobo, Jacqueline. "*The Color Purple*: Black Women as Cultural Readers." *Female Spectators: Looking at Film and Television*. Ed. E. Deidre Pribram. Avon: Bookcraft, 1988. 90–109. Print.

Bourdieu, Pierre. *Distinction: A Social Critique of the Judgement of Taste*. Trans. Richard Nice. Cambridge: Harvard UP, 1984. Print.

Boyd, Melba Joyce. *Discarded Legacy: Politics and Poetics in the Life of Frances E. W. Harper, 1825–1911*. Detroit: Wayne State UP, 1994. Print.

———. "Frances Harper, Amy Lowell, Sentimentality, and Literary Value: An Argument." Convention of the Modern Language Association. December 1993. Reading.

Bradstreet, Anne. *The Works of Anne Bradstreet*. Ed. Jeannine Hensley. Foreword by Adrienne Rich. Cambridge: Belknap, 1967. Print.

Branch, E. Douglas. *The Sentimental Years: 1836–1860*. New York: Hill and Wang, 1934. Print.

Brantley, Richard I. *Locke, Wesley, and the Method of English Romanticism*. Gainesville: UP Florida, 1984. Print.

Brown, William Hill. *The Power of Sympathy.* 1789. Ed. William S. Osborne. Albany: New College and UP, 1970. Print.

Buell, Lawrence. Introduction. *Longfellow's Selected Poems.* Ed. Buell. New York: Penguin, 1988. vii–xxxv. Print.

———. *Literary Transcendentalism: Style and Vision in the American Renaissance.* Ithaca, NY: Cornell UP, 1973. Print.

———. *New England Literary Culture.* New York: Cambridge UP, 1986. Print.

Burke, Kenneth. *Counter-Statement.* Los Altos: Hermes, 1931. Print.

———. "Four Master Tropes." *A Grammar of Motives.* Berkeley: U of California P, 1969. 503–18. Print.

———. *Rhetoric of Motives.* Berkeley: U of California P, 1969. Print.

Calhoun, Lucia Gilbert. "Mrs. Julia Ward Howe." *Eminent Women of the Age.* Ed. James Parton and Horace Greeley. Hartford, CT: S. M. Betts, 1868. 621–28. Print.

Campbell, George. *Philosophy of Rhetoric.* 1776. Ed. Lloyd F. Bitzer. Carbondale: Southern Illinois UP, 1988. Print.

Carby, Hazel. *Reconstructing Womanhood: The Emergence of the Afro-American Woman Novelist.* New York: Oxford UP, 1987. Print.

Cary, Stephen G, A. J. Muste, Robert Pickus, Bayard Rustin. "Speak Truth to Power: A Quaker Search for an Alternative to Violence." *American Friends Service Committee Archives,* 1955. Web. 17 Mar. 2016.

Charvat, William. *The Profession of Authorship in America, 1800–1870.* Cleveland: Ohio State UP, 1968. Print.

Christ, Carol. *Victorian and Modern Poetics.* Chicago: University of Chicago Press, 1984. Print.

Christian, Barbara. "The Dynamics of Difference: Book Review of Audre Lorde's *Sister Outsider.*" *Black Feminist Criticism: Perspectives on Black Women Writers.* New York: Pergamon, 1985. Print.

Clark, Gregory. "The Oratorical Poetic of Timothy Dwight." *Oratorical Culture in Nineteenth-Century America: Transformations in the Theory and Practice of Rhetoric.* Ed. Gregory Clark and S. Michael Halloran. Carbondale: Southern Illinois UP, 1993. 57–77. Print.

Clark, Gregory, with S. Michael Halloran. "Representations of Nature in Nineteenth-Century American Landscape Paintings and Travel Narratives." Conference on College Composition and Communication, Washington, DC. March 1995. Reading.

Clark, Gregory, and S. Michael Halloran, eds. *Oratorical Culture in Nineteenth-Century America: Transformations in the Theory and Practice of Rhetoric.* Carbondale: Southern Illinois UP, 1993. Print.

Clark, Suzanne. *Cold Warriors: Manliness on Trial in the Rhetoric of the West.* Carbondale: Southern Illinois UP, 2000. Print.

———. "Discipline and Resistance: The Subjects of Writing and the Discourses of Instruction." *Margins in the Classroom.* Ed. Kostas Myrsiades and Linda S. Myrsiades. Minneapolis: U Minnesota P, 1994. 121–36. Print.

———. "Julia Kristeva: Rhetoric and the Woman as Stranger." *Reclaiming Rhetorica*. Ed. Andrea Lunsford, et al. Carbondale: Southern Illinois UP, 1995. 305–18. Print.

———. "Rhetoric, Social Construction, and Gender: Is It Bad to Be Sentimental?" *Writing Theory and Critical Theory*. Ed. John Clifford and John Schilb. New York: MLA, 1995. 96–108. Print.

———. *Sentimental Modernism: Women Writers and the Revolution of the Word*. Bloomington: Indiana UP, 1991. Print.

Clark, Suzanne, and Kathleen Hulley. "An Interview with Julia Kristeva: Cultural Strangeness and the Subject in Crisis." *Discourse: Journal for Theoretical Studies in Media and Culture* 13.1 (1990): 149–80. Print.

Clarke, Norma. *Ambitious Heights: Writing, Friendship, Love; The Jewsbury Sisters, Felicia Hemans, and Jane Welsh Carlyle*. New York: Routledge, 1990. Print.

Clemens, Samuel. *The Adventures of Huckleberry Finn*. 1885. New York: Bantam, 1981. Print.

Clifford, Deborah Pickman. *Julia Ward Howe: Mine Eyes Have Seen the Glory*. Boston: Little Brown, 1978. Print.

Coffin, Levi. "Margaret Garner." *Reminiscences*. Cincinnati, 1876. N. pag. Web. 22 Dec. 2005. <http://aalbc.com/authors/margaret.htm>.

Cohen, Michael C. *The Social Lives of Poems in Nineteenth-Century America*. Philadelphia: U of Pennsylvania P, 2015. Print.

Collin, Grace Lathrop. "Lydia Huntley Sigourney." *New England Magazine* 27 (1902): 15–30. Print.

Collins, Martha. "Reclaiming the Oh." *Where We Stand: Women Poets on Literary Tradition*. Ed. Sharon Bryan. New York: Norton, 1993. 31–35. Print.

Collyer, Robert. "Whittier." *Clear Grit: A Collection of Lectures, Addresses and Poems*. Ed. John Haynes Holmes. Boston: American Unitarian Association, 1913. 277–93. Print.

Conley, Thomas. *Rhetoric in the European Tradition*. New York: Longman, 1990. Print.

———. "Scenic Views along the Path of a History of Rhetoric." Oregon Conference on Rhetoric and Composition. May 1993. Reading.

Connor, Stephen. *Dumbstruck: A Cultural History of Ventriloquism*. New York: Oxford UP, 2001. Print.

Cook, Deborah. *The Subject Finds a Voice: Foucault's Turn toward Subjectivity*. New York: Peter Lang, 1993. Print.

Copley, John Singleton. *Judith Sargent Murray*. c. 1798. *Heath Anthology of American Literature*, Vol. 1. Ed. Paul Lauter et al. Lexington, MA: D. C. Heath, 1990. 102. Print.

Corliss, Richard. "Bewitching Beloved." Rev. of *Beloved*, by Toni Morrison. *Time* 152.14 (5 Oct. 1998): 74–77. Web. 22 Dec. 2006.

Crothers, Samuel McChord. *The Gentle Reader*. New York: Houghton, Mifflin, 1903. Print.

Dall, Caroline H. "At Whittier's Funeral." *New England Magazine* 7 (1893): 652–55. Print.
Dana, Charles A., ed. *The Household Book of Poetry*. New York: D. Appleton and Company, 1859. Print.
Davidson, Cathy N. *Revolution and the Word: The Rise of the Novel in America*. New York: Oxford UP, 1986. Print.
Davis, Robert Con. "Freud, Lacan, and the Subject of Cultural Studies." *Margins in the Classroom*. Ed. Kostas Myrsiades and Linda S. Myrsiades. Minneapolis: U Minnesota P, 1994. 188–202. Print.
De Jong, Mary G. "Legacy Profile: Lydia Howard Huntley Sigourney." *Legacy* 5 (1988): 35–44. Print.
Delaumosne, Abbe. *Delsarte System of Oratory: Containing the Complete Work of L'Abbe Delaumosne*. 4th ed. New York, 1892. Print.
De Lauretis, Teresa. "Aesthetic and Feminist Theory: Rethinking Women's Cinema." *Female Spectators: Looking at Film and Television*. Ed. E. Deidre Pribram. Avon: Bookcraft, 1988. 174–95. Print.
———. *Alice Doesn't: Feminism, Semiotics, Cinema*. Indianapolis: Indiana UP, 1984. Print.
Delpit, Lisa D. "The Silenced Dialogue: Power and Pedagogy in Educating Other People's Children." *Harvard Educational Review* 58 (1988): 280–98. Print.
De Mille, A. B., ed. *American Poetry*. Boston: Allyn and Bacon, 1923. Print.
Derrida, Jacques. "The Heritage of the Pharmakon: Family Scene." *Dissemination*. Chicago: U of Chicago P, 1981. 142–55. Print.
Dickinson, Emily. "I died for Beauty—." *The Complete Poems of Emily Dickinson*. Ed. Thomas H. Johnson. Boston: Little Brown, 1960. 216. Print.
Didion, Joan. "An Annotation." *Some Women*. By Robert Mapplethorpe. Boston: Bullfinch P (Little Brown), 1995. 1–4. Print.
Dillon, Elizabeth Maddock. "Sentimental Aesthetics." *American Literature* 76.3 (2004): 495–523. Print.
Dobson, Joanne. "The American Renaissance Reenvisioned." *The (Other) American Traditions*. Ed. Joyce W. Warren. New Brunswick: Rutgers, 1993. 164–82. Print.
———. "Reclaiming Sentimental Literature." *American Literature* 69.2 (1997 June): 263–88. Print.
———. "Sex, Wit, and Sentiment: Frances Osgood and the Poetry of Love." *American Literature* 65 (1993): 631–50. Print.
Dolph, Joseph M. "Taste in Eighteenth-Century English Rhetorical Theory." Diss. U of Oregon, 1964. Print.
Donawerth, Jane. *Conversational Rhetoric: The Rise and Fall of a Women's Tradition, 1600–1900*. Carbondale: Southern Illinois UP, 2012. Print.
———. "Hannah More, Lydia Sigourney, and the Creation of a Women's Tradition of Rhetoric." Rhetoric Society of America Convention. June 1998. Reading.
———, ed. *Rhetorical Theory by Women before 1900: An Anthology*. Lanham, MD: Rowman and Littlefield, 2002. Print.

Douglas, Ann (Wood). *The Feminization of American Culture.* New York: Doubleday, 1988. Print.

———. "Mrs. Sigourney and the Sensibility of the Inner Space." *New England Quarterly* 2 (1972): 163–81. Print.

———. "The Scribbling Women and Fanny Fern: Why Women Wrote." *American Quarterly* 1 (1971): 3–24. Print.

Douglass, Frederick. "Narrative of the Life of Frederick Douglass, an American Slave." *Norton Anthology of American Literature.* 3rd ed. Vol. 1. Ed. Nina Baym, et al. New York: Norton, 1989. 1873–1937. Print.

Dwight, Timothy. "Mrs. Sigourney." *New Englander* 95 (April 1866): 330–58. Print.

Easthope, Anthony. *Literary into Cultural Studies.* London: Routledge, 1991. Print.

Eastman, Mary Henderson. *Aunt Phyllis's Cabin; or, Southern Life as It Is.* 1852. Upper Saddle River: Gregg P, 1968. Print.

Ede, Lisa. "Rhetoric vs. Philosophy: The Role of the Universal Audience in Chaim Perelman's 'The New Rhetoric.'" *The New Rhetoric of Chaim Perelman: Statement and Response.* New York: UP of America, 1989. Print.

Ede, Lisa, and Andrea Lunsford. "Feminism, Experience, and Writing." Conference on College Composition and Communication. Apr. 1994. Reading.

Elliott, Emory, ed. *Columbia Literary History of the United States.* New York: Columbia UP, 1988. Print.

———. *Revolutionary Writers: Literature and Authority in the New Republic, 1725–1810.* New York: Oxford UP, 1982. Print.

Emerson, Ralph Waldo. "Fate." *Ralph Waldo Emerson.* Ed. Richard Poirier. New York: Oxford UP, 1990. 345–66. Print.

———. "The Poet." *Ralph Waldo Emerson.* Ed. Richard Poirier. New York: Oxford UP, 1990. 197–215. Print.

Epstein, Barbara Leslie. *The Politics of Domesticity: Women, Evangelism, and Temperance in Nineteenth-Century America.* Middletown, CT: Wesleyan UP, 1981. Print.

Evans, Dylan. *Emotion: The Science of Sentiment.* New York: Oxford UP, 2001. Print.

Ezell, Margaret J. M. "Breaking the Seventh Seal: Writings by Early Quaker Women." *Writing Women's Literary History.* By Ezell. Baltimore: Johns Hopkins UP, 1993. 132–60. Print.

———. *Writing Women's Literary History.* Baltimore: Johns Hopkins UP, 1993. Print.

Felman, Shoshana. "Education and Psychoanalysis: Teaching Terminable and Interminable." *Yale French Review* 63 (1983): 21–41. Print.

"The Female Poets of America." *North American Review* 68 (1849): 413–36. Print.

Fern, Fanny. *Ruth Hall and Other Writings.* 1855. Ed. Joyce W. Warren. New Brunswick: Rutgers UP, 1986. Print.

Fetterley, Judith. "Commentary: Nineteenth-Century American Women Writers and the Politics of Recovery." *American Literary History* 6 (1994): 600–611. Print.

———. *Resisting Reader: A Feminist Approach to American Fiction.* Indianapolis: Indiana UP, 1978. Print.

Finch, Annie. *The Ghost of Meter*. Ann Arbor: U of Michigan P, 1993. Print.

———. "Phillis Wheatley and the Sentimental Tradition." *Romanticism on the Net* 29–30 (2003). Web. 22 Dec. 2006.

———. "The Sentimental Poetess in the World: Metaphor and Subjectivity in Lydia Sigourney's Nature Poetry." *Legacy* 5 (1988): 3–18. Print.

Finch, Annie, Laura Mandell, and Peggy Davis. *Poetess Poetics: A New Look at a Lyric Tradition*. Now online as *Poetess Archive*. Ed. Laura Mandell, Mary Waters, and Matthew Christy. Texas A&M University. 2006. Web. 17 Mar. 2016.

Fisher, Philip. *Hard Facts: Setting and Form in the American Novel*. New York: Oxford UP, 1985. Print.

Fliegelman, Jay. *Prodigals and Pilgrims: The American Revolution against Patriarchal Authority, 1750–1800*. New York: Cambridge UP, 1982. Print.

Flint, Kate. "Is the Native an American? National Identity and the British Reception of *Hiawatha*." *The Traffic in Poems: Nineteenth-Century Poetry and Transatlantic Exchange*. Ed. Meridith L. McGill. New Brunswick: Rutgers UP, 2008. 63–80. Print.

Forster, Michael. "Johann Gottfried von Herder." *Stanford Encyclopedia of Philosophy*. Stanford University. 2001. Web. 17 Mar. 2016.

Foster, Frances Smith. "African Americans, Literature, and the Nineteenth-Century Afro-Protestant Press." *Reciprocal Influences: Literary Production, Distribution, and Consumption in America*. Ed. Steven Fink and Susan S. Williams. Columbus: Ohio State UP, 1999. 24–35. Print.

———. "Frances Harper, Amy Lowell, Sentimentality, and Literary Value: An Argument." Modern Language Association Convention. December 1993. Reading.

———. "Gender, Genre, and Vulgar Secularism: The Case of Frances Ellen Watkins Harper and the AME Press." *Recovered Writers/Recovered Texts: Race, Class and Gender in Black Women's Literature*. Ed. Dolan Hubbard. Knoxville: U Tennessee P, 1997. 46–59. Print.

———. *Written by Herself: Literary Production by African American Women, 1746–1892*. Bloomington: Indiana UP, 1993. Print.

Foucault, Michel. *Discipline and Punish: The Birth of the Prison*. Trans. Alan Sheridan. New York: Random Vintage, 1979. Print.

———. "On the Genealogy of Ethics: An Overview of Work in Progress." *Michel Foucault: Beyond Structuralism and Hermeneutics*. Ed. Hubert L. Dreyfus and Paul Rabinow. Chicago: U of Chicago P, 1983. 229–52. Print.

———. "What Is an Author?" *Critical Theory since 1965*. Ed. Hazard Adams and Leroy Searle. Tallahassee: Florida State UP, 1986. 138–47. Print.

Fowler, William J. "Whittier and Tennyson." *Arena* 37 (1892): 1–11. Print.

Frank, Anne. *Anne Frank: Diary of a Young Girl*. New York: Prentice Hall, 1993. Print.

Frederick, John T. "Hawthorne's 'Scribbling Women.'" *New England Quarterly* (1975): 231–40. Print.

Freibert, Lucy M., and Barbara A. White, eds. *Hidden Hands: An Anthology of American Women Writers, 1790–1870.* New Brunswick, NJ: Rutgers UP, 1985. Print.

Friere, Paulo. *Pedagogy of the City.* New York: Continuum P, 1993. Print.

Fuller, Edmund. "The New Compassion in the American Novel." *American Scholar* (1957): 155–63. Print.

Fuller, Margaret. *Love Letters of Margaret Fuller.* Ed. James Nathan (later Gotendorf). Introduction by Julia Ward Howe. 1903. New York: Greenwood, 1969. Print.

———. *Woman in the Nineteenth Century and Kindred Papers Relating to the Sphere, Condition and Duties of Woman.* 1851. New York: Norton, 1971. Print.

Furth, Leslie. "'The Modern Medea' and Race Matters: Thomas Satterwhite Noble's *Margaret Garner.*" *American Art* 12.2 (Summer 1998): 36–57. Print.

Gaillet, Lynee Lewis. "George Jardine: Champion of the Scottish Philosophy of Democratic Intellect." *Rhetoric Society Quarterly* 28 (Spring 1998): 37–53. Print.

———. *Scottish Rhetoric and Its Influences.* Davis, CA: Hermagoras P, 1998. Print.

Gilbert, Sandra M., and Susan Gubar. *The Madwoman in the Attic: The Woman Writer and the Nineteenth-Century Literary Imagination.* New Haven, CT: Yale UP, 1979. Print.

Glenn, Cheryl. *Rhetoric Retold: Regendering the Tradition from Antiquity through the Renaissance.* Carbondale: Southern Illinois UP, 1997. Print.

Golden, James L., and Edward P. J. Corbett. Introduction. *The Rhetoric of Blair, Campbell, and Whately.* By Golden and Corbett. Carbondale: Southern Illinois UP, 1990. 1–21. Print.

Graham, Maryemma. Introduction. *Complete Poems of Frances E. W. Harper.* Ed. Graham. New York: Oxford UP, 1988. xxxiii–lvii. Print.

Greene, Brenda M. "Remembering as Resistance in the Literature of Women of Color." *Rethinking American Literature.* Ed. Lil Brannon and Brenda M. Greene. Urbana, IL: National Council of Teachers of English, 1997. 97–114. Print.

Griswold, Rufus Wilmot, ed. *The Poets and Poetry of America.* 2nd ed. New York, 1842. Print.

———. Preface. *The Female Poets of America.* Ed. Griswold. 16th ed. New York: P. F. Collier, 1855. 3–6. Print.

Gruenewald, David A. "The Best of Both Worlds: A Critical Pedagogy of Place." *Environmental Education Research* 14.3 (2008): 308–24. Print.

Haight, Gordon. *Mrs. Sigourney: The Sweet Singer of Hartford.* New Haven, CT: Yale UP, 1930. Print.

Hajela, Deepti. "Ground Zero Vista Dedicated by Mayor." *Columbian* [Vancouver, WA] 30 Dec. 2001. Print.

Halloran, S. Michael. "The Rhetoric of Picturesque Scenery: A Nineteenth-Century Epideictic." *Oratorical Culture in Nineteenth-Century America: Transformations in the Theory and Practice of Rhetoric.* Ed. Gregory Clark and S. Michael Halloran. Carbondale: Southern Illinois UP, 1993. 226–46. Print.

Halpern, Faye. *Sentimental Readers: The Rise, Fall, and Revival of a Disparaged Rhetoric*. Iowa City: U Iowa P, 2013. Print.

Harper, Frances Ellen Watkins. *A Brighter Coming Day: A Frances Ellen Watkins Harper Reader*. Ed. Frances Smith Foster. New York: Feminist P, 1990. Print.

———. "The Slave Auction." *Cherokee Nation* educational site, 2011. Web. June 2007.

Harris, Susan K. "'But Is It Any Good?': Evaluating Nineteenth-Century American Women's Fiction." *The (Other) American Traditions: Nineteenth-Century Women Writers*. Ed. Joyce W. Warren. New Brunswick, NJ: Rutgers UP, 1993. 263–79. Print.

———. *Nineteenth-Century Women's Novels: Interpretive Strategies*. New York: Cambridge UP, 1990. Print.

Harrison, Kimberly. *The Rhetoric of Rebel Women: Civil War Diaries and Confederate Persuasion*. Carbondale: Southern Illinois UP, 2013. Print.

Haslett, Tim. Interview with Hortense Spillers. *Black Cultural Studies*. 4 Feb. 1998. Web. 26 Mar. 2002.

Havazelet, Ehud. "Second Person." *New York Times*. Opinionator: Draft, 14 July 2014. Web. 22 July 2014.

Hawthorne, Nathaniel. *The Blithedale Romance*. Ed. Seymour Gross and Rosalie Murphy. New York: Norton, 1978. Print.

———. "Nathaniel Hawthorne: Letters to William D. Ticknor." Ed. Lucy M. Freibert and Barbara A. White. *Hidden Hands: An Anthology of American Women Writers, 1790–1870*. New Brunswick, NJ: Rutgers UP, 1985. 356–58. Print.

Hendler, Glenn. "The Limits of Sympathy: Louisa May Alcott and the Sentimental Novel." *American Literary History* 3 (1991): 685–706. Print.

Henning, Martha L. *Beyond Understanding: Appeals to the Imagination, Passions, and Will in Mid-Nineteenth-Century American Women's Fiction*. New York: Peter Lang, 1996. Print.

Higginson, Thomas Wentworth. *Margaret Fuller Ossoli*. Boston: Houghton Mifflin, 1912. Print.

Hillis, Newell Dwight. *Lectures and Orations by Henry Ward Beecher*. New York: Fleming H. Revell, 1913. Print.

Hobbs, Catherine, ed. *Nineteenth-Century Women Learn to Write*. Charlottesville: U of Virginia P, 1995. Print.

Hoeller, Hildegard. "The Aesthetics and Politics of American Sentimental Writing Reconsidered." MLA Convention. Dec. 1993. Address.

Hollander, John, ed. *American Poetry: The Nineteenth-Century*. 2 vols. New York: Library of America, 1993. Print.

Holloway, Karla F. C. "Cultural Politics in the Academic Community: Masking the Color Line." *College English* 55.6 (Oct. 1993): 610–17. Print.

hooks, bell. "bell hooks speaks on community." *bell hooks: Brown Visiting Scholar in Feminist Studies*. Nov. 2002. Web. 12 Dec. 2002.

———. *Rock My Soul: Black People and Self-Esteem*. New York: Washington Square P, 2004. Print.

———. *Salvation: Black People and Love*. New York: Harper Perennial, 2001. Print.

———. *Sisters of the Yam: Black Women and Self-Recovery*. Boston: South End P, 1993. Print.

———. *Teaching Critical Thinking: Practical Wisdom*. New York: Routledge, 2009. Print.

———. *Teaching to Transgress*. New York: Routledge, 1994. Print.

———. *When Angels Speak of Love*. New York: Atria Books, 2011. Print.

———. *Where We Stand: Class Matters*. New York: Routledge, 2000. Print.

———. *Yearning: Race, Gender, and Cultural Politics*. Boston: South End P, 1990. Print.

Horner, Winifred. *Nineteenth-Century Scottish Rhetoric: The American Connection*. Carbondale: Southern Illinois UP, 1993. Print.

Howe, Florence. Introduction. *No More Masks! An Anthology of Twentieth-Century American Women Poets*. Ed. Howe. New York: Harper Collins, 1993. xxix–lxvi. Print.

Howe, Julia Ward. "Appeal to Womanhood throughout the World." 1870. Bulletin of Christ the King Episcopal Church, Willingboro, NJ. 19 May 2014. Print.

———. *At Sunset*. Ed. Laura E. Richards. Boston: Houghton Mifflin, 1910. Print.

———. *From Sunset Ridge: Poems Old and New*. Boston: Houghton Mifflin, 1898. Print.

———. *The Hermaphrodite*. c. 1840s. Ed. Gary Williams. Lincoln: U Nebraska P, 2009. Print.

———. *Hippolytus*. 1858. *America's Lost Plays*. Vol. 16. Ed. Barret H. Clark. Bloomington: Indiana UP, 1941. 77–128. Print.

———. *Julia Ward Howe and the Woman Suffrage Movement*. Ed. Florence Howe Hall. Boston: Dana Estes and Company, 1913. Print.

———. *Later Lyrics*. Boston: J. E. Tilton, 1866. Print.

———. *Leonora; or, The World's Own*. 1857. *Representative American Plays*. Ed. Arthur Hobson Quinn. New York: Century, 1917. 387–427. Print.

———. *Margaret Fuller (Marchesa Ossoli)*. 1883. Boston: Little Brown, 1905. Print.

———. *Passion-Flowers*. Boston: Ticknor, Reed, and Fields, 1854. Print.

———. *Reminiscences: 1819–1899*. Boston: Houghton Mifflin, 1899. Print.

———. *Words for the Hour*. Boston: Ticknor and Fields, 1857. Print.

"Infancy." *Godey's Lady's Book* 30 (Feb. 1845): frontispiece. Print.

"In Memoriam: Marcus Dale Bowman." *Columbian* [Vancouver, WA] 29 Mar. 2013. Print.

Irving, Washington. "The Wife." *Washington Irving: History, Tales and Sketches*. New York: Library of America, 1983. 759–66. Print.

Jackson, Helen Hunt. *Mercy Philbrick's Choice*. 1876. New York: AMS Press, 1970. Print.

Jackson, Virginia. "The Poet as Poetess." *Cambridge Companion to Nineteenth-Century American Poetry*. Ed. Kerry Larson. New York: Cambridge UP, 2011. 54–75. Print.

Jackson, Virginia, and Eliza C. Richards. "'The Poetess' and Nineteenth-Century American Women Poets." *Poetess Archive Journal* 1.1 (2007): n. pag. Web. 22 May 2015.

Jacobs, Harriet Ann. *Incidents in the Life of a Slave Girl*. 1861. Ed. Henry Louis Gates Jr. New York: Oxford UP, 1988. Print.

Jaffrey, Zia. "The Salon Interview: Toni Morrison." *Salon*, 2 Feb. 1998. Web. 12 July 2001.

James, Henry. Rev. of *Later Lyrics*, by Julia Ward Howe. *North American Review* 104.219 (Apr. 1867): 644–48. Print.

Jarratt, Susan C. *Rereading the Sophists: Classical Rhetoric Refigured*. Carbondale: Southern Illinois UP, 1991. Print.

"John Greenleaf Whittier." *Athenaeum* 78 (1892): 354–55. Print.

"John G. Whittier and His Writings." *North American Review* 69 (1854): 31–53. Print.

Johnson, Barbara. "Apostrophe, Animation, and Abortion." *A World of Difference*. Baltimore: Johns Hopkins UP, 1987. 190–220. Print.

Johnson, Nan. *Gender and Rhetorical Space in American Life, 1866–1910*. Carbondale: Southern Illinois UP, 2002. Print.

———. *Nineteenth-Century Rhetoric in North America*. Carbondale: Southern Illinois UP, 1991. Print.

———. "The Popularization of Nineteenth-Century Rhetoric: Elocution and the Private Learner." *Oratorical Culture in Nineteenth-Century America: Transformations in the Theory and Practice of Rhetoric*. Ed. Gregory Clark and S. Michael Halloran. Carbondale: Southern Illinois UP, 1993. 139–57. Print.

———. Pre/Text Re-Invws. March–April 2000. Archive: U Texas Arlington. Web. 22 April 2015.

Johnson, Wendy Dasler. "Cultural Rhetorics of Women's Corsets." *Rhetoric Review* 3–4 (2001): 203–33. Print.

———. "Male Sentimentalists through the 'I—s' of Julia Ward Howe's Poetry." *South Atlantic Review* 64.4 (1999): 16–35. Print.

———. "Reviving Lydia Huntley Sigourney." *The Transatlantic Poetess*. Spec. issue of *Romanticism on the Net* 29–30 (Feb.–May 2004): n. pag. Web. 22 June 2015.

Jones, Howard Mumford. "Whittier Reconsidered." *Critical Essays on John Greenleaf Whittier*. Ed. Jayne K. Kribbs. Boston: G. K. Hall, 1980. 53–60. Print.

Kaplan, E. Ann. "Is the Gaze Male?" *Women and Film: Both Sides of the Camera*. New York: Routledge, 1983. 23–35. Print.

Kelley, Mary. *Private Woman, Public Stage: Literary Domesticity in Nineteenth-Century America*. Chapel Hill: U North Carolina P, 2002. Print.

Kerber, Linda. "Separate Spheres, Female Worlds, Woman's Place: The Rhetoric of Women's History." *Journal of American History* 75 (1988): 14–15. Print.

Kete, Mary Louise. "The Reception of Nineteenth-Century American Poetry." *Cambridge Companion to Nineteenth-Century American Poetry*. Ed. Kerry Larson. New York: Cambridge UP, 2011. 15–35. Print.

———. *Sentimental Collaborations: Mourning and Middle-Class Identity in Nineteenth-Century America*. Durham, NC: Duke UP, 2000. Print.

King, Grace. *Balcony Stories*. 1893. Albany, NY: New College and UP, 1994. Print.

Kintz, Linda. "Motherly Advice from the Christian Right: The Construction of Sacred Gender." *Discourse* 17 (1994): 49–76. Print.

Kirkland, Caroline M. *A New Home—Who'll Follow? or, Glimpses of Western Life*. New York, 1836. Print.

Kitzhaber, Albert. *Rhetoric in American Colleges, 1850–1900*. Dallas: Southern Methodist UP, 1990. Print.

Kolodny, Annette. "The Problem of Persuasion in a Culture of Coercion." Unpublished essay in course packet for Gender and Writing. Ohio State U, 1989. Print.

Kribbs, Jayne K. Introduction. *Critical Essays on John Greenleaf Whittier*. Ed. Kribbs. Boston: G. K. Hall, 1980. xiii–xl. Print.

Kristeva, Julia. *Black Sun*. Trans. Leon S. Roudiez. New York: Columbia UP, 1989. Print.

———. "From One Identity to an Other." *Desire in Language*. Ed. Leon S. Roudiez. Trans. Thomas Gora, Alice Jardine, and Leon S. Roudiez. New York: Columbia UP, 1980. 124–47. Print.

———. "A Holy Madness: She and He." *Tales of Love*. Trans. Leon S. Roudiez. New York: Columbia UP, 1987. 83–100. Print.

———. *Language: The Unknown*. Trans. Anne M. Menke. New York: Columbia UP, 1989. Print.

———. *Revolt, She Said: An Interview by Philippe Petit*. Trans. Brian O'Keeffe. Ed. Sylvere Lotringer. Los Angeles: Semiotexte(e), 2002. Print.

———. "Revolution in Poetic Language." *The Kristeva Reader*. Ed. Toril Moi. New York: Columbia UP, 1986. 89–136. Print.

———. *Sense and Nonsense of Revolt: The Powers and Limits of Psychoanalysis*. Trans. Jeanine Herman. New York: Columbia UP, 2000. Print.

———. "Stabat Mater." *The Kristeva Reader*. Ed. Toril Moi. New York: Columbia UP, 1986. 160–86. Print.

———. "Women's Time." *The Kristeva Reader*. Ed. Toril Moi. New York: Columbia UP, 1986. 187–213. Print.

———. "Word, Dialogue and Novel." *The Kristeva Reader*. Ed. Toril Moi. New York: Columbia UP, 1986. 34–73. Print.

Krueger, Christine L. *The Reader's Repentance: Women Preachers, Women Writers, and Nineteenth-Century Social Discourse*. Chicago: U of Chicago P, 1992. Print.

Krumholz, Linda. "The Ghosts of Slavery: Historical Recovery in Toni Morrison's *Beloved*." *African American Review* 26.3 (1992): 395–408. Print.

Lacan, Jacques. *Ecrits: A Selection*. Trans. Alan Sheridan. New York: Norton, 1977. Print.

Lanham, Richard A. *A Handlist of Rhetorical Terms*. Berkeley: U of California P, 1991. Print.

Lanier, Sidney. *The Science of English Verse*. New York: Charles Scribner's Sons, 1880. Print.

Larson, Kerry, ed. *The Cambridge Companion to Nineteenth-Century American Poetry*. New York: Cambridge UP, 2011. Print.

LaRue, Cleophus J. *The Heart of Black Preaching*. Louisville, KY: Westminster John Knox P, 2000. Print.

Lauter, Paul. "The Literatures of America: Comparative Discipline." *Redefining American Literary History*. Ed. A. LaVonne Brown Ruoff and Jerry W. Ward Jr. New York: Modern Language Association, 1990. 9–35. Print.

Lehuu, Isabelle. "Sentimental Figures: Reading *Godey's Lady's Book* in Antebellum America." *The Culture of Sentiment*. Ed. Shirley Samuels. New York: Oxford UP, 1992. 73–91. Print.

Lesko, Barbara S. "The Rhetoric of Women in Paraonic Egypt." *Listening to Their Voices: The Rhetorical Activities of Historical Women*. Ed. Molly Meijer Wertheimer. Columbia: U of South Carolina P, 1997. 89–111. Print.

Li, Wanlin. "Towards a Sentimental Rhetoric: A Rhetorical Reading of Rebecca Harding Davis's 'Life in the Iron Mills.'" *Style* 47.2 (2013): 193–205. Print.

Linton, William James. *Life of John Greenleaf Whittier*. London: W. Scott, 1893. Print.

"Literary Women of America: Mrs. Lydia H. Sygourney." Editorial. *Ladies Repository* (Feb. 1855): 65–70. Print.

Lloyd, D. Myrddin. "Ode." *New Princeton Encyclopedia of Poetry and Poetics*. Ed. Alex Preminger and T. V. F. Brogan. Princeton, NJ: Princeton UP, 1993. 855–57. Print.

Locke, John. *An Essay Concerning Human Understanding*. 1689. Ed. Peter H. Nidditch. New York: Oxford UP, 1975. Print.

Loeffelholz, Mary. "A Difference in the Vernacular: The Reconstruction Poetry of Frances Ellen Watkins Harper." *From School to Salon: Reading Nineteenth-Century American Women's Poetry*. Princeton, NJ: Princeton UP, 2004. 94–127. Print.

———. *From School to Salon: Reading Nineteenth-Century American Women's Poetry*. Princeton, NJ: Princeton UP, 2004. Print.

———. "Mapping the Cultural Field: Aurora Leigh in America." *The Traffic in Poems: Nineteenth-Century Poetry and Transatlantic Exchange*. Ed. Meridith L. McGill. New Brunswick, NJ: Rutgers UP, 2008. 139–59. Print.

———. "The School of Lydia Sigourney." *From School to Salon: Reading Nineteenth-Century American Women's Poetry*. By Loeffelholz. Princeton, NJ: Princeton UP, 2004. 32–64. Print.

Logan, Shirley Wilson. "Black Speakers, White Representations: Frances Ellen Watkins Harper and the Construction of a Public Persona." *African American Rhetoric(s): Interdisciplinary Perspectives* (2004): 21–36. Print.

———. *"We Are Coming": The Persuasive Discourse of Nineteenth-Century Black Women*. Carbondale: Southern Illinois UP, 1999. Print.

———, ed. *With Pen and Voice: A Critical Anthology of Nineteenth-Century African American Women*. Carbondale: Southern Illinois UP, 1995. Print.

Longfellow, Henry Wadsworth. *Selected Poems*. Ed. Lawrence Buell. New York: Penguin, 1988. Print.

Lorde, Audre. "Poetry Is Not a Luxury." *Sister Outsider: Essays and Speeches by Audre Lorde*. Freedom, CA: Crossing P, 1984. 36–49. Print.

Lowance, Mason. "Jonathan Edwards and the Knowledge of God." *Language of Canaan: Metaphor and Symbol in New England from the Puritans to the Transcendentalists*. Cambridge, MA: Harvard UP, 1980. 249–76. Print.

Luedtke, Luther S., and Winfried Schleiner. "New Letters from the Grimm-Emerson Correspondence." *Harvard Library Bulletin* 23 (1997): 399–465. Print.

Lunsford, Andrea, ed. *Reclaiming Rhetorica: Women in the Rhetorical Tradition*. Pittsburgh: U of Pittsburgh P, 1995. Print.

Lystra, Karen. *Searching the Heart: Women, Men, and Romantic Love in Nineteenth-Century America*. New York: Oxford UP, 1989. Print.

Mahon, A. Wylie. "The Queen of Hearts." *Canadian Magazine* 56.4 (1921): 349–52. Print.

Mailloux, Steven. "Rhetoric and Interpretation." *Rhetorical Power*. By Mailloux. Ithaca, NY: Cornell UP, 1989. 3–56. Print.

Maranhao, Tullio. *The Interpretation of Dialogue*. Chicago: U of Chicago P, 1990. Print.

Marshall, David. *The Surprising Effects of Sympathy: Marivaux, Diderot, Rousseau, and Mary Shelley*. Chicago: U of Chicago P, 1988. Print.

Matthiessen, F. O. *American Renaissance: Art and Expression in the Age of Emerson and Whitman*. New York: Oxford UP, 1941. Print.

Mattingly, Carol. *Appropriate[ing] Dress: Women's Rhetorical Style in Nineteenth-Century America*. Carbondale: Southern Illinois UP, 2002. Print.

———. "Telling Evidence: Rethinking What Counts in Rhetoric." *Rhetoric Society Quarterly* 32.1 (Winter 2002): 99–108. Print.

———. *Well-Tempered Women: Nineteenth-Century Temperance Rhetoric*. Carbondale: *Southern* Illinois UP, 1998. Print.

May, Caroline, ed. *American Female Poets*. Philadelphia: Lindsay and Blakiston, 1853. American Female Poets Series. *Amazon*. Web. 30 Oct. 2008.

———, ed. *Pearls from the American Female Poets*. New York: World Publishing House, 1869. Print.

McGill, Meredith, ed. *The Traffic in Poems: Nineteenth-Century Poetry and Transatlantic Exchange*. New Brunswick, NJ: Rutgers UP, 2008. Print.

McMurdoch, James E. *Orthophony, or Vocal Culture: A Manual of Elementary Exercises for the Cultivation of the Voice in Elocution.* Boston: Houghton Mifflin, 1898. Print.

Melchior, Bonnie. "A Marginal 'I': The Autobiographical Self Deconstructed in Maxine Hong Kingston's *The Woman Warrior.*" *Biography* 17 (1994): 281–95. Print.

Merish, Lori. "Embodying the 'New Negro': Sentimentalism and the Reconstruction of 'Blackness' in the Work of Pauline I. Hopkins." Modern Language Association Convention. December 1993. Reading.

Michaelsen, Scott. "Sympathetic Roadblocks and Battle Hymns: Social Transformation in 19th and 20th Century Sentimentalisms." New Mexico Women's Studies Convention. 1994. Reading.

Miles, Tiya. "'Circular Reasoning': Recentering Cherokee Women in the Antiremoval Campaigns." *American Quarterly* 61.2 (2009): 221–43. Print.

Miller, Perry. *The Life of the Mind in America: From the Revolution to the Civil War.* New York: Harcourt Brace, 1965. Print.

———. *The New England Mind: The Seventeenth Century.* Cambridge, MA: Belknap, 1939. Print.

———, ed. *The Transcendentalists.* Cambridge, MA: Harvard UP, 1979. Print.

Minh-ha, Trinh T. *Woman, Native, Other: Writing, Postcoloniality, and Feminism.* Bloomington: Indiana UP, 1989. Print.

Minifee, Paul A. "Rhetorical Analysis of Sermons Written by Bishop James Walker Hood of the African Methodist Episcopal Zion Church." College Conference on Communication and Composition. Denver, 2001. Reading.

"Miss Huntley's Poems." *North American Review* 1 (1815): 111–21. Print.

Monaghan, E. Jennifer. "Literacy Instruction and Gender in Colonial New England." *Reading in America.* Ed. Cathy Davidson. Baltimore: Johns Hopkins UP, 1989. 53–82. Print.

Moody, Joycelyn, and Elizabeth Cali. "Frances Ellen Watkins Harper." *Oxford Bibliographies.* New York: Oxford University Press, 2013. Web. 9 Mar. 2014.

Morrill, John S. "Lady Jane Grey, Queen of England." *Encyclopaedia Britannica Online.* Web. 8 Aug. 2014.

Morrison, Toni. *Beloved.* New York: New American Library, 1987. Print.

*Mountain Stage.* National Public Radio. WNYC, New York. 19 Sept. 1993. Radio.

"Mrs. Howe and Her Commentator." *Atlantic Monthly* 98 (July–Dec. 1906): 572–73. Print.

Mulcaire, Terry. "Public Credit; or, The Feminization of Virtue in the Marketplace." *Publication of the Modern Language Association* 114.5 (Oct. 1999): 1029–42. Print.

Mullan, John. *Sentiment and Sociability: The Language of Feeling in the Eighteenth Century.* Oxford: Clarendon Press, 1988. Print.

Mulvey, Laura. "Visual Pleasure and Narrative Cinema." *Screen* 16.3 (Autumn 1975): 6–18. Print.

Nate, Richard. "Metonymy." *Encyclopedia of Rhetoric*. Ed. Thomas O. Sloane. New York: Oxford UP, 2001. 496–98. Print.

Nathan, James. Prefatory Note. *Love Letters of Margaret Fuller*. By Margaret Fuller. Ed. Nathan (later James Gotendorf). 1903. New York: Greenwood, 1969. Print.

Nichols, B. Ashton. "Monologue." *The New Princeton Encyclopedia of Poetry and Poetics*. Ed. Alex Preminger and B. V. F. Brogan. Princeton, NJ: Princeton UP, 1993. 798–800. Print.

Okker, Patricia. "Sara Josepha Hale, Lydia Sigourney, and the Poetic Tradition in Two Nineteenth-Century Women's Magazines." *American Periodicals: A Journal of History, Criticism, and Bibliography* 3 (1993): 32–42. Print.

Oliver, Kelly. Introduction. *Ethics, Politics, and Difference in Julia Kristeva's Writing*. Ed. Oliver. New York: Routledge, 1993. 1–22. Print.

Olson, Steven. *The Prairie in Nineteenth-Century American Poetry*. Norman: U of Oklahoma P, 1994. Print.

*Oratorical Culture in Nineteenth-Century America: Transformations in the Theory and Practice of Rhetoric*. Ed. Gregory Clark and S. Michael Halloran. Carbondale: Southern Illinois UP, 1993. Print.

Pace, Joel. "Towards a Taxonomy of Transatlantic Romanticism(s)." *Literature Compass* 5.2 (2008): 228–91. Print.

Pamuk, Orhan. *The Naive and the Sentimental Novelist*. New York: Vintage Books, 2011. Print.

Parille, Ken. "What Our Boys Are Reading": Lydia Sigourney, Francis Forrester, and Boyhood Literacy in Nineteenth-Century America." *Children's Literature Association Quarterly* 33.1 (2008): 4–25. Print.

Parrington, Vernon Louis, ed. *The Connecticut Wits*. New York: Thomas Y. Crowell, 1954. Print.

Parsons, Francis. *Six Men of Yale*. New Haven, CT: Yale UP, 1939. Print.

"Passion-Flowers." Rev. of *Passion-Flowers*, by Julia Ward Howe. *Knickerbocker* 43 (1854): 353–62. Print.

Peabody, W. B. O. "Mrs. Sigourney and Miss Gould." *North American Review* 40 (1835): 430–54. Print.

Peacham, Henry. *The Garden of Eloquence*. 1593. Gainesville, FL: Scholars' Facsimiles, 1954. Print.

Peaden, Catherine Hobbs. "Understanding Differently: Re-reading Locke's *Essay Concerning Human Understanding*." *Rhetoric Society Quarterly* 22.1 (Winter 1992): 74–90. Print.

Pearce, Roy Harvey. *The Continuity of American Poetry*. New York: Holt, Rinehart, 1969. Print.

Pease, Donald E. "New Americanists: Revisionist Interventions into the Canon." *boundary 2* 17.1 (1990): 1–37. Print.

Perry, Bliss. "Whittier for To-day." *Atlantic Monthly* 54 (1907): 851–59. Print.

Peterson, Carla L. *"Doers of the Word": African-American Women Speakers and Writers in the North (1830–1880)*. New York: Oxford UP, 1995. Print.

Petrino, Elizabeth A. "'Feet So Precious Charged': Dickinson, Sigourney, and the Child Elegy." *Tulsa Studies in Women's Literature* 13 (1994): 317–38. Print.

Phillips, Elizabeth. *Emily Dickinson: Personae and Performance*. University Park: Pennsylvania State UP, 1988. Print.

Pickard, John B. *John Greenleaf Whittier*. New York: Holt, Rinehart and Winston, 1961. Print.

———, ed. *Memorabilia of John Greenleaf Whittier*. Hartford, CT: Emerson Society, 1968. Print.

Plato. *Phaedrus*. Trans. W. C. Helmbold and W. G. Rabinowitz. New York: Macmillan, 1956. Print.

Poe, Edgar Allan. "Critical Notices: Mrs. Sigourney—Miss Gould—Mrs. Ellet." *Southern Literary Messenger* 2.2 (1836): 112–28. Print.

———. "Letters to Mothers." *Southern Literary Messenger* 5 (1839): 257–62. Print.

———. "The Philosophy of Composition." *The Norton Anthology of American Literature*. 3rd ed. Vol. 1. Ed. Nina Baym et al. New York: Norton, 1989. 1459–66. Print.

———. "Sigourney's Letters." *Southern Literary Messenger* 2 (1836): 505–6. Print.

Puttenham, George. *The Arte of English Poesie*. 1589. Kent, OH: Kent State UP, 1906. Print.

Railton, Stephen. "'Assume an Identity of Sentiment': Rhetoric and Audience in Emerson's 'Divinity School Address.'" *Seeing and Saying: The Dialectic of Emerson's Eloquence* Carbondale: Southern Illinois UP, 1986. 31–48. Print.

Raum, Elizabeth. *Julia Ward Howe*. Chicago: Heinemann-Raintree Library, 2004. Print.

Read, Thomas Buchanan, ed. *The Female Poets of America*. 1848. Detroit: Gale Research, 1978. Print.

Reed, T. V. "Affirmative (Bl)Actions: The Drama of the Black Panthers." Pacific Northwest American Studies Association Conference. Spokane, WA. Mar. 2002. Reading.

Reid, Thomas. *Essays on the Intellectual Powers of Man*. 1785. Cambridge, MA: MIT UP, 1969. Print.

Reynolds, David S. *Beneath the American Renaissance*. Cambridge, MA: Harvard UP, 1988. Print.

Richards, Laura E., Maud Howe Elliott, and Florence Howe Hall. *Julia Ward Howe*. 2 vols. Boston: Houghton Mifflin, 1916. Print.

Ritchie, Joy, and Kate Ronald, eds. *Available Means: An Anthology of Women's Rhetoric(s)*. Pittsburgh: Pittsburgh UP, 2001. Print.

Robinson, David. *Apostle of Culture: Emerson as Preacher and Lecturer*. Philadelphia: U of Penn P, 1982. Print.

Rose, Jane E. "Conduct Books for Women, 1830–1860: A Rationale for Women's Conduct and Domestic Role in America." *Nineteenth-Century Women Learn to Write*. Ed. Catherine Hobbs. Charlottesville: U of Virginia P, 1994. 37–58. Print.

Royster, Jacqueline Jones. *Traces of a Stream: Literacy and Social Change among African American Women*. Pittsburgh: U Pittsburgh P, 2000. Print.

Royster, Jacqueline Jones, and Gesa E. Kirsch. *Feminist Rhetorical Practices: New Horizons for Rhetoric, Composition, and Literacy Studies*. Carbondale: Southern Illinois UP, 2012. Print.

Samuels, Shirley, ed. *The Culture of Sentiment*. New York: Oxford UP, 1992. Print.

Sanchez-Eppler, Karen. *Touching Liberty: Abolition, Feminism, and the Politics of the Body*. Berkeley: U of California P, 1993. Print.

Sayers, Edna Edith, and Diana Gates. "Lydia Huntley Sigourney and the Beginnings of American Deaf Education in Hartford: It Takes a Village." *Sign Language Studies* 8.4 (2008): 369–411. Print.

Scharnhorst, Gary. *A Literary Biography of William Rounseville Alger (1922–1905): A Neglected Member of the Concord Circle*. Lewiston, NY: Edwin Mellen P, 1990. Print.

Schiller, Friedrich. *Naive and Sentimental Poetry, and On the Sublime: Two Essays*. 1795. Trans. Julius A. Elias. New York: F. Ungar, 1967. Print.

Schnog, Nancy. "Inside the Sentimental: The Psychological Work of the Wide Wide World." *Genders* 4 (1989): 11–25. Print.

Schor, Naomi. *Reading in Detail: Aesthetics and the Feminine*. New York: Methuen, 1987. Print.

Sheridan, Thomas. *A Course of Lectures on Elocution: Together with Two Dissertations on Language; and Some Other Tracts Relative to Those Subjects*. London, 1762. Print.

Sherman, Joan R., ed. *African American Poetry of the Nineteenth Century: An Anthology*. Urbana: U of Illinois P, 1992. Print.

Showalter, Elaine. *Sister's Choice: Tradition and Change in American Women's Writing*. Oxford: Clarendon P, 1991. Print.

Sigourney, Lydia Huntley. *Letters of Life*. New York: D. Appleton and Co., 1866. Print.

———. *Letters to Mothers*. Hartford: Hudson and Skinner, 1838. Print.

———. *Letters to Young Ladies*. 1833. 5th ed. Gibbs Press, 2008. Print.

———. *Lucy Howard's Journal*. 1858. Whitefish, MT: Kessinger Publishing, 2007. Print.

———. *Poems*. Philadelphia: John Locken, 1842. Print.

———. "Return of Napoleon from St. Helena." *An American Anthology, 1787–1900*. Ed. Edmund Clarence Stedman. Boston: Houghton Mifflin, 1900. N. pag. Web. 9 Jan. 2003.

———. *Traits of the Aborigines of America: A Poem*. Cambridge, MA: Cambridge UP, 1822. Print.

———. *Zinzendorff, and Other Poems*. New York: Leavitt, Lord, 1836. Print.

Sigourney, Lydia Huntley, et al. *The Young Ladies' Offering; or, Gems of Prose and Poetry*. Boston: Phillips and Sampson, 1849. Print.

"The Sigourney Circle of Chichester, Vermont." *Atlantic Monthly* 54 (1807): 573–74. Print.

Silverman, Kaja. *The Subject of Semiotics*. New York: Oxford UP, 1983. Print.

Silverman, Kenneth. Foreword. *The Connecticut Wits*. Ed. Vernon L. Parrington Jr., Elizabeth P. Thomas, and Louise P. Tucker. New York: Thomas Y. Crowell Co., 1969. vii–xx. Print.

Slick, Matthew J. "The Five Points of Calvinism." *Calvinist Corner*. N.d. Web. 25 Sept. 2002.

Smith, Adam. *An Inquiry into the Nature and Causes of the Wealth of Nations*. 1759. Edinburgh: Printed for Oliphant, Waugh & Innes, 1817. Print.

———. *Rhetoric and Belles Lettres*. 1763. New York: Thomas Nelson and Sons, 1963. Print.

———. *The Theory of Moral Sentiments*. 1759. Ed. D. D. Raphael and A. L. Macfie. London: Clarendon P, 1976. Print.

Smith, Dinitia. "Laureates Convene, Waxing Poetic." *New York Times*, 28 Apr. 2003. Web. 22 May 2003.

Smith, Stephanie A. "Heart Attacks: Frederick Douglass's Strategic Sentimentality." *Criticism* 34 (1992): 193–216. Print.

Smith, Timothy L. *Revivalism and Social Reform in Mid-Nineteenth-Century America*. New York: Abingdon P, 1957. Print.

Smith-Rosenberg, Carroll. "The Body Politic." *Coming to Terms: Feminism, Theory, Politics*. Ed. Elizabeth Weed. New York: Routledge, 1989. 101–21. Print.

———. *Disorderly Conduct: Visions of Gender in Victorian America*. New York: Oxford UP, 1986. Print.

"Songs of Labor and Other Poems." Rev. of *Songs of Labor*, by John Greenleaf Whittier. *Brownson's Quarterly Review* 16 (1850): 540. Print.

Sorby, Angela. *Schoolroom Poets: Childhood, Performance, and the Place of American Poetry, 1865–1917*. Durham: U of New Hampshire P, 2005. Print.

Sparhawk, Frances C. "Whittier, the Poet and the Man." *New England Magazine* 7 (1892): 293–98. Print.

Spillers, Hortense. "All the Things You Could Be by Now If Sigmund Freud's Wife Was Your Mother: Psychoanalysis and Race." *Female Subjects in Black and White: Race, Psychoanalysis, Feminism*. Ed. Elizabeth Abel, Barbara Christian, and Helene Moglen. Berkeley: U of California P, 1997. 135–58. Print.

———. *Black, White, and in Color: Essays on American Literature and Culture*. New York: Routledge, 2003. Print.

Spivak, Gayatri Chakravorty. *Outside in the Teaching Machine*. New York: Routledge, 1993. Print.

Stancliff, Michael. *Frances Ellen Watkins Harper: African American Reform Rhetoric and the Rise of a Modern Nation State*. New York: Routledge, 2011. Print.

St. Armand, Barton Levi. "Dark Parade: Dickinson, Sigourney, and the Victorian Way of Death." *Emily Dickinson and Her Culture: The Soul's Society*. By St. Armand. New York: Cambridge UP, 1984. 39–78. Print.

Still, William. *The Underground Railroad*. Philadelphia: Porter and Coates, 1872. Print.

Stokes, Claudia. *The Altar at Home: Sentimental Literature and Nineteenth-Century American Religion*. Philadelphia: U of Pennsylvania P, 2014. Print.

Stowe, Harriet Beecher. *Uncle Tom's Cabin*. New York: Penguin, 1981. Print.

Stradley, Kathleen. "Stirring the Spirit, Moving the Soul: George Aiken's *Tableax* of Uncle Tom's Cabin." Unpublished essay. 1993. Print.

Sutherland, Christine Mason, and Rebecca Sutcliffe, eds. *Changing Tradition in the History of Rhetoric*. Calgary, AB: U of Calgary P, 1999. Print.

Swearingen, C. Jan. *Rhetoric and Irony: Western Literacy and Western Lies*. New York: Oxford UP, 1991. Print.

Tannen, Deborah. *Talking from 9 to 5: How Women's and Men's Conversational Styles Affect Who Gets Heard, Who Gets Credit, and What Gets Done at Work*. New York: William Morrow, 1994. Print.

Taylor, Ula Y. "'Read[ing] Men and Nations': Women in the Black Radical Tradition." *Souls* 1.4 (1999): 72–80. Print.

Tharp, Louise Hall. *Three Saints and a Sinner: Julia Ward Howe, Louisa, Annie and Sam Ward*. Boston: Little Brown, 1956. Print.

Thompson, Lawrance. *Young Longfellow, 1807–1843*. New York: Macmillan, 1938. Print.

Thoreau, Henry David. "Walden; or, Life in the Woods." *Walden and Resistance to Civil Government*. Ed. William Rossi and Owen Thomas. New York: Norton, 1992. 1–191. Print.

———. *A Week on the Concord and Merrimack Rivers*. Ed. Carl F. Hovde, William L. Howarth, and Elizabeth Hall Witherell. Princeton, NJ: Princeton UP, 2004. Print.

Todd, Janet. *Sensibility: An Introduction*. New York: Methuen, 1983. Print.

Tompkins, Jane. "'Indians': Textualism, Morality, and the Problem of History." *Ways of Reading*. 3rd ed. Ed. David Bartholomae and Anthony Petrosky. Boston: Bedford, 1993. 583–605. Print.

———. *Sensational Designs: The Cultural Work of American Fiction, 1790–1860*. New York: Oxford UP, 1985. Print.

Tonkovich, Nicole. *Domesticity with a Difference: The Nonfiction of Catharine Beecher, Sarah Josepha Hale, and Margaret Fuller*. Jackson: U of Mississippi P, 1997. Print.

———. "Writing in Circles: Harriet Beecher Stowe, the Semi-Colon Club, and the Construction of Women's Authorship." *Nineteenth-Century Women Learn to Write*. Ed. Catherine Hobbs. Charlottesville: U of Virginia P, 1995. 145–75. Print.

Trapp, Marjorie Jane. "Sentimental Poetry of the American Civil War." Diss. U California–Berkeley, 2010. Web. June 2015.

Trill, Suzanne, Kate Chedgzoy, and Melanie Osborne, eds. *Lay By Your Needles Ladies, Take the Pen: Writing Women in England, 1500–1700*. London: Arnold, 1997. Print.

Trinder, Peter W. *Mrs. Hemans*. Bangor: U of Wales P, 1984. Print.

Tuckerman, H. T. "Passion Flowers of Poetry." *Southern Quarterly Review* 9 (July 1854): 181–91. Print.

Underwood, Frances H. *The Life of Henry Wadsworth Longfellow*. Boston: B. B. Russell, 1882. Print.

"Unitarian Universalist Principles and Purposes." *Unitarian Universalist Association*. Jan. 2007. Web. 26 Apr. 2015.

"United Methodist Church." *Conservapedia*. 17 Apr. 2011. Web. 7 Dec. 2013.

Vaughn, Maggi. "Laureates Convene."

Veblen, Thorstein. "Conspicuous Consumption and the Servant-Wife." *The Awakening*. Ed. Margaret Culley. New York: Norton, 1976. 138–40. Print.

von Arnim, Bettine. *Goethes Briefwechsel mit einem Kinde [Goethe's Correspondence with a Child]*. 1835. Berlin: Karl-Marx-Werk, 1986. Print.

von Frank, Albert. "Margaret Fuller on passion flowers." Personal communication. 22 Oct. 1999.

Vox, Valentine. *I Can See Your Lips Moving: The History and Art of Ventriloquism*. Tadworth, Surrey, UK: Kaye and Ward, 1981. Print.

Wagenknecht, Edward. *Henry Wadsworth Longfellow: His Poetry and Prose*. New York: Ungar, 1986. Print.

———. *Longfellow: A Full-Length Portrait*. New York: Longmans Green, 1955. Print.

Wagner, Jonathan F. "Nazism and Sentimentalism: The Propaganda Career of Karl Goetz." *Canadian Journal of History* 24 (1989): 63–81. Print.

Waldstein, Edith Josephine. *Bettine von Arnim and the Politics of Romantic Conversation*. New York: Columbia UP, 1988. Press.

Walker, Cheryl, ed. *American Women Poets of the Nineteenth Century*. New Brunswick, NJ: Rutgers UP, 1992. Print.

———. "Frances Harper." *American Women Poets of the Nineteenth Century*. Ed. Walker. New Brunswick, NJ: Rutgers UP, 1992. 238–57. Print.

———. "Julia Ward Howe." *American Women Poets of the Nineteenth Century*. Ed. Walker. New Brunswick, NJ: Rutgers UP, 1992. 148–67. Print.

———. "Lydia Sigourney." *American Women Poets of the Nineteenth Century*. Ed. Walker. New Brunswick, NJ: Rutgers UP, 1992. 1–23. Print.

———. *The Nightingale's Burden: Women Poets and American Culture before 1900*. Bloomington: Indiana UP, 1982. Print.

Warhol, Robyn R. "As You Stand, So You Feel and Are: The Crying Body and the Nineteenth-Century Text." *Tattoo, Torture, Mutilation, and Adornment*. Ed. Frances E. Mascia-Lees and Patricia Sharpe. Albany: SUNY Press, 1992. 100–25. Print.

———. *Gendered Interventions: Narrative Discourse in the Victorian Novel.* New Brunswick, NJ: Rutgers UP, 1989. Print.

———. "'Reader, Can You Imagine? No, You Cannot': The Narratee as Other in Harriet Jacobs's Text." Modern Language Association Convention. December 1993. Reading.

Warner, Susan. *Wide Wide World.* 1852. Ed. Jane Tompkins. New York: Feminist P, 1996. Print.

Warren, Joyce W. *The American Narcissus: Individualism and Women in Nineteenth-Century American Fiction.* New Brunswick, NJ: Rutgers UP, 1984. Print.

———. *Fanny Fern: An Independent Woman.* New Brunswick, NJ: Rutgers UP, 1992. Print.

Watts, Emily Stipes. *The Poetry of American Women from 1632–1945.* Austin: U of Texas P, 1977. Print.

"Wearing Apparel." *McClure's Magazine.* N. pag. 1896. Print.

Weidner, Heidemarie Z. "Silks, Congress Gaiters, and Rhetoric: A Butler University Graduate of 1860 Tells Her Story." *Nineteenth-Century Women Learn to Write.* Ed. Catherine Hobbs. Charlottesville: U of Virginia P, 1994. 248–63. Print.

Weisenburger, Steven. *Modern Medea: A Family Story of Slavery and Child-Murder from the Old South.* New York: Hill and Wang, 1999. Print.

Welter, Barbara. "The Cult of True Womanhood: 1820–1860." *American Quarterly* 18 (1966): 151–74. Print.

Wertheimer, Molly Meijer, ed. *Listening to Their Voices: The Rhetorical Activities of Historical Women.* Columbia: U South Carolina P, 1997. Print.

Wexler, Laura. "Seeing Sentiment: Photography, Race, and the Innocent Eye." *Female Subjects in Black and White: Race Psychoanalysis, Feminism.* Ed. Elizabeth Abel, Barbara Christian, and Helene Moglen. Berkeley: U of California P, 1997. 159–86. Print.

———. "Tender Violence: Literary Eavesdropping, Domestic Fiction, and Educational Reform." *Yale Journal of Criticism* 5 (1992): 151–80. Print.

Wheatley, Phillis. *Poems on Various Subjects, Religious and Moral.* 1773. Facsimile in William H. Robinson's *Phillis Wheatley and Her Writings.* New York: Garland, 1984. Print.

Whipple, E. P. "Mrs. Sigourney's Poems." *North American Review* 142 (1849): 497–503. Print.

White, Eugene. *Puritan Rhetoric: The Issue of Emotion in Religion.* Carbondale: Southern Illinois UP, 1972. Print.

Whittier, John Greenleaf. *Complete Poetical Works of John Greenleaf Whittier: Household Edition.* Boston, 1863. Print.

———. *Leaves from Margaret Smith's Journal.* Boston: Ticknor, Reed and Fields, 1849. Print.

———. *A Sabbath Scene.* Illus. by Baker, Smith, and Andrew. Boston: John P. Jewett, 1854. Print.

———. *Whittier on Writers and Writing*. Ed. Edwin Cady and Harry Hayden Clark. Syracuse, NY: Syracuse UP, 1950. Print.

"Whittier's, Bacon's, and Lowell's Poems." *North American Review* 68 (1849): 261–62. Print.

"Whittier's Poems: Lays of My Home and Other Poems." *Southern Quarterly Review* 4 (1843): 516–19. Print.

"Whittier's Poems Written during the Progress of the Abolition Question in the United States." *Boston Quarterly Review* 1 (1838): 21–33. Print.

Williams, Gary. *Hungry Heart: The Literary Emergence of Julia Ward Howe*. Amherst: U of Mass P, 1999. Print.

———. "Julia Ward Howe, Her Husband, His Friend, and *Passion Flowers*." Pacific NW American Studies Association Conference. April 1993. Reading.

Wilson, Harriet E. *Our Nig; or, Sketches from the Life of a Free Black*. Introduction and Notes by Henry Louis Gates Jr. 1859. New York: Vintage Books, 1983. Print.

Yalom, Marilyn. *A History of the Breast*. New York: Ballantine, 1998. Print.

Yee, Shirley J. *Black Women Abolitionists: A Study in Activism, 1828–1860*. Knoxville: U of Tennessee P, 1992. Print.

Zagarell, Sandra A. "Collective Identities in Lydia Sigourney's *Lucy Howard's Journal* and Harriet Jacobs's *Incidents in the Life of a Slave Girl*." Modern Language Association special session, "The Collective Subject in Mid-Nineteenth-Century America." 1995. Reading.

Zavarzadeh, Mas'ud, and Donald Morton. "(Post)modern Critical Theory and the Articulations of Critical Pedagogies." *Margins in the Classroom: Teaching Literature*. Ed. Kostas Myrsiades and Linda S. Myrsiades. Minneapolis: U of Minnesota P, 1994. 89–101. Print.

# Index

Italicized page numbers indicate illustrations.

Abraham and Isaac (biblical drama), 67
activist poets, 6. *See also* Harper, Frances Ellen Watkins
affect, slippage into effect, 42
African Americans: *Anglo-African* (Harper), 46; antebellum women writers, 36, 40, 45; black churches and inward transformations, 157–58; Foster on twentieth-century black critics, 147; Margaret Garner, 51, 53, 60–70; Harper on lessons for black readers, 146–50; Harper's recommendation for discussion groups, 158; Israelites' hard-won freedom compared to, 60; "On Being Brought from African to America" (Wheatley), 148; Royster on goals for black women's literacy, 41–42; Royster on women writers, 19, 51, 135, 145, 149; self-presentation by women artists and writers, 52; sermons by, 219n. 6; women, ambivalence and subversion, 53–54; women as nursemaids, 71. *See also* Harper, Frances Ellen Watkins
African Methodist Episcopal (AME) Church, 54, 147, 151, 157, 226n. 4
Alcott, Louisa May, 190
*American Female Poets* (May), 1–2
American Indians, in *Lucy Howard's Journal*, 99–101

*American Poetry* (anthology), 215n. 2
"Amos." *See* "Imitation of Parts of the Prophet Amos" (Sigourney)
*Anglo-African* (Harper), 46
"Answer" (Howe), 193–94
antebelllum nursemaid, 71, *72*
antebellum verse, 22, 31
antebellum women poets. *See names of individual poets*
antebellum women writers, 23, 36, 40, 42–43, 45
apostrophes: in backdrop for sentimental poetry, 174; Blair on use of, 87, 111–12, 175–76; class criticism and, 164–65; classic, 128–29; defined, 93; implications for women writers, 174–75; in modern verse, 177; Sigourney's use of, 163, 166, 168–69, 171–74, 177–78, 180; work of, to gather audiences, 176–77
Aristotle: advice to rhetors, 63, 140; art vs. persuasion, 4; on function of tragic poet, 64; on heightened language in elegies, 175; rhetoric, classical definition of, 2
association tactic, and ethical appeal, 57–58
audience identification, first-person ethos and, 60–62
Axer, Jerzy, 220–21n. 15

*257*

Barthes, Roland, 116–17, 185
"Battle Hymn of the Republic, The" (Howe), 111–14, 122, 188–89, 201
Baym, Nina, 38, 93, 165, 201, 223n. 9
"Be Active" (Harper), 1, 10
Beecher, Catharine, 162–64
*Beloved* (film), 51–52, 64, 67, 73–74, 74
*Beloved* (Morrison), 64
Bennett, Paula, 4, 165–66, 188
Benveniste, Emile, 73, 121–22, 178
"Bible Defense of Slavery" (Harper), 144
Bigelow, Gordon E., 213n. 4
Black Lives Matter movement, 157–58
Blair, Hugh: Bigelow on, 213n. 4; codes of rhetoric by, 169; definition of poetry, 195; Howe and, 115; instructions for lively exchange, 189; *Lectures on Rhetoric and Belles Lettres*, 7, 111, 175; on poetry and elevation of sentiments, 23–24; on pulpit oratory, 218n. 6; "Rhetoric," 194–95; on use of apostrophe, 87, 111–12, 175–76; on work of poetry, 174
Blasing, Mutlu Konuk, 108, 110, 127, 130
Booker T. Washington School, 159
Brown, William Hill, 11
Burke, Kenneth, 145
"Bury Me in a Free Land" (Harper), 55–56
Butler University, 180

Calhoun, Lucia Gilbert, 196–97, 200–201
Campbell, George: advice to student rhetors, 94; gendered implications in writing of, 24; Harper's appropriation of sentimental tactics of, 141; mental faculties compared to human virtues, 88–90; on metonymy vs. metaphor, 78; and new psychological rhetoric, 7; and new science of the human mind, 87; on raw passions vs. acceptable virtues, 8, 18; rhetoric, codes of, 169; rhetoric, empirical definition of, 9; on rhetorico poetic tradition, 213n. 4; on sympathy as engine of persuasion, 139; on Whittier's *A Sabbath Scene*, 116–17
"Canticles" (Solomon), 192
Channing, Edward T., 9
Christianity, radical, 147–48
*Christian Recorder* (periodical), 150–51
Civil War: Margaret Garner and, 51, 53, 60–70; Harper and, 18, 59–60, 136, 153, 155–56; Howe and, 201, 205
Clark, Suzanne: on critical pedagogy, 150; on discourse, 193; on Howe's work, 185–86; on rhetoric as sentimental, 184, 203–4; on sentimentalism, 169–70; on woman's apostrophe, 176
class and gender, common marks of, 178–82
class criticism and apostrophe, 164–65
class issues, Sigourney and, 163, 182
clearings, Morrison's, 158–59
Clifford, Deborah Pickman, 199
Coffin, Levi, 64–65, 68
Collins, Martha, 108, 130–31
"Colored People of America, The" (Harper), 135
commemorative poems by male poets, 129–30, 214n. 10
common schools, at the site of segregation and slave auctions, 159
Connor, Steven, 70, 220n. 12, 220n. 13
Continental romanticism, 205
Continental sentimentalism, 198
"Contrast, The" (Harper), 143
"Coquette et Froide" (Howe), 190–91
"Coquette et Tendre" (Howe), 191–92
"Correspondence" (Howe), 32–33
critical pedagogy, 136–37, 150, 159

dame schools, 98, 223n. 12
Davis, Jefferson, 156–57
death: in childbirth, 104; of Garner, 68–69; in *Lucy Howard's Journal*, 105
"Death of an Infant" (Sigourney), 79–80
Delpit, Lisa, 136–37, 159–60
Demme, Jonathan, 73–74
dialogue, 183, 189–90, 194–95, 207
Dickinson, Emily, 115, 190
discourses: Clark on, 193; dialogue associated with philosophical and literary, 189; dominant, 17–26, 215n. 16; religious, poetic coquetry and, 33–35; sentimental, political implications of, 201
displacement, in language, 21–22, 85
Dobson, Joanne, 165
domestic roles, for nineteenth-century women, 26–32, 39–40
dominant discourses, learning of, 17–26
Donawerth, Jane, 27, 163, 186–87, 189, 206, 216n. 8
doubleness of the female, 47–48
Douglas, Ann, 89–90, 90, 164
Dwight, Timothy (the elder), 181–82
Dwight, Timothy (the younger), 90–91, 162, 180–82

education of girls, in *Lucy Howard's Journal*, 102–4
elegies: Aristotle on heightened language in, 175; by male poets, 129–30, 214n. 10; Sigourney and, 76–77, 101–5, 221n. 1; Whittier's for Sigourney, 183
emancipation poems, 59
Emerson, Ralph Waldo, 110, 113, 151, 214n. 8
empiricism, rhetoric of, 9, 170
English studies (after 1865), 3
Enlightenment rhetoric, 78, 139–40

epistemology, sensationalist, 169
erotic dialogue, usefulness of, 195
erotic verse, Howe and, 33, 185, 200
ethos: first person, and audience identification, 60–62; flexibly gendered, 78–79; liminal, 54–57; metonymies of, 86–87; ventriloquism as Harper's strategy of, 70

"Factor in Human Progress, A" (Harper), 146
faculty psychology, Harper and, 140
"Fancy Etchings" essays (Harper), 39, 150–51
"Fellow Pilgrim, The" (Howe), 33–34
*Female Poets of America, The* (Griswold), 31
feminism, in Harper's poetry, 58–59
*Feminist Rhetorical Practices* (Royster and Kirsch), 206–7
Fern, Fanny, 24, 173–74, 216n. 5
Finch, Annie, 166, 196
Foster, Frances Smith, 141–42, 146–47, 151, 226n. 4
Foucault, Michel, 141
Frank, Anne, 224–25n. 20
freedom, hard-won, of Israelites compared to African Americans', 60
"Free Labor" (Harper), 142
"Fugitive's Wife, The" (Harper), 57–58, 144–45
Fuller, Edmund, 5–6, 213n. 6
Fuller, Margaret, 32, 200

Gallaudet, Rev., 104
Garner, Margaret, 51, 53, 60–70
Garrett, Thomas, 199
gatherings, Harper's, 158–59
gender and class, common marks of, 178–82
gendered personae, shifts in, 91–97
Giuliani, Rudy, 175

Goethe, Johann Wolfgang von, 196
Greek drama, rhetorical prosopopoeia in, 63
Griswold, Rufus, 31
Gruenewald, David A., 136

Haight, Gordon, 82, 164
"Handsome Harry" (Howe), 34, 187
Harper, Fenton, 30
Harper, Frances Ellen Watkins, 52; activist agenda of, 17, 55–56, 67–68, 136–37; association and dissociation in poems, 61–62; "Be Active," 1, 10; challenges to convention, 141–44; "The Colored People of America," 135; critical reread of "race," 144–46; critics of, 70–71; defiant writing of, 36, 39–42, 45–47; early life of, 54–55; as expert in art for humanity's sake, 73; "Fancy Etchings" essays, 39, 150–51; feminism in poetry of, 58–59; fight for women's issues, 219–20n. 11; genre boundaries and, 4–5; *Iola Leroy*, 160; lessons for black readers, 146–50; lessons for white readers, 137–41; poetic ventriloquism, 51–54, 56–57, 60–62; on poetry's effect on the mind, 10–11; poetry's significance to, 45; response to white sympathizers, 57–58; rhetorical and educational goals of, 69–70, 136, 140, 145, 152; "The Slave Mother: A Tale of the Ohio," 51–52, 60–62, 64–65, 66–67; on spirit of rhetoric, 139–40; Unitarianism of, 57, 136, 151–52, 153–54, 155, 158, 218n. 5, 227n. 6; use of metonymy, 18–23, 30, 85–86; use of rhetorical prosopopoeia, 63; "Words for the Hour," 135, 155–56; writing and lecturing prior to and during marriage, 29–30
Havazelet, Ehud, 195
Hawthorne, Nathaniel, 3, 179, 198–99

"Heart's Astronomy, The" (Howe), 201–2
Hemans, Felicia, 78–84, 222n. 3
Herder, Johann Gottfried, 105
Higginson, Thomas Wentworth, 200
Hobbs, Catherine, 3
Holloway, Karla, 148
hooks, bell, 45, 150, 159–61
Horace, on purpose of art, 195
Howard, Lucy. See *Lucy Howard's Journal* (Sigourney)
Howe, Florence, 22
Howe, Julia Ward, 110; audiences' misreading of, 189; "Battle Hymn of the Republic," 111–14, 122; childhood of, 217n. 9; coquetry, poetic, 33–35, 190–94; coquette, cultural context of, 188–89; defiant writing of, 37–38; dialogue in rhetoric of sentiment, 189–90; dialogue of charged absence, 194–95; domestic expectations and writing, 31–32; early life of, 114–15; on Emerson's poems, 110; erotic verse, 33, 185, 200; followers of, 197–200; many "I—s" of, 108–11; marriage of, 186; "Master" poems, 123–27, 197–98; omission from May's anthology, 200; as second woman revisionist, 201; seduction of male literary establishment, 123, 203; sentimental semiotics and desire, 184–86; transcendentalism, 32, 112, 187; use of metonymy, 18, 32; Williams on, 187; women as resistant readers of, 202. See also *Passion-Flowers* collection (Howe)
Howe, Samuel Gridley, 187, 197, 199
humanity, discerning, 144
*Hungry Heart: The Literary Emergence of Julia Ward Howe* (Williams), 186

identification between hearers and orators, writers and readers, 57, 229n. 9

"Imitation of Parts of the Prophet Amos" (Sigourney), 91–97, 103, 168–69
industrialization, Harper on, 142–43
"Infancy" (illustration from *Godey's Lady's Book*), *19*, 19–20
*Iola Leroy* (Harper), 160
Irving, Washington, 129–30
"I Thirst" (Harper), 152–55

Jackson, Helen Hunt, 190
Jacobs, Harriet Ann, 141, 171
Johnson, Barbara, 174, 177

Kant, Immanuel, 138
Kennedy, John F., 147
Kete, Mary Louise, 166
*King James Bible:* book of Amos, 92; "Song of Solomon," 185, 192–93
Kirsch, Gesa E., 206–7
*Knickerbocker* (periodical) reviewer, 197–98
Knight Library, University of Oregon, 82
Kristeva, Julia: on intersection of print and feeling, 169; on "Song of Solomon," 192; on textual discordance, 91–92; on women's melancholy and language, 44; on writing, 17, 47
Krueger, Christine L., 223n. 11

"Lady Jane Grey" (Sigourney), 167–68
Lanham, Richard, 171
Lathrop, Jerusha Alcott, 81
learning outcomes, outward and inward, 156–61
*Lectures on Rhetoric and Belles Lettres* (Blair), 7, 111, 175
*Letters to Mothers* (Sigourney), 99
*Letters to Young Ladies* (Sigourney), 8, 88, 103–4, 182, 223n. 10
Lincoln, Abraham, 113
Locke, John, 169, 214n. 11

Logan, Shirley Wilson, 53
logos of antebellum sentimentalism, 20, 48
Longfellow, Henry Wadsworth, 123–24, 127–30, 187, 197
Lorde, Audre, 41
"Lost Sister, The" (Sigourney), 171–74, 176–78, 228–29n. 7
*Lucy Howard's Journal* (Sigourney), 25–29, 43, 79, 97–101, 221–22n. 2, 224n. 17
"Lydia H. Sigourney" (engraving, circa 1860), *77*
"Lyric I, The" (Howe), 108–9

Mahon, A. Wylie, 201–2
male literary establishment, response to Howe, 198–200, 203
male poets, 29, 44, 110–11, 127–30, 214n. 10
male readers, Howe's flirtation with, 33–34
marriage, and publishing careers of women poets, 29–30, 81–82, 89–90, 98, 186
Maryland slave law, 54–55
masculine voice, in Howe's "Coquette et Tendre," 191–92
"Master" poems of Howe, 123–27, 197–98
maternal metaphors, 216n. 8
May, Caroline, 1–2, 200
McCarthy, Joe, 6
memorization and recitation, effect of, 73
metonymies: of antebellum American women poets, 42–43; as bridge of public-private, 85–86; of ethos, 86–87; in learning dominant discourses, 19–23; metaphor compared to, 78–79; in rhetoric of sentiment, 18; in writing defiantly, 45–47. *See also names of individual poets*

"Mill-Stream" (Howe), 186
*Modern Medea* (Weisenburger), 64
morality of verse, 27–29
moral sentiment, 214n. 8
Morrison, Toni, 51–52, 71–75, 158
"Moses" (Harper), 59–60
"Mother Mind" (Howe), 35, 125–27, 197
mothers and motherhood: death in childbirth, 104; Howe's writing on pregnancy and childbirth, 35; *Letters to Mothers* (Sigourney), 99; in *Lucy Howard's Journal* (Sigourney), 98; in nineteenth century, 99; "The Slave Mother" (Harper), 51–52, 60–62, 64–65, 66–67

Native Americans, in *Lucy Howard's Journal*, 99–101
"Nature" (Longfellow), 127–30
Newton, Thandie, in *Beloved*, 74
Nichols, B. Ashton, 195
*Nineteenth-Century American Women Poets* (Bennett), 4

"O Captain! My Captain!" (Whitman), 175
odes, 87
Ohio slave laws, 66
"On a Prayer Book" (Whittier), 138–39
"On Being Brought from Africa to America" (Wheatley), 148

*Paradise* (Morrison), 71–73
Parker, Theodore, 112, 154, 217n. 10
"Parting Hymn of Missionaries to Burmah" (Sigourney), 175
partners, prospective, reading for qualities of character and spirit, 144
*Passion-Flowers* collection (Howe): audience for, 185; dialogue of, 187; male champions of, 198–99; "Master" poems, 123–27, 188, 197–98; publication of, 184; rhetorical aim, 195–96, 202–3; women's response to, 200–202

pathos, in current rhetorical studies vs. in sensationalist epistemology, 8
Peabody, Thomas H., 187, 197
Pendery, John L., 68–69
personae monologues, 57
personal pronouns, 178
personification, in backdrop for sentimental poetry, 174
persuasion, 3–5, 6, 9, 63, 139, 213n. 4
Peterson, Carla L.: "Doers of the Word," 76; on Harper, 42, 151–52, 156; on sentimental literature, 22, 84–85
*Philosophy of Rhetoric* (Campbell), 7
Poe, Edgar Allan, 79–80, 82, 127, 178–79
*Poems* (Howe), 115
"Poet, The" (Emerson), 151
poetry: conflations of literary with familiar activities, 22–23; definition of, 195; effects on the mind, 10–11; and elevation of sentiments, 23–24; and emotional healing, 44–45; liminal ethos, 54–57; persuasion in, 3–5, 6, 9; power of change and faith, 150–56; Schiller's four divisions of, 196; sentimental vs. romantic forms, 196; as subcategory of persuasion, 213n. 4; value of, in memorialization of great people, 105–6; work of, 174
"Poetry" (Sigourney), 1
Poliziano, 105
Pound, Ezra, 127
power: abuse of, and warped human relations, 137–38; of change and faith, poetry and, 150–56; codes of, in language of slave markets, 138; poetry as metaphor of, for women, 46–47; political, of sentimentalism, 201, 204; slave markets as matrix of, 150

*Power of Sympathy* (Brown), 11
"Power of Verse, The" (Short), 180
prostitution, 143
psychoanalytic paradigms, African Americans and, 45
psychological rhetoric, 7
public speaking, advocates for, 104
pulpit oratory, 218–19n. 6

race, critical reread of, 144–46
reading lists, modernists and, 6
"Reclaiming the Oh" (Collins), 130–31
religion and spirituality: Harper and, 151; in *Lucy Howard's Journal*, 99–100
religious discourses, poetic coquetry and, 33–35
*Reminiscences* (Howe), 200
resurrection, textual, in *Lucy Howard's Journal*, 105
"Return of Napoleon from St. Helena" (Sigourney), 162–63
rhetoric: Aristotle's classical definition of, 2; codes of, 169; empirical definition of, 9; as sentimental, 184; spirit of, 139–40. *See also* sentiment, rhetoric of
rhetorical bridge building between black and white women, 54
rhetorical prosopopoeia, 63
rhetorical ventriloquism, 56–57, 62–63
Richardson, Samuel, 170
romantic sentimentalism, 123
Royster, Jacqueline Jones: on African American women writers, 19, 51, 135, 145, 149; call to connect historical studies to today's rhetorical exchanges, 206–7; communicative goals in African American women's literacy, 41–42; on Harper, 41, 152; on listening to women's voices, 3
*Ruth Hall* (Fern), 173–74

*Sabbath Scene, A* (Whittier), 116–22; "A keen and bitter cry," *119*; "A lank-haired hunter," *118*; "The open window sill," *120*; "Plump dropped the holy tome," *119*; "To give it to the Devil!," *121*; "A wasted female figure," *117*
Schiller, Friedrich, 196
science of the human mind, new, 139
Scottish Enlightenment, 205
Sedgwick, Catharine, 200
semiotics, 169–71, 184–86
sentiment, moral, 214n. 8
sentiment, rhetoric of: and call to community, 176–78; dialogue in, 189–90; empiricism and, 170; as historic discourse, 4; as matrix for Longfellow's and Whittier's poetry, 131; metonymies in, 10–11, 18; rubric of Enlightenment rhetoric and, 78; Whittier and, 111
sentimental discourse, political implications of, 201
sentimentalism: codes and theorists of, 7–9, 169–70, 214n. 11; as construction, 214n. 13; Continental brand of, 198; conventions of, 171; as dominant discourse, 215n. 16; of 18th and nineteenth centuries, 5–6; Enlightenment roots of, 11; goals of, 141; lessons from logos of, 48; and male poets, 110–11, 127–28; and persuasion, 63; political power of, 201, 204; rhetorical aim or logos of, 20; as rhetorical and unstable construct, 107; romantic, 123
sentimental literature, 84–85
sentimental personae, ambiguity in gender and identity of, 114
sentimental semiotics and desire, 184–86
sentimental vs. romantic forms of poetry, 196

"Sentiments in a Sermon" (Sigourney), 86–87, 88–90, 103
Short, Lydia, 180
Sigourney, Charles, 81–82, 223n. 13
Sigourney, Lydia Huntley, 77; apostrophes, 168–69; curriculum for young women, 90–91; "Death of an Infant," 79–80; defiant writing of, 36–37; Dwight's review of autobiography, 180–82; as elegist, 76–77, 101–4, 221n. 1; on emotional effects of verse, 43; flexibly gendered ethos of, 78–79; focus on women's strength, 222n. 7; Hemans and, 83; "Imitation of Parts of the Prophet Amos," 91–97, 103, 168–69; instruction on memory, 8; interweaving texts with domesticity, 26–29; *Letters to Young Ladies*, 8, 88, 103–4, 182, 223n. 10; *Lucy Howard's Journal*, 25–29, 43, 79, 97–101, 221–22n. 2, 224n. 17; male persona of, 97; marriage and writing, 81–82, 89–90; needlework and writing, intersection of, 25–26; negative response by literary critics, 164–65; poems in memory of Hemans, 80–81; "Poetry," 1; popular appeal of, 82, 164; process and rhetorical context in pathos of, 165–69; as prophet, 95–96; response to Poe's charges of imitation, 84–85; response to treatment of "lower classes," 182; as sentimental preacher, 85–90; use of apostrophes, 163, 166, 171–74, 176–78, 180; use of metonymy, 18, 86–87; use of sentimental conventions, 163; voices of the undead, 105–7; Whittier's elegy for, 183; *Zinzendorff* collection, 174–75
Sigourney Circle, Chichester, Vermont, 180
Sigourney Society, 180
Silverman, Kaja, 21

Silverman, Kenneth, 181–82
"Slave Auction, The" (Harper), 137–41, 147–48
slave markets: as classrooms, 156–57, 159; codes of power in language of, 138; Harper's lessons on, 136–37; as matrix of power, 150
"Slave Mother, The: A Tale of the Ohio" (Harper), 51–52, 60–62, 64–65, 66–67
slavery: "Bible Defense of Slavery" (Harper), 144; Harper's work to heal wounds of, 136; Maryland laws, 54–55; Ohio laws, 66
Solomon, King, 192
"Song of Solomon," 185, 192–93
"Soul, The" (Harper), 142
Spillers, Hortense, 45, 157–58
"Stanzas" (Howe), 187
Still, William, 23, 30, 55–56, 142
Stowe, Harriet Beecher, 64, 69
syllogism, sentimentalism's lack of, 10
"Syrophenician Woman, The" (Harper), 143

tears: in "Imitation of Parts of the Prophet Amos" (Sigourney), 94–95; reader sympathy and, 116–17; in "Sentiment in a Sermon" (Sigourney), 88
textual discordance, defined, 91–92
textual surfaces, disruption of, 169
Thompson, Lawrance, 129
Thoreau, Henry David, 214n. 10
Todd, Janet, 167–68, 170, 176
transcendentalism, Howe and, 32, 112, 187
Transcendentalist Club, 187
transformative dialogue, sentimental strategies in tactics of, 207
"true womanhood," 86, 90, 97–99, 101, 111, 130, 148
Truth, Sojourner, 135–36
Tuckerman, H. T., 198

"Two Offers, The" (Harper), 39–40, 46–47
typography, agitated, 166–68, 170–71

Underground Railroad, 64–65
Underwood, E. H., 128
Unitarianism, 57, 151, 153–55, 226–27n. 5, 227n. 6
University of Oregon's Knight Library, 82

"Vashti" (Harper), 58–59
ventriloquism: Connor on, 220n. 12; as Harper's strategy of ethos, 70; magic of, 70–75; poetic, 51–54; rhetorical precedent for, 62–63; as tactic of nineteenth-century bridge building, 60–61; voices of, 57–60
voices: Connor on, 220n. 13; of Garner, 53, 61, 68–70; historic, projection of, 71; masculine, in Howe's "Coquette et Tendre," 191–92; of the un-dead, Sigourney and, 105–7; of ventriloquists, 57–60
von Arnim, Bettine, 33, 190

Walker, Alice, 71–73
Walker, Cheryl, 1, 2, 165, 188
Ward, Samuel, 115
Warhol, Robyn, 171
"Washday Rosary" (Howe), 31–32
Watkins, Gloria (bell hooks), 159
Watkins, William, 54–55
Weisenburger, Steven, 64, 68, 69
Welter, Barbara, 97–98
Wheatley, Phillis, 148–49
white sympathizers, 57–58, 141
Whitman, Walt, 127, 175
Whittier, John Greenleaf: marital status and literary career, 29; "On a Prayer Book," 138–39; rhetoric of sentiment and, 111, 131; *A Sabbath Scene*, 116–22; Sigourney and, 183, 230n. 16

"Wife, The" (Irving), 129–30
Williams, Gary, 186, 188
William Watkins Academy for Negro Youth, Baltimore, 54–55
Winfrey, Oprah, 51–52, 73–74, 74, 75
womanist, as term, 217–18n. 15
women, as resistant readers of Howe, 202
women college graduates, 39
women poets: courage to speak, 11–12; erotic sentimental, 188; Harper's lessons for, in "The Two Offers," 46–47; marriage, and publishing careers of, 29–30, 81–82, 89–90, 98, 186; sentimental, 47. *See also names of individual poets*
women preachers, 96
women's education, Sigourney as advocate for, 104
women's literary circles, 180
women writers: African American, self-presentation by, 52; antebellum, 23, 36, 40, 42–43, 45; apostrophes, implications for, 174–75; Royster on African American, 19, 51, 135, 145, 149; tension between writing and domestic expectations, 30
"Words for the Hour" (Harper), 135, 155–56
writing: costs of, for women, 29–35; defiant, 36–48; Kristeva on, 17; between lives, 25–29; marriage and, for women, 81–82, 89–90; what women want from, 24–25

*Yale Book of American Verse* (1912), 23
Yee, Shirley J., 122
*Young Ladies' Offering, The; or, Gems of Prose and Poetry*, 83–84

*Zinzendorff* collection (Sigourney), 174–75

WENDY DASLER JOHNSON is an associate professor of English at Washington State University Vancouver whose writing and research focus on cultural rhetorics of women and other non-dominant people. She has published articles in *Rhetorica, Rhetoric Review, South Atlantic Review,* and other journals.

# Studies in Rhetorics and Feminisms

Studies in Rhetorics and Feminisms seeks to address the interdisciplinarity that rhetorics and feminisms represent. Rhetorical and feminist scholars want to connect rhetorical inquiry with contemporary academic and social concerns, exploring rhetoric's relevance to current issues of opportunity and diversity. This interdisciplinarity has already begun to transform the rhetorical tradition as we have known it (upper-class, agonistic, public, and male) into regendered, inclusionary rhetorics (democratic, dialogic, collaborative, cultural, and private). Our intellectual advancements depend on such ongoing transformation.

Rhetoric, whether ancient, contemporary, or futuristic, always inscribes the relation of language and power at a particular moment, indicating who may speak, who may listen, and what can be said. The only way we can displace the traditional rhetoric of masculine-only, public performance is to replace it with rhetorics that are recognized as being better suited to our present needs. We must understand more fully the rhetorics of the non-Western tradition, of women, of a variety of cultural and ethnic groups. Therefore, Studies in Rhetorics and Feminisms espouses a theoretical position of openness and expansion, a place for rhetorics to grow and thrive in a symbiotic relationship with all that feminisms have to offer, particularly when these two fields intersect with philosophical, sociological, religious, psychological, pedagogical, and literary issues.

The series seeks scholarly works that both examine and extend rhetoric, works that span the sexes, disciplines, cultures, ethnicities, and sociocultural practices as they intersect with the rhetorical tradition. After all, the recent resurgence of rhetorical studies has been not so much a discovery of new rhetorics as a recognition of existing rhetorical activities and practices, of our newfound ability and willingness to listen to previously untold stories.

The series editors seek both high-quality traditional and cutting-edge scholarly work that extends the significant relationship between rhetoric and feminism within various genres, cultural contexts, historical periods, methodologies, theoretical positions, and methods of delivery (e.g., film and hypertext to elocution and preaching).

**Queries and submissions:**
Professor Cheryl Glenn, Editor
E-mail: cjg6@psu.edu
Professor Shirley Wilson Logan, Editor
E-mail: slogan@umd.edu

**Studies in Rhetorics and Feminisms**
Department of English
142 South Burrowes Bldg.
Penn State University
University Park, PA 16802-6200

*Other Books in the Studies in Rhetorics and Feminisms Series*

*A Feminist Legacy: The Rhetoric and Pedagogy of Gertrude Buck*
Suzanne Bordelon

*Regendering Delivery: The Fifth Canon and Antebellum Women Rhetors*
Lindal Buchanan

*Rhetorics of Motherhood*
Lindal Buchanan

*Conversational Rhetoric: The Rise and Fall of a Women's Tradition, 1600–1900*
Jane Donawerth

*Feminism beyond Modernism*
Elizabeth A. Flynn

*Women and Rhetoric between the Wars*
Edited by Ann George, M. Elizabeth Weiser, and Janet Zepernick

*Educating the New Southern Woman: Speech, Writing, and Race at the Public Women's Colleges, 1884–1945*
David Gold and Catherine L. Hobbs

*Women's Irony: Rewriting Feminist Rhetorical Histories*
Tarez Samra Graban

*Claiming the Bicycle: Women, Rhetoric, and Technology in Nineteenth-Century America*
Sarah Hallenbeck

*The Rhetoric of Rebel Women: Civil War Diaries and Confederate Persuasion*
Kimberly Harrison

*Evolutionary Rhetoric: Sex, Science, and Free Love in Nineteenth-Century Feminism*
Wendy Hayden

*Liberating Voices: Writing at the Bryn Mawr Summer School for Women Workers*
Karyn L. Hollis

*Gender and Rhetorical Space in American Life, 1866–1910*
Nan Johnson

*Appropriate[ing] Dress: Women's Rhetorical Style in Nineteenth-Century America*
Carol Mattingly

*The Gendered Pulpit: Preaching in American Protestant Spaces*
Roxanne Mountford

*Writing Childbirth: Women's Rhetorical Agency in Labor and Online*
Kim Hensley Owens

*Rhetorical Listening: Identification, Gender, Whiteness*
Krista Ratcliffe

*Feminist Rhetorical Practices: New Horizons for Rhetoric, Composition, and Literacy Studies*
Jacqueline J. Royster and Gesa E. Kirsch

*Rethinking Ethos: A Feminist Ecological Approach to Rhetoric*
Edited by Kathleen J. Ryan, Nancy Myers, and Rebecca Jones

*Vote and Voice: Women's Organizations and Political Literacy, 1915–1930*
Wendy B. Sharer

*Women Physicians and Professional Ethos in Nineteenth-Century America*
Carolyn Skinner

*Praising Girls: The Rhetoric of Young Women, 1895–1930*
Henrietta Rix Wood